SLIEVE DONARD'S DOMAIN

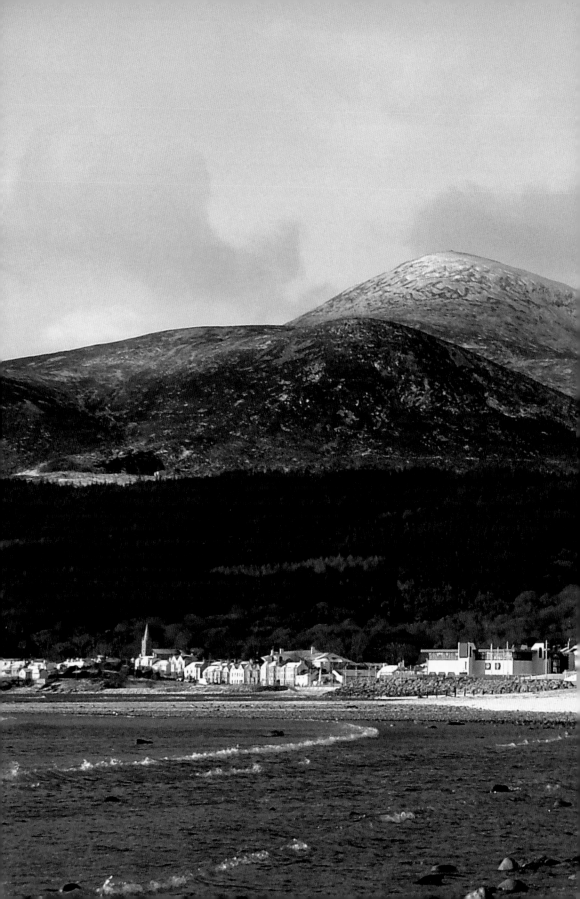

SLIEVE DONARD'S DOMAIN

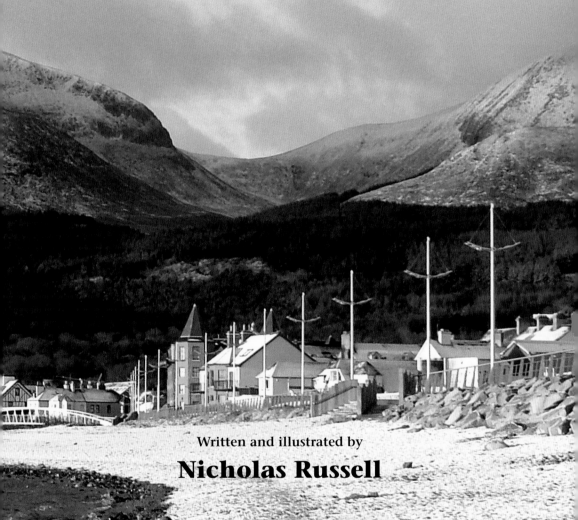

Written and illustrated by

Nicholas Russell

Ballaghbeg Books

First published 2011
by Ballaghbeg Books, Newcastle
Email: russelltollymore@gmail.com

Text © Nicholas Russell
Photographs © Nicholas Russell
Photographs on pages 93, 97 and 139 as credited
Maps on page vi and 245 reproduced from the OSNI
with the permission of the Controller of HMSO
© Crown copyright, date 25th February 1955.

ISBN 978-0-9557922-2-9 HB
ISBN 978-0-9557922-3-6 PB
A catalogue record for this book is available from the British Library

Printed by Hudson Killeen, Blanchardstown, Dublin 15

Frontispiece: Slieve Donard from Newcastle beach
Slieve Donard Hotel

CONTENTS

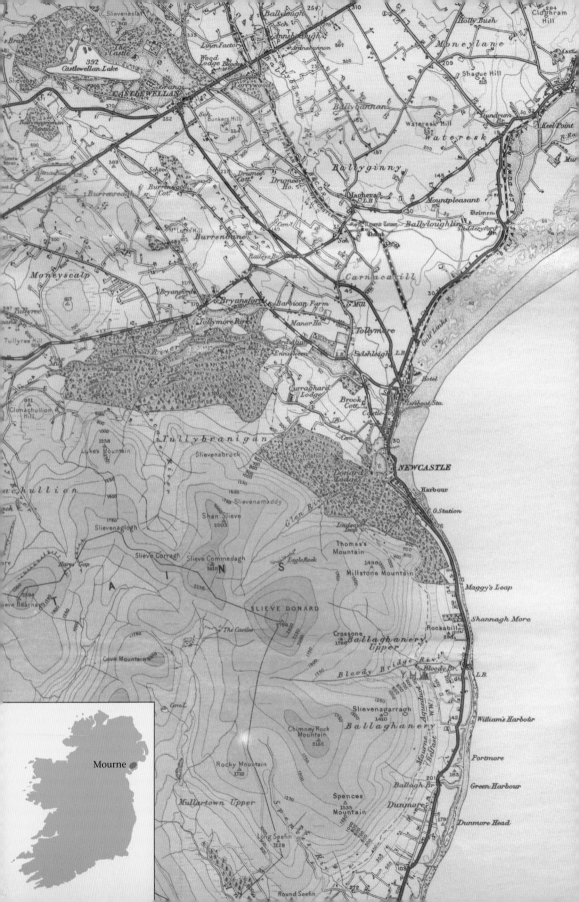

For my parents Patrick Aloysius Curran
and Maureen née Sawey

GETTING TO THE TOP
OF SLIEVE DONARD

'The glory of Co. Down, and of Newcastle in particular, is the grand mountain-range that towers over the plains of Lecale and Iveagh, and over the Irish Sea.'
OFFICIAL GUIDE TO COUNTY DOWN AND THE MOURNE MOUNTAINS; ROBERT LLOYD PRAEGER, 1898

One of the most interesting descriptions of a climb to the top of Slieve Donard is that given by the great Irish scholar, John O'Donovan who was collecting the Irish names of the mountains for the ordnance survey. He climbed Slieve Donard on Tuesday 23rd April 1834 and on his return sent a report to survey headquarters at Phoenix Park, Dublin. He climbed Donard from the harbour and followed the stream called Amy's river which flows down from above the quarry, along the side of Kennedy's Hill, King Street, then under Condy's bridge and into the sea.[1]

'When at Newcastle, I had imagined that I could run up to the top of it in a few minutes, but I soon learned that I had to climb a mountainous region never since the creation subdued by the hand of cultivation and never to alter its primeval features until the world shall be resolved into its ultimate elements. The ascent from Newcastle is difficult and dangerous in consequence of the rocky and steep surface of the passage which leads to the base of Slieve Donard. In this passage you are guided for the distance of a mile by a mountain stream now almost dried up, but in winter precipitous and large as its wide and (well washed) rocky channel sufficiently shows. This stream is said to divide the Millstone Mt from Thomas Mt, two very high mountains situated at the base of S. Donard to the N.E. & N. and originally considered a part of it, before these mountains received separate names. When you arrive at the source of this stream, you turn towards the west a little above the summit of Thomas' Mt where the ground though rugged and full of holes becomes comparatively level. This is called *(The top of the hill)* by the country people, who do not include it in the Millstone Mt, Thomas's Mt, or Slieve Donard. From this place Donard is seen, towering majestically and awfully above the neighbouring mountains, which, though they present a grand appearance from Newcastle, *here* sink into comparative insignificance, not because they are so much lower than Donard, but because that mountain is

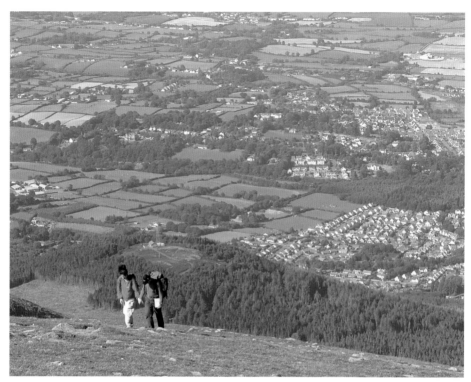

Getting to the top

magnified and rendered stupendous by its (overhanging) contiguity, and the others diminished by distance and comparison.

Up this steep and rocky passage I skipped from stone to stone with the agility of a goat, but was obliged to wait for my guide whom age had rendered less vigorous. I gained the top and looked in every direction, astonished! Amazed! 'Till contemplation had her fill!!'[2]

For those who likewise wish to experience O'Donovan's amazement, the routes to the top of Slieve Donard are now well established. Good mountain boots to help you safely to the top have improved immeasurably over recent decades. Awareness of the need to dress sensibly and be prepared for a change in weather is a call wisely and widely listened to nowadays by the prudent. Indeed, with so many aids making the journey to the top easy, including the comforting reassurance of a mobile phone lest one might need help, we might be forgiven if we were blasé about an ascent to the summit. It wasn't always so simple of course.

For a climb to the top of Donard in the Victorian era a man might take off his jacket and roll up his shirt sleeves but women were seriously hampered by their full length skirts. The expectations of how long a climb would take have greatly changed from those given by a roving correspondent in August 1874.

The granite trail follows the line of the narrow gauge railway that formerly brought granite down to the harbour from the quarry above

'The time taken in climbing to the summit is usually from three to four hours, and the descent is nearly as long a task. Well trained climbers may ascend in two hours and a half; and there is a resident of Newcastle who, leaving home at one o'clock, visits the mountain-top and returns punctually at five; this being regarded as a feat beyond emulation.'[3]

The Slieve Donard Race

Races to the top of Donard were likely part of a warrior's training in millennia past. One of the old names for the part of the strand near Dundrum was 'the shore of the champions' because it was here that the youth of the ancient Ultonians were trained in wrestling and the race. Mountain races are a truly formidable test of fitness and stamina.

The tradition of a regatta and sports day at Newcastle began in 1894. The main events at that time were, unsurprisingly, nautical. The main sailing race saw boats racing over an eight mile course towards a marker at the Annesley Arms hotel, onwards to Dundrum bar and then to Stag rock before returning to the harbour. The rowing races were fiercely contested too as reputations were made and lost. Visitors without a nautical background looked forward either to the tug of war or to the horse racing which was confined to animals whose owners resided within a twelve mile radius of Newcastle station.[4] The first prize of £5 was then a lot of money. The regatta organisers were always trying to make the day an interesting and exciting one. Frequently visitors were disappointed when lack of wind made the boat races uninteresting.

In 1903 the sports were under the auspices of the local employees of Messrs Fisher & Le Fanu who were the contractors then rebuilding the ruined south pier of the harbour. A unique event was now introduced. It was the first go-as-you-please race up to the top of Slieve Donard. Entries were taken only from Messrs Fisher & Le Fanu's men and no fewer that twenty-nine turned out. The competitors were permitted to select what route they pleased and either run or walk to the top of the mountain; then, to descend at the Bloody Bridge and walk the two miles along the Ballagh road back to Newcastle. There were two checking stations, one, of course, at the top of the mountain and another at the Bloody Bridge. After the first mad rush about half dropped out. The race was won by J. Trimble in one hour twenty-eight minutes, closely followed by W. Johnston in one hour twenty-nine minutes.[5]

The classic annual Donard race has continued unbroken since it started in 1945. Over the years the race has seen many routes. In 1945 and for many years thereafter the race followed the format of the original Fisher & Le Fanu race in that it was known as a 'go as you please' event where the runners started at the Newcastle rural council office and the only checkpoint was the mountain summit. In intervening years the descent to the Bloody Bridge with the reserve draining

A runner in training on top of Shan Slieve

2.7 miles along the coast road was introduced. In 1998, the decision was taken for safety reasons to revert to the original up and down route starting at the Newcastle Centre and back to Donard Park. However, since 2003, and in order to allow more spectators to see the finish, the race has reverted to its original 1945 format and starts and finishes at the Annesley Buildings. The most successful competitor in the race's history is Deon McNeilly who has won the race nine times and has numerous other placings. He was the first to complete the race in under an hour, a feat he accomplished in 1998 with a time of 55.08 minutes. Deon smashed through Mike Short's record of 1 hour 4.14 minutes which had endured for twenty-one years since it was set in 1977.[6]

The 2000 race was also a British championship race which was won by Ian Holmes in 50 minutes 30 seconds, the fastest ever up and down, though the finish was in Donard Park. Since then, and with the finish being returned to Newcastle Centre, comparing record times has been a bit problematic. A notional time of 2 minutes 30 seconds, the usual time taken by elite runners, is now added to Ian Holmes time to 'extend' his race to the Centre. This gives him a time of 53 minutes and makes him still the outright winner. Notional times don't count though and it is unfortunately necessary to make distinctions between the records for the two courses.

A new course record for the Slieve Donard race was set in 2010 when Stephen Cunningham of the Mourne Runners finished the race with a time of 54.33

minutes. The present ladies record holder is Charlene Haugh who finished with a time of 65.26 minutes in 2009. There are races within races and increasing interest is focused on the descent time. 2010 was the third year in a row that a new record for this part of the race was posted with Stephen Cunningham taking the honours. 'Bogman' reported on the event for the *Mourne Observer* with his usual impeccable humour.

> 'Stephen also picked up the fastest descent award with a new record time of 16 minutes 42 seconds, yes dear readers, that is from the top of Slieve Donard to the Newcastle Centre, without the help of any mechanical aids.'[7]

One can only admire the stamina, sure-footedness and nerves of steel of competitors as they fly back down the mountain side purging from their minds the horrible consequences of the slightest misjudgement or missed step on stony ground. The stones and scree on the upper slopes of Donard, the rough heather that hides treacherous holes, the gully of the Black Stairs and the projecting tree roots all along the banks of the Glen River are ankle hazards at the best of times. It is no wonder that the masters of the fast descent have been described as a special breed. When Gary Bailey broke through the 17 minute barrier in 2009 with a descent time of 16.59, it was an awesome, even frightening, accomplishment. Now Stephen has set the descent time at 16.42.[8] A feat beyond emulation? The rest of us poor mortals, however, have probably over the years considered easier ways of getting to the summit and back down again. Thoughts have even turned to rail and car.

A railway to the top of Donard

Many ideas for the improvement of Newcastle were mooted at the start of the 1900s. A sober *Down Recorder* noted that among the 'somewhat chimerical schemes...opened up by irresponsible Belfast correspondents' was the hope of seeing excursion boats plying to the new pier, streets lighted by electricity (there were only a handful of lights then in the whole town), a good military band on the promenade, a fleet of pleasure boats and motor launches in the bay, motor cars running to Bryansford and the Bloody bridge and a cog railway up Slieve Donard.[9] In Wales, the first sod for the Snowdon mountain tramroad was cut on 15th December 1894. Many alpine railways were already in existence at this time but the Snowdon railway to the 3,560 ft. summit was the first in Britain. The following year Snaefell mountain, the 2,034 feet high centrepiece of the mountainous northern half of the Isle of Man, was reached by a mountain railway on 21st August 1895.[10] Despite the charges of irresponsibility, the possibility of a railway, if not the money, was certainly there.

'Are we nearly there yet?'

The idea of a railway to the top of Donard first got serious consideration at the end of the 1920s. The Newcastle urban council asked the clerk of the council to reconnoitre a route. At this time the council did not have much money to hand and could ill afford to have a route professionally surveyed. As the clerk had formerly worked with the Belfast and County Down Railway, the council decided to ask him to check out a possible route and give an unofficial recommendation[11]. The clerk was already on the council payroll so this arrangement cost the council nothing. The first expedition to the top of Slieve Donard had to be called off on account of descending cloud but a successful ascent was made the following day,

The east slope of Donard up which an early railway was contemplated

when, accompanied by his young son Patrick, a route following the existing bogie line to the quarry and above was checked out. The best possibility was a clockwise spiral route above the quarry up the conical slope of the mountain to the summit. There is no record of official council deliberations about a mountain railway. It was likely realised early on that no matter how desirable the project, it was utterly beyond the council's financial means. Cautious councillors would have been loath to antagonise the ratepayers with such an ambitious scheme when they were already paying the large loan for the town sewerage. The council were probably also mindful of how the novel switchback railway behind the Slieve

Donard hotel had come and gone some thirty years earlier. Further consideration of the scheme was deferred and the great depression of the 1930s followed by war left the idea in abeyance.

By the mid 1950s the urban council was suggesting a scenic railway along the lines of that at Snowdon, costing then about £30,000. Hopes rose to such a height that by 1957 the possibility of even a helicopter service was being reviewed. 'Helibuses may take tourists to mountain top' was the heading in the paper[12]. One of the merits of the 'hover' service was deemed to be its flexibility. Tourists could be brought directly from Nutts Corner Airport, as it then was, to Newcastle.

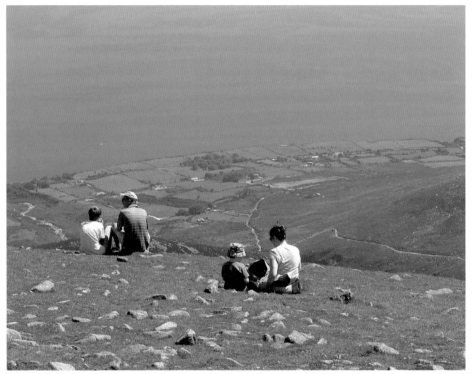
Enjoying the view and a well deserved rest on Donard's summit

'It would put us ahead of all the other resorts', said one businessman, 'and it would bring the peak to within five minutes of the beach. What a plateau for picnics in the summer!'[13]
Nothing came of it.

The notion of a railway to the top of Donard resurrected twice during the 1960s. In June 1963 the urban council were given a quote of £117,000. The outlay on equipment for the scenic railway was put at £78,000 plus £39,000 for civil engineering works. This scheme became known as the aerial railway as it was based on chairlifts. It was to be 9,450 feet long, and was comprised of thirty-six

four-seater cabins capable of taking two hundred and fifty people to the summit and back in an hour.[14] This scheme foundered on the concerns of the ratepayers. Despite the support of the council, too many townspeople believed that the chair-lift would never justify itself and would ultimately prove a burden rather than a blessing. The tourist board noted the lack of support and quietly dropped the idea.[15]

November 1965 saw a variation of the aerial railway emerge again. The chairman of Newcastle urban council informed the monthly meeting that the county surveyor, Mr C.A. Craig, was investigating an ambitious tourist attraction. The proposal was to construct a scenic mountain road above the Bloody Bridge leading to a mountain car park and then possibly laying a chair lift to the summit of Slieve Donard. The new road was to follow the line of existing road leading to the quarries at the top of the Bloody Bridge valley. A bridge was then to be erected at this point just below the first quarry and the road to continue to a height of 1,786 feet above sea level ending at Crossone plateau. This was considered the best place for the car park and panoramic views would be available. From here the summit of Slieve Donard was only about a further half-a-mile and 1,000 feet higher up. A chair-lift from the car park to the summit was not thought to be too difficult to erect. The council and the tourist board were enthusiastically behind the idea. In announcing the proposal, the general manager of the tourist board declared 'we see no conflict with the aesthetic protection of the Mournes in such a scheme'.[16] Local landowners pointed to the poor local road infrastructure and were far from enthusiastic. Some locals warned about the hazards of strong wind on chairlifts and the salt corrosion that would come from proximity to the sea and others pointed to the frequency with which cloud obscured the summit yet at least two men's wages would still need to be paid no matter what the weather conditions. Whether on account of opposition or lack of government funding, the scheme did not progress. We should remember that the town ratepayers were faced with two other major schemes at that time, namely the widening of the main street and an extension to the Annesley Mansions. Both of these other schemes did take place.

The apparently irrepressible plan for a mountain railway surfaced again during the 1980s and 1990s. This final saga was quite protracted. It got the name of 'funiculaire railway' as it was akin to the little railway to the top of Montmartre and Sacré Coeur at Paris. This railway was to start at King Street and follow the old bogie line to the quarry and thence to the top of Donard. There were great plans for a restaurant at the summit which would be embedded into the rock so as not to be too obtrusive yet would offer magnificent panoramic views. In the search for funding however from both the EU and government, Down district council had to place the scheme within the context of numerous other activities for improving tourism in South Down. Former councillor, Michael Boyd, told me of many meetings with a multitude of consultants as various proposals were tabled, costed,

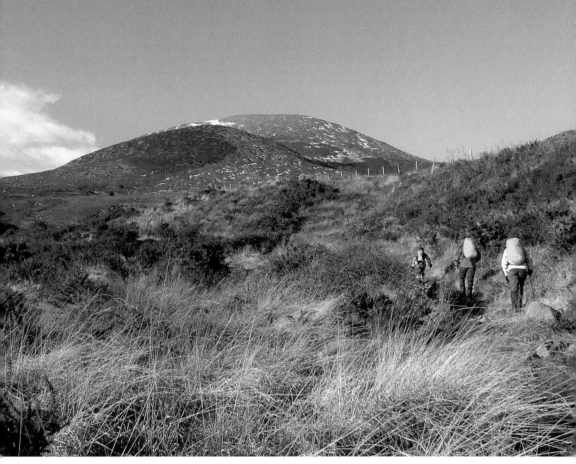

A road was proposed up the Bloody Bridge valley with a car park on top of Crossone, seen here below a snow flecked Donard

queried and put back for revision. The funiculaire railway idea dragged on and on but occasional letters of opposition in the press were sufficient to show a lack of full local support and funders finally turned away. The prospect of an easy ride to the top of Donard has now probably receded for good and walking boots will be needed from now on. Anyway, the view at the top will always be sweeter when one has expended energy to get there.

The first car to the top of Slieve Donard

It may surprise readers to know that the first car to the top of Donard successfully made the journey about 1959. The idea was a publicity venture for one of the larger Belfast garages who held a franchise for Haflinger vehicles. The Haflinger was a small, lightweight, four wheel drive off-road vehicle made by the Austrian firm of Steyr-Daimler-Puch. Certain features were to the vehicle's advantage in this gruelling test; it had an exceptionally low centre of gravity due to low placement of the chassis. Front and rear differential locks enabled the Haflinger to make progress even if only one wheel was in firm contact with the ground. The centre of the axle was designed above the centre of the wheel remarkably

increasing ground clearance. This was important as the trial would have been quickly over if low clearance had allowed a boulder to damage underneath. Finally in the vehicle's favour was its fully independent suspension which permitted a generous amount of free movement to each half-axle. In the 1950s there could be no more demanding test of a vehicle's off road capabilities than a drive to the top of Slieve Donard. Accordingly, on the day selected a photographer and members of the press were invited to watch this extraordinary challenge. The Haflinger started off from the Bloody Bridge. It had the advantage of being able to avail of the road to the quarry which was at the very head of the valley. The real test then started once it left the quarry to continue a slow but steady climb to the top. We should remember that the slope was not then as degraded by erosion as it sadly is now after the passing of tens of thousands of visitors' feet. Anyone who has ascended to the summit of Slieve Donard by this route would be only too aware of the taxing severity of the gradient and the need to carefully watch where you put your feet. The Haflinger edged forward and upward. The author's father, Patrick, who had been present as a child at the selection of a possible route up the mountain for a railway, was one of the press representatives who now witnessed the Haflinger's remarkable accomplishment.[17] He recalled that the vehicle did indeed have a number of difficult moments but these were usually overcome by reversing a little and taking a different angle. Photographs were duly taken at the top to mark the success and the Belfast garage was very happy. The Haflinger safely returned back down the mountain.

The Ice House

Walkers going to Slieve Donard via the Glen River valley will see the igloo shaped top of the ice house on the other side of the river as they approach the end of the forest. This relic of landlord days was built, it is thought, sometime between the 1840s and 1850s to serve the needs of Donard Lodge.[18] In those days before refrigeration, it was necessary to either salt, pickle or smoke food in season to preserve it for leaner times. Only the rich were then able to afford a custom built cool house. Until fridges became widely available in the 1960s most houses used a pantry box with a fine mesh door which was hung on a wall in the coolest part of the house.

In the building of the ice house the side of the hill beside the river was dug out, a drain laid down and then walls of finely dressed granite built up in circles. Each course of granite was progressively wider than the one below so that the house resembled an inverted egg. The cupola of the ice house was finished in brick with a ventilation hole left at the very top. The rough granite cladding that can be seen on the outside disguises the fine workmanship and dressed stone of

The final stretch to the summit which was negotiated by the Haflinger vehicle

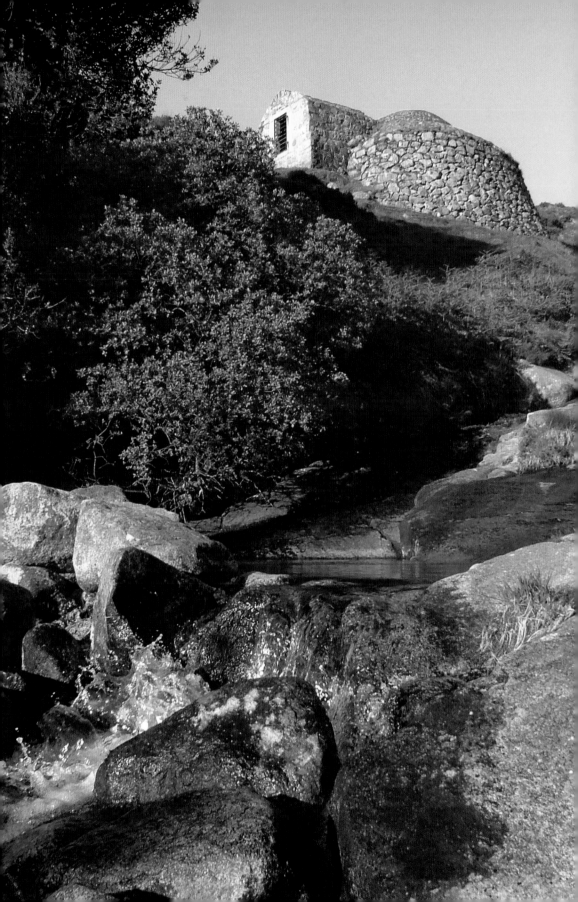

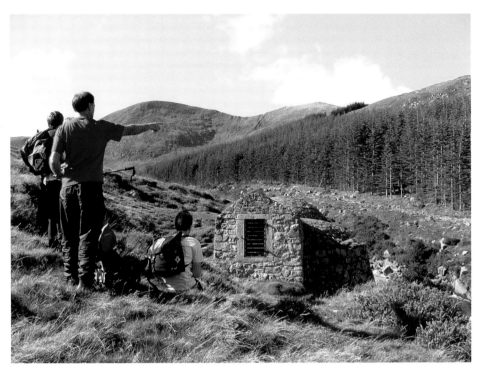

The ice house is worth a second look

the interior. Indeed, the building of the outwardly tapering walls called for masons of some considerable skill. When built, the exterior walls were covered again with earth to provide further insulation. Decades ago it was not unknown for certain walkers to defy the dangers and using the recessed hand and footholds cut into the granite of the interior walls, descend to the bottom of the ice house in order to light up their primus stove and make a cup of tea.[19] When refurbishing the ice house in the 1990s, the National Trust replaced the need to use these handholds by bolting in a twenty rung metal ladder. The building as seen at the moment as one passes by is quite deceptive. There is as much again below the surface that cannot be seen. A locked grill now guards the entrance but formerly there were three doors along the entrance passage way acting as temperature barriers to stop warmer air getting in.

The presumption has been widespread that the ice house was filled with ice from the Glen River. Some ice may indeed have come from the Black Stairs on the rare occasions that it froze but having visited the area during a prolonged cold spell I have found the Glen River to be just too fast flowing to freeze. Most of the ice was probably obtained by rolling snow down the slopes making large snowballs that were then lifted into the ice house and solidly packed down.

Ice house as seen from the Glen River

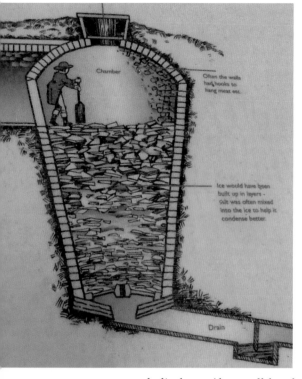

Chamber

Often the walls had hooks to hang meat etc.

Ice would have been built up in layers - salt was often mixed into the ice to help it condense better.

Drain

Weather, of course, was much colder decades and centuries ago. The ice house is worth a second look and it is possible to look inside from the former ventilation circle on top of the dome.

Early hunters

Weather permitting there is much to muse on as one takes a rest at the top of Donard. Certainly thousands have passed this way over the millennia. Neolithic man, explorers, St Donard, pilgrims, Vikings, perhaps John de Courcy, Earls and Marquis, outlaws and fugitives, shepherds and smugglers, soldiers and surveyors, the wall builders and botanists, engineers for the water commissioners, miners and tunnel navvies, American G.I.s and Royal Navy sailors on shore leave from ships of the channel fleet in Dundrum Bay, fleeting runners and climbers. Above all by the thousands there have been the visitors, sight-seers, day trippers and tourists from eminent Victorian ladies and gentlemen to mill girls treasuring the fresh air during a precious brief excursion from the little streets and grinding mills of smoggy Belfast.

New insights to early man in Mourne continue to be made since professor Evans wrote sixty years ago,

'We may suppose that the hills were visited for their berries and abundant game, but I cannot think that there was ever anything more than temporary squatting above the tree line. I have never picked up a scrap of flint or any other relic of prehistoric man among the High Mournes.'[20]

About 1985, Mourneman Jimmy Moore was coming to the end of a long walk in the mountains. He had crossed the top of Slieve Muck and was following the Mourne wall down the steep slope towards the valley below when he decided to take a break and enjoy the panorama before him. As he sat on the ground below the buttress some yards to the north of the wall taking his refreshment, something unusual beside him caught Jimmy's eye. From the open slope he picked up a beautifully worked Neolithic flint spear head, albeit with one tang broken. When he showed it to me twenty-five years later, it was still obviously an item he deeply treasured and a wonderful memento of a day's walk in the Mournes. Jimmy had found the flint that eluded professor Evans.

Thousands have come to the top of Slieve Donard. Here two walkers enjoy a rest

Anyone who has ever hunted wild animals, or more likely, tried to photograph them without the aid of a telescopic lens, will know that they are exceedingly wary and will move off long before you get anywhere near them. Similarly, trying to approach within effective arrow or spear range presented obvious problems for prehistoric man on the wide open slopes of the mountains as the quarry was likely to notice any approaching hunter and disappear in plenty of time. The location of the flint find below the buttress of the Slieve Muck escarpment points towards a particular hunting technique, showing astuteness on the part of the prehistoric hunters and a sound knowledge of the topography.

The hunters had two possible options. In the first scenario some would take hidden positions on top of the Muck escarpment while companions below both flushed game up the Yellow Water valley (Bann Road) from the south and other hunters showing themselves towards the east at Slievenaglogh gradually manoeuvred the nervous animals high up the east slope of Slieve Muck until they were hemmed in by the cliff face and had to escape a hail of spears from the hidden hunters above.

In former days deer and pig would have been part of the menu for the early hunters. The mountains then would have looked a lot different. As the eminent

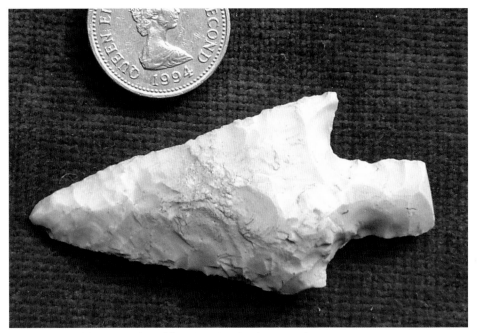

A finely worked flint spear-heard found under the Slieve Muck escarpment

botanist of the Mournes, Robert Lloyd Praeger, tells us, 'trunks and roots of the Scotch fir are dug out of the bogs up to 1000 feet elevation, far above the limit at which it will now grow'.[21] Slieve Muck means 'mountain of the pigs'.[22] Wild boar were a prime food source for Ireland's first people, the Mesolithic hunters, but the boar went extinct in Neolithic times probably as the farmers cleared the forest.[23]

The second and more feasible plan also posits group cooperation to make a successful hunt and indeed, the use of hunting dogs would have made it much easier still. With some people blocking escape down the White Water valley between Pigeon Rock and the escarpment edge of Slieve Muck, others would encircle the Spelga valley from the north. Any animals grazing there would then be frightened towards the south and coming against the human barrier would be deliberately forced to move up the western slope of Slieve Muck where the river Bann has its source. As the hunters and possibly dogs closed in from the north the trap was set. Animals trying to escape either went over the edge of Slieve Muck escarpment to certain death or risked being speared trying to break through the encircling cordon of hunters. In the event of a successful hunt a missing spear could be easily overlooked in the ensuing excitement of celebration or we could simply imagine the spear flying over the cliff edge onto rocks below, breaking the tang and detaching itself from the shaft and becoming lost. The mechanics of the hunt are my conjecture based on local topography but the beautifully worked spear head remains mute testimony that prehistoric man hunted the high Mournes.

The escarpment of Slieve Muck which was exploited by prehistoric hunters

Small Passage Grave with Cairn on slopes of Slieve Donard

Once while searching along the eastern rim of Slieve Donard for possible sites for smugglers' signal fires, I noticed a substantial pile of stones. I thought it might be a cairn built by early pilgrims but I was puzzled why it was so separated from the others in front of St Donard's cairn. Only as I walked around the pile, putting the sun behind me so that I could photograph it, did I notice what appeared to be parallel lines of edging stones. A similar line of stones was mentioned by Professor Evans as present at the summit cairn of Slieve Donard.

> 'There are several small cairns, too, on the site of 'the Great Carn', the summit cairn of Slieve Donard, but all that can now be seen of the grave or 'cell' it once covered are two parallel rows of upright slabs, possibly part of the passage that led into the grave.'[24]

I have been unable to find the parallel rows that Evans referred to. Perhaps they were part of the slight trough immediately behind the summit cairn but were pulled out by some visitor to throw up on top of the cairn? Much has obviously changed in the intervening sixty years since Evans wrote about the stones. As to the short row of parallel stones leading into a small cairn to be found a little way down the slope of the eastern rim, I hope this site may receive due archaeological attention before too long. Facing east out over the Irish Sea, the possible alignment of these stones with the winter solstice raises the most interesting speculation.

19

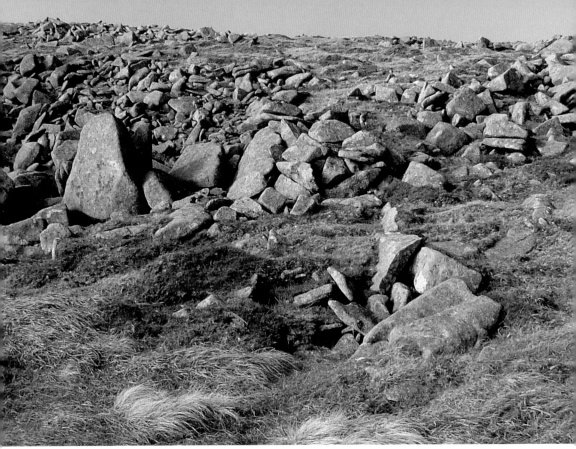

Parallel stones leading to a small cairn. The passage alignment is towards the rising winter sun

Wells on top of Slieve Donard

When the ordnance survey worker and great Irish scholar, John O'Donovan, climbed Slieve Donard on Tuesday 23rd April 1834, one of his reasons for doing so was 'to wash off in S. Domangard's well the many sins I had committed by cursing dogs, ganders, over inquisitive people, and petty country landlords.'[25] Although no springs of water are to be seen now on the summit, weary climbers who have brought refreshment with them might be amazed to know that in the past there were not one but two wells on the top of Donard.

Some years ago after a long dry spell of weather, I undertook a climb to the top of Slieve Donard. For a change I varied my route and went straight up the front as viewed from Newcastle. I recall promising myself that I would not come this way again as the slope was a continuous pile of boulders, some of which were unstable underfoot and therefore dangerous to walk on. I particularly recall my surprise when I was almost at the top. Just before the skyline allowed a view of the front cairn I heard the sound of water vigorously flowing below the boulders. I could not see or access the water to take a drink but was astonished that after the extended period of drought, water of any nature should be flowing with such

hearty energy so close to the summit. This enthusiastic act of nature was first mentioned in 1744 by Walter Harris, who in his description of Slieve Donard stated, 'From the Northern Brow of this Mountain issues an exuberant Fountain, which emits more than half a Foot of Water immediately, rapid, and pure'.[26]

The water on the top of Donard had the discerning approval of Mary Delany, one of the great personalities of eighteenth century Down. She wrote about a walk she took with her goddaughter in September 1758.

'The castle of Dundrum is a ruin on a very steep rude shapen hill, a vast extent of the sea, on which were several vessels, chiefly fishing-boats; and the vast mountains of Moran [Mourne], which are so near us that we can perceive the rivers which run down the side of them. The highest mountain, they say, is a mile and half perpendicular, and on the top of it is a well of fine water'.[27]

Fifty years after Harris, Rev Francis Chambers left us an account of his visit to the top of Donard in 1795.

'...and taking off my shoes, by the help of the growing heather, climbed its steep and craggy side from one rock to another till at last we gained Donard's top where there is cairns or rather pillars seemingly for devotion, where there is considerable space level. As could be expected in such a place in the centre of which is a well of good water of which I drank and on turning towards Lecale I was somewhat lost in surprise as St John's Point seemed to stretch as far into the sea as isle-a-Long does from Lecale.'[28]

We owe our best understanding of the fate of the wells at the top of Donard to John O'Donovan, the collector of place-names for the ordnance survey. Writing in 1834 to the head of the ordnance survey, Sir Thomas Larcom, he gave his opinion for the disappearance of the wells.

'As the prospect from the Summit of this mountain is so well known, as you yourself have been on it, I shall avoid foolish descriptions, but I cannot avoid writing down a few thoughts that struck my mind very forcibly. There are two circular *cairns* on its summit, one to the

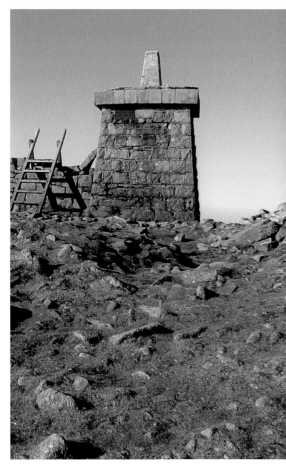

This hollow behind the summit cairn may have been part of the passage leading into the original grave built by Neolithic man

21

N.E., and the other to the S.W., the former is now much destroyed, and the well which my guide informs me was *springing* in the centre of it filled up with stones. This, he says, was done by the *Sappers*. If it were they who filled this well with stones they seem to have had very little to do! But my opinion is that it was done by some *devout* visitor, who thought it his duty to destroy every vestige of Superstition. The *cairn* to the S.W. is much more perfect, but

St Donard's cairn which overlooks Newcastle and Maghera. There was once a well near here

destroyed in a great measure to erect the Trig. Station, which in the course of ages may puzzle antiquarians to discover its scientific use. The well in this cairn is now dried up and I can scarcely believe that it ever contained Spring water. To the East of the well there is a stone, which to me appears to have been used by the Saint as an altar, and it would also appear probable that he had roofed this *cairn* and used it as a little 'chapple'. This conjecture is corroborated by the fact that Sir William Petty called it a Chapple, and Colgan a *church*. I am also of opinion that this cairn had been originally used as a druidical place of worship and that the hermit took advantage of the pile [as the Sappers have of the chapple] to form a little (house and) place of worship for himself and his visitors.'[29]

It is interesting to note O'Donovan's emphasis that the well was 'springing'. It wasn't just a hole that rain water had gathered in.

O'Donovan had his doubts that the sappers were to blame for filling in the well and I can only agree. It would have been very much in the sappers' interest to protect rather than destroy their water supply. As there was no well or spring extant at the time of O'Donovan's visit and on account of him making particular

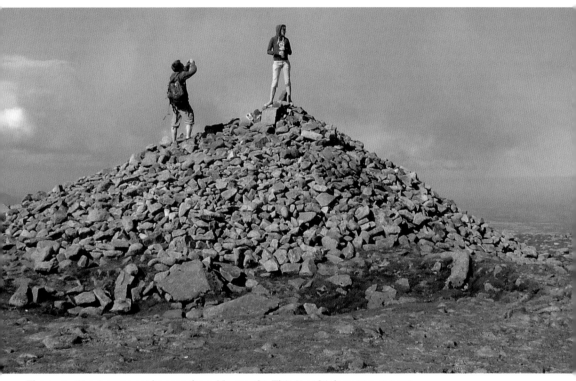

The summit cairn cannot be seen from Newcastle. This is as high as you can get

mention of it I had thought that the wells disappeared on the summit sometime between the camping of the sappers in 1826 and O'Donovan's visit in 1834. However in Black's guide book of 1884 we find the following mentioned:

'Near the summit, only a few yards from the Great Cairn, is a well or spring of water, cold and clear, coming up apparently through the fissures of the stones.'[30]

The first edition of Black's guide appeared in 1854 and rather than the spring somehow making a reappearance after O'Donovan's visit, I believe that the Scottish compilers of the guide were relying on information that was already quite outdated when they first wrote those lines and that the error remained uncorrected in subsequent issues.

By the early nineteenth century holy wells in county Down became, unfortunately, places of notoriety. At Struel Wells outside Downpatrick, finding the rock that was supposedly St Patrick's bed on the steep hill overlooking the wells became an excuse for young couples to find a bed of their own. Reports such as the following about Struel Wells appeared with annual frequency in the local paper even years after Donard's wells had already been filled.

> 'The degrading and immoral superstition connected with these wells still flourishes. Last Saturday afternoon, being the eve of St. John's Day, and on the Saint's festival also, droves of ignorant devotees made their usual pilgrimage to these annual resorts for the indulgence of heathenism and debauchery... The numbers of those who assisted this year at the pious orgies of the wells were much smaller than in past times...'[31]

> 'Last Sunday being 'big Sunday' and Midsummer Eve, the crowds of besotted pilgrims to Struel wells were unusually numerous; and we are informed that the train from Belfast on that day brought a good many persons to this painful annual exhibition of superstition and indecency. To no purpose has it been denounced by the Roman Catholic clergy of this town and neighbourhood.'[32]

It is quite feasible therefore that the wells at the cairns were filled in, as O'Donovan has suggested, by someone wishing to extinguish what they regarded as superstitious practices. I am optimistic that St Donard's well might still be found. In this regard much depends on the meaning of those lines of O'Donovan:

> 'There are two circular *cairns* on its summit, one to the N.E., and the other to the S.W., the former is now much destroyed, and the well which my guide informs me was *springing* in the centre of it filled up with stones.'

For long enough I understood this sentence to mean that St Donard's well existed in the centre of his cairn, the one that overlooks Newcastle. The likeliest location for the well was a recess on the seaward side of this cairn. A cursory examination of the recess however, showed that it was used at some stage by smugglers as a signalling point. Had this indeed been the site of Donard's well, smugglers would have had a strong enough incentive to fill it in and adapt the location to their own needs. Certainly, as a signalling site with height and seclusion, it is magnificent. Reflecting again on O'Donovan's writings and bearing in mind the description given by Rev Chambers, I have come to the conclusion that St Donard's well is not in the middle of the cairn as stated but in the middle of the cairns. When mention was made that the well 'was *springing* in the centre of it...', the 'it' refers to the summit and not to the cairn. The addition of that last letter 's' makes a world of a difference. More work will be needed before the location St Donard's well is found. If the summit of the mountain, and especially the area between the cairns, is ever the subject of additional archaeological examination, then thirsty climbers may yet joyfully witness the renaissance of the hidden exuberant spring.

SLIEVE DONARD
A PLACE OF PILGRIMAGE

It has been persuasively argued that the roots of pilgrimage on Slieve Donard go back to pagan times. Slieve Donard was one of the many places in Ireland where the festival of the Celtic god Lugh was celebrated.[1] Lughnasa on 1st August celebrated the start of the harvest and was one of the quarterly feasts of the old Irish year[2]. The other three were Samhain on 1st November, Imbolc on 1st February and Beltaine on 1st May – May Day. When Christianity came to Ireland, these feasts of Celtic culture were adapted and subsumed. As Tomás Ó Fiaich wrote,

> 'Even the holy places and objects of pre-Christian Ireland – the sacred wells and stones and trees – were incorporated into the Christian tradition. The festival of Lugh at the end of July was baptised by the thousands who later honoured St Patrick on the Reek. The pagan festival at the beginning of spring was replaced by St Brigid's feast on 1st February. Even the heroes of the earlier tales were given a place in the Christian pantheon. For example King Conor Mac Nessa was made a contemporary of Christ and died in an attempt to defend him, and Oisín was brought back from Tír na n-Óg to be baptised by Patrick.'[3]

The main feature of Lughnasa was the coming together on a height of the people from the surrounding countryside. It would have been necessary to hold such assemblies on a day of leisure so the custom of gathering was transferred to a nearby Sunday. Although his feastday is in March, St Donard's pilgrimage at the end of July supplanted the customs associated with Lugh and as the practice of pilgrimage itself faded the only residual trace of the old custom was the gathering of people to pick ripe blaeberries on the mountain on Blaeberry Sunday. Rev James O'Laverty, in writing about the parish of Kilcoo, mentions that Drumena means the hill of the *Aonach* or assembly.[4] While now only remembered in the name, this assembly likely had its origins in the festival of Lughnasa. It was at such assemblies O'Laverty says that 'the people learned the history and laws of their country and the warlike deeds of their ancestors; they enjoyed music, dancing and recitation of poetry, and witnessed feats of arms, athletic sports and horse racing.' The feis is now the nearest equivalent of this ancient assembly. Indeed when the Gaelic League held the first feis in Newcastle in 1904 it was on the weekend of Saturday and Sunday, 30th and 31st of July, evoking Lughnasa and the *Aonach*.

Long before St Domangard or Donard made the top of the mountain holy by his prayers, fasting and by building a chapel, early man had made it special by the

The unusual placement of these 'praying' stones near
St Donard's cairn suggests the meditative work of a pilgrim

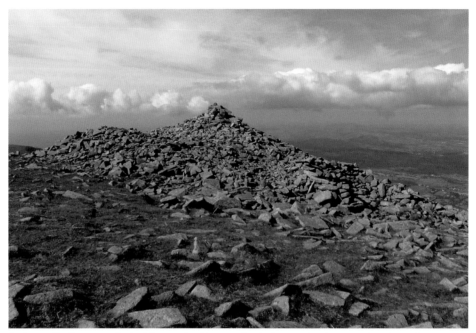

St Donard's Cairn overlooks Newcastle. Here in this holy spot land meets the sky and you can stand in the clouds

erection of the two burial cairns. From studying Neolithic monuments around the Irish Sea, some archaeologists are of the opinion that mountains were very likely sacred places for them, connected with spirits and myths. Mountains were places where the land meets the sky, where you can stand in the clouds, or even overlook clouds when above the cloudline. Mountains are where water, earth, sky and stone meet, places perhaps where other worlds could be seen or entered.[5] Building a burial cairn in such a place where the dead would be close to the otherworld would have seemed appropriate.

A leading Irish archaeologist recalled that in certain areas of Britain dead were left exposed on hill tops. The discovery of unurned cremations of a man and a woman at Murlough[6] should not close us to the possibility that means other than cremation were used for disposing of the dead. Any archaeological verification for such a practice on the top of Donard can go no further than oblique suggestion.

'Sites such as Audleystown court tomb or Slidderyford dolmen may be the expression of something more than a ritual associated with the dead. In fact in some cases, the burial ritual may have included rites which ended with only part of the body being placed in the tomb – possibly, in certain instances, only the vital organs.'[7]

The top of Donard was long regarded as a sacred place. The earliest reference to pilgrimages to the top of Donard was clearly given by the Franciscan historian,

Dr James Gibson found unurned cremated remains near this part of Murlough sandhills in 1958

Fr John Colgan, when he wrote the following passage in his Lives of Irish Saints *(Acta Sanctorum Hiberniae)* in 1645.

> 'In the territory of Iveagh and Diocese of Dromore there are two churches dedicated to S. Domangard, one {which is at the foot of a very high mountain overhanging the eastern sea}, is called *Rath Murbhuilg* by the ancients, but at this day *Machaire Ratha; -the other on the summit* of that lofty mountain, *far removed from the habitation of every human being,* and which is frequented by great multitudes of pilgrims, etc. Hence this mountain, which was called Sliabh Slainge by the ancients, is at this day commonly called Sliabh Domhangaird from this Saint.'[8]

Walter Harris, author of *The Antient and Present State of the County of Down,* in 1744, recorded the following in a quite different tone.

> 'St. Domangard, corruptly written Donard, a disciple of St. Patrick, spent the life of a hermit on this mountain and built a cell or oratory on the top of it towards the close of the 5th century; for he died (according to the martyrology of Tamlaght) in the year 506, on the 24th March, which day is sacred to his memory. But the patron day seems to be the 25th of July, St. James's Day; for then the bigoted members of the Church of Rome in this neighbourhood climb up this mountain to do penance and pay their devotion perhaps to both saints.'[9]

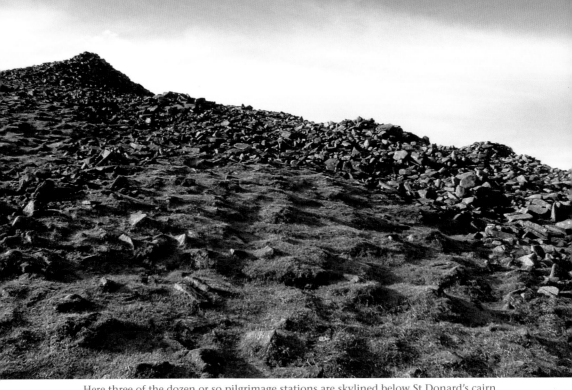

Here three of the dozen or so pilgrimage stations are skylined below St Donard's cairn

Forward sixty years and the Rev John Dubourdieu in his 1802 work, *Statistical Survey of the County of Down,* addressed this discrepancy of two different dates for celebrating the saint's feast that had apparently puzzled Harris.

'Slieve Donard: St. Domangart, a disciple of St. Patrick, founded a noble monastery at the foot of this mountain; his festival is on the fourth of March, yet the patron day is the twenty-fifth of July, when the Roman Catholics climb the mountain to perform their penance; probably it was changed to that season, which is more favourable for ascending the mountain'.[10]

Dubourdieu spoke no Irish and was patently unfamiliar with Irish customs. He was unaware of the tradition of gathering on heights to mark the beginning of the harvest, on the festival of Lughnasa. Although he got the date of Donard's feast wrong, (stating the 4th instead of the 24th of March) this could be excused as a printer's error. Even old Irish calendars of saints show uncertainty as to the dates of St Donard's festival as the calendar of Oengus gives his feastday as March 18th and also mentions 18th April.[11] Dubourdieu's brief comment about Slieve Donard however is of more importance in verifying that the practice of pilgrimage was still extant at the start of the nineteenth century.

The comment of Rev Francis Chambers, quoted earlier, that he saw in 1795 'cairns or rather pillars seemingly for devotion'[12] is an important insight into how a pilgrimage on Donard's summit was conducted. The pillars were the stations at which the pilgrims said the penitential prayers. Stones were piled up forming

30

small cairns about waist high. Many mounds have probably tumbled with the wind and it is by no means easy to make distinctions between nature and the hand of man. The destination of the pilgrims was the cell and chapel of St Donard traditionally at the front or north east cairn of Slieve Donard. Depending on which side of the mountain they were coming from, pilgrims may have first paid a visit to St Mary's chapel near the Bloody Bridge at Ballaghanery or to Maghera before starting their ascent. All that is visible now at Ballaghanery is the restored arch.[13] Once at the holy place on the top of Slieve Donard the normal practise of a pilgrim was to 'do a round' at a station saying a set number of prayers at each one. Putting a stone on top of a station cairn is not dissimilar to present practice of lighting a candle in church where the intention of one's prayer symbolically endures after one has left. The practice of 'doing a round' is still carried out by pilgrims at Lough Derg or by those undertaking the *turas* at Glencolumbkille and the format endures in the fourteen 'stations' of the Cross.

An interesting comment about the cairns and stones at the summit was made in 1786 in Wilson's *Post-Chaise Companion*. In the process of describing the road as it existed then from Dublin to Downpatrick, the author expanded on the environs of Castlewellan.

'A little beyond is Slieve Donard, one of the highest mountains in Ireland. On the top of this lofty mountain are two amazingly large kerns, or heaps of stones. In one of them there are apartments contrived for the priests to say mass in – Such huge heaps of stones are to be met with in almost every part of Ireland. It cannot be with certainty determined what these kerns or vast heaps owed their origin to. It is probable that some of them are funeral piles or monuments of the dead; and that others were the works of old Irish Roman Catholics, who upon certain days of the year, carried stones by way of penance to the top of some very high hill.'[14]

Some pilgrims certainly would have carried stones as an act of penance but it probably would have been the exception rather than the general practice. There is no such enduring practice elsewhere, as for example the pilgrimage walk to the top of Croagh Patrick. Unless a penitential load was carried on one's back it was hardly carried by hand as these would have been kept free to keep balance and aid climbing. It would have been easier and more likely for pilgrims to collect stones on the last few hundred yards of the climb. There certainly is a remarkable scree of stones below the front cairn as well as the numerous pilgrimage station cairns. The top of Slieve Commedagh, by comparison, is virtually bare but it was likely well scoured of loose stone by the ice sheets. Apart from possibly carrying up a stone, the taking of the waters at the well in St Donard's cairn was surely a most welcome part of the pilgrimage practice.

The pilgrimage was again mentioned in 1846 by the Parliamentary Gazetteer of Ireland in tones quite scornful and dismissive, clearly influenced by the tenor of Harris's earlier remarks.

31

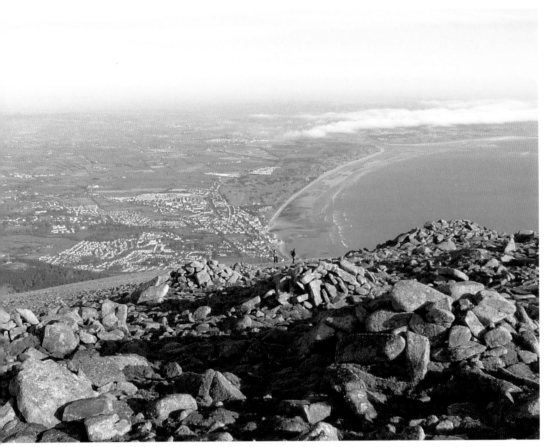

Pilgrims said their prayers and made their penances, perhaps barefoot, around these station cairns

'On July 25th, the patron day of St. Donard or Domangart, the alleged disciple of St. Patrick, the roman Catholics used to climb Slieve-Donard, in performance of penance and pilgrimage; and near the summit of the mountain are the remains of two rude edifices, the ground around which formed the central place of their superstitious devotions.'[15]

Even after the passage of centuries, the piles of stones that constituted the stations still cluster around the front cairn. No such piles are to be found at the summit or great cairn but then that was not the focus of the pilgrims' interest. Many of the stations have tumbled over the centuries and some are hardly recognisable as the 'pillars' they once were. From the top of the front cairn I counted about a dozen but I felt a more rigorous survey would reveal more. The exact number of stations is not so important as the fact that this is a place held holy and sanctified by prayer and penance. Such were the feelings of William Beatty, author of the first guide to Newcastle.

Pilgrimage pillar stations in front of St Donard's cairn

'He (who climbs to the top) is standing now on holy ground, for the sainted Donard (Domangard) has hallowed this cloud-capped mountain with his presence, and tradition has pronounced the rude edifice on the summit to have been the cell or oratory built by this disciple of Saint Patrick towards the close of the 5th century.'[16]

However, the practice of making a pilgrimage by climbing Slieve Donard was dying out at the end of the great famine. With the demise of Irish came also the withering of the ancient custom of going to the mountain top at the end of July to mark the festival of Lughnasa. The passing of the Catholic Relief Act in 1829 ended the penal laws and gave more scope to Catholics in the practice of their religion. At Bryansford the first catholic chapel had been built by Fr Robert Taylor in 1760 and the improving conditions also made it more attractive, as well as easier, for pilgrims to visit the important Patrician sites at Downpatrick. If, having made the climb to the summit, you are tired and feel like having a moan because of blisters or weariness, then spare a though for the early pilgrims who likely

33

climbed to the summit and made the rounds of the stations barefoot. Christian denominations in Newcastle have always had a special affinity with psalm 120, so if through frailty, illness or advancing years one is no longer able to visit St Donard's cairn physically, the opening lines of that psalm make for a most consoling mental sharing in the ancient spirit of pilgrimage.

> 'I lift up my eyes to the mountains:
> From where shall come my help?
> My help shall come from the Lord
> Who made heaven and earth.'

A different pile of stones away from the front of St Donard's cairn and down over the eastern crest, caught my eye and I have thought it connected in a practical way with the pilgrimages. Had the inside of the structure not been littered with boulders, I would have kept my first impression, based on its size and shape that it was quickly built to shelter someone in a sleeping bag. However, the evidence was there down under the stones that this had been a fire-place. The surrounding stones, I realised, were intended to shelter the fire from the wind. Bringing fuel,

The remnants of the round tower at Maghera mark the site of St Donard's monastery

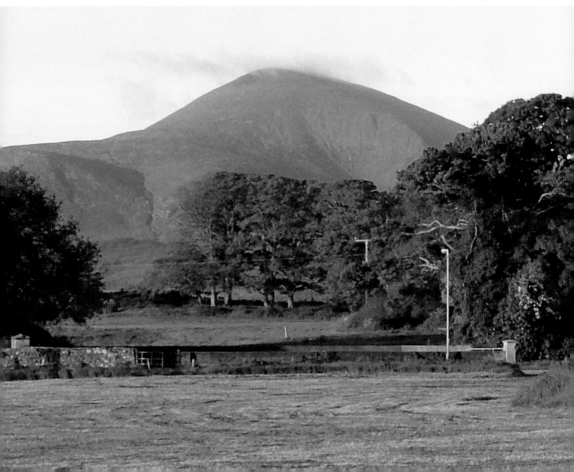

be it wood or peat, up to the height required a lot of effort even using a pack animal like a donkey. Unless a fire was sheltered from the wind, the fuel would burn away in no time. Using the slightly more sheltered lee of the mountain, rather than the very top, helped to conserve the precious fuel and the embrace of stonework protected the fledgling fire. Only a superficial examination was needed to determine that fires had been lit here. While it may possibly have been used by smugglers I do not think this fire site can properly be attributed to them. An archaeological investigation is required to verify the stronger possibility that this is really an old cooking site known in Irish as a *fulacht fiadh*. This means the 'cooking place of the deer', although these sites are sometimes also referred to as 'cooking places of the *fianna*'.[17] Water from the natural spring known as St Donard's well was originally near to hand. Note the scatter of small stones on the left of the photograph. Stones such as these would have been heated in the fire and then rolled down the incline into a wooden trough or cauldron of water into which the food was placed when the water had been brought to boil. Meat particularly young meat was usually roasted by placing the joint on a hot stone and covering it with a mound of hot stones, the fat running from the meat also played a part by igniting and continued to heat the stones.[18] If this is, as

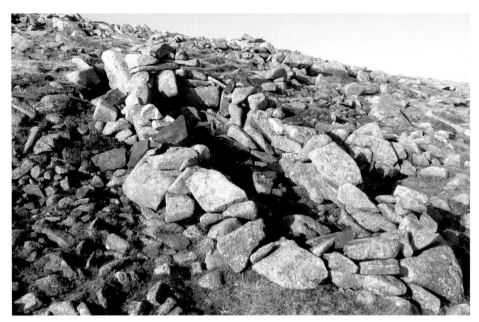

This is possibly a *fulacht fiadh* or an ancient cooking place. The small stones on the left would have been heated in a fire at the top and then rolled down into a trough of water to boil and cook food to sell to pilgrims

suspected, what is known in archaeological terms as 'a burnt mound', it would be a rare find on Slieve Donard as the frequency of excavated burnt mounds in Co Down is extremely slight, with only 22 examples being noted in available literature. In the absence of excavation and radiocarbon dating of charcoal, I would tend towards the assumption that it dates to the post medieval period and likely to have flourished during the era of the penal laws as a cooking place to cater for the crowds of pilgrims gathering on the summit at the traditional time of Lughnasa, but doing so now in honour of St Donard.

While near St Donard's cairn it is worth having a look on the seaward side for what I would call the 'praying stones'. The juxtaposition of these two upright stones is symbolic of hands joined at prayer. A friend subsequently gave a closer examination to verify that there were two distinct stones and by clearing a bit at the bottom could see how they were wedged upright. While this arrangement of stones may still have happened naturally and there are certainly plenty of other stones on the mountain top that project upwards, nevertheless, in light of the mountain's history of pilgrimage, I feel their symmetry is just too unusual to be coincidence. Each visitor will doubtlessly have his or her own opinion but I regard these striking stones as the artwork of a pilgrim in the distant past; a little act of faith composed in granite that remains powerful, prominent and beautiful in its simplicity; a timeless reminder of why St Donard came to this lonely place centuries ago.

Slieve Donard viewed from the summit of Drinnahilly

SMUGGLERS ON
THE MOUNTAINS

Among the comments made in 1187 by Giraldus Cambrensis, the chronicler of the Norman invasion of Ireland, was the remark that Ireland was rich 'in wine, although not in vineyards'. He explained further: 'foreign commerce supplies it with wine in such plenty that the want of the growth of vines, and their natural production, is scarcely felt'[1] Shane O'Neill, who in his time (*circa* 1560) built merchant strongholds at Ardglass, was known to exchange surplus hides, lint and wool for wine and the richer products of the sunny south. At one time he had over two hundred tuns of the red wine of France and Spain in his cellars at Dundrum.[2] Mary Delany would write from Mount Panther in July 1750 that Dundrum was still the place to go for wine. 'Monday evening, went to Dundrum, a mile off, a pleasant nest of cabins by the sea-side, where may be had kitchen chairs, French white wine, vinegar, Hungary water, and capers...The French white wine is five pence per bottle – we have not yet tasted it.'[3]

The busy time for the smugglers was the eighteenth century[4]. Duties were rising on a range of commodities and demand was growing fast for goods such as tea and tobacco. The main fishing grounds for Newcastle fishermen were near the Isle of Man and it would have been a short haul to call into Peel on the west side of the island to obtain merchandise. The Isle of Man became a huge storehouse or entrepôt centre and wines, tobacco, brandy and tea were imported in vast quantities.[5] Duties charged on the island on imported goods were comparatively negligible; brandy and rum and spirits were charged one pence per gallon, tobacco half a pence per pound and tea at two and a half percent of its value[6]. The island's position, both strategically and constitutionally, helped to make it 'the very citadel of smuggling', as Edmund Burke described it in his speech on American taxation in 1774.[7] The very short sail over to the coast of Mourne made the practice of fiscal evasion a most attractive and remunerative occupation. The building of the first harbour at Newcastle in 1809 actually owes much to the activities of the local smugglers. Richard, 2nd Earl Annesley, was a commissioner of the revenue and in 1806 became chief commissioner of the newly separated board of excise. As head of the excise, Richard Annesley could hardly ignore the flagrant evasion of excise duty taking place on his own doorstep in Ireland and he made a case to the government of George 3rd that it was 'necessary and expedient' to secure a safe berthing place for excise ships.[8] It was very convenient for the improvement of the Annesley estate that the harbour just happened to be in his part of Dundrum Bay.

The entrance on Percy Bysshe bluff to the secret cave used by the smuggling McNeilly's **39**

Newcastle coastguard station built in 1855

One of the two pistol loops at the entrance to the coastguard station

The coastguard was established in Newcastle by 1821.[9] William Richard, 3rd Earl Annesley, rented the old castle at the mouth of the Shimna to the revenue service. It was rather a family arrangement as the officer in charge of the Preventative Service was his nephew, Captain Francis Charles Annesley, R.N. The old castle had seventeen apartments and other members of the service lived there with their families. One of these was William Beers, who had two sons born in the castle, William and Francis. William Beers, jun., built Beers cottage on the Bryansford Road which later was to become the residence of Richard Valentine Williams, better known as the poet Richard Rowley. Both William and Francis Beers were to come to prominence with the fracas of Dolly's Brae. When Francis Charles Annesley died in 1832, the 3rd Earl decided to knock

down the old castle and build a hotel instead. The customs service was obliged to transfer to the harbour. The coastguard houses in King Street were built and the service used the house overlooking the harbour which, to this day, still bears the name 'the Watch House'. Here were laid out the bodies of those drowned at sea especially those lost in the awful calamity of Friday 13th January 1843. It was part of the job for the coastguard to search every boat that came into the harbour. In later years when the harbour had been reduced to a ruin by storms this meant in practice giving the fishermen a hand to pull their boats up out of the water and in return the coastguard got a fish or two for his breakfast.

A new coastguard station was built in 1855 overlooking the harbour. The porch of the station was fortified by two pistol gun loops. The provision of these gun loops reflected the political anxieties of the time when it was feared that the coastguards, as servants of the crown, might be attacked by Fenians. The station had its limitations[10] and at the council meeting of January 1908 Joseph Thornton called on the Admiralty to construct proper water closets at the station. Now, of course, the station has long been converted to private housing.

Smugglers at Leganabruchan

It was a glorious sunny day when I determined to find the smugglers' cave on Leganabruchan which dominates the skyline north of the Bloody Bridge.

The arch of St Mary's, Ballaghanery, with Leganabruchan mountain in the middle background. The smugglers' cave is close to the summit and commands a great view over to the Isle of Man

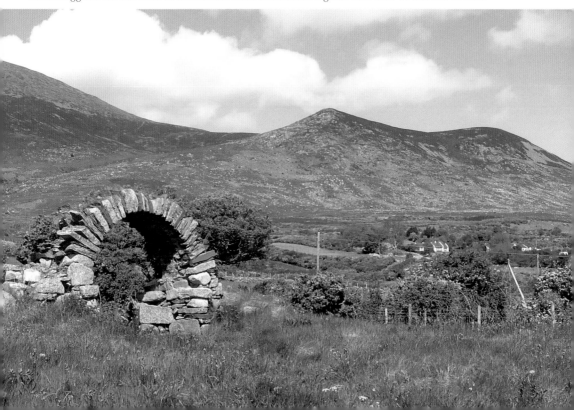

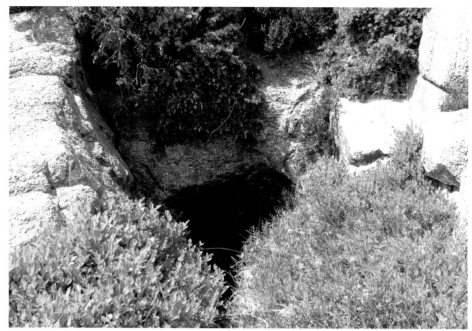

The top edge of the elusive cave can easily be missed

Approaching up the Bloody Bridge valley, I had been told to look for the large rock slab on the upper seaward side of the mountain. The cave, I was casually informed, was about one hundred metres up past the slab. I was not to follow the well worn summit path but to bear right near the top and on arriving at a long stretch of rock face on the seaward side, to favour a higher trail. The actual cave opening could be easily missed as the entrance was at the bottom of a small little hollow above the path. It would help to look for a break of about five feet where the wall of rock went back a bit. 'It's not easy to find' were the last words I was given. I was to remember those words well as I got to the top and found so many rocks and innumerable little sheep trails. Back and forth I tramped wondering whether to go higher or lower and whether the cave was perhaps about two hundred rather than a hundred metres past the large slab.

Though I didn't know it until fortune favoured me, there are actually two holes about five metres apart and I found the higher and smaller one first.[11] It was a disappointment. Scarcely bigger than the entrance to a badger's sett, I was immediately deterred by the wet entrance. A large roughly pointed stone was just inside the entrance and I felt from this that no one had been in there for some time. I could have stuffed my rucksack into the hole but being alone on the mountain side it would have been foolhardy to also risk squeezing into a small hole in the ground lest difficulties were encountered. A quick look with the torch nevertheless showed that after the narrow entrance the hole went back a couple

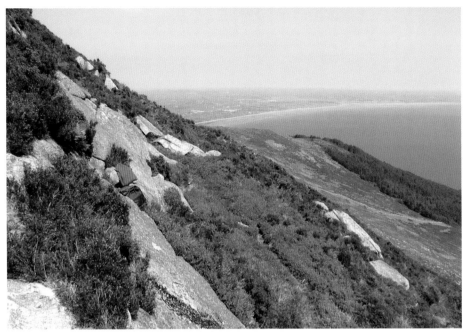

Looking north from where the jumper marks the start of the little hollow and below it the end of the little shelf. It is from these topographical features that *'Lagán an Bhruacháin'* – Leganabruchan derived its name

Looking south from the vicinity of the smugglers' cave

43

of metres and then upwards out of sight. I imagined it was possible to stand upright inside at the back but the space seemed small. My disappointment was short lived as I spotted a promising gap in the rock slightly lower down to the south. This was the cave described by Professor Estyn Evans as 'one of the most interesting of the many reputed smugglers' caves in the Mournes'.[12]

The low entrance to the smugglers' cave reveals itself as one steps up the slope a bit from the grassy ledge along the rock face. The first sight is of a neat little cup of a depression with rock face on three sides and the black hole of the cave mouth at the bottom. The entrance to the cave is about a metre across and can only be entered by crawling in on one's stomach. To the left of the entrance is a small hole about twelve centimetres in diameter. This smaller hole is dog-legged and I couldn't get my arm to the end from either outside or inside the cave. It was not a natural feature but was man made.

Despite the warmth of the day, the entrance to the cave was quite wet and I was grateful for the recommendation to bring a plastic sheet with me to avoid any mud at the entrance. If you intend to inspect the inside of this cave for yourself, don't forget to bring a torch. Once the entrance has been crawled through it is possible to stand up. The cave is variously about seven feet high but it is quite narrow and slanted as one progresses further in and it is really only possible to stand up by leaning against one wall. Much of the walls inside are damp from water seeping through cracks in the granite and part of the floor is a shallow pool of water and mud. At a rough guess the cave was about seven metres from the entrance to the back. It narrows at the half-way mark but fortunately the floor rises slightly and the footing is dryer. The end of the cave provided a slight widening by comparison with the squeeze of the last few feet but I was nevertheless on my hunkers. While undoubtedly the cave could be a place of shelter and the floor could be greatly improved by adding a pile of heather, this was not a cave to be comfortable in. Even to be taking shelter from rain, one would get just as wet from the crawl inside. The pervading damp inside did not lend this cave to being a storage place for smuggled goods and certainly not for tobacco. The place however, was certainly very important to the smugglers and someone had spent a lot of time chiselling out the small supplementary hole at the side of the entrance.

The significance of the site became apparent as I sat at the crescent shaped mouth of the cave entrance considering whether I should enter by crawling or going in feet first on my back. The rock above the entrance, despite the passage of time, showed the severe scorch and charring of fire. The smugglers had used this place as a site for signalling. With a good fire lit at the entrance mouth of the cave, the lip of the little depression hid the light from being seen from anywhere below on the coast road. The projecting walls of rock on either side ensured the light could not be seen from the nearby hills. The projecting shoulder of Drinneevar on the left meant that the men of the preventative service stationed in the old

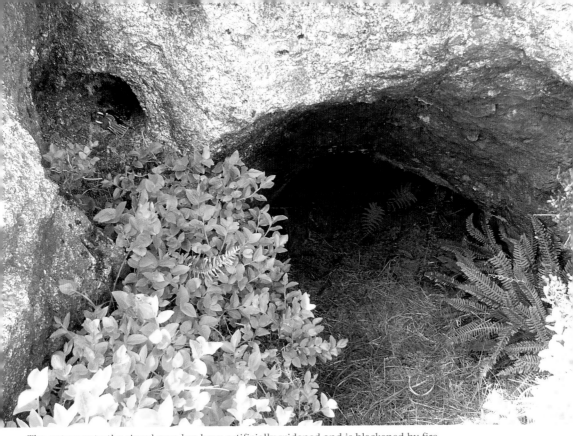

The entrance to the signal cave has been artificially widened and is blackened by fire. On the left, with keys for scale, a vent hole has been bored to the inside of the cave to improve the draw of the fire

Magennis castle at the mouth of the Shimna in Newcastle were blind sided. More importantly, with the fire lit tight to the right hand side of the cave entrance, as would appear from the rock to have been the practice, the glow that could be seen by the coastguard station at St John's Point would have been negligible.[13] They would have been too far away to influence events even if they had spotted a signal light. From the lofty height of Leganabruchan, the light of the fire would only shine across the sea beckoning boats from the Isle of Man. It was a magnificent location for such a directional signal fire. It spoke volumes both about the caution of the smugglers in protecting the source of the light and of their masterful knowledge of the local topography in their choice of such an appropriate and superior location. The importance of the hole carved in the rock to the left of the entrance now became clear. A fire lit in the hollow would have been rather stultified and prone to smouldering without a good 'draw'. The twelve centimetre hole at the left, which angles down to just inside the roof of the low cave entrance, was intended to improve the flow of air as a mini chimney and would greatly have enhanced the burn of the fire. The outer crescent shaped entrance to the cave has also been improved by a chisel. The evidence of the smoke that once would have filled the cave's interior is still everywhere to be seen in the darkened crevices that have remained untouched by the water weeping from the walls.

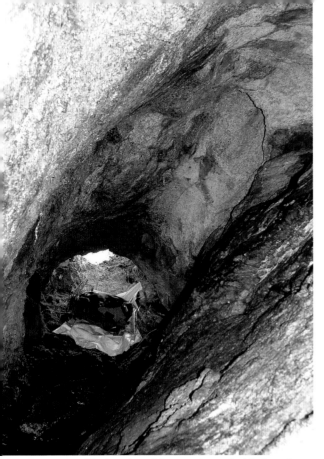

The interior of the cave is smoke blackened

The name Leganabruchan is from the Irish *'Lagán an Bhruacháin'*, meaning 'little hollow of the little shelf'[14]. Previously I had imagined that the name was derived from the amphitheatre like hollow at the head of the Glen Fofanny river on the landward side of the ridge. Now I took great delight in appreciating the tongue in cheek Irish humour of giving the nod to the illegal activity of smuggling by referring to one tiny spot on the whole mountain. The 'little hollow' approached by 'the little shelf' was none other than the smugglers' signalling station. I was sitting in it, in Leganabruchan, enjoying the panorama of Dundrum Bay. That the mountain owed its Irish name to the activity of smugglers was a reminder both of the antiquity of their trade and of its importance in the local area.[15] As the importation of brandy declined due to the vigilance of the coastguards and the rise of home made spirits, the cave at Leganabruchan may have had another lease of life as a place to distil poteen. Professor Evans has preserved the ominous fact that the area was known locally as 'The Nab'.[16] In mentioning this detail, however, I do not think it refers to the apprehension of distillers or smugglers but that he has likely preserved for us a mnemonic of the Irish *Nábadh*, meaning 'a neighbour' or possibly a contraction of *Nia biach*. The Irish humorously refers to a large upright boulder a little lower down the hill which enjoys a commanding position over the immediate coastal plain.

Signalling from Donard's Summit

The site *par excellence* for signalling has to be the summit of Slieve Donard. On one of my visits to the summit I was wondering about the chances of finding St Donard's well. I was particularly interested in the horse-shoe shaped recess on the seaward side of his cairn which is the front one overlooking Newcastle. In the course of a cursory examination I discovered to my surprise that the stones at the bottom of the recess were all severely scorched by fire. We should remember that there is absolutely no fuel for a fire on the top of the mountain. To make one

requires a lot of effort to bring up the combustible material. The intensity of scorch and its wide distribution over the bottom of the recess indicated that this was much more than a casual campfire of some burning sticks. The open end of the recess faces the sea and astonishment changed to admiration at how this most commanding site was adapted by smugglers as a signalling station towards the Isle of Man. The side wall would have prevented a fire from being seen from Newcastle and the convex brow of the mountain makes it impossible for the fire to be seen from any other location but the sea. I have discounted the possibility of this being the site of some of the celebratory bonfires that have taken place on the summit of the mountain, of which more later.

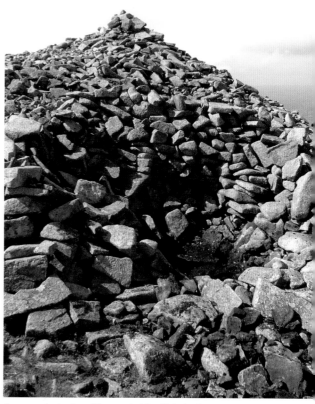

A smuggler's signalling point built into the east side of St Donard's cairn

One and possibly two more signalling sites were discovered on a subsequent visit. Most visitors, myself included, when on the top of Donard will go to the summit cairn and likely walk down to the front or St Donard's cairn. They will then have 'done Slieve Donard' and rightly enjoy the satisfaction of the achievement. The visit on which the signalling points were discovered was on a bright but bitterly cold February day. The ice remained frozen on the sunless side of the mountain yet numerous hardy souls were on the top of the mountain and had come well prepared for the bracing conditions with hot soup and tea. The chill factor of the wind froze my fingers as I tried to take photographs and this persuaded me to move down off the top plateau to the east side of the mountain where it was still sunny but the wind not so piercing. I was looking for further evidence of Slieve Donard being used as a signalling vantage point and keeping an eye for heaps of stones that would have been piled up by the hand of man rather than by nature. The first promising pile was not large but its horseshoe shape, similar to the adjunct on St Donard's cairn, prompted me to check below the moss in the depths of the recess. Weathering and rain over many decades would remove all traces of fire on the surface but I was happy to find that the evidence endured deeper below on the charred stones. The site faced out directly towards the Isle of Man.

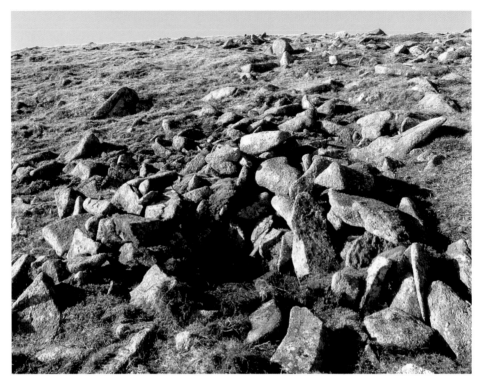

This small fireplace below the crest of Slieve Donard would have sent its light out over the Irish Sea towards the Isle of Man

While Slieve Donard had the advantage of height, the summit would often have been obscured by cloud and many other locations lower down besides Leganabruchan were doubtlessly used as signalling points. The quarry on the shoulder of Millstone mountain above Drinneevar facing out to the Isle of Man, for instance, could easily and quickly have been reached from the harbour and admirably served the smugglers' purpose for signalling. An ongoing game of 'cat and mouse' would have been played out with the local excise men. A hint that this may have been extensive was given in Bassett's 1886 guide to County Down.

'The number of discovered caves in Down is quite large, but there is reason to believe that it is altogether out of proportion to the number undiscovered. Newcastle has more belonging to the former category than any other place in the county, and in connection with many of them there are stories of thrilling human interest'.[17]

'Stories of thrilling human interest' is discreet Victorian code for smuggling. With the exception of the story of the McNeilly's which W.J. Fitzpatrick recorded from Big Margaret McCartan, these tales from the smuggling days were not written down and have now disappeared. We can no longer know how deeply, if at all, the fishermen at the harbour were engaged in smuggling. I rather suspect

however, that a 'them and us' mentality was engendered to such an extent between those engaged in smuggling and the excise men in the old castle below at the Shimna, that it contributed more profoundly than hitherto realised to the forging of the harbour area's still strong and proud sense of clan.

The Smugglers' Secret Chamber at Maggie's Leap

A discovery with links to the days of smuggling was made at Maggie's Leap over fifty years ago by a ship-yard worker called Noel Kirkpatrick. He was taking diving lessons from an instructor called Mike Suchard and they had both just finished a leisurely inspection of Maggie's Leap gorge and then made their way out to sea about a hundred metres from the rocks. Noel tells the story:

'It was while enjoying this slow swim that by chance on looking up at the almost vertical rocks I saw what looked like a small open doorway on the steep rocky hillside. While Mike was keeping watch from the sea I went ashore and started climbing the rocks. It was impossible for me to spot the door from my vertical position. Meanwhile Mike was treading water and when he saw my plight he started to direct me by hand signals until I at last found the doorway. I felt quite excited as I made my way into the man made chamber which was approximately 6 foot long by 3 foot wide by 4 foot high.

Disappointingly it was bare except for a large coil of rope which was in such poor condition that when I tried to lift it, it started to disintegrate. I signalled to Mike to come up and see for himself. While I was waiting for him to come ashore I examined the doorway and found rusted hinges where a door had been at one time. As there was not enough room for the both of us in the small chamber I made my way straight down to meet Mike and then he went up to have a look. When he came down we discussed this unusual man-made cavity which could only be seen from the sea and wondered for what purpose it had been used.'[18]

Determining the function of this cavity leads us to speculation which is not very satisfactory for historians who like to deal with facts. It is most likely that the cavity was another signalling point for smugglers. The fire on the height of Leganabruchan would have guided the smugglers' boat from afar, but once the boat came near to land a signal was needed to mark the hazardous cliffs in the dark. The chamber at Maggie's Leap is almost a mile from the Bloody Bridge. Not only would a signal here serve as a caution about the dangers of the rocks but it was likely part of the smugglers' warning perimeter. Lookouts along the road could detect any patrol of the preventative service, as the customs men were then known, approaching from the Newcastle direction where their headquarters were in the old castle. Going over the cliff and down a rope to the chamber allowed the lookout to safely send warning signals to boats approaching the Bloody Bridge landing place to stand off and make a run for it. On the other hand Donard's

The ruins of the coastguard house at St John's Point, with the bay window that faced east over the Irish Sea towards the Isle of Man

Cove is only a few hundred yards to the north so a signal may have been to direct the lighter where to land its cargo depending on the tide and the choppiness of the waves.

The work of cutting the rock face to make the secret chamber while hanging from a rope over the crashing waves was a remarkable feat. It is a further reminder of how important this surreptitious trade was in the area. It was important to give a place of refuge to the lookout as the penalties were severe.

> 'It is enacted that any person or persons making, or aiding or assisting in the making any light, fire, flash, or blaze, or signal on or from any part of the coast or shores and being duly convicted thereof shall forfeit and pay the penalty of one hundred pounds.'[19]

Warnings were important to save the smugglers' boats from being seized as they constituted a big investment. For those aboard who were caught the sentence was 'to be carried or conveyed on board of any of His Majesty's Ships of War, in order to his being impressed into His Majesty's Naval Service'. Anyone caught wearing any 'vizard, mask or other disguise' was guilty of a felony and was to be transported as a felon for the space of seven years and if they returned before the end of the seven years they were 'to have execution awarded against him, her or them as persons attainted of felony without benefit of clergy.'[20]

In the face of such penalties it is no surprise that many smugglers made a run for it when approached by ships of the preventative service.[21] One smuggler had a very narrow escape in October 1820. The boat had just landed contraband at Glasdrumman when it was spotted and chased by the twelve gunned revenue cutter *Hardwicke* commanded by Lieutenant S. Mottley. The smuggler sailed into Dundrum Bay and during the chase the revenue cutter, not having the smugglers' familiarity with the local hazards, crashed onto the dangerous rocks of the Cow and Calf and sank.[22]

Before leaving the area of Maggie's Leap an addendum is necessary to *Where Donard Guards* about how the chasm got its name. The old name for the place in Irish was *Coiscéim na Cailli* meaning the footstep of the cormorant. This came about as the low tidal rocks in the vicinity of the chasm were frequented by cormorants that would step off the rocks into the sea at the approach of a fisherman's boat. An extended meaning of *cailleach* (cormorant) in Irish was an old woman, a hag, and this accounted for the chasm's early English name of 'The Hag's Leap'. It was surmised in our previous book that the story of Maggie leaping the gorge with a basket of eggs on her head had likely begun in the vivid imagination of a jarvey. The evolution of the name however is a curious smörgåsbord or fusion of fishermens' placenames, former customs of egg gathering, and disguised Irish. Centuries ago, to supplement the diet, it was common practice in coastal areas to collect seagulls' eggs in season. An egg collector needed both hands free while climbing around the rocks and so eggs that were gathered were usually put into a little basket tied onto the head. The fishermen's term *Coiscéim na Cailli* has already been mentioned but there was also another Irish name for the area namely *maighrí liopaí*. The name Maggie's Leap is actually a mnemonic from the Irish meaning 'big lipped salmon'. Before stocks of this noble fish disappeared, the fishermen of old knew this was a good place to catch the mature, big lipped, salmon hugging the coast en route to their spawning grounds. So if you are ever inclined to tell a visitor about a certain fair maid on her way to market who jumped the chasm to escape the importunities of a suitor, without breaking one of the basketful of eggs she was carrying on her head, just remember that Maggie was originally a salmon.

Other fishermens' names in the local area have also been transposed from the Irish as English mnemonics. William's Harbour, south of the Bloody Bridge, was originally *Buille lán ar buarach* meaning 'a full cast of the net in front of (by) early morning'. A little further south again and Green Harbour was originally *Greim ar buarach* meaning 'a bite by early morning'. The fishermen knew that fish liked to feed where streams and rivers entered the sea and this location at the mouth of Crock Horn Stream must have been a particularly successful place. Broad Cove opposite Shannagh Mor outdoor education centre is a mnemonic for *broideadh cóibe,* meaning 'a bunch of bites (as in fishing)', Dulusk Cove is from the Irish *Dulasach cóibe,* meaning 'eager bites' and Dane's Bridge Point between Annalong

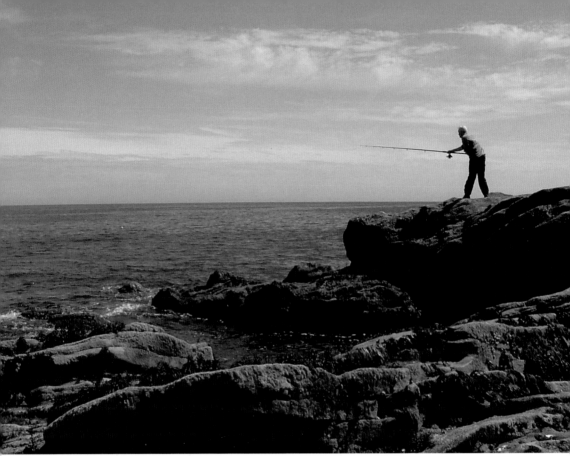

Many coastal name-places are mnemonics of the Irish used by the early fishermen

and Ballymartin is a mnemonic for *Deán brideoige poinntín* which may be translated as 'the fishing net at the head of the narrow arm of the sea'. The topography would indicate that this site was availed of as a natural tidal fish-trap.

Donard's Cove

I have no doubt that this sea cave not far north of Maggie's Leap was used by smugglers. John O'Donovan writing from Downpatrick to his superior at Mountjoy Barracks in April 1834 recorded for us a tradition about this cave.

'S. Donnaght says Mass every Sunday on his altar on the North-western cairn on the mountain. There is also a cave running from the sea shore at the south of Newcastle to the summit (if report be true) at Slieve Donard, through which cave some men have been so foolhardy as to venture up to the summit of the mountain; but after they had gone to a certain distance, they were met by St. Donnaght *in his robes*, who admonished them of the foolishness of their adventure, and Lord bless your soul, Donnaght was right, for it is difficult to climb up the steep side of that wild mountain in the open air and under the broad light of day, not to say in a dark steep (cave). He also told them that it was to be his own peculiar residence until the day of Judgement.'

In more superstitious times a story like this would have acted as a very powerful deterrent to stop any casual exploring, leaving the way clear for smugglers to stash material here until they could later move it safely inland.

At roughly ten metres across, a boat can be comfortably rowed in past the entrance rocks in calm weather. There is a sunken rock at the entrance but it is passed over without any danger at high tide and there is room to go round it at other times. A shingle beach awaits at the mouth of the cave where a boat could be safely landed and pulled up out of the water. Part of the roof of the cave has collapsed above the small shingle beach and it would have been possible to gain access by coming down about five metres on a rope. Contraband could also have been hauled up on a rope at a time convenient for a smuggler. During stormy weather this hole in the roof acts to amplify to a roar the sound of the waves crashing into the cave and allows spray to gush forth. Donard's Cove would really just have been of limited use to smugglers on account of it only being accessible from the sea during particularly calm weather.

But maybe I am underestimating the bravery, knowledge, skill and ability of the boatmen. It may have been precisely this risk of a boat being dashed against rocks, that would normally deter many a sensible man from approaching when a choppy sea was running, that made the place attractive to smugglers as a cave likely to be undisturbed. The added detail of the vision of St Donard appearing 'in his robes', ie. as he would have been for Mass, imparted a very strong religious taboo against going near the place.

Smuggling at the Bloody Bridge

Smugglers used many locations along the Mourne shores to land their goods. The lovely small sandy beach a little south of Annalong, called Wreck Harbour was one such obvious place. The name of this place is a mnemonic for the Irish *Reacht ar buarach* meaning 'early morning activity'. While the activity in question could refer to fishing, it is quite likely that it refers to the work of smugglers for whom it was a favoured landing place. It was their *Reacht* or commotion that gave the little beach its name.

The entrance to Donard's Cove on a calm day. Note the submerged rock

The entrance to Donard's Cove from above

Tradition however particularly favours the area of the Bloody Bridge as being one of the smugglers more popular landing places along the Mourne shore. There were good reasons for this choice. The water off-shore, as the lifeboat men will tell you, is particularly deep. This allowed the large boats to come very close to the shore and greatly speeded the transfer of goods to the land. There is a sweet little shingle beach about five metres wide that gave boats a clear run safely onto land without any dangerous rocks to negotiate. This wonderful landing spot, north of the present car park at the Bloody Bridge, is a rare feature along a rocky and cliff-bound coast. The small landing spot cannot be seen from the car-park and likewise could not have been observed centuries ago by coastguards patrolling on the road above. Directly behind this landing spot is the cave known as the 'Smugglers' Hole', a gash in the cliff face that extends back a good ten metres and which allowed goods to be stashed in a hurry if need be. The cave is a very wet place with water constantly dripping from above and, as I have found to my cost, very slippy underfoot. At the very back however, high on the left, the rock has split and would have allowed smugglers to climb up higher and hide goods above storm tide levels.

The small shingle landing strip at the Bloody Bridge;
a scarce feature along this rocky shore

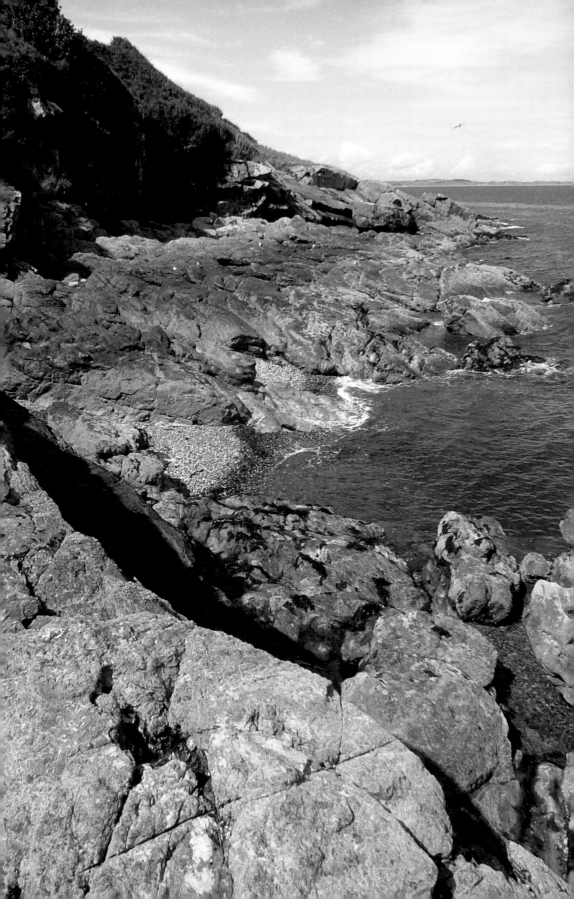

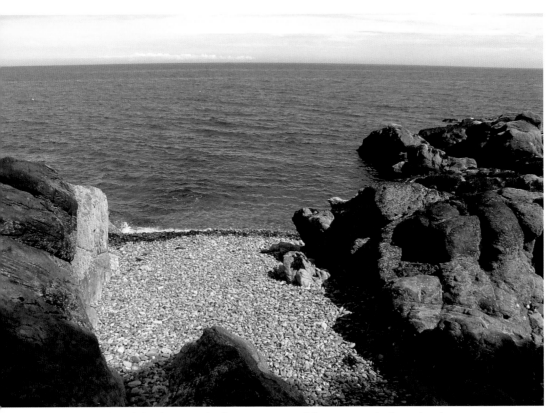

The shingle landing strip looking out to sea with an approach clear of rocks

I do not advocate this climb in the dark with the rock wet and slippy.[23] Apart from the advantage of the beach's concealed location, the landing place enjoyed remoteness. The Bloody Bridge was well along the patrol beat for the Newcastle coastguards who may have had to walk as far as the Ballagh Bridge on their nightly patrol to meet their counterpart from the coastguard station at Annalong.

In addition to the small shingle cove, a very speedy transfer of contraband would also have been effected at the Bloody Bridge thanks to the landscape feature which I would call 'the ramp'. A convenient sloping shelf of rock leads from the water's edge right uphill. By using this natural bare-rock stairway, men avoided stepping over boulders and stones with heavy loads where balance was much more difficult and progress slow. A lighter could approach and by the expedient of throwing a rope to willing hands ashore at the foot of the ramp, the cargo would have been pulled through the waves to the land without the boat endangering itself at the water's edge. Despite there being a fissure across the middle of this ramp, the gap narrows to insignificance and it would not have presented a problem even at night to the men familiar with its location. Such is the gradient of the rock it would even have been possible for men to run up this slope.[24] The transferring of goods from sea to land was the riskiest time in the whole operation when the smugglers were most vulnerable to detection. Speed was critical and it was astute

56

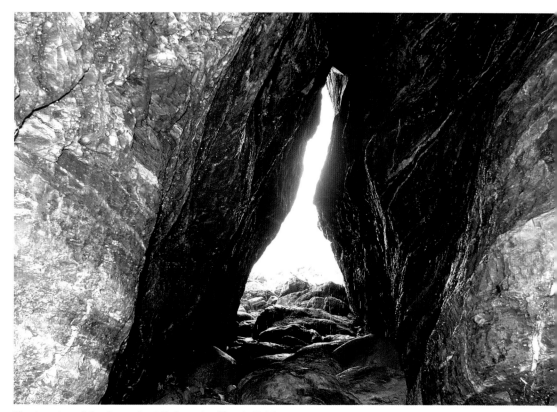
The interior of the Smugglers' Hole at the Bloody Bridge

use of natural features such as the ramp that gave smugglers an important edge in their constant battle of wits with the revenue man. Nowadays the ramp is one of the locations frequently enjoyed as a stand by fishermen.

One of the main reasons why the smugglers favoured the Bloody Bridge was the fast exit that was possible up the river valley and quickly away through the mountains along the Brandy Pad to the waiting markets. To speed the operation along, smugglers were using 'pre-packaging' before the term was ever heard of. Tea and tobacco were portioned into manageable weights for easy handling.[25] Tobacco bales were usually split but much would have depended on the physique and strength of the carrier. A half bale weighed nearly thirty kilos and was a bit more manageable. Bales this size are known to have been carried by women. Brandy was usually delivered in small size kegs tied in pairs that allowed them to be slung over a man's shoulders and then quickly transferred over the back of a horse, the kegs balancing each other.[26] Numerous hidey holes were made around the mountains as fall-back positions in case of a revenue raid. Holes and cavities were artfully constructed of stones and sods usually large enough to hold what a horse or donkey would carry on its back. One such secret cavity came to light a few years ago much to the surprise of a weary walker. The walker was taking a rest on a boulder when it suddenly gave way and revealed the hollow behind.

This natural ramp from the edge of the sea facilitated quick removal of smuggled goods up off the beach

The Smugglers' Cave at Blue Lough

When my Granda's Granda was young an' single,
Them was the days o' the Smugglers' Pad;
The panniered ponies stampin' the shingle,
Each o' them led by a mountainy lad;
For the schooner has jeuked the preventive cutter,
She's landin' her cargo at dead o' night,
Runlets full o' what's better nor butter,
Bales o' silk for weemin's delight.
Stow them away on the ponies' backs,
An' aff up the hills by the mountain-tracks;
The journey's far, an' the travellin' slow
To the cave that only the smugglers know.[27]

Of all the caves of Mourne, the one at the west end of the Percy Bysshe cliff face near the Blue Lough is certainly known to have been used as a refuge and storage place by smugglers. On a sunny day it is a beautiful walk up past the Annalong wood to the Blue Lough which lies 'like a sapphire in the hollow of a hand that touches the slopes of Binnian'.[28] This cave nearby will forever be associated with the McNeilly's and the 'battle of Kilkeel'.

The McNeilly's lived on a hill farm at Moneydarragh. They were a family of six brothers, all big strong fearless men who owned a boat called the *Mary Stuart* in which they smuggled brandy, wines, silks, tobacco and anything else that would turn an illicit penny. The story of the battle of Kilkeel began on a winter night with a strong gale blowing and a full moon.[29] The look-out man, Johnny Savage, was standing on the Bank Head awaiting the arrival of the *Mary Stuart* when he heard a signal whistle from a man called Davy, one of the McNeilly servants. The news he brought was grim. The *Mary Stuart* had been on her way down the Bar of Carlingford when she was sighted by the coastguards. Davy had been in Newry and heard that the soldiers based there had orders to ride to Annalong to seize the cargo. The contraband was due to be off-loaded at a rocky stretch of coast called the Dane's Bridge in about three hours time at high tide. The weather was too rough to launch a skiff to warn the *Mary Stuart* so Johnny Savage ran to tell the McNeilly's that their plans to land the cargo had been found out and that the military were on their way from Newry to get it.

Henry McNeilly, the eldest of the family, told Savage to get help to land the cargo and bring it to the secret cave in the mountains while he and his brothers would ride to Kilkeel and create a diversion to delay the soldiers. They galloped their horses along the coast road until the reached the bridge at Kilkeel. While the youngest brother held the horses the other five made their way from house to

The path towards Annalong Wood and the smugglers' secret cave on Percy Bysshe bluff. Percy Bysshe is seen here as a little shadow, mid right of centre, above the trees and under the imposing bulk of Slieve Lamagan

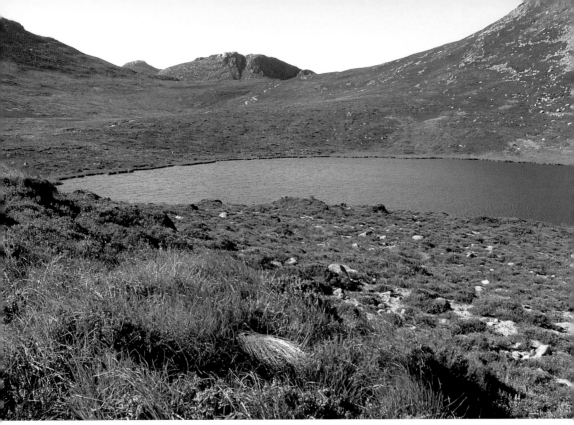

The Blue Lough with the tip of Ben Crom in the background. The Lough has been described as 'a sapphire in the hollow of a hand that touches the slopes of Binnian'

house, breaking open doors, shouting and bringing people out into the street. The troop of soldiers arrived into a scene of pandemonium. The town was in an uproar and in the dark the soldiers were unable to use their guns or swords and resorted to hand to hand fighting with the crowd. In the meantime the McNeilly brothers took their stand on the bridge and fought to prevent the soldiers passing. The soldiers were no match for the strong McNeilly's but one of them managed to strike Henry a fierce blow and knocked him senseless. The other brothers realised that they had to get the wounded man away otherwise they would all be identified and that meant hanging or transportation for life. They carried the wounded man back to the horses and galloped at full speed to the mountains. As daylight broke they led their horses through the mountains until they came to the Blue Lough. The climbed the mountain till they came to an opening in the rocks. This was the cave that Savage and his men had brought the smuggled cargo to on donkeys' backs. The wounded man was carried in and laid down among the brandy. Some of the men stayed in the cave for a day or two until Henry was strong enough to go home. Then, when things quietened down, the smuggled goods were taken out and carried on donkeys' backs along the smugglers' pads through the mountains and onwards to the buyers at Belfast.

When I first went looking to find the McNeilly cave I nearly gave up in despair. Only that I had come so far up the Annalong valley and knew that the

60

cave had to be somewhere nearby helped me persevere with my search. The cave is certainly not to be conveniently noticed from the path leading up the valley to the Blue Lough. One must go right up the slope at the western end of the upper buttress close to the Lough. There, round the corner of the buttress, is the small entrance. It is a low hole in a cleft of the granite face and the entrance floor is usually fairly muddy. I cannot write of the excitement of exploring this place without asking all who would seek to find this cave to exercise all due prudence and care. A torch is essential, especially as we will see, to appreciate the far back reaches. Being accompanied makes good sense as does letting someone know exactly where you are going.

Having negotiated the low entrance one can comfortably stand up in a tunnel about seven or eight metres long and over a metre wide. The walls weep with water and the floor is wet with numerous puddles. The cave progressively narrows until it becomes so pinched that most give up believing they have come to the end. This is the case with those who enter without a torch and who operate by feeling their way around in the dark. However, there is a further extension to the cave at a higher level and it is this part that chiefly commands my calls for an abundance of caution. Right at the very back when the walls on either side squeeze in to block further ingress, there is a ledge high on the right hand side over one and a half metres above the floor. A judicious stone on the floor was

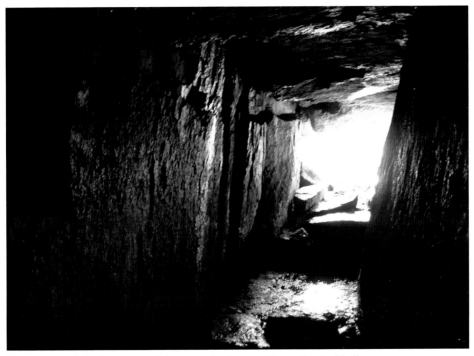

The interior of the front part of the smugglers' cave at Percy Bysshe bluff

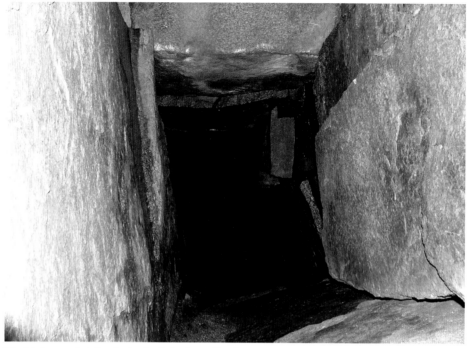

The higher part at the far back of the Percy Bysshe cave

long ago placed there to provide a foothold to climb up but the gap is quite narrow, requires agility and the move upwards is not without peril. From here the cave extends roughly another seven metres or so. The walls have widened out again but the floor slopes and a man could not stand upright. Part of the wall and floor in this back part weeps with water but the sloped granite floor means the cave is fairly dry and would have been an excellent storage place. With bundles of heather spread on the floor it would have been comfortable enough and I have known climbers who bivouacked here overnight.[30] The cave is a wonderful hiding place and its existence in earlier days would have been a closely guarded secret. Ah, if only the walls could talk.

The Greatest Smuggler in the Kingdom

In the late 1760s and the 1770s, Mourne, meaning the coast line from Rostrevor to Newcastle, was the main location of activity for smugglers in the more northern reaches of the Irish Sea. The organising genius in the traffic seems to have been Arthur Hughes of Greencastle near Newry, described by no less a person than Luke Mercer, head of the Irish revenue vessels, as 'the greatest smuggler in the kingdom'.[31] Hughes seems to have operated in tandem with Jeremiah Atkinson of Glasdrumman and was involved in the running of rum into Ireland.

They owned a vessel between them. In 1771 two vessels were reported to have been dispatched to the Welsh coast to take goods destined for Annalong off a vessel owned by Hughes.

It is Jeremiah Atkinson of Glasdrumman house who is of particular interest to us. He had taken a lease of land at Murlough near the twelve arches and died there on 6th April 1809. The notice of Jeremiah's death appeared in the Belfast newsletter on Friday 21st April 1809: 'Suddenly at Murlough on the 6th inst. Capt. Jeremiah Atkinson, of Lord Annesley's yeomanry battalion – the poor man's friend, and a genuine loyalist. His remains, attended by a large circle of friends, and a numerous concourse of people, were interred in Kilkeel churchyard.'[32] His name had been neatly chiselled on the standing stone on the Flush Loney apparently in the year 1775. Previously I had imagined this act of graffiti arose simply from the fact that Jeremiah held land nearby. The placing of his name in such a bold fashion on the standing stone now gives rise to conjecture that it was a very public victory sign over the excise man with the standing stone symbolising the rude and emphatic mark of triumph. One must also remember the politics of that time. Francis Charles Annesley had succeeded to the Newcastle and Castlewellan estate in 1770 and his son, Richard was a commissioner of the revenue. Any 'victory sign' supporting the smugglers would rightly been

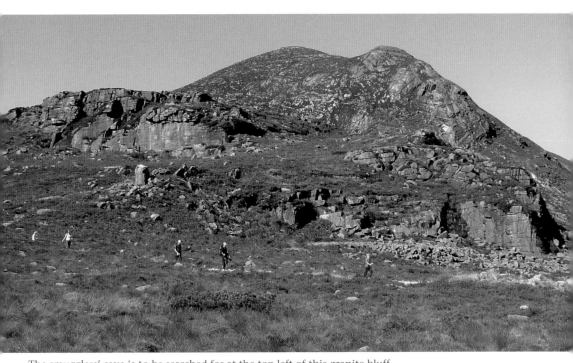

The smugglers' cave is to be searched for at the top left of this granite bluff

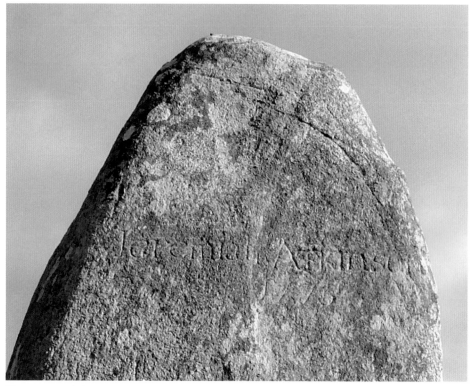

The carving of the smuggler's name on the standing stone made it a rude victory sign to Earl Annesley who was in charge of the Customs Service

interpreted as a sign of defiance against the Annesleys and not have been tolerated. The Annesleys, however, could do nothing about the sign as the standing stone was just outside their territory on the estate of Lord Downshire. The flaunting of Jeremiah Atkinson's name on the stone thus survived. A successful run by the smugglers brought money to many local people who often helped by acting as look-outs, unloading cargo or lending horses to move the contraband. The death notice, 'a poor man's friend', may now be considered code for the benefits brought to many by his clandestine smuggling activities.

> Silks for Her Ladyship
> Webs that gleam an' shine;
> All the southern Summer
> In His Lordship's wine.
> Gold for the sailor-man
> Silver for the lad,
> Them was days o' plenty,
> On the Smugglers' Pad.[33]

The Brandy Pad

To the south of Slieve Donard the Brandy Pad wends its way along the 550 metre contour from the Bloody Bridge, along under the Castles and over to the Hare's Gap. The descent from the Hare's Gap to the valley of the Trassey River below is too steep and rocky for pack animals. Instead, the trail hugged the Slieve Bernagh side of the valley passing along under the cliff face until a more manageable descent was possible near the present road to the Slieve Bernagh quarry. From seizures made elsewhere we know that the popular and most frequently smuggled goods along this path were tea, tobacco and brandy. The customs men of Cloughey station, for instance, made a seizure of a quantity of contraband goods at Ballyhalbert on the Ards after Christmas 1836. While this is outside our area of interest, we note that the customs seized forty-two bales of tobacco and twenty-one kegs of brandy.[34] Tea by then had had its day as a smuggled item. In 1770 a pound of Souchong tea cost 7s 6d at Downpatrick. For comparison you could then buy a half kilo of beef for 2d or a quarter of lamb for 2s 6d (mutton, lamb and fed veal were all sold by the quarter in those days).[35] The trade in tea as a smuggled item had been interrupted by war with France and with the reduction in tea duties in 1784 it was virtually eliminated as a smuggled item. By 1855 the price of Souchong in Belfast was 4s.[36] It was still expensive enough to warrant tea caddies with locks but for the smuggler the returns no longer made it a viable item to run.

On the Brandy Pad at the back of Slieve Donard

Brandy Pad under the Castles of Commedagh

Tobacco was introduced into England in 1565 and soon became an established item even for the poorest. Normally unprocessed tobacco would have cost between 8d and 1s a pound. However the government imposed an excessive duty of four shillings on every pound. The smuggler could sell it for a lot less. A half bale of tobacco weighed 65lb (about 30 kilos) but many a man carried a full bale off the shore. One such bale safely brought to market made a saving of £13 on excise duty which at the end of the eighteenth century was much more than many men earned in an entire year. We know from a surprising discovery made at Kilkeel that tobacco featured high on the smuggler's list. In January 1868, work was finishing on a pier on the shore below Kilkeel where the small river empties itself into the sea. The men employed to remove the shingle to enlarge the accommodation came on an old cave, roofed and full of tobacco. There were some forty or fifty rolls in the cave but they were completely useless. It was supposed that the cache had been buried for twenty years or more. The place where the cave was found just happened to be the spot where the fishermen were accustomed to haul up their boats, yet nobody seemed to know anything about it.[37]

The path from the Bloody Bridge to the Hare's Gap might just as easily have been called the tea trail or the tobacco track were it not that a punitive duty on brandy after the Napoleonic wars made it the most lucrative and common

commodity transported along this path towards the end of the smuggling era. Brandy in bond cost, according to quality, between 3s and 5s a gallon but the duty on it was trebled to no less than 22s 6d. The attempted prohibition against French commerce in the enormous duties levied on their brandies and wines, brought on in retaliation corresponding prohibitive duties on Irish linen. It was this impact on the linen trade that was particularly felt in the north of Ireland. It brought the *Down Recorder* to lambast the government for 'the injurious operation of oppressive duties'[38]. The paper branded the government's policy as 'ignorant rapacity to be paralleled only with that of the savages, who to get at the fruit, cut down the tree'. Prophetically it warned:

> 'The temptation to smuggle, occasioned by the exorbitancy of the duty, is too overpowering to be counteracted by the utmost penalties of the law.'[39]

Brandy was the commodity of the hour. Many kegs must have quietly passed over the mountain trail on the back of donkeys with their hooves often wrapped with cloth to muffle sound. With the increasing vigilance of the coastguard on land and at sea, smuggling was becoming less of an economic proposition. Brandy, which was predominantly the last main item to be smuggled, was losing ground to the growing competition of domestic production of spirits, licit and illicit.[40] The name of the Brandy Pad is now just a vivid and colourful reminder of a past era.[41]

The Brandy Pad avoids the rocks at the head of the Trassey Valley by passing along the steep hillside above

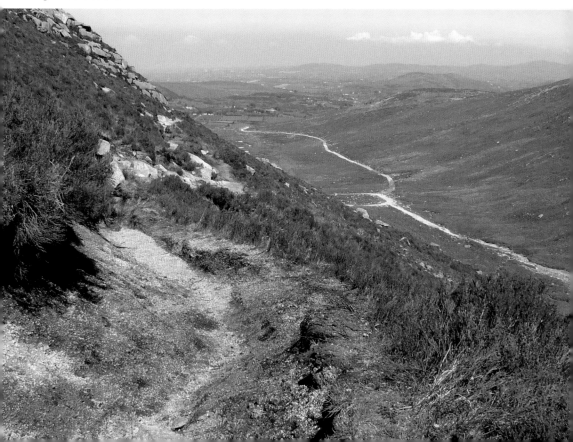

And so the contraband disappeared into the dawn mist. This part of the Brandy Pad is along the Trassey valley under Spellack cliff. Clanawhillan hill is in the middle background

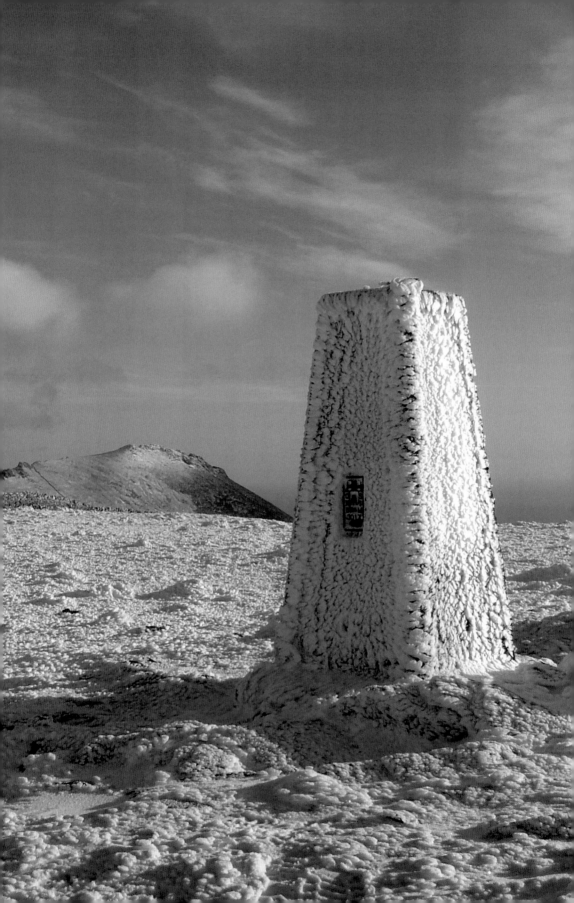

SLIEVE DONARD AND THE SURVEYING OF IRELAND

Slieve Donard has a special place in the history of the ordnance survey of Ireland. Early in the nineteenth century there were many complaints that the local taxes, then called the County Cess, were quite unfair. In 1824 a House of Commons committee recommended a townland survey of Ireland with maps at the scale of 6", to facilitate a uniform valuation for local taxation. The survey was directed by Colonel Thomas Colby, who had under his command officers of the Royal Engineers and three companies of sappers and miners. One of the officers who came over to assist Colby in Ireland was lieutenant Thomas Drummond. Not only had Drummond gained experience in the primary triangulation of England but he had unique talents as an inventor and mathematician, so much so that he was mentioned in the correspondence of Wordsworth as 'Drummond of calculating celebrity'.[1]

The first task of the surveyors was to precisely calculate the positions of a framework of points upon which the mapping could be based. Colby and Drummond toured Ireland in 1824 selecting the most suitable sites for signal stations. On account of its height it was no surprise that Donard was one of the original thirty points chosen on which to base the survey. From the top of Donard surveyors were able to take bearings on the high peaks of Wales, Isle of Man, Cumbria, Arran and the Borders as well as important vantage points in Ireland.[2]

Colonel Thomas Frederick Colby had entered the Royal Engineers when he was seventeen and two years afterwards lost his left hand by the explosion of a pistol. His zeal, patience and untiring energy in the English ordnance survey brought him to the notice of his superiors who employed him on the ordnance survey of Ireland[3]. The Irish triangulation began on Divis mountain near Belfast in 1825 as it was one of the most commanding of the stations observed from Scotland. Here he encountered the 'inveterate haze and fogginess' that made observations of distant stations in Ireland quite a problem. The following year the small squad of young sappers moved all the heavy signalling equipment to the top of Slieve Donard. Due to the lack of experience of his staff, Colby felt he had to camp on the top of the mountain and attend to many of the observations himself. His remarkable self control and patience is reflected in an incident that happened while working on Donard. Once when the light from the summit of Sca Fell in Cumberland became visible at a distance of 111 miles, an instrument was brought to bear on it after many trials. Colby was on the point of successfully finishing his observation when an officer on entering the observatory,

accidentally struck his elbow and threw the telescope off the bearing. With only one hand Colby could not again succeed to bring the telescope to bear. Had he been able to complete the observation it would, in the words of his biographer, have been 'a geodesical triumph, as including the longest side of a triangle ever attempted'.[4] A momentary gasp of anger escaped his lips, but although the sighting was lost he never afterwards alluded to the subject.

The problem of Ireland's murky weather was overcome by Colby's assistant, Thomas Drummond. Lamps could be used for night work but it had been impossible to make them bright enough to give satisfaction. Drummond used the powerful incandescence of burning quicklime to greatly improve visibility. His limelight, invented in 1825, was much brighter than the Argand lamps previously used by the survey.[5] He also greatly improved on Carl Friedrich Gauss's invention of the heliotrope. This was an instrument that used mirrors to reflect sunlight over great distances to measure positions.

The sappers, who earned one shilling a day, transported their tents and camping requirements as well as the signalling equipment to the top of Donard. They needed to bring up all the material to build an observatory and the three foot diameter theodolite itself weighed over two hundred pounds. Over the season of 1826 the survey officers observed for a long period to points as far south as the Wicklow hills. Their patience was probably often tried when mist and cloud descended on Donard. The light still needed to be kept lit every night to allow for possible observations from the other survey districts.

John O'Donovan visited the top of Donard eight years after the sappers had finished but he left one erroneous detail in his report back to ordnance survey headquarters at Phoenix Park.

'The Sappers have left a good many circular cairns on this mountain. I hope these will never be taken for Druids' circles or chapples of hermits, though I am fully convinced that their sojourn on this mountain will be handed down to posterity.'[6]

There are indeed a good many small cairns still extant around the front cairn or Saint Donard's cairn. These are the remnants of the stations where the pilgrims said their prayers usually walking round the small cairn as they did so, much as is still done at the cells at Lough Derg today. These small cairns were never constructed by the sappers of the ordnance survey. If anything, the sappers did more to destroy the great cairn at the summit than may be realised. When the men of the ordnance survey came to the top of Slieve Donard in 1826, two things were certainly needed; a level place at the very top for their observatory and a commanding uninterrupted 360° view. The summit cairn would have been in the way and had to go.

The top cairn was completely dismantled and the stones thrown to the side in order that the observatory would have precedence. The cairn now seen on the very top of Donard is a resurrection and not the original ancient monument.

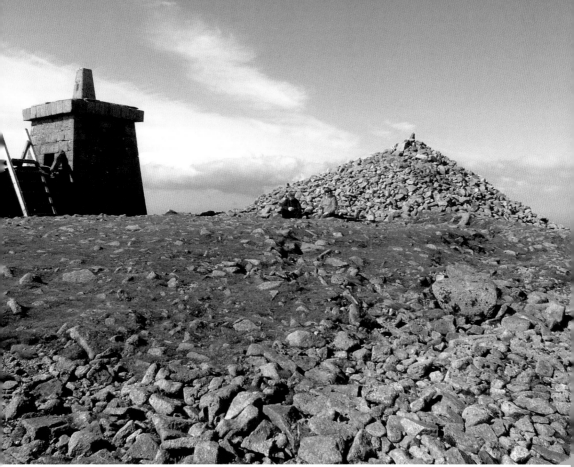

The stones in the foreground would have been part of the original cairn tossed aside by the survey party. The cairn had been described as a 'huge heap…piled up in a piramidical figure in which are formed several cavities.' The level base of the original cairn, on top of which the surveyors built their observatory, can be seen here across the centre of the picture. Note the edge on the right of the level area marking the end of the platform

The comparative perfection that O'Donovan noticed in the summit cairn six years later could be accounted for by the sappers possibly undertaking a quick reconstruction job before they departed. Tedious work it would have been but not an unduly long task for a team of soldiers. The original cairn was described by Harris in 1744.

> 'On the summit of this Mountain are two rude Edifices (if they may be so termed) one being a huge Heap of Stones piled up in a piramidical Figure, in which are formed several Cavities, wherein the Devotees shelter themselves in bad Weather while they hear Mass; and in the centre of this Heap is a Cave formed by broad flat Stones, so disposed as to support each other without the help of Cement.'[7]

This description suggests a corbelled passage grave comparable with that on Slieve Gullion.[8] It is likely that many of the broad flat stones mentioned were later incorporated into the Mourne Wall. At the time of writing we look forward to a report from archaeologist Sam Moore who conducted an investigation of the

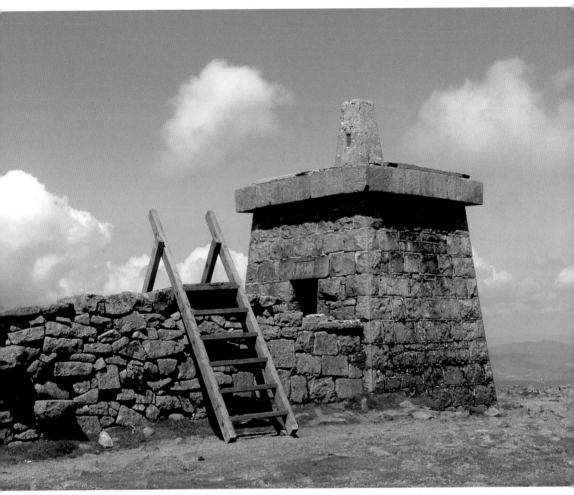

The water commissioners' stone shelter with the 1950 trigonometrical station on top

summit in 2008. His report is expected to show that the original cairn was surrounded with kerbstones.

The very base level of Donard's summit cairn would have been the obvious and envious site for the surveyor's observation platform. The toppling of the original cairn from its position on the early burial platform to make way for the observatory would have provided both the necessary all round view needed for the surveyor's sightings and account for the remarkable scree of loose stones, not bedded into the surface of the mountain, found in profusion immediately on the seaward side. Although the stonemen would have had their pick from this scree of any large boulders for the Mourne wall, there remains nevertheless an abundance of stone of a remarkably uniform and convenient size as could admirably have been used for building a cairn. Indeed a growing gap at the top

of the scree bears testimony to it currently being quarried by visitors wishing to add their personal pebble to the top of the present pile.

So much has changed on the summit since the visit of the surveyors. The present shelter was built in 1910, the Mourne wall followed not long after that and thousands of hikers still pass this way every year. Despite these changes readers are invited to look carefully at the relatively level patch on the east side of the shelter and behind the cairn (for a Newcastle man, the 'front' will always be the side towards the town). Discern if you will, a level area of stones, a platform with an edge still detectable on the seaward side. On Slieve Commedagh the ancient burial forms a platform on which a later accretion of stones forms the cairn. On Donard everything on top of the platform disappeared. Only the stones that formed the base of the platform now survive. Its diameter has been measured at just over twenty metres although it is recorded that in 1956 stones were spread over an area more than thirty metres in diameter. The present summit cairn was reconstructed at the end of the survey adjacent to its original location. The back end of the cairn rests on the edge of the level platform. The declivity in the ground

Close up of the benchmark faceplate on Donard triangulation pillar. These pillars are now obsolete on account of global positioning satellites (GPS)

immediately behind the cairn may be the result of large stones being prised out for inclusion in the Mourne wall but archaeological excavation would one day be necessary to determine whether this was the passageway that professor Evans imagined might have led into the tomb or the location of the well referred to by O'Donovan as 'dried up'.

While on the summit of Slieve Donard, it is worth having a good look at the finial on top of the stone shelter built for the Belfast water commissioners. This is the trigonometrical station. Cemented into the side of the marker is the brass ordnance survey plate with the 'crow foot' and the letters OSNIBM, standing for 'ordnance survey Northern Ireland bench mark'. The term 'benchmark' originates

The surveyors' camp site is shown by the two rings in the grass. Note the little track behind that led to the summit observatory

from the chiseled horizontal marks that surveyors made, into which an angle-iron could be placed to bracket ('bench') a leveling rod, thus ensuring that the leveling rod could be repositioned in exactly the same place in the future and thus keep all readings consistent. This is station number 3087 and the numbers on the ordnance plate show the stress of indentations where a levelling angle iron has been hammered into the securing holes in the course of subsequent survey work. The date above the door of the stone shelter on which the trig station sits is 1910 so this is not the same trig station referred to by John O'Donovan in 1834. The stone shelter on Donard formerly had a pyramid cap similar to the shelter on Slieve Commedagh but I rather suspect it was damaged by lightning. The present concrete triangulation finial that replaced the stone cap was placed on top of the shelter in 1950 when the country was re-surveyed. The wrecked remains of an earlier trigonometrical pillar still with its centre reinforcing bar lie below the NW side of the shelter. The iron reinforcing rod in the centre of the pillar would have been attractive to the lightning which ultimately caused its destruction. There are three triangulations stations in the Mournes; Slieve Donard, Slieve Muck and Slievemartin above Rostrevor. Now that global positioning satellites can precisely mark our location, these mountain-top trigonometrical stations are

long redundant and it only remains for John O'Donovan's prophecy of mystery to be fulfilled.

'The *cairn* to the S.W. is much more perfect, but destroyed in a great measure to erect the Trig. Station, which in the course of ages may puzzle antiquarians to discover its scientific use.'[9]

If there is an element of speculation as to the position used by the surveyors for their observatory, such is not the case with their camp. About a hundred metres down the landward side of the Mourne wall heading towards the Bloody Bridge the slope gives way to a reasonably level area. Here, on the south facing slope the tents were erected where they could avail of every possible bit of heat from the sun,. Army issue tents in those days were circular. The lie of the stones and the darker colour of the vegetation where the ground was disturbed show where at least two tents were situated. Other sites to the east may have subsequently disappeared under the building of the Mourne wall. To try and protect themselves in the gales that would sweep the mountain, the sappers piled stones and boulders around the edges of their tents to anchor them down, to give as much shelter as possible and to stop the wind getting under them and whipping them away. I find myself ambivalent however about the nearby rectangle of stones On one hand, being adjacent to the small quarry from which stone was extracted for the construction of the wall, it was likely a forge for pointing the 'jumpers' used in

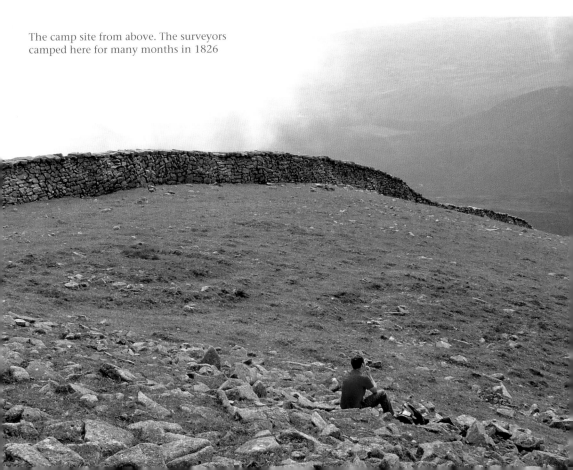

The camp site from above. The surveyors camped here for many months in 1826

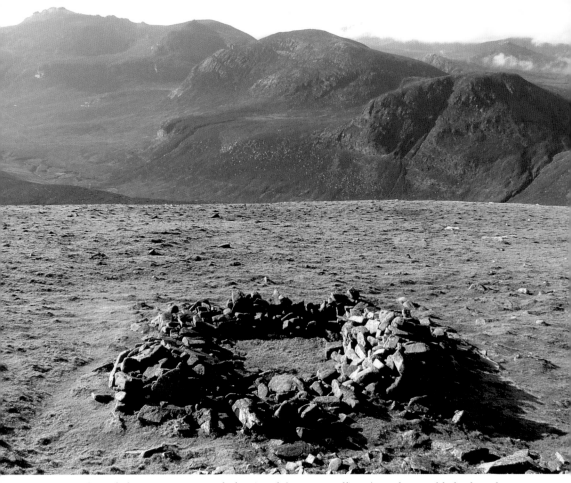

These shelter stones may mark the site of the survey officers' tent but could also have been a rough shelter for the men building the Mourne wall who frequently slept out on the mountain under a canvas during summer evenings

splitting stone. I find the construction of the walls just too jumbled and untidy to attribute the work to the master-builders of the wall. On the other hand I had wondered if the officers of the survey might have received this additional protection of a stone bulwark for their quarters, in deference to their rank. The rectangular construction however does not match the circular tents used by the sappers the outline of which is still evident on the grass surface though maybe the officers' tent was different. Trying to live and sleep in tents through howling winds must have been very trying on the nerves. Life on the mountains was difficult and could be dangerous. Drummond became seriously ill after enduring hardships in a sod hut on the top of a snowy Slieve Snaght in Donegal over the winter of 1825. Observers were blown out of their tents; Colby himself was hurt, Forsyth was nearly killed and two servants died in a snowstorm in trying to bring down the equipment.[10] Of the original twenty young cadets of the first batch who were trained for Ireland, only ten were still on the roster at the end of the first three years. The survey on the top of Slieve Donard ended in the middle of November 1826 as advancing winter precluded further observations.

Killed by lightning

Mention of people being killed during the survey brings to mind the much more recent tragedy of a walker being killed on the summit by lightning in April 2006. It was the Saturday just before Easter of that year when a group of walkers discovered the body of a 29 year-old man at the entrance to the stone shelter. The Mourne Mountain Rescue were tasked and, as the incident was a sudden death, a police presence was also needed. A coastguard helicopter from Dublin air-lifted two policemen and a doctor to the scene and the man was confirmed dead. The helicopter then returned to Donard Park with the man's body. A post mortem found 'no obvious cause of death', but witnesses said there were scorch marks on the man's chest and legs that would be consistent with a lightning strike. Such a strike would have stopped the heart and brain instantly. The young man was later identified as Carl Stephenson of Withernsea, East Yorkshire, who had come to Northern Ireland only a few weeks beforehand. He had been qualified in rock climbing, canoeing, caving and hill walking and loved to get out at every opportunity to enjoy the scenery. The rescue service noted that he had been well equipped and had plenty of food with him. A bronze plaque to his memory rests at the side of the summit shelter. 'In memory of Carl Stephenson. Died here tragically 08 April 2006, aged 29 years, struck by lightning while walking in the mountains he loved. This plaque was placed here by his colleagues.'

Plaque in memory of Carl Stephenson who was killed by lightning

A close look where the Mourne wall joins the west side of the summit shelter will reveal a bent iron post hammered into the ground. Originally the wall builders tied string to this post to aid alignment but the post was hammered into the ground so firmly it later proved impossible to remove and so was bent over and broken. There is a corresponding iron eye on the other side of the wall to which guide string was tied. Also nearby is the iron bar imbedded in cement that once formed the core of an earlier triangulation pillar until lightning dislodged and destroyed it. Lightning is attracted to iron and Carl had unfortunately just been close at the wrong time.

Local Bench Marks

Numerous examples of the surveyors' art are still to be found in the local area. Bench marks, sometimes referred to as datum points[11] or more commonly as 'crows feet', were carved by masons on walls, public buildings, and bridges. The most notable example in Newcastle is on the parapet in the middle of Castle Bridge on the landward side. The height of this mark was 29.94 above sea-level, but that was before renovations raised the height of the parapet during the street widening. Another example is at the Ballagh. Parking at the blue quarry, you walk south a short way until you meet a gap in the sea wall. The bench mark is carved on the top surface of the granite wall a dozen paces past this gap and looks across Dundrum Bay to St John's Point. A few other bench marks to look for around the town are:-

1) on the wall at Bryansford Road where it bends round to the Orange Hall;
2) low down on the right hand entrance pillar to St Colman's cemetery on the Tullybranigan Road;
3) on the north east side of the Priest's Bridge;
4) just above ground level on a rubble wall with red brick corners in the grounds of Enniskeen carpark;
5) on a rounded stone still peeping up at the side of the footpath beside the entrance to St Patrick's park on the Castlewellan Road.

If the grounds of St Patrick's Park come to be redeveloped in the years ahead, I hope this stone will be preserved. I noted a good example some years ago while coming down the lane from the Drinns forest above the water commissioners' house. This bench mark on the wall must now be covered with vegetation as I missed it on a recent search. A nice crisp example is carved on the entrance pillar to Greenvale nursing home in Castlewellan and I am sure there are many other examples to be found. Although these bench marks are not particularly rare, many have been lost in the course of redevelopment. Usually they are just overlooked. The attrition of these benchmarks is unfortunate and hopefully the days of their thoughtless removal will be at an end.

Bench mark low on outbuilding at Enniskeen hotel car-park

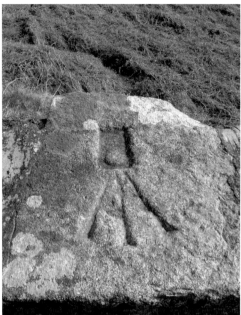

The bench mark on the sea wall at the Ballagh

This mark is to be found low on the right hand entrance pillar to St Colman's on the Tullybranigan Road

Crow's foot mark on the wall at the Orange Hall corner

This bench mark is on the footpath at the entrance to St Patrick's GAA park, Castlewellan Road, and is worth preserving

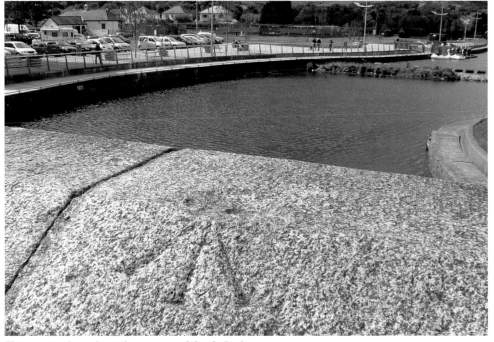

The surveyor's mark on the parapet of Castle Bridge

THE BOTANISTS

Becoming familiar with even a few plants that one is likely to meet on a walk to the top of Donard can add immensely to the pleasure of the excursion. The joy of recognition and discovery, especially for the scarcer plants, leaves the happiest of memories.

The earliest contribution to our knowledge of the plants of the Mournes came from Dr William Sherard, at one time British consul at Smyrna, a devoted botanist and founder of the chair of botany at Oxford. He visited several parts of Ireland in 1694. While partaking of the hospitality of Sir Arthur Rawdon, at Moira, he explored the Mourne Mountains and the shores of Lough Neagh.[1] Walter Harris in his history of county Down in 1744 recorded that Sherard had discovered a rare fern and brought it to England. 'This curious and rare kind of fern', wrote Harris 'has not as yet been found in any part of the world but on the Mountains of Mourne'. That sentence alone was enough to bring many botanists to search the mountains especially during the craze for ferns in the Victorian era. The fashion for ferns was then so strong that when the Slieve Donard hotel was opened by Lady Annesley in June 1898, there was a dedicated 'Fernery' room at the north end of the building.[2] Harris employed a botanist to search and catalogue rare plants found growing in the county during May 1743 and pronounced the searches a triumph with the discovery of 'savin with the leaves of cypress, on Slieve Donard'.[3] John White examined the flora of the district and particularly the Kilkeel neighbourhood and supplied notes of the local plants to the *Irish Flora* published in 1833. Others who looked at the botany of the mountains were John Templeton, Dr Mackay, William Thompson and Dr Whitley Stokes. Whitley Stokes, a lecturer on natural history in Trinity College, was especially interested in mosses. In his time he was suspended from his teaching function for three years for complicity with the United Irishmen. The mountains received attention from Henry Chichester Hart whose name stands high in the annals of Irish botany. He published the *Flora of the County Donegal* but the greater part of the edition was unfortunately destroyed by fire in the Dublin disturbances of 1916. Canon Henry Lett, a county Down man born in Hillsborough, wrote on the place names of Mourne and also walked the mountains in search of plants.[4] Two young men who had just started to add to our store of knowledge on Mourne plants died together in pursuit of their passion for botany. Charles Dickson, a Downpatrick solicitor, and Thomas Hughes Corry a brilliant botanist who had graduated with distinction at Cambridge both drowned in August 1883 after going out in a boat on Lough Gill, county Sligo, to collect mosses and ferns.

Sedum Rosea, or Roseroot, seen here in flower at the end of May, earned its name from the fragrance of the root when crushed. It is one of the botanical rarities of the Mournes

The small delicate Parsley Fern is well named. This very rare arctic-alpine species of fissures was found at Slieve Muck

The first systematic botanical exploration in the Mourne mountains took place over two summers from May to September in 1889 and 1890. Robert Lloyd Praeger and his mentor Samuel Alexander Stewart spent a total of forty days in the district. As Praeger reported to the Royal Academy, they had 'traversed on foot over 850 miles of mountain, valley or road; scarce a cliff or a stream of the least importance but has been visited and revisited; and it may be claimed that our examination of the flora has been reasonably complete'. So thorough were they that they even dragged all three high level lakes with a specially designed grappler to check the aquatic flora but nothing unusual was found. The deeper water of the mountain lakes (a sounding of 17 feet was taken in the Blue Lough near the Slieve Lamagan shore) actually yielded no plant life whatever and the bottom consisted of soft peat-mud. Their search ended with a list of 593 species with few

This outcrop at Slieve Muck hosts an ancient shelter cave used by herdsmen. Small rosettes of rare mountain saw-wort grow here. Roseroot and Parsley Fern are also found on adjacent rock faces

outstanding rarities. The paucity of alpine plants, however, was noted.[5] The Mourne Heritage Trust has recently conducted a survey over three seasons to take an inventory of the plants and grasses on the mountains. The work goes on.

I have a special admiration for the botanical dedication of Arthur Wilson Stelfox (1883–1972) who retired to Newcastle after working in the national museum in Dublin. One of the botanical rarities of the Mournes is Mountain Saw-wort (*saussurea alpina*) which was found by Praeger on Slieve Muck in 1893. This plant was not seen in flower for over forty years until 1937. The plant grows sparingly in fissures of dripping vertical shale rock. The only other colony in east Ireland is in county Wicklow. When Arthur Stelfox lived in Newcastle he visited the Mourne colony almost every year until his death aged eighty-nine.[6]

THE TUNNEL THROUGH THE MOUNTAIN AND ITS TRAGEDIES

'Heretofore the Silent Valley had been familiar only to a few, to the people of Mourne and to the poets who had made their songs and told their legends. In the future it was to be known through the length and breadth of the country as the fountainhead from which millions of gallons of pure water came to serve the people of a great city.'

<div align="right">IN SEARCH OF WATER BEING A HISTORY OF THE BELFAST WATER SUPPLY, BY JACK LOUDAN, P.78</div>

At the end of the nineteenth century the growing city of Belfast needed further supplies of good water. By an 1893 act of parliament, powers were granted to the Belfast water commissioners to intercept the Kilkeel and Annalong rivers and to acquire an extensive catchment area in the Mourne Mountains. The original intention was to build a reservoir at the Silent Valley or Annalong Valley and to convey the water from it by conduit, siphon and pipe to the Knockbreckan service basin at Carryduff. It was decided however to postpone the reservoir construction and bring the water to Belfast direct from the Kilkeel and Annalong rivers. The main track of pipe was laid in a trench and covered over with soil but a tunnel was needed to bring the water through Slieve Donard and Thomas mountains to the Newcastle side of the mountain.

Negotiations were opened with Lord Annesley to obtain way-leaves over his demesne and the further fields that would be affected by the pipe-line. Originally Annesley had indicated to the commissioners that they need not apprehend any unreasonable opposition from him but when approached by the commissioners' solicitors he dissented from the scheme.[1] The thorny question of compensation had raised its head. This became 'very adequate compensation'[2] when it was realised the promoters of the water works scheme wanted to take six acres in Donard demesne close to the Glen river and a further three acres close to the Shimna river to heap up the spoil coming from the tunnel. There were fears that the spoil heaps would be a great disfigurement and that Newcastle's water supply would be discoloured. Tunnelling was very expensive compared with a pipeline laid by 'cut and cover' and the Annesley estate probably expected a measure of

One of the water pipes above the Bloody Bridge bringing water to Belfast

this saving to be passed on in the compensation. A year later negotiations were still being conducted with agent Garrett quizzing the commissioners' engineer. Among the questions being asked was: 'whether the land in fee is to be fenced and what buildings are to be erected on it? What is the width of the ground to be taken for cut & cover? Who is to cut the trees? May Lord Annesley replant the sides when the pipes are laid? When would the work begin? How long would it take? It may save time', wrote the agent, 'if, when answering these queries, you would state the sum the Water Commissioners are prepared to give Lord Annesley if he accedes to their effecting a vast saving by avoiding the tunnel.'[3] The Belfast water commissioners declined to be held to ransom and dropped the idea of a tunnel exit at the Glen river and instead they bypassed the Annesley estate and tunnelled over to the Roden estate at Tullybranigan. The engineers didn't mind the extra tunnelling as it meant more money for them. As a result we have the pump house on the slopes immediately west of the Tullybranigan tributary river marking where the cut and cover pipe-line heads towards Tollymore and Belfast. The tributary coming down from Shan Slieve and Slievenabrock into the Tullybranigan river was the mountain boundary between the two landlords.

Hundreds of thousands of tons of shattered rock from the tunnel blasting were tipped on the Tullybranigan hillside. Nature has made a wonderful job of covering and hiding the rubble which is still to be seen where vegetation has been disturbed. Tip piles in the lower reaches of the slope towards the water house are a reminder that this whole area was a rubble wasteland at the beginning of the twentieth century. The water pipes can

The pump house on the slopes of Tullybranigan

still be seen both where they cross the Bloody Bridge river and the Shimna. If walking into Tollymore Park via the back entrance at the Priest's Bridge, the distinctive red gates used by the water commissioners mark the direct line down to the river where the pipes cross. When the arbitrator announced his awards for compensation, Annesley was granted only £1 for disturbance at Ballaghbeg.[4]

Belfast water pipeline 'cut and cover' scar on the fields of Tullybranigan

Nature is disguising the thousands of tons of tunnel spoil tipped at Tullybranigan

The Coming of the Navvies

The Belfast water scheme was dealt with in five separate contracts. The section in this area extended from the Annsborough valley to the Bloody Bridge river and included some exceedingly difficult and expensive work. It was a stretch of eleven and a half miles including seven and a half miles of siphon towards Annsborough and a tunnel of two and a quarter miles through the mountains. This contract was carried out by H. & J. Martin. The navvies descended on Newcastle and for the duration of the contract Tullybranigan became a mining camp. Up to three hundred workers came to take up residence in the town.[5] Details of conditions are sparse but an insight can be gleaned on account of reports of a police raid that came before the courts. Shortly after the tunnelling began sergeant Dickson and a number of Newcastle constables raided a Tullybranigan hut for the accommodation of men employed at the waterworks. As a result a man called Owen Trainor was charged with having a quantity of intoxicating liquor on his premises, he not being a person duly licensed to sell the same.[6] When the police entered they found six men playing cards and nine men were in bed. It was reported that often there were twenty-five men there. Near the defendant's bed 29 full bottles of porter were found and 96 empty ones with nine empty whisky

bottles, some found in a shed. It was pointed out that when the men went into town they would bring drink back with them. Drink was never sold in the hut. The defendant was let off with the lowest possible penalty. One is reminded of the words of Joe Marks's poem.

> But England's law has many a clause that reads between the lines
> And bould McAlea to the bench was hauled for selling stout and wine.
> Now the first before the judge to step and make a gallant stand,
> To kiss the Book and take the oath, was the famous John McCann.
>
> Sez he, 'I hin from near the weir an I work for McAlea
> And the stout was there, placed in my care, to be used for making tay'.
> 'Well if you keep stout for the working men what made you keep the wine?'
> 'There's many a time we needed wine to cream the workers' tay.
> And with no woman there to food prepare and the cook being far away,
> Aul John McCann and the working men drank porter for their tay'.[7]

The making of the two and a quarter mile tunnel through the mountains was a major engineering achievement. Some parts of the tunnel were at a depth of 600 feet below the surface of the earth and could only be worked from either side.

The question of adequate ventilation had to be considered. Shafts for air vents had to be sunk to help air circulation. Two shafts were blasted; one was on the seaward shoulder of Millstone mountain and the other vent was on the summit of Drinnahilly. The Drinnahilly shaft was 214 feet to the bottom and when the headings with the Tullybranigan end were compared they were in perfect line and level. Some people looking at postcards of Newcastle at the end of the nineteenth century are frequently mystified at the appearance of a little projection on the very skyline to the left of the shoulder of Millstone mountain. This was the flue of the air shaft. Acting like a chimney to draw air up out of the shaft below, it had to be built at the high point on the hill to avoid down drafts and for a while it became, in the

By act of parliament in 1889, the name of the Belfast Water Commissioners was changed to the Belfast City and District Water Commissioners, hence the abbreviation of BC&DW on this valve cover near the pump house at Tullybranigan

The ball finials on the pipeline gates carry the Belfast Water Commissioners abbreviation of BWC

borrowed words of The Prince of Wales, 'a monstrous carbuncle on the face of a much-loved and elegant friend'.[8] When the tunnel was finished and the water flowing to Belfast, the air vent was obsolete and Earl Annesley, recalling the derisory compensation the water commissioners had awarded, gave orders, probably with great satisfaction, that it was to be blown up. The shattered slabs of concreted stone are still there along with the tips of spoil extracted during the making of the shaft. Approaching the roundabout as one comes into town on the Castlewellan Road the remnants of the tower can still be see as a dimple on the skyline to the right of the wall that goes up the mountain. The demolition of that skyline blemish over a century ago to preserve the beauty of the mountains holds, I believe, an important and enduring message to all who would think of erecting masts, towers, windmills or other excrescences in areas of outstanding natural beauty. The vent tower at Drinnahilly remains intact although surrounded by trees.

For more than four years operations continued day and night on the four 'faces' from which the tunnel was attacked. One shift of men replaced another every eight hours. The calculations were the last word in precision. Two parties of miners, one at either end of the centre portion of the tunnel between the two air shafts, a distance of a mile and a half apart, and working towards each other, would meet eventually in a seven foot circle without having made more than a few inches deviation from their course.[9] The tunnel, however, was not without its sacrifice.

Man loses his Leg

The first recorded serious accident happened in June 1898. After several successive blasts of gelignite, the men of the morning shift were under the impression that all the charges laid had exploded. They were in the process of making further bores when an unexploded charge went off. A man named John Charles, who was sitting on a rock to hold the drill had portion of one of his legs blown off. Two other men named Magee and Sharkey, who were hammering, suffered severe injuries to their eyes and another man, Mick Whitley, was also hurt. A car rushed the injured man to the station but the 11.20am train to Downpatrick was just

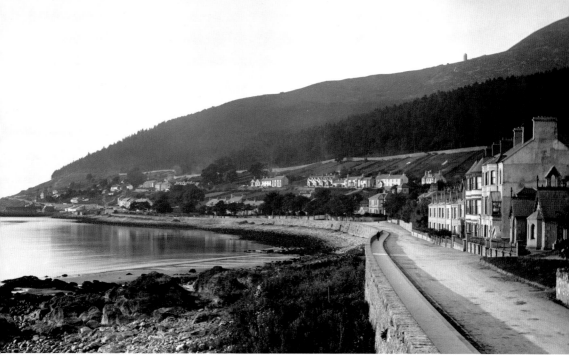

The square tower of the tunnel air vent blighted the mountain skyline for a number of years until Earl Annesley had it blown up. *Courtesy of the National Library of Ireland*

moving off. The poor man had to be taken the whole distance by road, a much slower and bumpier journey in those days when roads were tracks of stones and tarmacadam was not yet widely used.[10]

Three months later on Thursday 8th September a similar accident occurred. Five men were engaged in the Ballaghbeg shaft at blasting operations and eight holes had been fired. Sufficient material had not been dislodged by the explosions and the workers descended to prepare holes for recharging. While they were working at this, an unexploded charge went off and two men, John Traynor and John McKeever sustained terrible injuries. They were rushed to the station and then brought on stretchers to the Downe hospital. Several fellow workers who had been close by at the time of the explosion were very fortunate to escape with only a few scratches. Traynor was later interviewed about what had happened. He had just come over from Glasgow and had started work for Messrs H. & J.

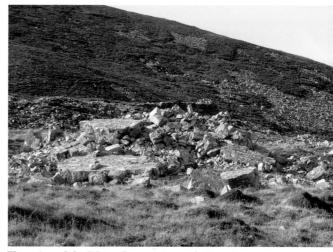

The ruins of the Water Commissioners' air vent after Annesley ordered its destruction when the tunnel was complete

97

Spoil heaps on the slopes of Drinneevar from the shaft sunk on the ridgeline to provide air circulation in the tunnel below

Martin two days previous. After eight holes had been fired he descended the shaft along with four others, including the ganger, Charles Mooney. He began to clear out one of the holes in which a charge had seemingly exploded. McKeever was beside him. Tested first with a copper scraper, the hole did not show signs of any explosive ingredients having been left in, something like sand being felt. He proceeded to loosen the material with a steel drill and then the explosion occurred. He was struck full in the face and hurled against the wall of the shaft. Struggling to his feet, all was dark to him and he became unconscious. Strange to say, although the wounds to his arms were severe, he was unaware of them for several days because the injuries to his eyes, one of which was burst, were so very painful. Traynor, in fact, completely lost his sight and McKeever's right eye had to be surgically removed. Early the next year local solicitor, Daniel McCartan, had to bring a case against Messrs Martin under the Workmen's Compensation Act on behalf of John Traynor. The injured man had recently left the infirmary as

nothing more could be done for him and he was removed to the workhouse. Before the accident his wages were 34s 9d (£1.73) a week but he had agreed to accept 17s (£.85) a week for his lifetime. Unfortunately, however, not a penny had been paid. The judge had no hesitation in awarding him his agreed pension together with arrears and costs.[11]

Fatalities too Common

Before 1898 ended, the tunnel would claim its first life. In the very early hours of 19th December a number of men on the night shift, among whom were William Donaghy, John Moffatt and Patrick Casey, descended the shaft to clear away debris from a gelignite explosion. In the ordinary course it was supposed that all the cartridges had been exploded. Some men were filling rubble into a wagon and Donaghy was picking on the face of the tunnel. The wagon was just half-filled, when Donaghy, it was believed, drove his pick into a hole in which a charge or a portion of a charge still remained. There was an instant explosion. Donaghy lived for about five minutes but he had been shockingly mutilated. Moffatt and Casey were wounded. The coroner ascribed the fatality to accidental means. The Home Office were supplied with the particulars of the accident but didn't think the presence of an inspector at the inquest was necessary as 'such unfortunate accidents were very common and that from the information before them they were of opinion that due care had been taken, there being no mystery attached to the circumstances'.[12]

Life was cheap then. The death of a navvy was not always deemed newsworthy. That there were other deaths in the course of the Belfast water scheme is certain. On one occasion two men were killed and although the incident does not seem to have been reported, John McCarthy of Drumena told the story of how one man had a lucky escape. The man was employed in the construction of the tunnel and, it appears, was warned by a little stranger that he was not required at work on a particular day so he turned and went home. Later that day some of his fellow workers were killed during a blasting accident in the tunnel. Those in charge of the job said they had not given any instructions for workers to stay away and the identity

This forty foot chimney was constructed on the summit of Drinnahilly to improve air circulation during the construction of the water tunnel. It is now masked by the surrounding trees. It was built, however, on the southern edge so if the trees are ever removed this tower will still not be seen from the town

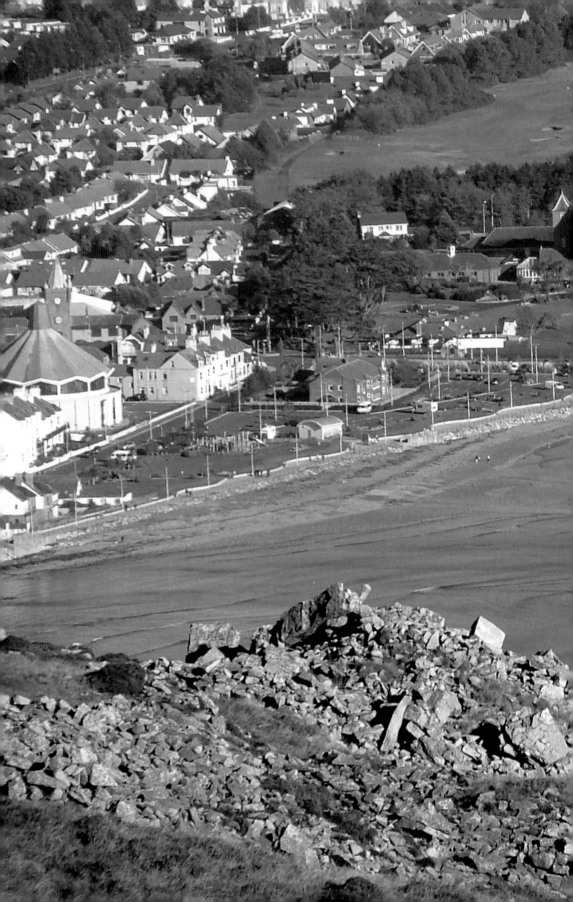

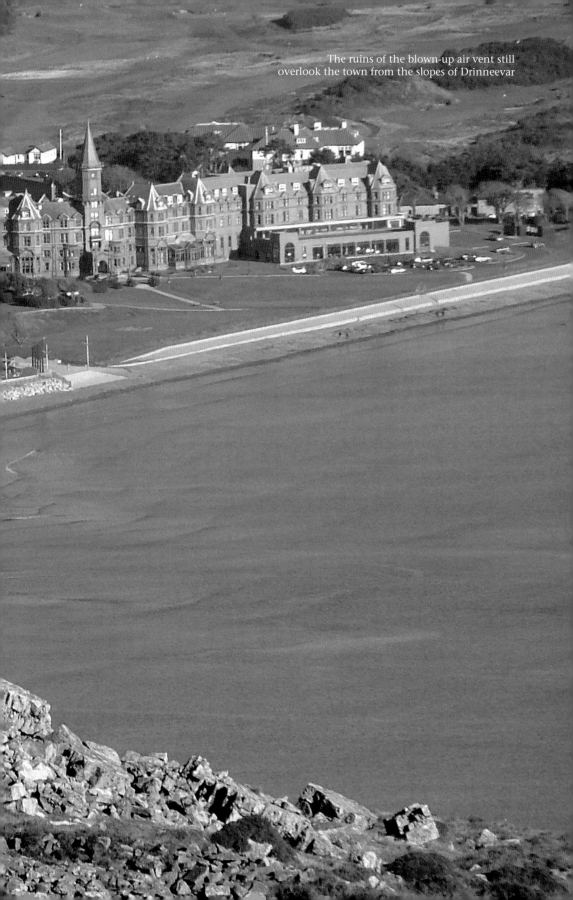

The ruins of the blown-up air vent still overlook the town from the slopes of Drinneevar

Looking over to Slievenamaddy, the distinctive red gates of the Belfast City Water Commissioners edge the laneway near Curragh Ard

of the little man was never known. John McCarthy was able to go into the story in greater detail. The man's name was John McEvoy, of Tullyree. 'I knew him well, and he went to work through Roden's Demesne at a place in the wall which is now built up. There was a smaller gateway there and as he was going through it a man of very small stature appeared and told him not to go to work that day. McEvoy took his advice and returned home. That same afternoon two men were killed in the tunnel while blasting the rock and had McEvoy been working he would have been assisting these two men. No-one could tell who the little man was and he was never seen afterwards. But it was generally believed that he must have been a leprechaun.'[13]

Accidents were so depressingly frequent that perversely it was near misses that became more interesting. When Newcastle man John McVey had a narrow escape from death in September 1899 the report was ominously prefaced;

'The Mourne waterworks scheme has a heavy toll of accidents, several fatal and tragic, and others less distressing.'[14]

A charge of gelignite had been laid and the workmen, including McVey, stood back the usual distance as a measure of safety. On the explosion, however, a large stone hurled along, glanced off the air pipe and broke McVey's leg below the knee. He was unfortunate but still a lucky man.

Another Newcastle man, Michael Murphy, was not so lucky. He had started work as usual for the morning shift at seven o'clock at the Ballagh end of the tunnel. At eight the roof of the tunnel fell in without any warning. The gang of men all managed to escape except Michael. He was killed instantly. All hands immediately got to work to clear away the debris but it took them almost four hours before they reached the lifeless body. Murphy was a quiet young man of twenty four but he had been unable to run for safety as he was lame owing to having had his legs broken as a boy. His father was already dead but his mother was left to mourn him. Michael Murphy's death at the start of January 1901 is the last mention of a fatality at the waterworks tunnel.

The whole track was completed in late 1901 and millions of gallons of water from the Annalong and later the Kilkeel river flowed through the conduit and siphons to the basin at Knockbreckan. Sir Robert McConnell, who had been chairman of the Belfast City and District Water Commissioners at the launch of the scheme in 1893, formally opened the valves of the Knockbreckan reservoir with a golden key on 2nd October 1901. The siphon pipes were doubled in capacity by 1937 and then tripled by 1956, providing a supply of thirty million gallons of water per day to Belfast and its vicinity.[15]

The visitor's entrance to the great Silent Valley reservoir, an oasis of peace

BONFIRES ON
THE MOUNTAIN

In these days of instant and pervasive light it is difficult to imagine both intense darkness and the awe in decades past of a big fire. The main street of Newcastle after the war was quite a dark place at night. There were very few street lights and shops could not afford to burn lights outside their premises. Neon lights didn't come to town until the 1960s. Fuel poverty had long before been a real concern. At the end of the nineteenth century coal unloaded at Newcastle quay cost 15/- a ton but so many were unable to afford this price that a coal charity was established in Castlewellan in 1892.[1] Annesley carefully guarded his trees and even had a forester, James Cowie, to patrol his estate to protect them from being cut for firewood. During the cold of the winter of 1894, however, the forester was allowed to reduce the prices for brushwood to 6d a donkey load or 1/6 a horse load. The cutting banks for turf extraction are scattered over the saddle between Millstone mountain and Slieve Donard. The quality of turf from these shallow banks was never great. At Castlewellan a bailiff called Stewart had been appointed to collect payment for turf cut out of the bog but when the bog was spent it was his task to warn people off it.[2] It was enough of a struggle for people to get fuel to keep their own homes warm so the extravagance of a large fire, apart from the time needed to build it, was beyond most people's economic means.

The most important bonfires in the area during the nineteenth century were for the local young gentry. When the earl of Hillsborough came of age in December 1865, the tenantry of Moneyscalp decorated the surrounding hills with bonfires. The tenants of Lord Roden did the same at Bryansford two years later when Viscount Jocelyn came of age on 22nd November 1867. The village was brilliantly decorated and when a signal rocket was sent up the bonfires on the surrounding hills were lit. Most impressive celebrations involving bonfires marked the coming of age of William Richard, 4th Earl Annesley, on 21st February 1851. A large bonfire blazed at Brook Cottage on the Bryansford Road, the home of William Beers. Bonfires blazed on the old castle of Dundrum and at the residence of Rev W. Annesley, Ardilea. In Castlewellan, however, a huge bonfire burned in the town centre and on Bunker's Hill a stupendous bonfire was prepared by the town's people which 'far surpassed by its magnificence and splendour, all others for miles around'.[3] These celebrations of 1851 saw the first mention of a bonfire on Slieve Donard. On Slieve Thomas and other mountains, blazing tar barrels and islands of whins were set on fire. The glare of the bonfires was seen by passengers on board the *Vanguard* steamer on its passage from Dublin to Glasgow while at

Such pleasing lighting of the town at night would have been unimaginable a century ago. Then council meetings referred to the 'stygian darkness' of the town's streets and councillors agonised where to place their few petrol lit street lamps

Downpatrick, the light could be seen from windows in the rear of Irish Street to the puzzlement of the occupants who knew nothing of the celebrations.

The Largest Bonfire

The largest of all bonfires on the summit of Slieve Donard must surely have been that on 7th July 1877. For three days workmen were engaged in bringing to the summit upwards of sixty tar barrels, two tons of coal and four barrels of petroleum.[4] This huge bonfire was to mark the return of Hugh, 5th Earl Annesley with his new bride to his ancestral home. The earl had married Miss Mabel Markham in London on the 4th July 1877. The rejoicings were a great success but after all the effort the bonfire on the top of Donard was spoiled by clouds. The disappointment of this particular bonfire was recalled a decade later in June 1887 when plans were being made to celebrate Queen Victoria's jubilee. The Newcastle committee in charge of planning for the occasion contemplated another bonfire on the top of Slieve Donard but in the end settled for an enormous bonfire on the sandbanks instead. For the occasion of the queen's diamond jubilee in June 1897 the local bonfire was on Peter's Hill.[5] The jubilee celebrations for King George V were marked in May 1935 by the council chairman, W.J. Kennedy, switching on a beautiful lighting effect at the council offices while bonfires burned at the summit

of Slieve Donard and at Castle Park. The coronation of Queen Elizabeth on 2nd June 1953 saw the rover scouts haul a substantial supply of turf up the mountain to light a beacon. Later that decade Newcastle scouts celebrated their fiftieth anniversary with a gigantic bonfire at the mouth of the Shimna river on 8th March 1958. Slieve Donard had a cap of snow at that time but assistant scoutmasters Will McCammon and Norrie Herron climbed to the top and lit the anniversary beacon when they received a signal rocket from the beach.[6] The location for these bonfires was the front of St Donard's cairn which allowed the fire to be seen far and wide. To this day it only takes the lifting of a sod or patch of moss below the front of the cairn to find evidence of blackened and scorched stones.

Such large, carefully considered and controlled fires are quite different from the casual and distressingly deliberate acts of arson which have taken place on the mountains over the last number of years with large tracts of heather being wantonly destroyed. An extended dry spell in April 2011 was followed by wholesale destruction on the mountains over the May Bank holiday when over 1,000 acres were burned by maliciously set fires. Appeals had to be made for people to stay off the mountains and road blocks set up by police to allow only

On account of the commanding view over Newcastle and the surrounding country, the celebration bonfires were lit on these stones below St Donard's cairn

The once beautiful wood at the head of the Trassey Road after it was ravaged by fire in the spring of 2011

emergency vehicles through to fight the fires. The damage wrought was appalling. In the heart of the Mournes alone, the Annalong wood and valley, Rocky Mountain, the Bog of Donard, and the slopes of Slieve Lamagan, Cove and Beg were turned to a black and ashy mess. It was an ecological disaster. The Mourne Observer summed up the awful harm done in the single word headline, 'Devastation'. Apart from the loss of scenic beauty in the destruction of woods and heather, incalculable damage was done to small mammals, insect life and nesting birds. Many have realised as a result of the fires that more must be done to protect this precious environment and not take it for granted. Thankfully nature will eventually recover. May it receive all the respect and help we can give.

This winter evening photograph from Newcastle beach hints at the awe a large bonfire on the summit would have caused in the past

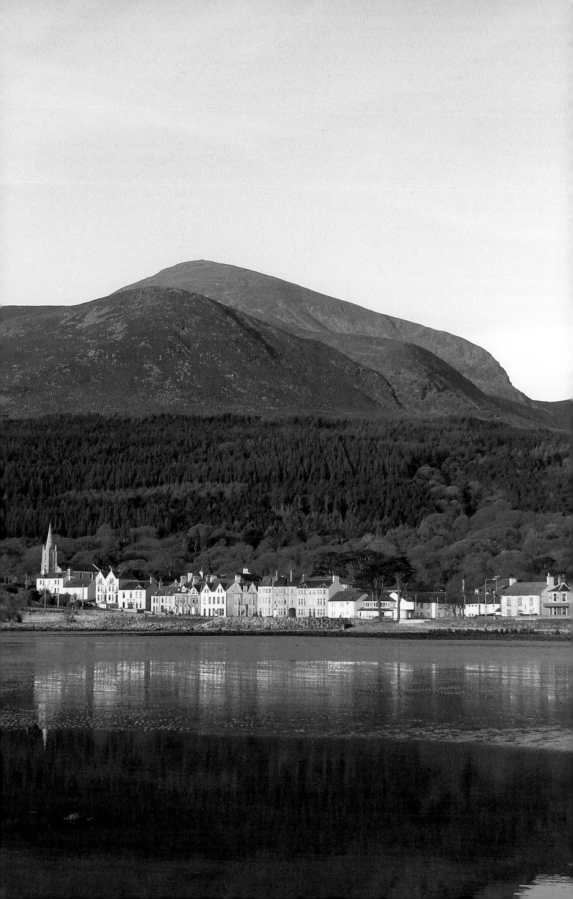

EARLIER NAMES OF SLIEVE DONARD

The Mournes have been referred to from ancient times as *Beanna Boirche*.[1] The mountains were also the place to which from time immemorial people drove their cattle to exploit the summer grass in the age old practice of transhumance. It is no wonder then that *Boirche* came to be identified not only as a place but also as a cowherd. There was even debate arising from the lost tale *Orgain Cathrach Boirche* 'the Destruction of the stone-fortress of Boirche', about where Boirche's fort was located. Monsignor O'Laverty contended it was in the parish of Kilcoo surrounded by nine satellite cashels in the townlands of Tullyree, Drumena and Moneyscalp.[2] Nowadays the name brings to mind the Castlewellan Irish medium primary school *Bunscoil Bheanna Boirche*. A century ago the name, albeit with a different spelling, was carried by Newcastle's famous gaelic team the Clannabarcaigh Hurlers.[3]

Apart from being referred to as *Beanna Boirche*, Slieve Donard was earlier known as *Sliabh Slángha*. The annals of the four masters, under the 'age of the world 2533', tell us 'Slángha, son of Partholan, died in this year, and was interred in the cairn of Sliabh Slángha.' Partholan himself was generally believed to be a mythical character who, it was said, led an invasion of Ireland 300 years after the biblical flood. Giraldus Cambrensis, the Norman chronicler, has corrupt forms of both Slángha and St Domangard.[4] In the county Down map of Ireland known as *Hiberniae Delineatio* published around 1685 and which was made as part of the Cromwellian settlement of Ireland, another corrupt form appeared. A phonetic mistake saw Donard's chapel being represented on the map as Leonard's chapel. The association of Leonard with Slieve Donard, even through it was an error, was nevertheless the likely inspiration for the naming of the four houses on the north side of Newcastle's Presbyterian church as Leonard's Terrace.

Slángha and Partholan

I have no doubt that Slieve Donard once bore the name Slángha but I rather think that these are not names of people as has hitherto been suggested by the annalists but surviving corruptions of mariners' terms. Mariners making landfall could also very easily have been thought of as 'invaders'.

To digress first for a moment, the author's grandfather was once given a beautiful small polished Neolithic stone axe which had been found, I believe, during early reconstruction work at the Royal County Down golf course. The label

Slieve Donard, or to give the mountain the saint's earlier name, Domangart, is a compound of the Irish *Domhain Gárda* meaning 'the guard or protector of the world'

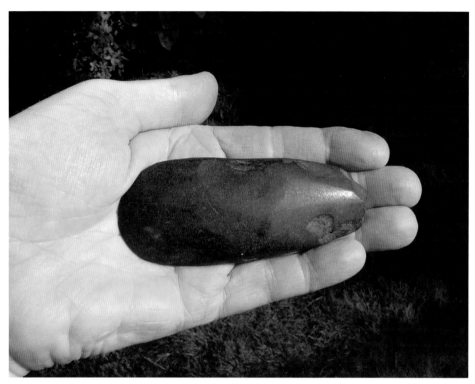

Polished Porcellanite axe-head found at Royal County Down golf course

with details of the find unfortunately came away and was lost. The axe is four inches, or ten centimetres, in length and someone has spent a long time polishing the edge to produce a sharp curved face. The stone is made of Porcellanite, a unique close-textured heavy rock with a blue-grey colour. It was formed when weathered basalt was baked at very high temperatures by intruding magma. Two sources exist in County Antrim, namely at the western end of Rathlin Island and also at Tievebulliagh, near Cushendall. Because of the exclusive nature of their source, finds of Porcellanite axes have greatly contributed to our understanding both of Neolithic settlement in Ireland and early trade patterns. Various finds of these axes throughout the British Isles show that considerable seafaring was involved.[5] The easiest form of travel in Neolithic times was by boat and this was the likely means by which the little Porcellanite axe arrived here from County Antrim. In its own way this local find is testament to sea-faring trade back in Neolithic times.

Two things were important for the early seafarers; landmarks to let them know where they were and safe landing places. From far out at sea and in fair conditions, Slieve Donard, with its height on the horizon, could be recognised by mariners. Slieve Donard would have been immensely important to early sailors

To early mariners *Slángha* represented a safe landing place on the sandy beaches of Dundrum Bay. Here a snowy Slieve Donard is viewed from Murlough sand dunes

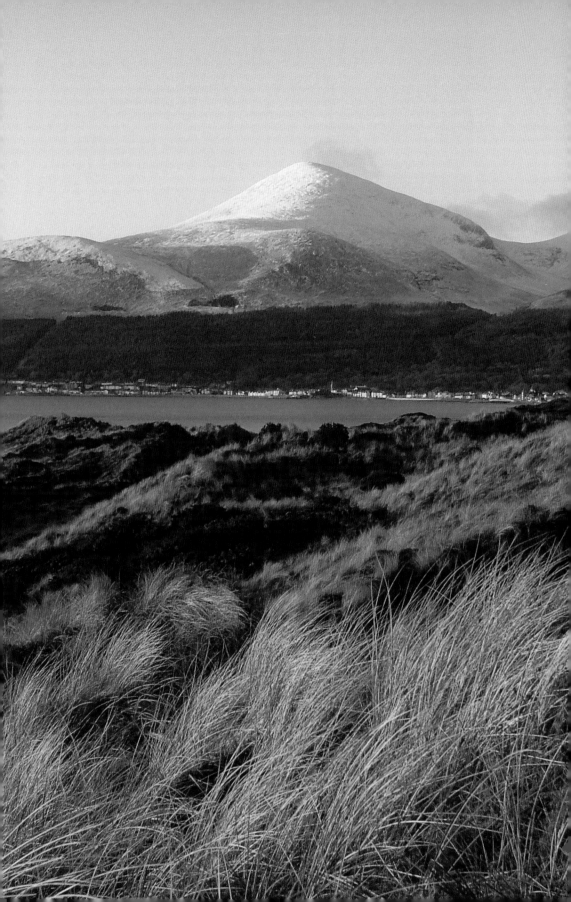

on the Irish Sea. Sight of our majestic mountain would have been welcomed as an indication of a good place to make landfall. Generally speaking the coast of Mourne and, for that matter, the coast of the Ards peninsula, is rocky. Dundrum Bay with its miles of sandy beach made a wonderful landing place and boats could be hauled up the shore. I believe the name Slángha was conferred on the mountain by sailors and is a surviving amalgam of *Slán,* meaning 'safe', and *gaoth* meaning 'an inlet of the sea'. *Slán gaoth*, with the elision of 'th', merged into Slángha. Slieve Donard earned its earlier name of Slieve Slángha for being a guiding beacon to the safe landing place of Dundrum Bay. Partholan might possibly be a corruption of *párthas na oileáin,* 'a paradise of islands', where *párthas* means Paradise, a palace, monastery or a garden and *oileán* means an island. One could easily conceive of Strangford Lough as a 'paradise of islands'. Rough Island and Magee Island near Ringneill Quay are only two of a number of Mesolithic sites in Strangford Lough that have been recognised.[6] The association of these two 'names' Slángha and Partholan with the mariner's beacon, Slieve Donard, would have been an easy progression.

Donard as Mount Malby

For a while during the reign of Queen Elizabeth 1st, Slieve Donard was given the name Mount Malby. Nicholas Malby had been condemned to death on 6th August 1562 for coining but was reprieved on consenting to serve under the Earl of Warwick in France. He served time in France and Spain before being sent to Ireland where he was appointed sergeant major in the army of Sir Henry Sidney. By 1571 Malby had become a captain and in March of that year he obtained a grant of the office of collector of the customs of Strangford, Ardglass and Dundrum. Along with Captain Thomas Chatterton and Sir Thomas Smith, he proposed colonising the north of Ireland with Englishmen to block the growth of Scottish power. On 5th October 1571 he obtained a grant of McCartan's country which was the barony of Kinelarty in county Down. The other proposers did well. Captain Chatterton obtained almost half of County Armagh and Sir Thomas Smith was granted a huge estate of 360,000 acres in east Ulster extending from Toome in County Antrim to the bottom of the Ards peninsula. There were conditions attached to these grants however. Every foot-soldier was to obtain a ploughland of 120 acres and every horseman 240 acres. The queen was to be paid 20 shillings rent per year for each ploughland and no Irish or Scots were to be given a lease longer than five years. It was at this time that he chose to rename Slieve Donard as Mount Malby. The name didn't stick and the colony didn't work. Four years later in 1575, Kinlarty was found to be desolate and waste and Malby's grant was revoked. He accompanied the army into Connaught and was appointed colonel or military governor of that province. Here he proved himself most unpopular as he harried the counties of the Burke family with fire and sword.

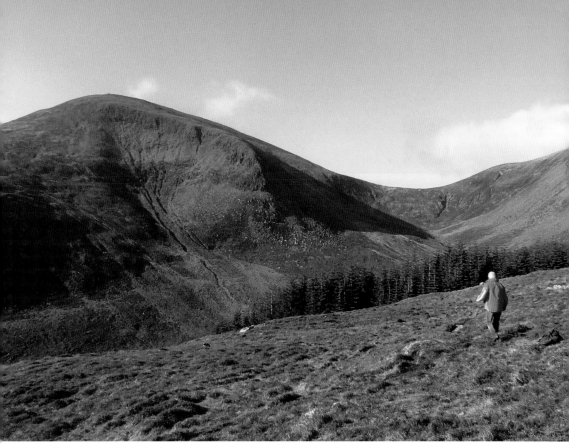

Slieve Donard and Eagle Rock from Slievenamaddy. Nicholas Malby, in his vanity, tried to name the monarch of the Mournes after himself

Having once been condemned to death for coining, it was quite ironic for Malby to go to war with Brian O'Rourke of Sligo because O'Rourke refused to expel certain coiners he maintained. In April 1578 Malby invaded O'Rourke's country, captured his chief castle and put the entire garrison to the sword. Three years before that Malby had taken part in the Earl of Essex's expedition against Sorley Boy and may have assisted John Norris and Francis Drake when the Scottish base of Rathlin Island was raided in July 1575 and all 600 inhabitants were killed. Nicholas Malby died at Athlone on 4th March 1584 and here in county Down the monarch of the Mournes fortunately retained its name of Slieve Donard.[7]

Derived from the Irish *Sliabh Dónairt*

Slieve Donard is derived from the Irish *Sliabh Dónairt*. Despite the other names and variations given to the mountain, the name of Donard has been associated with the peak for over a thousand years.[8] We are fortunate that John O'Donovan collected a legend about St Donard from Mrs Con Magennis at Ardbrin townland, Annacloan. O'Donovan was obviously very impressed with her. 'I am fully persuaded that no Con Magennis ever had (for a wife) a more civilised or more

115

elegant woman...She understands Irish very well, and is now the only repertory of the traditions and legends of Iveagh. She told me a number of legends connected with S *Downart,* from whom Slieve Donard derives its name, and with the fort of Seafin. These legends she does not believe, but she told them faithfully as she had heard them.'⁹ The legend is recorded here in the same spirit. This extract is from O'Donovan's letter back to ordnance headquarters in Dublin.

'When S. Patrick and his holy family came to Iveagh, and to that level district at the foot of the mountain called Slieve Donnart, he sent one of his servants to a neighbouring chieftain named Donnart to request of him to contribute something to the support of his clergy. Donnart, at this time a fierce and warlike pagan chief, desired the servant to go and drive home yon bull (pointing him to a certain field) to his master Patrick, but this was out of derision, because the fierce warrior well knew, that 20 persons would be unable to drive that bull to any place, in consequence of his furious and untameable character...Patrick's servant...goes to the field, and far from being able to drive home the mad bull, he narrowly escaped being killed by that fierce animal. So he returns to Patrick and tells him the whole transaction. Then Patrick said to his servant, as Donnart has given you leave to drive home the bull, take this halter with you, and as soon as you go to the place where the bull is, he will put his head into it, and then walk home with you [the power of God, you know, Sir, goes beyond any thing]. This was accordingly done and *mirabile dictu*! the animal having laid aside his native ferocity, walked over to the servant, put his head into the halter, and then walked home with him, meek and silent as the lamb when led to slaughter. So great are the favours bestowed by the Almighty on those he loves! Patrick then got the bull killed and salted.

Soon after this as the fierce Donnart was one day walking out from his habitation, the fort of *Rath Murbholg*, near where the old church of Magheraw stood, he misses his bull, and swore by the wind, the sun, and the moon, that he would banish Patrick and his clergy out of his territory. With that, Sir, he assembles his chosen troops, and coming to where Patrick, his family and his adherents were, accuses the saint of having sent his servant to steal his bull. Patrick replied that his servant had first obtained his highness's permission, but Donnart denied that he had granted any. Well, then, said the holy Patrick, if your great honour say so, you shall have your bull back again. So taking the feet, flesh and skin, and placing them together, as well as he could, he knelt down, Sir, on his bare knees on the ground, and prayed to the Disposer of all things to restore the bull to his former life and ferocity; and wonderful to be said! All the distorted joints of the animal were replaced in their respective sockets, and all the organs and instruments of motion and life – all the channels and conductors, of the animal fluids and Spirits of existence,

were restored to their original functions, and the bull started into life, resuming all his original fierceness. At the sight Donard was scared with dismay, and throwing himself at the feet of the saint, begged that he would take him under his protection, and make him one of his people by baptizing him. From this moment the warlike Donnart became a meek and humble disciple and after having become acquainted with the mild spirit of the Gospel, and seen the strict morality and self-refusal recommended in the book of life, he was induced to resign his chieftainship, abandon his fortified residence, give up the savage amusements of hunting the elk and other timid animals of the plain, and betake himself to fasting and praying on the highest apex of that wild and desolate range of mountains which formed the Southern boundary of his territory.'[10]

We should not believe that somehow the ancients were gullible and naïve in telling such stories. Even in our own times, numerous films or video games portray feats of strength, performance, or physical endurance to such a fantastic degree that belief in reality must necessarily be suspended. There is nothing new in embellishment. It makes for a good story. It would be a disservice however, to dismiss this legend as far fetched and of no significance, for it reminded the ancients of the consequence of failing in hospitality to a stranger, of the importance of humility, prayer and fasting and, after the example of St Patrick, of the value of complete trust in the providence of God. It belongs to the mists of time how on the mountain top Donard would make amends for his initial lack of welcome for St Patrick. Can we picture living on that high place and trusting for all one's needs on the providential goodness of visitors to such a remote spot? How different would have been the greeting and the hospitality they received by comparison? While Donard's life and privations on the height can only be imagined, it is certain that he changed his life profoundly for his memory and name endured with people and place for millennia. Even Walter Harris, a trenchant critic of Catholicism, would admit in his 1744 history of county Down that 'a tradition in this neighbourhood highly celebrates the virtues, devotion and miracles of St Donard.'

While the modern name of Slieve Donard derives from *Sliabh Dónairt* in Irish, earlier forms of the name were Domangart, or, as recorded by John Colgan writing at Louvain in 1645 *Domha[n]gaird i*. I mentioned earlier that the name Slángha is an amalgam of the Irish *Slán Gaoth* meaning 'safe inlet of the sea'. In a similar fashion it is most joyfully appropriate that our saint's name appears to be a compound of the Irish *Domhain Gárda* meaning 'the guard or protector of the world'.

117

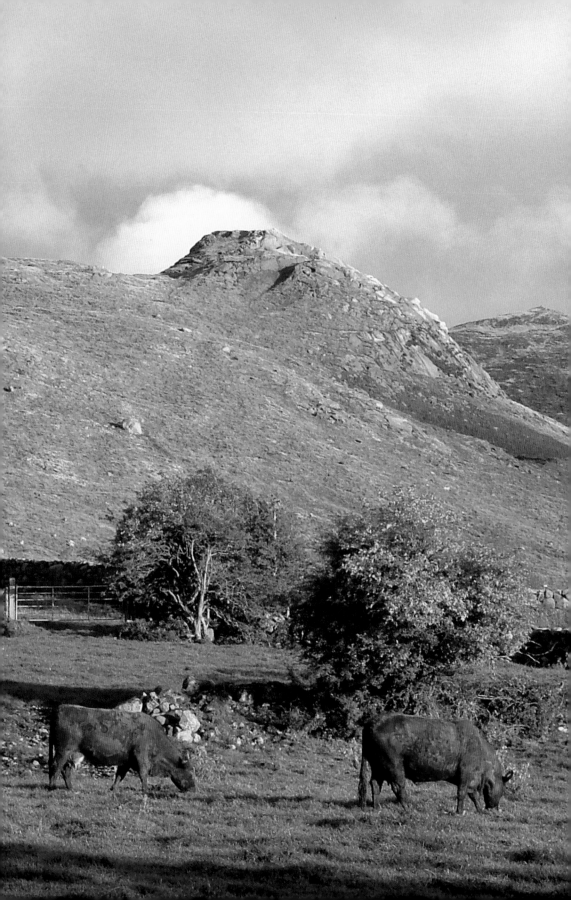

THE HERDSMEN

The Norman chronicler, Giraldus Cambrensis, commented on the land and livestock of Ireland. 'The tillage land is exuberantly rich, the fields yielding large crops of corn; and herds of cattle are fed on the mountains.' The summer grazing of cattle on upland and mountain pastures was formerly a widespread practice. The animals were driven to the grazing grounds in the early summer and taken home again in the autumn. Those who tended the cattle lived on the hills with them, milking them and making butter and cheese. The herders lived in huts or small houses, usually made of sods and wattle, which were renovated from year to year. This system of transhumance, generally known in Ireland as booleying, was practised in the Mournes from time immemorial. Booleying is an Anglicisation of the Irish word *buaile,* meaning a cattle-fold or milking place. Harris recorded the practice in 1744.

'In the bosom of the Mourne Mountains there is a place called the Deers' Meadow, and by some, the King's Meadow (because people have their grazing in it free) extending some miles in breadth and length; to which great numbers of poor people resort in the summer months to graze their cattle. They bring with them their wives, children and little wretched furniture, erect huts, and there live for two months, and sometimes more, and often cut their turf to serve for the next returning season; which done, they retire with their cattle to their former habitations.'[1]

Professor Evans and another archaeologist, Bruce Proudfoot, excavated part of a booley hut at the Deers' Meadow before it disappeared under the waters of the Spelga Dam. They found that the floor of the hut was marked by intense burning and charcoal from earlier occupation was found running beneath the walls.[2] It is worth keeping an eye out for the remnants of these huts. Professor Evans noted, 'the observant walker in the hills will notice in sheltered hollows by the banks of streams clusters of grassy mounds set in a green sward, or it may be small piles of stones under some rocky outcrop. These are the only tangible relics of the booley houses, and in most parts of Ireland they were deserted so long ago that the shepherd will tell you they are the remains of Danes' houses.'[3] Systematic survey work has begun, involving walking along all the main valleys in the mountains and many booley sites have been recognised and identified as a result.[4] By and large the huts were in groups, near flowing water and built on an area slightly raised above the surrounding ground to help keep the interiors dry. A number, for instance, were found alongside the streams above the Fofanny Dam.

An October evening below the tors of Hen Mountain

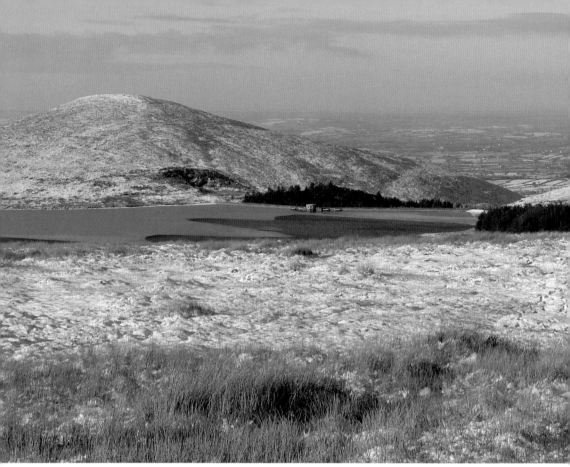

Spelga Dam now covers the pastures where formerly herds of cattle were grazed in summer

The Hare's Gap

Walkers, who set out to enjoy a walk in the Mournes and enter the mountains by the Trassey Track, should look at the stone enclosure at the Hare's Gap. Recent maps of the Mournes have unfortunately started to record this as a sheep-fold. Up until the famine rough pastures were grazed with store cattle rather than with sheep. This fact is recorded in many a place-name, as for example, in Dromara, *Droim mbearach,* 'Ridge of heifers' and perhaps in Slieve Croob, *Sliabh Crúba,* 'mountain of hooves', ie 'cattle'. Many of the stones used in the construction of the enclosure are of a size far beyond that necessary to retain sheep and mark this as a protective pound for cattle; as mentioned earlier, a *buaile,* meaning a cattle-fold or milking place. Note the hole low down on the large stone at the entrance which would have facilitated a keeper for a wooden gate now long gone. The enclosure is much older than realised. An obvious path leads down to what was once the floor of the Kilkeel River but which is now covered by the Ben Crom reservoir. Cows would have been brought back from the valley at night for

milking and protection. From this strategic position at the top of the col, a watcher could observe the distance of the Trassey river valley, could see a good length of the Brandy Pad over to the col between Commedagh and Slieve Beg and also down the Kilkeel valley. If danger threatened in one direction the cows could be driven off in another. While raiding parties had been a big worry for herdsmen until about the seventeenth century, fire and packs of dogs were a more enduring concern. The spring of 1853 was particularly dry. The crop reports stated that 'the long continuance of dry weather is beginning to tell on the flax and grass lands; and should we not soon be favoured with rain, the early-sown turnips must also suffer'. In the second half of May, fire broke out on the mountains. A vast breadth of country was destroyed as the fire continued to burn for nearly a week. Cattle that were grazing on the mountain were killed and a large number were seriously injured.

These mounds beside the river flowing into Spelga Dam are likely booley sites. In the distance, from the left, is the shoulder of Cock Mountain, Slievenamiskan and then Spelga

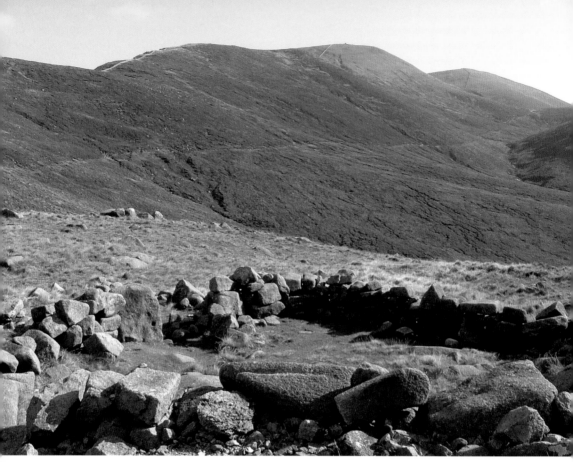

Good views of the surrounding area can be had from the cattle enclosure at the Hare's Gap

Slieve Commedagh and Shan Slieve

The name of Slieve Commedagh bears witness to its pastoral past. It is well named 'the watching or guarding mountain' as it is a wonderful vantage point. On the north-east side one could survey the valley of the Glen River which is still a main access route into the mountains. From the south side there is a commanding view of the Annalong valley and the path from the Bog of Donard to the Hare's Gap. This last was probably long used for the movement of livestock before it was more famous for the clandestine movement of brandy. From the north west side of Commedagh one could watch out over to Slievenaman, Clonachullion, Tullyree and Moneyscalp. David Kirk in his beautifully illustrated work *The Mountains of Mourne, a Celebration of a Place Apart,* posed a question about the Castles and the sculpted pillars to be found there. Referring to these pillars as 'Eternal sentinels', he asked, 'Were these the Watchers that gave the mountain its name?' While presently following the widespread presumption that the 'watching' relates to the guarding of cattle on the mountain, it is possible that the name is much older and refers to the watching by Neolithic man for the rising of the winter solstice

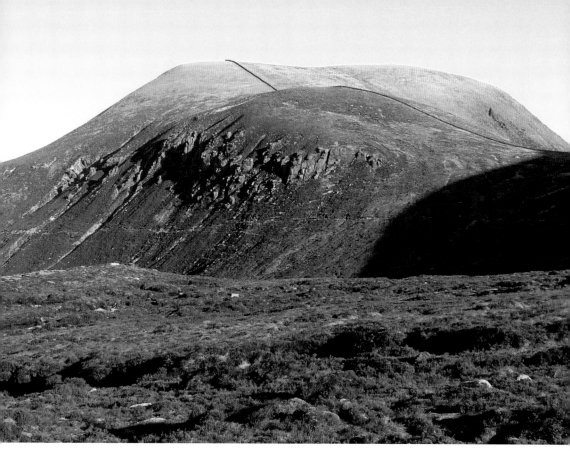

The Castles and the wedge shaped top of Commedagh, the mountain of watching, as seen from the Bog of Donard

sunrise. But more of this idea another time. When Annesley's agent, William Shaw, placed warning notices in the Downpatrick Recorder in 1870 that poison was laid on the mountains, he used a phonetic spelling of Slieve Kimida.[5] Professor Evans would later find the form 'Kiviter'. Rather than Kiviter being some kind of corruption of Commedagh it is likely an alternative, albeit long redundant, name used by shepherds and stock-men for the mountain. Walkers will know that the flat summit of Commedagh is a rather bleak place with virtually no grass worth grazing. Only down slope closer to the Brandy Pad where there is more shelter do conditions improve for growing grass. Kiviter would seem to be the remnant of the Irish *Cíob iarthair* meaning 'the coarse mountain grass of the back part'.

When it comes to watching from Commedagh there is reason to believe that the principal place of watching was the tor remnant on the col between Slieve Donard and Commedagh. Walkers coming up the Glen River valley will note a dimple on the skyline which becomes quite prominent as the head of the valley is reached. A little outcrop of rock, above the large gully on the flank of

123

Commedagh, survived the ice and proved attractive to early man. It appears that from ancient times this natural feature was adapted as a seat on account of the absolutely magnificent view right down the length of the valley. A close look at the back of the rock shows a roughness from the stone being broken off by stone mauls. This roughness at the back of the seat, visible in the photograph, contrasts with the smoothness of the weathered parts of the rest of the tor. Seated comfortably on this natural vantage point enjoying the panorama you can also appreciate another not inconsiderable benefit of this particular location. The rock behind the seat provides important shelter from the fairly constant breeze passing over the col between the two mountains. It is quite probable that it is this place of watching that has given the name to the whole mountain.

Shan Slieve, the lower extension of Slieve Commedagh which overlooks Tullybranigan, also deserves a mention here as it was somehow thought to have been named from a pastoral past. Shan Slieve is from the Irish *Sean Sliabh* meaning the old or ancient mountain. The Irish scholar P.W. Joyce addressed the problem of the name as follows:

'It appears difficult to account for the application of the word *sean* [shan], old, to certain natural features; for so far as history or tradition is concerned, one mountain, or river or valley, cannot be older than another.... It is probably that *sean* in names refers to use:- a river was called Shanowen,

Note the roughness on the rock where part of the stone has been broken away to make a seat and changing this skyline tor into a vantage point *par excellence* for watchers

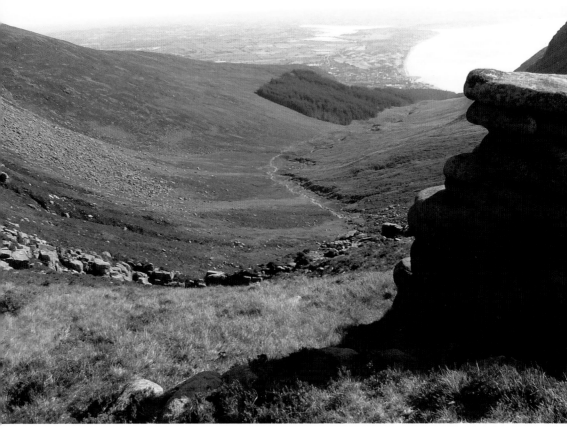

The commanding view of the Glen River valley from the watcher's seat

because the people had been from time immemorial living, fishing, or boating on it; a hill got the name of Shandrum because it was inhabited, cultivated or grazed, long before any other in the neighbourhood.'[6]

This pleasing explanation however has nothing to do with our Shan Slieve. The 'ancient mountain' is well called and its naming shows the imagination and sense of humour of our ancestors. Natural features were responsible for the name. As the sun passes obliquely over the face of the mountain on spring and early summer mornings, the various declivities are filled with shadow and impart a crinkled appearance to the mountain. Also, to the left of the Tullybranigan River you will see on the face of the mountain two long thin horizontal rock slabs across the front of the hill. Our ancestors looked at these and imagined them as wrinkles. Between the wrinkles and the crinkles the mountain easily earned its name as 'old'.

Place-names and herding

The local names around Spelga echo the former activity of summer herding. Spelga itself is derived from the Irish *speil,* (pronounced 'spell') meaning a herd of cattle. It is a corruption of the plural *speileacha,* 'herds of cattle'.[7] To the north of

125

The horizontal rock slabs were imagined as wrinkles thus giving Shan Slieve its name of 'old' mountain

the reservoir is the high ground of Spaltha meaning 'scorched or parched mountain'. The dry conditions on the mountain obviously did not sustain good grass compared with the damp meadow below. Slievenamiskan or Slievemiskan to the west of the reservoir comes from the Irish *Sliabh na Meascán* meaning 'mountain of the *meascáns* of butter'. Miskan is an anglicized form of the Irish *meascán* which is translated as 'a ball or lump, a pat of butter'. It was a common custom in those times to bury butter in the bog to preserve it. Frequently the butter maker may have either forgotten where the stash was placed or was unable to return to retrieve it. These hidden caches would subsequently be discovered by turf cutters decades or centuries later. Being then unfit to eat, these caches were often sold at Castlewellan market as a lubricant for the axles and wheels of carts. As to the naming of Butter mountain which overlooks the upper reaches of the Shimna river above Fofanny Dam, I feel that information was missed at the time of the gathering of place-names information by the ordnance survey in 1834. The received understanding is that Butter mountain is a translation of *Sliabh an Ime*. *Im* is the Irish word for butter. Nothing can be gainsaid now but I feel there were two names for the area and that Butter mountain derives from the Irish *bothóga* meaning huts, tents or flimsy dwellings. The temporary booley shelters

126

would have been preferable on the slopes of the hill where drainage was better and there was less likelihood of being tormented by the summer midges prevalent near the river. Certainly the churning of butter would have been a frequent task in the huts and the product would have been buried nearby for preservation but the name of the mountain probably owes more to it being a simulation of the sound of the Irish *bothóga*.

There are few indications of the colour of cattle in the early literature of Ireland. One of the better known examples is the brown bull of Cooley which was so coveted by queen Maeve that it led to the cattle raid celebrated in the epic tale, the *Táin Bó Cúalnge*. In earlier centuries the area around Slieve Croob (from *Sliabh Crúba*, 'mountain of hooves', i.e. 'cattle') was renowned for black cows. We learn from Harris, writing in 1744, that there were more black cattle grazing on Slieve Croob than any other mountain in the county. White cows were quite a rarity and their presence influenced local placenames. Aughlisnafin outside Castlewellan, despite the distracting presence of the later local name of Whitefort Road, is more likely a contraction of *Achadh lios na finne bó*, the field of the rath of the white (cow – understood). Much further afield, Lisnafin in County Tyrone has likewise been elided from its original *Lios na finne bó*.[8]

The Causeway Road as it looked in June 2005. Although now truncated by the modern Shimna Road, the Causeway Road was originally made to allow cattle to be taken from the old castle straight to the mountain pastures around Tullybranigan and back again in the evenings for milking

Newcastle promenade as it looked in August 1889 from the grounds of the Annesley Arms Hotel. The wall of the hotel grounds coincided with the back court of the former Magennis castle. The fore-ground was the likely area for the cattle pound which, for a period in the seventeenth century, gave Newcastle the name *Dún na mBó*, fort of the cows

The Causeway Road

Cattle were important in the early economy of Newcastle. At the beginning of the seventeenth century Newcastle was shown on maps as Dunemaw. Scholars believe this name likely came from *Dún na mBó*, fort of the cows.[9] When the former Magennis castle was sold to William Annesley in 1749, the description mentions 'a cow-house for 25 cows, stables for 30 horses, lofts for 300 loads of hay...large hay yard, great front and back court enclosed with walls of stone and lime'. The estate also embraced 1,350 acres of arable, meadow and pasture besides a great tract of mountain.[10] The main entrance to the castle was from the old castle bridge over the Shimna and through the pillared gates into the front court. The back court therefore was more likely reserved for the livestock. The southern boundary of the grounds of the Annesley Arms hotel, presently known as the Newcastle Centre, has probably remained unchanged from the back court of the

castle. A careful examination of the grounds of the old castle on Annesley estate maps shows that the lane to the shore, opposite the Methodist church, would match the southern edge of the castle's back yard. The cattle compound was convenient to the Causeway Road.

The Causeway Road, as its name suggests, was 'a way caused to be made' over the former large swampy area that existed around the confluence of the Shimna, Burren and Tullybranigan rivers. Richard Rowley mentioned how the sides of the Causeway Road were once planted with trees so that the roots would give extra stability to the causeway. The construction of this road over the swamp could well be contemporary with the reconstruction of the second castle at the Shimna in 1588. The road facilitated the daily movement of the cattle to the fields around Tullybranigan and the Bryansford Road and back to *Dún na mBó* in the evening for milking where they would be safe from any cattle raid. In the morning, after milking, the cows would be returned across the causeway to the pastures. 'Road' perhaps might then have been too grand a name for what was, after all, a cow track. Annesley's agent, George Shaw, apparently did not think too much of it in 1864 when he stopped it at one end. He was quite taken aback when he was challenged about it by the Grand Jury and the Causeway was found to be an old county road.[11]

Besides cattle, sheep are a relatively recent introduction on the Mournes with the black faced sheep proving especially hardy for the mountain conditions. Newcastle poet, Richard Rowley, captured the concerns for their safely in his 'Shepherd's Prayer'.

> Matthew, Mark, Luke, an' John,
> Bless the bed I'm sleepin' on;
> An' when the shepherd's fast asleep,
> Tramp the mountains, an' watch the sheep.
>
> John an' Matthew, Luke an' Mark,
> Guard thro' dangerous hours o' dark
> The wee lambs from the hungry fox,
> An' guide them, scramblin' the granite rocks.
>
> Mark an' Matthew, John an' Luke,
> Search stragglers in the boggy neuk;
> But when the daylight comes again,
> Ye needn't worry – I'll be outin' then.[12]

The shepherds too had to be hardy. Davy Bradford was one such. He was out on the mountains in all weathers. You could say he lived on the mountain for the

The hardy black faced sheep are well adapted to conditions on the mountains

The former home of Mourne shepherd, Davy Bradford who was in Downpatrick once in his life. The adjacent intersection of the Trassey, Moyad and Slievenaman roads is known locally as Bradford's Cross

remnants of his house where he looked after his elderly mother are still to be seen at Bradford's Cross, the name given to the junction of the Slievenaman/Kilkeel road with the Moyad and Trassey roads. Davy enjoyed the wide open space of the mountains yet in another sense his was a small world. He was never any further than Downpatrick in his life and that was only once. Like many another who lived in remote parts, Davy had a strong belief in 'the little people'. For him, they were real. After his mother's death Davy lived alone and his friends, thinking to play a prank on him, put a lighted candle in the window of the house. Far from seeing it as a welcoming sign, Davy thought that either his mother had come back from the dead or that the fairies had taken over the house. He was terrified and refused to enter the house for many days.

Sheep forage at Slieve Binnian in the Mournes

GRANITE MEN
AND THE QUARRIES

Men have been contending with the granite of Mourne since huge granite capstones were hoisted to the top of local dolmens about five thousand years ago. Farmers have long laboured to remove boulders from fields and the construction of the dry stone walls round the fields of Mourne show an enviable skill and are in themselves justly works of art. Before the war and certainly before machinery was widely available for the task, many boulders that were just too large for a farmer to move by himself were split into more manageable sizes by plug and feather to help clear his fields. My favourite story of the expertise of the stone men over modern mechanical methods was recorded by Harold Carson in his telling of the building of the Silent Valley Reservoir.

'All the energies and technical resources of the contractors were now concentrated upon the search across the floor of the valley for solid rock to secure a sound, watertight foundation for the dam wall. This extensive excavation work was seriously hampered by the presence in the earth of huge boulders which had to be split up before they could be lifted out of the trench by the crane men. Some of these massive rocks weighed more than a ton, and took several weeks to cut through with pneumatic drills. Then the stone masons of Mourne took over the job and, using the traditional method of hand splitting the boulders by the 'rede', they astonished the site engineers by cutting them up in a fraction of the time taken by the power drills.'[1]

Before the advent of the atomic age, geologists used the term 'fissility' in regard to the breaking of granite. They determined that within the Mourne granite mass 16° clockwise of true North was the direction in which the granite split best. This is the 'rede' of the quarrymen, a kind of grain in the granite which was recognised by the experienced stone-cutters as the best line to follow to crack the stone. The quarrymen also referred to the 'hard end' of the granite. This was 94° and was the direction in which splitting was most difficult. These directions were coincident with the principal system of joints, 16° being the direction of pressure and open joints, 94° being at right angles to the direction of pressure, where only latent joints occurred.[2] The horizontal jointing planes, however, were of medium cleavage and were referred to by the workmen as 'board'. These jointing planes were of better cleavage than the hard end but not as good as the rede. The vertical system of joints controlled the directions of the rivers and subsequent erosion. On a map, for instance, it is easy to see how the head waters of the Glen River and the Annalong River are so closely in alignment with each other and how the head

waters of the Kilkeel River and the lower glaciated valley of the Ben Crom reservoir, likewise follow a parallel path.

In the immediate locality of Newcastle I may tentatively number seven quarries. The lowest one on the mountain, not far south of the harbour on the road to Kilkeel, is known as the Blue Quarry and is now a car park and picnic spot. As its name suggests, this was a source of the blue coloured shale stone widely used in the construction of houses in the town before the advent and uniformity of cement blocks. It is a large quarry and much material was removed. It was already a substantial undertaking when featured on the survey map of 1859. One of the big advantages in the removal of so much heavy stone was that the gradient was all downhill to the quay. The quarry got a mention by the name of the Blue Quarry in court proceedings of 1895 when two women summoned each other for assault.[3] Later in 1901 other court proceedings referred to it as Maginn's Quarry. Two men who were involved in carting stones from the quarry had a fight over sheep trespassing at Ballaghanery.[4] The interesting detail from the court proceedings is that the stone from the quarry was being taken to the quay for export. It wasn't just granite that the stone boats took away. Business at this quarry likely improved when the Board of Trade enforced crown ownership of the shore and forbad extraction of stone, sand and gravel from it. However, when

Lynn's quarry in the foreground and the shed at Donard quarry in the background

136

Annesley later got a lease of the shore from the Board he allowed extraction as he could levy a toll. Robinsons of Annalong, for instance, supplied a Belfast order for 1,000 tons of stones from Newcastle beach in 1908. The face of the Blue Quarry is now largely masked by the growth of whins and the further planting of trees and grass has softened what was once a place of great industry. While space only allows for a consideration of the quarries closest to Newcastle and Castlewellan, it is pleasing to hear that a project is presently in hand to record and photograph all the quarries that were opened in the Mournes.

A second shale quarry is known to have been worked in the area around Enniskeen. In 1869, Rev John Robert Moore, once manager of the Annesley estates during the minority of William Richard 4th Earl Annesley, sold off thirty-six acres in surely the most scenic and desireable area above the Shimna river on the Bryansford Road. The sale notice was as follows:

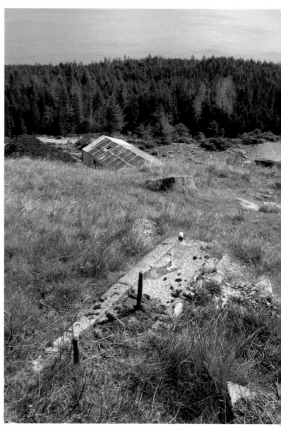

The bolts embedded in concrete, high on the west side of Donard Quarry, mark the remnants of the early bogie line terminus

'These lands are situated within a mile of Newcastle where there are an Episcopal Church endowed by Earl Annesley and not touched by Mr Gladstone's Bill, one Roman Catholic and two Dissenting Chapels. A large sum of money has been expended in trenching, fencing and draining these lands, and they have been 14 to 15 years in grass. They are ornamentally planted with trees and shrubs, now aged about 35 years and all registered. They occupy an elevated position, affording the most beautiful sites in Ireland, commanding magnificent views of sea and mountain, and the demesnes of Earls Annesley, Roden, the Countess Annesley, and the Marchioness of Downshire. The Shimnah River mears part of them. There is a good stone quarry in one of the fields, spring wells, etc. The roads and rivers are not charged for in the lease. The purchaser must be approved of at the Office of the Head Landlord, the Earl Annesley. The Railway from Belfast to Newcastle is now open. The above is well worthy the attention of a Building Company. Immediate possession can be given.'[5]

Enquiries have not revealed the location but as it would not have been a granite quarry and also being on private land I have not investigated it further.

The other five are granite quarries and are found around Millstone Mountain. Three of these are obvious in the sense that they are excavations into the mountain leaving huge gouges and attendant tips of spoil. The quarries are Lynn's, directly above the harbour following the bogie line now called the granite trail. Secondly the main granite quarry a few hundred metres to the west, sometimes called Donard Quarry, and thirdly the square sett quarry out of sight from the town just over the shoulder of Drinneevar on the east slope of Millstone above Ballagh Park. I have collectively counted the workings on the south-east side of Millstone as one unit although there are at least three or more quite small workings on the slopes of the hill besides the main quarry. A fourth quarry, small and not so obvious, is to be found a little to the right of Donard quarry and was likely an early test area. It was also convenient to the original end of the bogie line. Rusted metal bars projecting from a shaped granite bed are to be found well up on the right hand side of Donard quarry and are the only remnants of the bogie line terminus. It also reveals how much the quarry has been deepened from the time the railway was laid. Some burnt and weathered timbers, perhaps from an early trolley, have been stuffed down a hole near these rusted bars. Square setts would have been produced at all the quarries but the one over the shoulder of Drinneevar was particularly ideal for sett production as the horizontal fault planes were of such ideal thickness as to minimise the amount of finishing work required on the stone. The fifth and the earliest granite quarry, in the broad sense of a source for stone, is the high open hillside of Millstone on the left side of Amy's stream separating Millstone from Thomas. It was work here that gave the mountain its name and we examine this area later in more detail.

The horizontal planes in the Ballagh quarry favoured the production of long lengths of granite ideal for sills and cribben (pavement kerbs) and also for the production of road setts. The granite block in the foreground bears the marks of the drill holes in which were placed the plug and feathers used to split it

Trails around the mountain circa 1770. *Courtesy of David Good, Myra Castle*

Early Trails on the Mountain

A look at the trails on the mountains is instructive about the development of granite. An early watercolour of Newcastle around 1770 clearly shows well established trails on the mountain both round the shoulder of Drinneevar from King Street and up the river valley to Millstone.[6] Initially I had looked on the lines on the mountain as being the rivers as they were depicted on the watercolour by a light blue tint. This might indeed be intended to show the Glen river and Amy's river but could not apply however to the three lines on and around Drinneevar; they had to be trails. Allowing that the artist does not attempt precision of scale and that a measure of artistic license was likely employed as judged by the representation of four or five boats with masts at the site of the present harbour, one may proffer the following interpretation. The lowest trail along Drinneevar represented the road to Kilkeel. The middle trail would appear to be the riding vista that has an entrance from Delarey Terrace and extends for half a mile or so towards the Ballagh. Even today, while the traffic whizzes busily along the Kilkeel road below, this is a glorious walk on a sunny summer morning. I have wondered who was responsible for this early road to no-where. In the absence of any records I surmise that William Annesley, born in 1709, is the best candidate. William was advanced to the peerage of Ireland on 20th September 1758, as Baron Annesley

The Ballagh quarry, with its narrow bedding planes, was ideal for the production of square setts. This was also the source of the stone for the old quay

of Castlewellan, in recognition of his land improvements. He it was who made the straight road from Clough through Castlewellan to Kilcoo and who bought the Newcastle estate from Mr Edward Matthews in 1747. On the strength of its appearance on the 1770 watercolour picture, and long before the existence of the promenade, I mark this as Newcastle's first custom tourist trail. The road was especially provided that the magnificent view out over Dundrum Bay might be enjoyed, a glory that doubtlessly was intended to reflect on the lord of the soil. It certainly would have been an asset of the Annesley estate much envied by those coming to Newcastle to drink the goats' whey. The riding vista ends abruptly at the boundary wall where a large turning circle was constructed for the carriages of the gentry. Another smaller carriage turning circle, presently much filled with growth and other detritus, also exists not far above Delarey Terrace and from this circle there was access via a back gate at the end of Lady Annesley's wall to the grounds of Donard demesne.

Before leaving the environs of Delarey Terrace, readers will be aware of suggestions that the name of this terrace derived from the name of a family resident there by the name of O'Leary[7]. I would like to suggest however that, under the influence of the Gaelic revival which was strong in Ireland when these houses were constructed, the builder chose an Irish name to highlight the views

that were obtained from this elevated site. Delarey, to my mind, is derived from the Irish *Deil-léir; deil* in compound words meaning 'two' and *léir* meaning visible, plain, clear, open or perceptible, giving a rough translation of 'two view' terrace. From the front of the houses there were magnificent marine views out over Dundrum Bay and windows at the back of the terrace gave views, such as they were, onto the mountain slopes. The views at the back may not have had the scope and grandeur of those at the front but they provided scenes of wooded nature that many an occupant of terraced houses in Belfast would have envied.

It is the third or highest trail, shown on the watercolour on the slopes of Drinneevar that is of particular interest. The significance of this third trail could easily be overlooked especially as the main point of the picture is the castle at the Shimna. The existence of the track is an important clue that granite was already being developed at Newcastle by 1770. This third trail represented the long steady incline used by horses and carts to reach the granite quarries on the seaward shoulder of Millstone which are out of sight from the town. The quarry above the Ballagh Park lost its primary position with the opening by John Lynn[8] in 1824 of another quarry closer to hand and directly above the harbour. I believe it is worth drawing attention to the remarkably consistent gradient achieved in the

This ridge of rock was cut sometime in the early 18th century to make a road to the granite quarry at the Ballagh behind Drinneevar

construction of the road up round the shoulder of Drinneevar. It is steep but still manageable by draught animals. In fact it was probably designed with the capabilities of horses in mind. The cutting through a ridge of solid rock at one point, to enable the line and gradient to be maintained, suggests the work of a surveyor. It was not a trail that followed contours and happened by chance. There were many parts where the road had to be built up. Such care and effort in the road's construction is a sure sign of its importance and certainly renders this route deserving of a respectful second look in its own right. It would have been from this quarry above the Ballagh that the granite was drawn for the construction of 'the quay' in 1808.[9] Whoever was responsible for the road, and likely it was again the work of William, Baron Annesley of Castlewellan, this is a beautiful walk through the forest leading to wonderful views at the ridge of Drinneevar.

Lynn's and Donard Quarry

Directly above the harbour is the old quarry, so called to distinguish it from the later and larger quarry a few hundred metres to the west. I refer to the old or first quarry on the face of Millstone mountain overlooking the town as Lynn's and the other as the Donard quarry. This last was the one worked until most recently and mention of 'the quarry' needed no further clarification. Early in the existence of Lynn's quarry it had already supplied the stone for numerous important undertakings in the county. Lewis's dictionary tells us:

> '...a quarry was opened in 1824, by J. Lynn Esq., and the stone is conveyed from the mountain by a railroad to the pier, where large quantities of it are shipped. From this quarry was raised the stone for the court-house, new prison, infirmary, and fever hospital of Downpatrick; the chapel of ease in this town (St John's, Newcastle); and the spire of Inch Church.'[10]

There is no record when Donard quarry to the west of Lynn's was opened but it must have followed very shortly after the first as we find Annesley's trustee, Rev John Robert Moore referring to 'quarries' shortly after William Richard, 3rd Earl Annesley's death in 1838. Moore's correspondence to try and secure work for the area has left us an interesting picture of the state of this industry. In November 1839 he wrote:

> 'Stones of any dimensions, however large, can be procured in the Newcastle quarries, and also loose on the face of the mountains. They have never been well worked. The distance from the quarry to the quay is I suppose about ¾ of a mile; there is a railway the greater part of the road and a continuous one could easily be made to the quay. The wages for workmen are very low here; labourers generally have 10d or at the most 1s. per day; stone cutters keeping their tools in repair from 2s 6d to 3s.
>
> I cannot refer you to any person who has experience in the quarrying business, except to Mr Lynn the architect of the County Prison which has

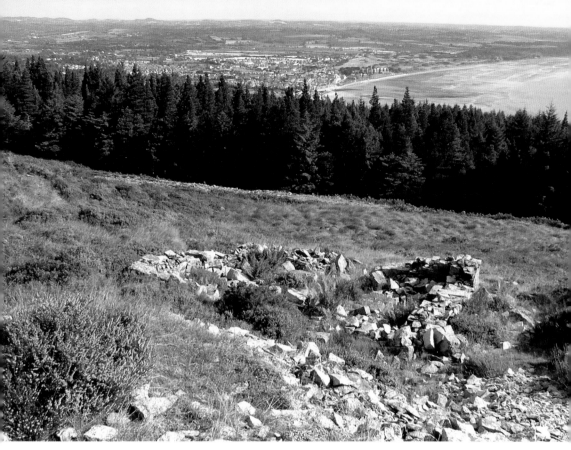

The remains of the engine house at the side of Lynn's quarry, mentioned in the letters of Rev J.R. Moore, trustee of the Annesley estate

been built at a cost of £73,000 from the quarries of Newcastle. The late Lord Annesley had let it to him for some years at a cheap rate, and took it from him again at the expiration of his lease, considering it had not been sufficiently worked.

It is not in my power to explain everything to you connected with the quarries; suffice it to say that the quality of the granite to be procured in them far exceeds any other to be met with in Ireland. The stone can either be procured of an orange, or blue shade and fine or coarse…There is an excellent engine house in perfect repair, with ropes machinery etc. for letting down the stones, an excellent smith's shop and the enclosed yard for stone cutters 'shades'…'[11]

The Rev Moore did not have much success with his solicitations for business. 1840 saw him writing to the estate solicitor, Hugh Wallace of Downpatrick, to see if a deal could be made with a client.

'I enclose you two letters concerning Newcastle quarries. I look upon Magowan as a person without capital to carry on the works in such a manner as to be really profitable to Lord Annesley. Mr Ritchie you see will guarantee

Donard quarry

the tonnage on the stone to the estate but this would be nothing if the quarries were badly worked for three years. It would be greatly for the interest of Newcastle to have the quarries at work and perhaps you could enter into some arrangement with Mr Ritchie.'[12]

Two years later Rev Moore was still extolling the merits of the quarries, this time to a Rathfriland merchant, Mr Bankhead.

'Relative to the Newcastle quarries, they are, I believe the very best in this part of Ireland. Lord Annesley's trustees would be very glad to enter into arrangements with a solvent company, to let them for any space of time not exceeding 7 years, and subject to such conditions as their legal adviser would suggest. There is some machinery on the premises which could with a small expenditure be made available, such as a railway from the quarry to the pier, cranes, ropes, etc.

There is a good blacksmith's shop on the ground and a place for erecting sheds for stonecutters, also a good slated house in the mountains adjoining the quarries.'[13]

Shortly after this Rev Moore, to improve business, had a road constructed up the mountain to the quarries about the year 1843–1844. He was most likely encouraged in this task by his sister, Priscilla Cecilia countess of Annesley who had

144

an interest in developing the spa waters high up the mountain slopes above Donard Lodge. Her acquaintance, Dr Alexander Knox, noted in 1845 that this spa could be reached 'by a bracing walk or by a carriage-way newly constructed, when there is anything to deter from up hill walking'.[14]

At the height of the famine, the many representations of Rev Moore to the Board of Works at Dublin finally bore fruit when repairs were made to Newcastle harbour. To help provide stone for this work Rev Moore gave up possession of the quarry engine house, tramway, and crane. Later he regretted this. Assurances had been received that stones could be obtained from the Newcastle quarries for the building of St Paul's at Castlewellan but when the contractor for the church approached the inspector of the harbour works, he met with opposition. A new harbour inspector was appointed but the new man was just as intractable so Rev Moore was obliged to complain to the inspector of the Board of Works.

'He has hitherto allowed stones to be got but not at all in a gracious manner having compelled the church men to take them from a part of the mountain from which they cannot be got without endangering the engine house. When the stone was even lowered to the road, he refused the use of the crane which is Lord Annesley's property, to put them on the carts, merely for the sake of opposition, as he was not using the crane at the time....The church contractor has been forced to dismiss eight of his good stone cutters this day and unless you, dear sir, will use your kind exertions to put a stop to this shameful conduct the whole church must be stopped as there is no supply of stones on the ground nor can they be procured but from the mountain at Newcastle.'[15]

Through perseverance however, St Paul's Church, Castlewellan, was completed and consecrated by the bishop of Down, Connor & Dromore on 1st December 1853.[16] All the granite used in the construction of the church came from the quarries on the Annesley estate.

In 1852 the Downpatrick diarist, Aynsworth Pilson, wrote an article on his recollections of early Newcastle and included details of quarrying.

'Our reminiscences of Newcastle are varied, just as events happened to strike and fix upon the memory at different periods. In childhood,[17] our recollections are of a few scattered fishermen's cabins, bleak-looking and comfortless – the very personification of poverty. Not a single plant, or shrub, or tree, save the brown heather and the blue mulberry 'decked the mountain's brow', where now the luxuriant pine shoots forth its stately pyramidal form in beautiful luxuriance. Wild, dreary, and inhospitable in the extreme was then the appearance of the place, but withal there reigned around that grandeur of nature, which can never be effaced, save by some such convulsion as that which first called it into being.

Anon, the sounds of industry began to be heard; the sledge and the bar of the quarryman, the hammer and chisel of the stone-cutter, the clanking of the anvil, the raising of huge blocks of granite by means of curiously constructed

machinery, and their conveyance upon trucks on an iron-shod tram-way, gave signs that the value of the rich deposits had begun to be appreciated by the enterprising builder, – there villas, mansions, churches arose, taking the place of those squalid habitations which offended the eye and saddened the heart. Improvements of various kinds followed each other in quick succession, until the place has now become so well worthy of the name conferred upon it by an eloquent writer, 'The Irish Scarborough, or Queen of northern bathing places.'[18]

Various entrepreneurs tried working the quarries after John Lynn took his business to Annalong. The Board of Trade used stone from the quarries to repair the harbour in June 1847 much to the relief of the Annesley Trustee, Rev John Robert Moore, who had been desperate to obtain local work so badly was the area affected by the famine. For a while Thomas Scott was a part proprietor of the quarries. He also worked quarries for Lord Downshire and doubtlessly benefited from the harbour extension at Dundrum in 1862.[19] However, his business fell apart after the Grand Jury decided in July 1868 to abandon Newcastle harbour to its fate. Scott no longer had any prospect of obtaining parliamentary funds to enlarge and improve the harbour on which he had hoped to levy tolls and he committed suicide in Dublin three months after the Grand Jury decision.[20] Short leases for the quarries seem to have been the order of the day. A Mr Coulter of Belfast sought a twenty-one year lease in 1882 but was told that three years would be the likely maximum and even this was doubtful as he hadn't yet paid his rent. The early 1890s saw the quarries being let to the local joinery and building firm, J. & F. Neil. The agent, Moore-Garrett, writing to Earl Annesley, recommended a re-letting but the duration of a lease had now dropped to just one year.

> 'Neil's agreement for the Quarry at Newcastle has expired. He charged McAleenan 2/6 a load for stone quarried and delivered. For years this quarry paid you nothing. I think you cannot do better than re-let it to Neil for another year.'[21]

One happy consequence of the re-letting was the beautiful Castle Bridge over the Shimna. Neil won the Grand Jury contract to replace the old narrow bridge that had spanned the river from the time of William lll and used the two main shades of granite, the grey and the tan, to a most pleasing effect.[22]

Requests for rent for quarries crop up frequently in the correspondence of the Annesley estate. A Belfast builder, J.C.G. Robinson, often received reminders. A typical note was that of 13th April 1891 from Annesley's agent, Moore-Garrett.

> 'I have authorized Messrs Murland to give you time till 4th prox. I wish you would pay more regularly and so save me trouble and yourself costs.'

It is not always clear who was leasing what quarries and the historical record is more blanks than details. Robinson's rent demand appears to have been in respect of Ballymagreehan quarry outside Castlewellan. If Robinson received an unusual degree of patient tolerance from the Annesley estate over his debts it was because

St John's Church of Ireland at the Black Rock is one of the finest Mourne granite buildings in Newcastle

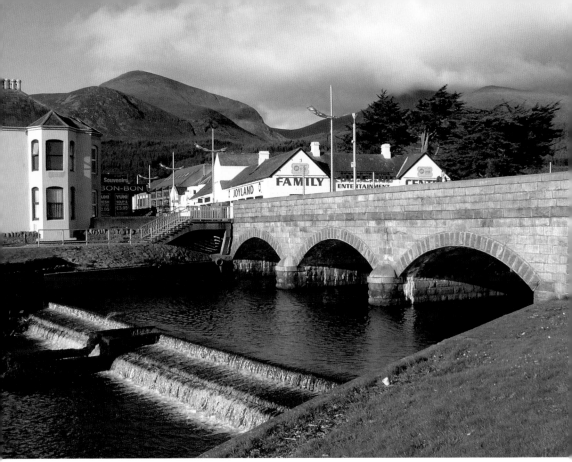

Local building firm J. & F. Neill used the two tones of Newcastle granite to a very pleasing effect in the 1893 construction of Castle Bridge

he was negotiating at the same time for a substantial building site in Newcastle at the start of the Bryansford Road. An agreement was finally signed in August 1893 for a frontage of 88 feet and part of the demesne. The site was at that time described by the agent as 'the best available in Newcastle'. The result was the terrace of four fine granite buildings known as Mount Royal. However, Moore-Garrett had written to Robinson in March 1893, 'I am informed that you have closed the Ballymagreehan quarries. Is this so?' The granite for Mount Royal might have come from Lynn's quarry above the harbour but it is known that Robinson did indeed continue working Ballymagreehan so it may still have been economical for him to have his stone quarried there and transported to Newcastle.

One quite important letter in the Annesley estate correspondence was an early draft to Thomas Andrews, chairman of the Belfast and Co Down Railway (BCDR) opening negotiations for the site of the future Slieve Donard Hotel. Annesley's agent thought to urge the railway company to avail of local stone. 'I would suggest to you to take a lease of the granite quarry above the pier and so supply yourselves and the public with the best of all building material from a convenient distance.'[23] The company had their own plans and the hotel was built with red

148

The fine granite façade of Mount Royal

Ruabon brick and sandstone dressings from Dumfries. About the only thing local used was pit sand from Dundrum. The BCDR may not have availed of the local granite but from the very beginning when the prospectus for the Downpatrick, Dundrum and Newcastle railway company was published in November 1865, the carriage of granite to Belfast was mooted as making shares in the company a very attractive and remunerative investment.

> 'In addition to the ordinary goods traffic, it is anticipated that a large business will be done in the carriage of Granite from Newcastle to Belfast and elsewhere, the Mourne Granite being of such superior quality as to have been selected for the construction of the late Prince Consort's Monument, now in course of erection in London; and also in the carriage of Flax and Fish, with which Belfast is now largely supplied from Newcastle, Kilkeel and Annalong.'[24]

With the destruction of the pier at Newcastle, granite was carted at great inconvenience to Dundrum for onward shipment. The chairman of the Downpatrick, Dundrum and Newcastle railway had noted that the volume of trade in all commodities from Dundrum port in 1868 was nearly 10,000 tons, 'and all of this, he optimistically claimed, 'will, no doubt, find its way along our railway to Belfast'.[25]

The Peak and Slow Decline of the Granite Industry

We get a glimpse of the state of the local granite industry at the start of the twentieth century from a local government inquiry held in the Annesley Memorial Hall in September 1903. The inquiry was held into the need to increase the yearly expenditure on the roads of the Kilkeel rural district, and Newcastle then was part of that rural district. The county surveyor, a Newcastle man called J. Heron who built Eastern Lodge at the bottom of Kennedy's Hill, told the inquiry that the roads were in a worn out condition. It was particularly difficult, he told the inquiry, to get contractors to undertake maintenance work. He believed this difficulty was due to the scarcity of labour caused by emigration and also to other employment being available, particularly in the granite industry and the large works in progress in the district for the Belfast Water Commissioners. The cartage necessary in connection with the road contracts was also expensive and difficult to obtain as many horses and carts were employed in the granite trade. Another surveyor endorsed Heron's submission and gave evidence that 'of late, more granite quarries had been opened, and the existing quarries were worked more

The BCDR were invited to lease the mountain quarry to be able to build their new hotel from local granite but chose instead to build the Slieve Donard Hotel from red Ruabon brick

energetically, this being borne out by shipping returns.'[26] It would seem that the end of the nineteenth and the very start of the twentieth century were good, if not the best of times, for the granite quarries.

In 1903 there were high hopes for the local granite trade as the new harbour neared completion. In May of that year the quarries on the face of the mountain were converted into a limited liability company with a capital of £2,000. The directors were Mr J.H. Windle and J.T. Barrett of Oldham and Matthew King, JP, and Daniel McCartan, solicitor, of Newcastle. The secretary and manager of the company was local man Thomas Acton who was a great Gael, an athlete and known as easily the best at pucking a hurling ball. Unfortunately the granite trade went into recession. Two months before the new harbour was completed market depreciation had reached such a state that the dressing prices of setts in the several grades were lowered by 1s a ton, to 7s, 8s, and 9s per ton for the respective sizes.[27] The trade union sett-makers in the Slieve Donard Company's quarry went on strike.[28] The advice of the trade union leaders counselling the sett makers to go on strike for higher wages at a time when there were virtually no orders to execute was lambasted as 'sheer wrong-headedness'. The work at the pier was now complete as was the Ballyroney railway extension so employment opportunities in the area that winter were scarce. The sett-makers returned to work in February of 1906. A year later the picture was not just so grim as the new harbour began to show benefits to the local economy especially the quarries. January of 1907 saw a steamer shipping out 300 tons of granite setts from the Slieve Donard quarries for Manchester and the following month the steamer *Oak* sailed for Manchester with a cargo of 350 tons. This last was the largest steamer and the largest cargo until that time that had left the renovated harbour. Many other stone boats would convey worked granite from the quarries to Belfast and beyond but the increasing use of tarmacadam in the construction of roads saw demand decline. Streets of cobbles have great character but the demand for better road surfaces sadly saw swathes of the granite workers art being covered over with black bland bitumen. One such sorry loss in Newcastle was Donard Street and only a tiny remnant of the former glorious cobble expanse presently remains on the footpath at what was a back entrance to the Donard hotel. I am sure I am not alone in envying Newry for retaining the cobbled street alongside the canal?

In May of 1907 there were short lived hopes that the area would find some relief from grinding poverty when the Royal Commission on Congestion sat in Castlewellan. Fr R.J. Murphy representing Kilkeel Rural Council made a submission. He was then parish priest of Glassdrummond and while his remarks about the granite industry would relate closely to the Annalong district they broadly reflected the situation at Newcastle too.

'The women earned at embroidery about 3s a week. The sites of some of the best quarries had been taken as part of the catchment area for the Belfast waterworks, nor could anything paid to the landlord in respect of such

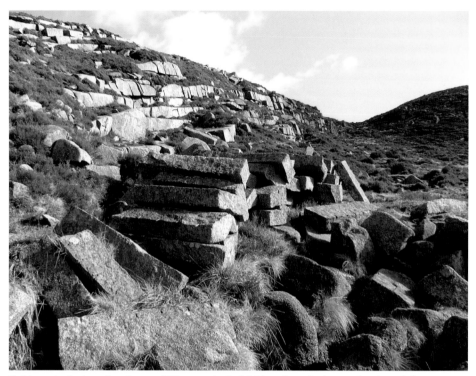

Cribben stacked on the slopes of Slievenaglogh. Making these kerbs was hard work for £1 a week

acquisition compensate the district for the loss. Many of the stone workers had emigrated. Those engaged at kerbs in summer would earn from 18s to £1 a week, and those at setts about 25s'.[29]

Jumping forward to more recent times, the firm of Isaac Hamilton & Sons had the lease of the quarries at the start of the 1960s and purchased one of the latest compressors. This was installed at a specially constructed building at the quarry and made a remarkable change from the old way of doing things. The foreman, Sam McCullough, obligingly gave a demonstration to a visitor in November 1961. To show the machine's capabilities he switched on the engine, picked up a pneumatic hammer and in a few seconds had bored a hole clean through a slab of granite as though it were a lump of cheese. The specially designed hammer with its tungsten carbide tipped drill had a striking power of 19lbs weight and could strike the granite 3,200 blows per minute. By way of comparison a hand stone cutter with a 3lb hammer averaged about 43 blows a minute. Another advantage, Sam added, was that half-a-dozen air-lines could be taken from the compressor each operating the same type of hammer. Indeed a six hundred foot air hose line was installed to convey power to various points of the quarries. This was awesome change indeed.

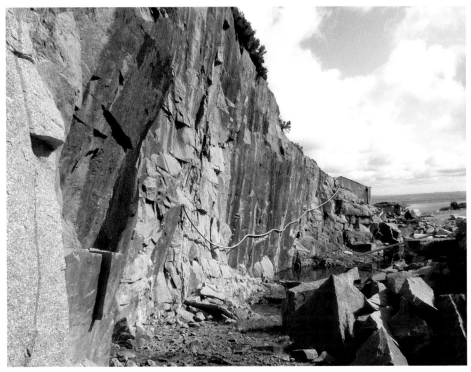

The blue hose for the compressed air snakes across the wall of Donard quarry

A Quarry Worker Reminisces

Among one of the last to regularly work at the Slieve Donard quarry was David McCauley of Kilkeel.[30] Coming, as he said himself, 'from the bogs of Ballyroney', he started work at the local quarries in 1970 for McConnells of Annalong when he was eighteen. David and another stone-man, Hugh Forsythe, made the daily journey from Kilkeel, unlocking the two forestry gates and driving up the forest trail to the quarry at the front of Millstone mountain to start at 8.30am summer and winter. When a stone had to be got ready for cutting from the rock face, the important first step was the marking out of the line. The pneumatic hammer with a long drill bit would be used to bore out a series of holes along the desired line of separation. Holes might be drilled every foot or two feet, really depending on the size of the block to be detached. It was dusty work and every so often the compressed airline would be used to blow out the holes. No talk of health and safety then. David remembered ruefully being told off once by the foreman when one of his bore-holes was slightly out of alignment. It was wasted time and effort to have to trim the granite afterwards and risked spoiling the whole block. Apart from the holes being drilled through the rock down to the horizontal joint below,

153

a punch chisel was used to hammer out a line by hand on the surface of the rock between the bore-holes – joining up the dots, so to speak. This line encouraged the rock to break clean and straight.

David has attended many health and safety courses in his time and he laughed as he now recalled how they used to work with the black grainy blasting powder and the gelignite. Blasting powder made a softer sound compared with the gelignite when it exploded and was the preferred method of taking out a block from the quarry face as it gave more control. Powder was also preferred because it was a gentler explosion and less likely to shatter the rock. Clearing out corners and unwanted ends of rock was best and quickly done by gelignite. When the line of holes was ready, a measure of powder was poured in and a length of cordex fuse cord inserted. The powder and fuse would be tamped down with the end of a wooden broom handle. On top of the powder would be poured some fine sand. This would have been riddled beforehand to ensure there were no granite chips in it. The presence of granite flakes in the sand could cause a spark in the tamping down and set off a premature explosion. The tamping rod had to be wood for the same reason; to avoid creating a spark. And so the line of holes was filled; powder and fuse, tamp, maybe more powder, tamp, sand, tamp, more sand, tamp and so on until the hole was firmly filled up. The tamping was necessary to ensure a firm and concentrated explosion.

When gelignite was being used, it was important to measure the depth of the borehole before inserting the sticks which measured about six inches each. That way you would know if a stick of explosive had got wedged in the hole and hadn't dropped the whole way down to the bottom. Before the detonator was married to the gelignite it had to be joined to the fusewire and David recalled one man who would put the fusewire into the receiving gap in the top of the detonator and then crimp the two together by biting down on the detonator with his teeth. The gelignite was like plasticine and the small detonator would then be pushed into the top of the last stick going into the hole. Before an explosion was let off, one of the police would come up from the station to act in a supervisory capacity and to oversee security. The task was really a rather perfunctory one and more interest was frequently shown towards the teapot at the smithy forge. Explosions were usually carried out once or twice a week and an effort was made to get more stone out during the summer so as to have an adequate supply back at the yard to work on during the winter. Besides, taking the heavily loaded lorry down the steep slope from the quarry in winter gave too much anxiety. David remembered that before explosions took place, another constable called Brown would sometimes come up to the quarry on a motor bike. After a check had been made to ensure no member of the public was near enough to be endangered, the workers either retired to the shed that had the heavy protective beams overhead or went down slope from the quarry as far as the forest wall and the fuse was lit. When it came

In quieter times dynamite for quarry blasting was kept in this small store with its concrete roof. In case of an accidental explosion a large defensive berm, now becoming overgrown with heather, was built between the dynamite store and the quarry buildings

to lighting a powder fuse as opposed to a cordex one, David was at pains to tell me that it didn't burn as fast as Hollywood used to show in the films. He also found that working with the powder gave him a sore head so there must have been fumes to which he was susceptible. There were no hard hats in those days and a respectful caution always had to be shown when gelignite was being used.

Mention has already been made of John McVey of Newcastle sustaining a broken leg during blasting of the water tunnel through the mountain to Tullybranigan. Even though he was standing at what was presumed a safe distance a rock had come flying down the tunnel to inflict injury. In March of 1905 a young man named John Johnston, aged about 27, was not so fortunate at Ballyward. He was employed on a section of the new railway line under construction between Newcastle and Ballyroney when a large stone struck him on the head after a gelignite explosion and killed him. At the time a warning horn had been sounded and Johnston and his companions had retreated to what was considered a safe distance. The foreman, who was well experienced with explosives, could not account for the stone carrying so far as the hole at which blasting was taking place had been covered with fir faggots and old brushwood.[31]

It sometimes happened that there was a misfire and no explosion took place. There might have been a fault in the fusewire or more likely, as David said, 'bad housekeeping'. It was a situation no-one liked and it meant a long wait. Someone was always going to have to approach the charge to see what had gone wrong. Those were different times and with different expectations and David admitted that after one such misfire the men had to leave the unexploded gelignite in place overnight before approaching it cautiously the next morning. Those were the days when there were only sheep around. A walker to two might come over to the quarry during the summer to see how things were done but by and large the quarry was a very lonely place to work.

At the end of the nineteenth century it was possible to buy explosives over the counter at Beattie's hardware shop at Newcastle where the Avoca hotel is today. David McCauley remembered being sent in 1970 to McCammon's hardware at Castlewellan to buy explosives for the quarry. Previously it had been the convenient practise to keep a store of explosives near where they were needed. Back in December of 1898, Mr White, a civil engineer with H. & J. Martin Ltd, contractors for the water pipeline to Belfast, obtained permission at Castlewellan monthly court to establish a gelignite magazine close to the shaft at Ballaghbeg in Lord Annesley's demesne. The magazine was stated to be properly isolated and not more than a ton of the explosive would be stored at one time. A similar arrangement had also been come to later for the Slieve Donard quarries. The little explosives store is still to be seen to the west of the quarry and a huge berm of granite spoil was built up between the magazine and the quarry sheds to act as a protective blast barrier. Heather is now softening the outline of the large defensive berm The practice of storing explosives at the quarry had long been discontinued

by the time David started work there. Nevertheless, he recalled with awe how it was still possible at the start of the troubles for him to collect explosives at Castlewellan. McCammon's kept the explosives in a cardboard box in their store at Back Lane, behind their shop. David put the powder, detonators and gelignite into the back of his landrover and drove back to Newcastle and up to the quarry. There was a welcome simplicity in life then that has since been smothered by an avalanche of regulations all intended for the best.

The plane joints at Donard quarry are not exactly horizontal but have a gentle inclined slope. After an explosion had separated a block from the quarry face, chains would be put round it to pull it out. Rollers would also be put underneath as far as possible to help remove it. Moving large blocks was difficult work but the slight downward slope was a help as a block slid out that bit easier. When a block got momentum and started moving it could come away in a sudden tumbling rush and David recalled that Alan McConnell lost a leg when it was crushed by a moving chunk of granite. A block 8feet by 10feet by 4feet would weigh almost nineteen tons and while large, was not uncommon.[32] Lifting machinery was often pushed to the edge of tolerance with wheels sometimes off the ground trying to transfer big loads onto the bed of a lorry. The lorry would have been backed up as close as possible to the quarry face while men and machine strained to shift blocks onto the wooden skids. Resting the granite on top of the skids on the bed of the lorry made it easier for a forklift to remove the load later back at the home yard but more importantly it stopped the granite from sliding about especially on the downward slope from the quarry. Granite could not be put on top of granite as the danger of a shifting load was too great. The lorry would deliver the granite to McConnell's yard at Carrigenagh Road at the Silent Valley where the main cutting and dressing of the stone was done.

Some dressing and preparation of the stone was necessary on site and a smithy operated at the quarry to sharpen the punches. The iron tools had to be heated so that sharp points could be hammered back or good edges restored. There was a skill even in the quenching of the red hot metal after it had been worked. Plunging the hot tools into cold water could cause such tension between the rapidly cooled surface of the metal and the still hot core that the tool could shatter and it would have to be thrown away. After quenching the tools were hard but they still could not be used as they were too brittle. They needed to be reheated and cooled. This reheat also called for skill and fine judgment. The tool to be tempered was placed on top of the fire, not in it. Just as boiling eggs need to be watched if you want them cooked but still soft inside, so, the blacksmith carefully watched as the reddening glow on the metal moved down the haft towards the point. Experience and skill determined the exact moment to pull the metal from the fire just as the colour of the point started to change. Quenching and tempering the metal when the point was starting to glow purple was ideal but if the point got red hot one would have to start all over again.

Except for a very rare extraction, work at the quarry has now finished. It was dirty, dusty, dangerous work. David McCauley still has the scars on his hand, as probably had all the stone-men, from the occasional accidental smashing of the knuckles or hand when the hammer missed the top of the punch. The loud booms of the explosions that echoed over Newcastle in decades past have now ended but David passionately believes that we should give deeper appreciation to the skills our forefathers achieved extracting, cutting, moving, dressing and building with this stone. I note with pleasure that a project is presently underway to record and photograph all the granite workings in the Mournes. It is a precious heritage and a legacy that holds a rich potential for tourism. The skills and memories are still there even if the quarries are closing. Granite is a beautiful stone and the memory of those who worked it and their monumental efforts deserve to be cherished for future generations.

The Bogie Line

I once found a granite square sett which measured 6" x 6" x 8" (15cm x 15cm x 20cm), roughly about the size of a loaf of bread. When put on the scales it weighted in at 1½ stone or ten kilos. Lift a few granite boulders on the beach sometime and the message is simple, granite is heavy. Given the thousands of tons of setts, lengths of cribben and other granite products that were fashioned over the decades, it would have been impossible to get these goods to market without a convenient form of transport. It is much easier to move heavy material over water than over land and so the proximity of the sea to the local quarries was crucial in the early development of this resource at Newcastle.

Samuel Lewis in his topographical dictionary tells us 'The stone is conveyed from the mountain by a railroad to the pier, where large quantities of it are shipped'. The bogie line was installed by John Lynn in 1824 when he opened the quarry and this narrow gauge railway stayed in existence for nearly 120 years until the rails were lifted to aid the war effort in the 1940s. The remarkably consistent gradient between the quarry and King Street allowed an inclined plane system to be used. The trolley buckets or bogies were loaded by aid of a steam crane at the quarry and drawn down to the buffers at Forge Row by the force of gravity. As they descended, the laden wagons pulled up the empty ones and a siding allowed the wagons to pass each other. I seem to recollect that the mighty monumental blocks of granite that acted as buffers at the side of Forge Row were removed in the early 1960s though there were still other stones left.

The granite trail from King Street up to the quarry follows the former bogie line and one particularly pleasing feature of the restoration was the revealing of the granite blocks that formed the bed of the track with the holes drilled in them to allow the metal rails to be pinned to the stone. No wooden sleepers were used. The bedding of the metal rail directly to the granite underneath called for

Note the notch in the spoil heap where the bogies entered the quarry and the oblique line through the bracken on the right where the second line was later made

Granite was brought from the quarries to the harbour in bogies like this

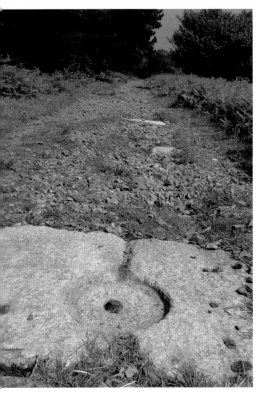

The pulley wheels for the cable pulling the bogies up and down the hill were recessed in granite blocks

precision alignment of the stones as the slightest unnecessary projection would cause dangerous wear on the cable. The observant walker will note both the circular recesses in the granite for the pulleys and also some short lengths of the small original rail hammered upright at the side of the path.

The development of the bogie line is best followed on ordnance survey maps. The original track, or mineral railway as it was referred to on the maps, was a straight line from King Street up the mountain side to the quarry on Millstone Mountain. As you cross the stile at the top of the granite trail, notice the notch in the spoil heaps straight ahead which was left to receive the bogies. However, the fortunes of Lynn's quarry ended with his lease. William Richard, 3rd Earl Annesley, before he died in August 1838, removed the quarry from Lynn as he considered it had not been sufficiently worked. With the coming to prominence of the new quarry between Millstone and Thomas Mountains, the bogie line was diverted to serve it and the ordnance map of 1859 shows the railway dog-legging above the forest line over to the new quarry. At this stage Lynn's quarry had completely ceased to function and was not even thought worthy of inclusion on the map. The rapid expansion of Belfast at the later end of the nineteenth century saw an increased demand for granite and while the boom lasted the old quarry got a new, albeit brief, lease of life. The original bogie line was spoken for so a new second line had to be constructed and the ordnance map of 1902 shows this leaving from the eastern side of the old quarry and descending obliquely with the first bogie line to emerge on King Street at the side of Annesley Terrace. Virtually no trace of this second railway survives on the ground but from the higher slopes of Millstone Mountain the line it followed is clearly discernable through the bracken.

The Bloody Bridge and Hare's Gap Quarries

Space allows only the briefest of mentions of the quarries along these important entrance routes into the Mournes. Visitors who avail of the Bloody Bridge valley to climb to the top of Slieve Donard will pass the workings of at least five quarries. This area in the past was the site of major workings. One of the lower quarries is into the bank of the river but this is not usually noticed by walkers who do not actually pass the former workings. It is this quarry that has given rise to a modern puzzle. Still to be found marked on the maps on the north side of the upper reaches of the Bloody Bridge river is 'Crannoge'. 'Crannoge' is normally understood as a fortified lake dwelling but the Irish dictionary by Dinneen also gives us a translation of 'a structure of wood'. I had walked the upper reaches of the valley many a time searching the landscape to no avail for some possible sign of a long lost cattle pound that would explain the reason why crannoge was marked on the map. The map placed the crannoge at the junction of the Crossone tributary and the Bloody Bridge River. The ground at this site however proved to be quite guttery and unsuitable and there was not the slightest evidence on the

This is the Crannoge of the ordnance survey maps. It is a substantial man-made island of granite tippings from quarrying into the side of the river bank

161

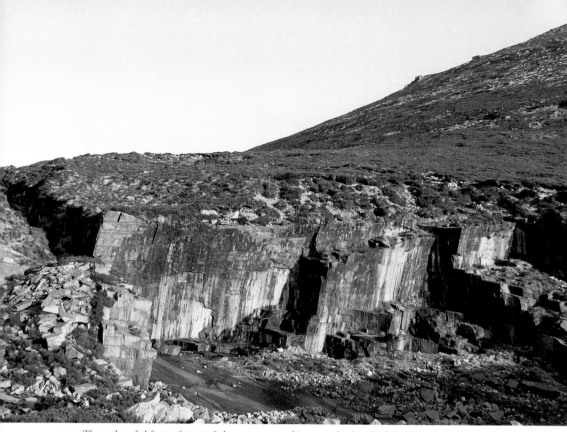

The colourful face of part of the quarry workings at the head of the Bloody Bridge valley

landscape of any early habitation. The answer, when it came, seemed only too obvious. Crannoge was the name the early quarry-men gave to their growing mound of tailings from the workings at the river bank. The river may originally have flowed round the tailings on both sides to give the dump the semblance of an island. The tipping grew into quite a substantial mound and the river now only flows round it on one side. This man made 'island' is to be seen just above where walkers must now cross the river from the north bank to the south bank to join the quarry road en route to the summit. The name 'crannoge' has been erroneously placed on the map higher up the Bloody Bridge valley than necessary.

While the river bank workings may not be noticed, walkers can look for old quarries on the slopes of Crossone, on the upper reaches of Carr's Face, on the high southern slopes of Slieve Donard and finally and most impressively the extensive quarry at the head of the valley. This former site of great activity is now at peace and the only sounds are the headwaters of the Bloody Bridge river running through it and, in season, the nesting ravens.

On the other side of the mountains as you go up towards the Hare's Gap there were a number of quarries. The nearest to be seen on leaving the Trassey wood are a couple of small workings on the north slope of Spellack. Quite the largest quarry however was up the valley on the right at the tip of Slieve Bearnagh's north slope

by the entrance to Pollaphuca valley. This was quite a substantial working. The old Brandy Pad trail favours this side of the valley as well and if you are heading towards Slieve Bernagh this route is worth considering. If you wish to avoid clambering over boulders on the final steep climb to the Hare's Gap and are heading toward Slievenaglogh direction, another granite trail on the left of the valley is an attractive route. The track starts opposite the cliff face of Spellack, from the Irish *Spealag* meaning 'pointed rock'. Bear up to the left and the track takes you past two small quarries. En route to the gully that leads to the stile over the Mourne wall, you will pass at least three stores of granite lengths, sectioned out and stacked in preparation for final dressing as cribben, or road kerbs. I find these piles a moving memorial to a once thriving industry and a reminder, if one was needed, of the hard work of men eking out a living in all weather conditions.

Derivation of Crossone

While looking at the quarries in the Bloody Bridge valley, I would like to consider the derivation of Crossone, the eastern spur of Slieve Donard which separates the Glen Fofanny and Bloody Bridge rivers. The *Place-Names of Northern Ireland* described it as 'of uncertain origin', and explanations 'are fraught with

Cribben near the Hare's Gap

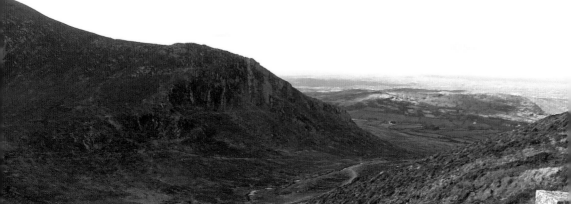

difficulties'.[33] The difficulty comes from the officer of the ordnance survey recording in his notebook the name 'Cros Eoghain' which he interpreted at 'Owen's Cross'. The boundary survey maps at this same time, circa 1830, recorded the form 'Cross eoin'. The Placenames project, going back to how this would have sounded in Irish, have most properly reasoned that the name is derived from a compound of *cros* meaning 'cross or slant' and *abhainn* 'river'. This, however, only works in the singular with one river so the question becomes, what river was it? The answer to this, I believe, is the little tributary, a small single river, which slants downhill from its source between Slieve Donard and Crossone to join the Bloody Bridge river. It is unnamed on maps. It is this tiny river that attracted the Irish name *cros abhainn* or 'the slanted river' and gave its name to the mountain behind it. Looking at the bigger picture on the map, the same description could, of course, apply to Glen Fofanny river as it slants across to join the Bloody Bridge River were it not that it already enjoyed a name.

While in the vicinity of the Bloody Bridge River, it is necessary to address again the erroneous legend about how the Bloody Bridge got its name. It is true that in this area of Ballaghanery English prisoners were killed by their Irish captors during the war of 1641–42. Too many still maintain however that the bridge got its gory name because the bodies of the dead prisoners were thrown off it into the river which then ran red with blood. Not so. It is recorded in an article *Round Rostrevor* in the Downpatrick Recorder of 22nd August 1874 that two men, decades earlier, were racing their horses along the road from Greencastle fair. This was a time when the width of the original bridge over the river was much smaller as can be verified by examining the underside of the structure. The horsemen were vying with each other, each seeking to be first over the narrow bridge, when the lead horse misjudged the line of the road and galloped off the road over the edge on the wrong side of the parapet. The second horse followed before his rider could rein him in. Horses and riders were dashed on the rocks below and the river ran red with blood. The two events have become confused. The murder of the prisoners in 1642, while in the custody of the Magennis clan, was a sorry enough affair without the untruthful and poisoning embellishment of the desecration of the bodies.[34] Rev W. Armstrong Jones, rector of St John's Parish Church, gave a warning in 1949 about the 'lurid stories' of dark deeds that were supposed to have taken place at the Bloody Bridge lest they would 'perpetuate the intolerance and religious bigotry which have disgraced our past and to which our present generation is not immune'.[35] Originally the name for the river was the Midpace River. This was interpreted as the Mid Pass and was thought to refer to the pass of Ballaghanery. Midpace River however is from the Irish *Mí-ádh Páis* meaning 'unfortunate/unlucky death' and alludes to the accidental deaths of the riders whose horses misjudged the edge of the bridge parapet and galloped over the edge of the void to the rocks below before they could be reined in.

This stream, with Slieve Donard in the background, joining the upper reaches of the Bloody Bridge river was called in Irish *cros abhainn*, 'the slanted river' and gave its name to the mountain beside it, namely Crossone

Ballymagreehan

No mention of working granite in the local area would be complete without a mention of the quarries of Ballymagreehan. A couple of miles outside Castlewellan towards Kilcoo, the main quarry is high on the remote face of old Carragh Mountain above the Largy Road[36]

I have a special affection for this bleak area as my maternal great-grandfather used to walk over the top of Slievenalargy hill to his work at the quarry. Another distant relation was present when James Canning was killed at the quarry in February 1899. It was from Slievenalargy hill that a natural slab of granite was selected as a monument capstone for the grave of St Patrick.[37] There is no record of when the quarry was opened but its genesis may have been born out of frustration on the part of Annesley trustee, Rev John Robert Moore, over his difficulties obtaining granite from the quarries at Newcastle for the building of St Paul's, Castlewellan.

Three A's combined in the decade after 1856 to give a real boost to Ballymagreehan granite, namely Annesley, the Arsenal and Prince Albert. When William Richard, 4th Earl Annesley came of age in 1850 he moved from Donard Lodge, Newcastle to reside at Castlewellan in the cottage built by his grandfather. The rat infested habitation was far from ideal and the earl quickly decided to build a castle for himself in the baronial style. His new residence used granite sourced on his estate at Ballymagreehan. The catholic churches of Leitrim, Kilcoo and St Malachy's of Castlewellan were also later built using granite from Ballymagreehan hill.[38] The use of granite in the construction of the Ulster Bank, the Northern Bank buildings, and the Methodist gospel hall in Castlewellan conveyed a reassuring sense of stability and solidity. Likewise built from Ballymagreehan granite was the Fountain Bar built by P.F. McCartan to the designs of Joseph McAleenan. While the granite faced premises were under construction, the embryo bar was mistaken by a visitor for a church, whereupon a local wag observed, 'Who shall say it will be prayerless?' Praising the Fountain Bar at its opening, a writer declared, 'there is an air of thoroughness and substance about the whole building which must give great satisfaction to both these gentlemen'. What was said about the Fountain Bar, would apply equally to all; 'the building in its pleasing effect is a striking proof of the possibilities of native granite'.[39]

Events on the continent and tests by the arsenal of Woolwich brought about a remarkable boost for local granite in the 1860s. After France invaded Italy in 1859 there were serious concerns that France might also invade England. The prime minister, Lord Palmerston, set up the Royal Commission on the Defence of the United Kingdom. The commission's brief was to enquire into the state and sufficiency of fortifications both existing and planned for defending the kingdom, particularly naval dockyards. As a result the arsenal at Woolwich conducted a series of tests to find which stone would be best suited to withstand

The road up to Ballymagreehan quarry gives panoramic views of the distant Mournes

bombardment. Specimens of granite from Annesley's quarries, together with samples from various other localities in Scotland and England were experimented on in 1864 by direction of the War Office. The strongest pressure stress endured by any of the other samples before being crushed came to 12,800lbs, but the sample from this district survived a pressure of 34,000lbs and then yielded without any explosion. Ballymagreehan granite showed its superiority over all the other samples for withstanding the forces of heavy shot. The commission embarked on an intensive program of fortification, mainly affecting the naval ports on the south coast of England but also including Belfast, Cork and Lough Swilly. There is no evidence that the results of the tests at Woolwich brought any orders for local stone from the War Office but the results were seized upon for a different purpose. The same quality of toughness which made the granite so valuable for fortifications made it equally suitable for paving surfaces exposed to heavy traffic.[40] By extension we should have a heightened respect for the granite workers who daily laboured with this hardest of rocks, making building blocks, cribben and setts. I have a particular respect for one stone worker, Paddy Grant. Paddy, in his day, had been a stone worker at Ballymagreehan quarry outside Castlewellan and before he died had made his own headstone from granite that he had chiselled into the shape of a celtic cross. Every time I look on this

headstone in Kilcoo cemetery I recall his fervour and pride in telling me, 'Ballymagreehan granite is the hardest in the world'.

The death of Prince Albert in December 1861 left Queen Victoria in the depths of grief. She closely followed the designs and construction of her husband's memorial. From the quarry near Castlewellan, large blocks were extracted and sent to London for the base and pedestal of the Prince Albert monument, the stone having been selected from amongst others by the Queen herself.[41] The choice of Ballymagreehan granite for the base of the Albert memorial at Hyde Park was most fortuitous and was still being loudly trumpeted by the McCartans, owners of the Castlewellan quarries, fifty years later. This endorsement by the monarchy we would now call a public relations coup and the prestige of being associated with such a famous monument certainly resulted in many granite orders from Belfast and England.

Man killed by steam boiler explosion

At the end of the nineteenth century the main Ballymagreehan quarry was leased to the Belfast firm of John Robinson and Son, stone merchants of Queen's Quay, Belfast. Not only did Annesley's agent, James Moore-Garrett, have to write

War Office tests in Victorian times proved that the granite from Ballymagreehan quarry was superior to all others in withstanding the forces of heavy shot. Today, under new management, the quarry provides crushed stone for road building and industry

frequently to them for payment of the rent but the proceedings of Castlewellan court record numerous decrees awarded to employees seeking to recover unpaid wages. It was while Robinson had the lease of the quarry that James Canning, a stone cutter, was killed on 28th February 1899 and another man James McComish was hurt when a steam boiler exploded.

The boiler had suddenly exploded about 2.20pm on that day in 1899 and Canning was very badly scalded and also injured by flying timber and died two hours later in great agony. The Crown later took a case against Robinsons for neglect of duty as the boiler had been bought second hand and no record existed for its cleaning or examination. The firm were completely exonerated of all responsibility as the boiler had been bought from a respectable firm and Robinson's engineer had not only been present at the time of purchase but had installed the boiler at the quarry. Luck had definitely played a part in that only one man and not more had been killed. Just before the boiler had exploded a stag hunt had passed by and all the men had rushed out of the quarry to see the excitement and thus were fortunately not in the vicinity. The men were only out of the quarry for about four minutes and the quarry foreman, James Jones, was actually in the process of calling them back to work when there was an almighty bang. James Canning had not left the quarry but rather climbed the bank adjoining the boiler shed to get a better view when the explosion happened. The boiler was blown thirty or forty metres away and when Canning was picked up he was found to be severely scalded and injured. He had simply exclaimed that he was 'done'. The foreman, James Jones was examined about the boiler's working pressure and Edward Doyle, the man who used to clean the boiler were both examined at court but the board of trade inspector said no-one was to blame as the fault lay with the inherent weakness of the furnace. James Canning had received an awful wound to the mouth and had been struck on the chest during the explosion. Doctor Megaw deposed that James had died from the blow over the heart, accelerated by the shock of the scalds.[42]

The granite trade declined and so did the fortunes of Ballymagreehan quarry. It is presently held by McConnell's of Annalong who work it occasionally though the hardness of the stone presented problems when they first tried to crush the rock for road aggregate. David McCauley who worked at this quarry for McConnell's, told me of other activities that formerly took place there when the quarry was not being worked for stone. The remote location was utilised by an enterprising person to make poteen. The local sergeant in Castlewellan became aware that brewing was taking place and the still was raided. The poteen was brought back to the station 'to protective custody' and put in one of the cells. Before long a fax message came from the Revenue that they would be coming down from Belfast to take possession of the poteen, to analyse it and then destroy it. The sergeant, who was partial to a wee drop, knowing the fate of the spirit, resolved that it should not all go to waste and he arranged for some poteen to be

taken out of each of the seized bottles and for them to be topped up with water instead. After the Revenue had collected the haul, they duly notified the station of the results of the analysis and the sergeant was greatly surprised to hear that even after his dilution the result of the tests returned a reading of 110% proof. The Ballymagreehan poteen was as hard as the granite where it was made; it was clear as a crystal and a discerning palate pronounced an awed verdict that it was 'real firewater'.

McCartan's and other quarries

Four quarries formerly operated on Ballymagreehan hill within a few hundred metres of each other. Another was worked at the bottom of Altnadua hill[43]. The road to the largest, just simply known as Ballymagreehan quarry, was up a steep hill off the Largy Road. A second quarry once known at McEvoy's but now known as the Largy quarry is also accessed off the Largy Road. The other two quarries, known as Rush's and McCartan's, were accessed from the Altnadua Road. Rush's quarry is scarcely noticeable from Altnadua road when you reach the top of the hill although McCartan's is more evident from the spoil tip and roofless buildings on the side of the mountain.

Largy quarry was a small working now overgrown with whins off the Largy Road. It was from this quarry that the stone was extracted to build the church of

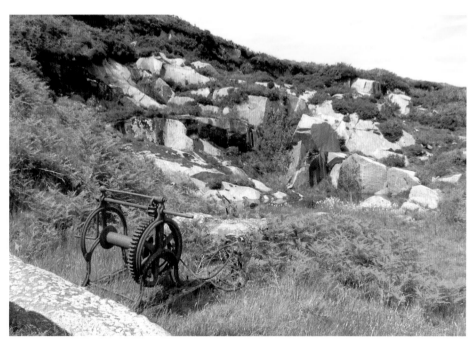

An old hand operated crane at the site of Rush's quarry

McCartan's quarry at the side of Ballymagreehan hill is now overgrown. The pivot for the crane can be seen in the foreground

St Malachy at Kilcoo. The walling of the church and the ninety foot tower was of rock-faced ashlar and dressing of Ballymagreehan granite supplied by Mr McEvoy. At the solemn dedication of the church on Sunday 30th June 1901, the parish priest, Fr Magee, thanked Mr McEvoy and all who had active part in the work. Among his acknowledgements was a special word of thanks to the Marquis of Downshire who had given him the stone of which the church was built for practically nothing. Initially this caused me quite some puzzlement as Ballymagreehan was part of the Annesley Estate. However, Mr McEvoy was able to extract granite from the hill in Slievenalargy townland just a few fields from the boundary between the townlands of Slievenalargy and Ballymagreehan. This boundary was also the demarcation between the estates of Lord Downshire and Earl Annesley, the boundary between Kilcoo and Castlewellan parishes and the rural district boundary between the unions of Kilkeel and Banbridge. Thus, while the granite for Kilcoo chapel came from the same hill as Ballymagreehan quarry, albeit separated by a few hundred yards, it was in the province of Lord Downshire, as the landlord of Slievenalargy, to exercise great generosity regarding the cost of the stone. Such a liberal gesture on the part of Downshire was in marked contrast to the begrudging attitude on the part of Annesley two decades earlier when St Malachy's church at Castlewellan was under construction. Then sand had to be

171

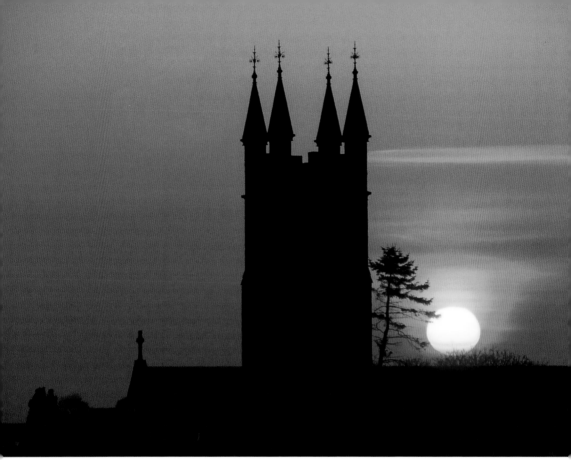

Silhouette of St Malachy's Church, Kilcoo. Granite for its construction came from the Largy quarry under generous terms from the Marquis of Downshire

brought in from afar in a veritable wagon train of farmers' carts to break Annesley's embargo on sourcing local sand from the beach at Newcastle.

Rush's quarry, or to give it its full title, Rush & McCrickard's, was a compact working lying between the more substantial quarries of Ballymagreehan and McCartan's. They used to run an advert: 'If you want to build with the 'rale' thing, a church, a bank, a grotto or a mansion – come to us'. One of the more important commissions here was the statue of St Patrick made in 1932 for Saul.

By extensive advertising and by the undoubted merit of their work, McCartan's made the name of Ballymagreehan granite synonymous with quality. A typical advert from over a century ago would start with the banner 'Castlewellan Granite – selected from 42 competitors to build the base of the Albert Memorial, Hyde Park, London'. Their work was then itemised under the headings of monumental, builders' materials and county work. The firm were justly famous for monumental work and they listed the following in their repertoire; 'headstones, celtic crosses, vaults, tablets, and all kinds of tomb requirements (polished and plain samples) on application; designs submitted. Don't send your orders away, and save money.' Under builders' materials, 'prices given for …ashlar, window and door sills, steps, landings, panels (moulded and

fancy work), coping, etc.' County work entailed supplying kerbing, channelling, road metal and crushed granite for granolithic work. An interesting synopsis of Castlewellan quarries appeared in the paper during October 1906, seven months after the opening of the Ballyroney railway extension to Newcastle.

'Benefiting by the readier means of transportation now available, the local granite industry, or at least that section of it controlled by Mr P.F. McCartan, a man of versatile business genius and capacity, is going ahead. At present he employs over forty men at Ballymagreehan quarry. Orders are being executed for many different parts of the United Kingdom, where the superior quality, the uniformity of colour, and the durability of the granite are readily recognised. Mr McCartan's new manager, a skilful designer possessing long experience in the business, is doing much to advance the reputation of the material, and to commend its more extensive utilisation, not merely for monumental work, but in architecture generally. It is always an advantage when granite is procurable in blocks of large size. Only the other day, for a special contract, a block was dislodged at Ballymagreehan 16' x 12' x 6 feet and weighing 88 tons. As understood, Mr McCartan intends to introduce thoroughly up-to-date appliances at the quarry. Therefore, a greater development of the industry may be expected. It might be accelerated if the GNR Company would provide cranes at Ballyward and Castlewellan stations for heavy loading.'[44]

Detaching large blocks of granite was not uncommon at McCartan's quarry. December 1903 saw the blasting out of a sixty ton block of granite. This block had been special ordered by Messrs S. & T. Hastings, monumental sculptors at Downpatrick, for the great tombstone of Colonel Forde, Seaforde.[45] Sections of this block were taken by McCartan's to make a huge artistic celtic cross for a venerated member of the clan, Fr Eugene McCartan who, on his death, was parish priest of Larne. The celtic cross erected over his grave outside St Mac Nissi's Church, Larne, stands over fifteen feet in height when added to its pedestal. The following description was given of it;

'The cross, which is highly polished, is about 10ft 9ins in length, 3ft 6ins across the arms, and is chastely ornamented with Celtic borderings and devices....Altogether this monument proves the superiority of Irish workmanship, taste and skill, as well as the durability of the Castlewellan granite.'

Fortunately it is not necessary to go to Larne to appreciate the craftsmanship and expertise of McCartan's masons as an almost similar cross standing 10ft 6ins and finished in exactly the same style was erected in St Mary's cemetery, Main Street, Newcastle, in memory of Michael McCartan, J.P. of Arundel Terrace. He was the father of Daniel McCartan one of the moving lights in the adoption of the Towns Improvement Act, which by its formal approval on 27th April 1904 saw Newcastle change from a village to a town.

The delicate tracery design on this celtic cross at the McCartan grave, St Mary's, is a tribute also to the skill of local granite masons

Altnadua and Daniel O'Connell

While researching the granite industry of Ballymagreehan, I got talking to Mr O'Higgins of Altnadua House, the house nearest the quarry where the dark stone it was built from was quarried. The house had been built by earlier generations of the family who had come from Sligo and the former outhouse built from stone from this quarry has family initials and the year carved into a cornerstone. Mr O'Higgins confirmed the local tradition that Daniel O'Connell had stayed at Altnadua House.

O'Connell had been called to the bar in 1798 and had built up an enormous practice. He had likely been on his way to the assizes at Downpatrick when he was obliged to stop over. Not all his visits to the area however were auspicious. One of O'Connell's sons told the story of an escape his father had at Castlewellan a couple of years after founding the Catholic Association to secure emancipation.

'It is well known that my father's life was many times attempted. Some of his escapes were, indeed, little less than miraculous. In one or two instances I heard the particulars either from himself or those who accompanied him. The following occurred either in 1825 or 1826. He was travelling on the Northern circuit to attend a case for which he had been specially retained. He had to change horses at a post town called Castlewellan, County Down, and a plot was laid by which it was arranged that his enemies should pour into the town, get up a riot with the Roman Catholic peasantry, who it was known, intended to meet their future Liberator there, and in the confusion shoot him dead! But a shopkeeper whispered to him as his carriage drew up at the post inn door, 'For God's sake, Mr O'Connell, don't stop; the Orangemen are pouring in. Go on with the horses you have.'

A word to the post-boys, and away went the carriage with the poor jaded beasts lashed to a gallop; but just as they left the town and were descending a steep hill one of the horses fell, breaking part of the harness. My father was inclined to stay in the carriage while his servant returned to town for fresh horses and harness. But this man, who was of a strong and determined character, and (though he rarely spoke directly to him) devotedly attached to

174

his person, for once broke through his habitual reserve, declined to permit my father to remain in the carriage, and insisted that he should get out and proceed on foot. Said he: 'They will do nothing to me, sir. I am only a servant. Take your pistols and go through the wood, or I will leave your service for ever!' My father was obliged to submit, and presently made his way accompanied by a friend, Nicholas Mackey (who, having some hint of the planned attack, had volunteered to share the dangers of the journey), through some plantations which enabled them to avoid the gathering Orangemen, whose signal cries and whistles could be heard on every side. Half an hour later the carriage overtook them, and the servant related how he had been surrounded and closely questioned by armed men, who, misled by his statements, had then returned to the town, believing my father was still there. This faithful retainer died in 1834, but there is no record that he ever again threatened to leave his beloved master.'[46]

Notable Granite Headstones and Memorials

Foremost among the many granite memorials in the area, special mention must be made of the war memorial in front of the former Annesley Arms hotel, presently Newcastle Centre. Carved by Francis Wiles, born in 1881, who exhibited with the Royal Academies of England and Ireland, this sculpture is a particularly

Wiles's sculpture using local stone to commemorate the war dead of the area is a beautiful work of art; 'inspiring music to the eye'

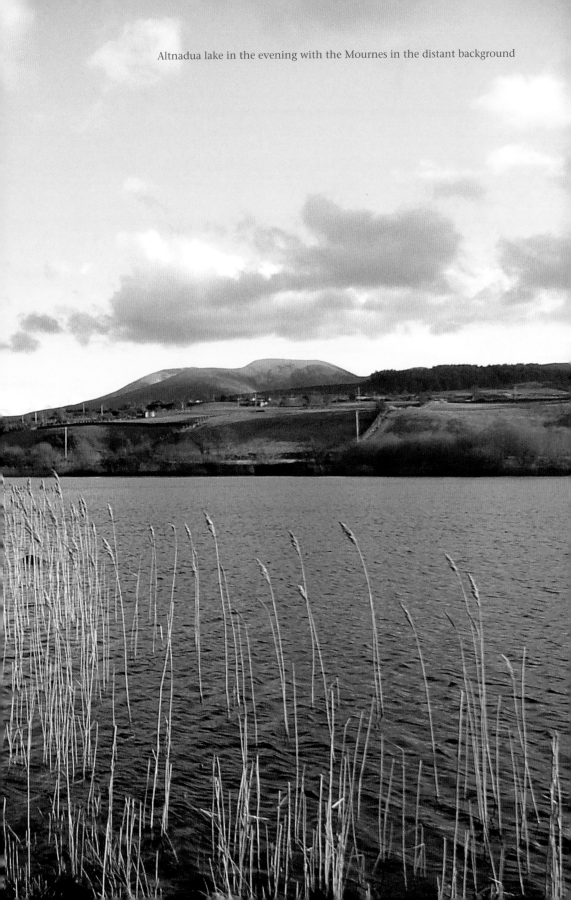

Altnadua lake in the evening with the Mournes in the distant background

beautiful work of art. In 1926 when the memorial was in contemplation the *Down Recorder* wrote encouragingly, 'A memorial ought to speak of the future as well as the past, to be inspiring music to the eye and to the mind.'[47]

I had long been familiar with the many granite crosses over the graves in the bottom southern corner of St Mary's cemetery, Newcastle. Four of our family graves are located in that sector but beyond a cursory inspection over the years I had not taken a really close appreciative look at the nearby crosses until now. Mentioning any grave in a cemetery is quite invidious and there are many in St Mary's and other local cemeteries that I have admired. At another time I hope to tell the important and fascinating histories of more headstones in the area but at the moment we look at the southern bottom corner of St Mary's. The gravestones there are certainly worth a second look to understand the magnificent ability of the local masons. Some sides of the celtic crosses were cut by machine but other parts retain the punch marks where the granite was shaped by hand. There were no power tools in those days. These parts display a particularly fine evenness of surface which was constantly judged by the eye of the mason as he hammered the stone. These are works of remarkable proficiency and superb skill. Some crosses would have taken the mason hundreds of hours painstakingly reducing the hard granite surface to an enviable flatness. McCartans were proud of the work they produced and even sent samples to the industrial exhibition at the great feis held in Newcastle at the end of July 1904. Irish manufacturers sent articles to this feis ranging from homespun tweeds to cycles and reaping machines, crochet and Carrickmacross lace and well as specimens of Bryansford needlework industry. Special praise for the organisation of this feis was given to Martin McCafferkey, the school teacher of Castlewellan and John Henry King of Newcastle. Of the many beautiful memorials in St Mary's cemetery, the grave of the King family is a worthy example of the quality of both stone and skill from Ballymagreehan.

An eminent geologist described Ballymagreehan granite as a rare composition of hornblende, quartz, feldspar and mica which takes a magnificent polish.[48] The grave of Matthew King, J.P., the father of John Henry, is surmounted by a large facsimile of the cross of Cong and is highly polished on all facets. The cross of Cong was an oak processional cross thirty inches high covered in fine gold filigree, silver, copper and bronze. One of the special features of the cross was a large polished piece of rock crystal in the centre under which had been placed a relic of wood believed to be from the True Cross. The relic is since lost but the semi-transparent crystal was once intended to allow it to be viewed. This crystal is beautifully represented on Matthew King's grave by a wondrously polished spherical granite pommel in the centre of the cross. From the roundels to the curved arms and the curved top of the pedestal, the glorious polish of the granite is everywhere and we should remember that putting a polish on a curved surface of granite was infinitely more difficult than a flat one. The glassine finish allows a close examination of the grain of the stone and the grain of this cross is

The chisel punch-marks on this Mourne granite headstone are the work of deceptive skill where the mason's eye finely judged the evenness of the finished surface

The fine grain of Ballymagreehan granite shows up well on this highly polished headstone of the Cross of Cong

exceptionally fine. It is most appropriate that Matthew's grave should be marked with a monument that obviously took such a long time to bring to perfection, for Matthew King, as chairman of Kilkeel rural district council, member of Down council and for many years vice-chairman of Newcastle urban council, gave of his time with boundless generosity to promote the welfare of Newcastle. He headed the list of twenty-one local electors who petitioned the Local Government Board in January 1904 to have the Towns Improvement (Ireland) Act adopted for Newcastle and when this petition was granted he was elected one of the twelve town commissioners. After his death, his wife gifted their home and adjacent garden to the parish of Maghera. The home, formerly known as Maryville, is now the residence of the parish priest and their walled garden at the bottom of Savoy Lane later became the site of the Church of Our Lady of the Assumption. The cross of Cong was hidden for decades during the persecutions of the penal laws before being presented to the Royal Irish Academy in 1839. Today the cross remains in the National Museum of Ireland where it is one of the treasured artefacts on display for visitors. By extension, the granite cross of Cong in St Mary's is one among a number of wonderful crosses here that can worthily be brought to the attention of visitors as treasures in granite commemorating not only the deceased but the skilful accomplishments of local craftsmen.

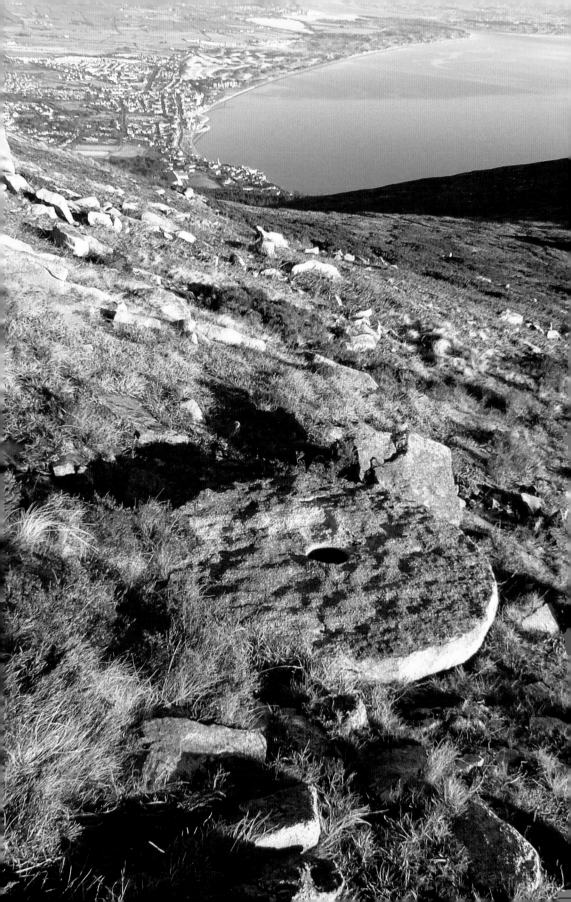

MILLSTONES

The earliest written mention of millstones on the mountain is found in 1740. A book by a London publishing house entitled *The Present State of Great Britain and Ireland* was produced in 1738 but was unfortunately full of mistakes and misrepresentations. The book was supposed to be a truthful description of the manners and customs of the people of the country but the author, in his ignorance, made so many offensive errors that a number of literary gentlemen formed themselves into a society to collect material for a book of their own to correct his fantasies. Letters were sent to the learned and the curious in every county requesting their cooperation. To give them an idea of what was being sought a rough sketch of county Down was at once published. The labours of the society unfortunately did not succeed as well as wished. There is every reason to believe that the eminent physician, Sir Hans Sloan, was deeply interested in the undertaking. It is the likely preference of Sir Hans for the county of his birth that brought about county Down being given the first place in the general survey. One of the very few remaining copies of that rough but truthful sketch of this county was found in King's Inns Library, Dublin, in 1874 by Joseph Lawrence and copied to the Down Recorder. The part relevant to Newcastle and the millstones reads:

'The highest hills in the country are the mountains of Mourne, the base of which terminates on the sea shore; they run up to a great height. Those who have measured them say that Slieve Donagh is three miles in gradual ascent, and half-a-mile perpendicular; they are reckoned among the highest in the Kingdom; visible at a great distance and are useful landmarks for sea-faring men on this and neighbouring coasts. They afford variety of plants and many springs of water; great numbers of cattle graze upon them in Summer time, (being commons to the county); in one above Newcastle, are quarried good mill-stones; in another, called the Diamond-mount, are found crystals, but mostly of a smoky colour.'[1]

The *Bró*, or hand quern, had long been used in Ireland for the grinding and preparation of meal. Irish tradition attributes their first introduction to Cormac Mac Airt, who is said to have lived in the second century.[2] The repetitive weary work of turning the hand mill was usually the job of slaves or women. The bigger the stone the more laborious the task of milling and stones over 55cm in diameter would have been too unwieldy to operate as hand rotary querns and are regarded as millstones. The grain to be milled was fed into the space between the upper and lower stones through a central hole in the upper stone (nowadays this is referred to as the 'eye'), and was ground between the moving upper stone and the

The 'biscuit millstone', so named on account its flat and regular profile being easily noticed coming up the hill. It is to be found on the lower slopes of Slieve Donard across from Millstone Mountain

Close-up of the *comla* or door of the millstone

stationary lower stone. At least four of the stones round Millstone mountain, the Head of the Hill, and the flank of Slieve Donard, have the central hole already bored in them. In Irish this was known as the *comla* or door, a hole in the upper stone through which the corn was admitted from the hopper. I have measured the 'door' of one millstone at 11½ inches in depth though doubtlessly this would have been much reduced in the final finishing of the stone.

Superstitious practices may well have attached themselves to the making of this part of the millstone. Holed stones were invested with aphrodisiac powers. Couples, for instance, used to signify their engagement by clasping hands through the hole of the Hole Stone at Doagh, Co Antrim. In country homes, hand querns had to be dismantled at night as well as the band taken off the spinning wheel to stop the fairies having the use of them. The Norman chronicler, Giraldus Cambrensis, noted the mill of St Lucherinus at Ossory which would not work on Sundays and never ground any corn which had been obtained by thieving or pillage.[3] Certainly the stonemen on the hillside would have been wary of disturbing the little people. Work on many stones was abandoned when flaws subsequently came to light and the hairline cracks on some stones are readily seen. So many blanks for millstones, however, still lie around the hillside that one cannot help wondering if they were deserted because the workers felt the stone 'had lost its luck'. A clue may reside in the Irish *comla breac*. Literally this means 'the speckled door' but the actual meaning is 'the magic door of fairy dwellings among the rocks'. The sunshine on the hill would have ensured there would have been all too many places of shadow amid the stones and heather; too many speckled doors. Perhaps a hand was clipped with a hammer or a sharp splinter of granite stung the face, but that might have been enough to walk away from a stone on which much effort had already been expended. There would be no point in trying to open a *comla* in a stone when the little people had shown their displeasure at being disturbed. One stone in particular has made me wonder. It is a completed millstone lying in the boggy saddle between Millstone and Donard. Rather it *was* a completed millstone for it broke clean across the middle. But only half of the stone is to be found. We may wonder where the other half has gone. Why bother removing it after it was destroyed? I hardly see the broken stone being re-cut. Was one half taken away to spite the little folk; perhaps, one half was left to keep them happy and stop them

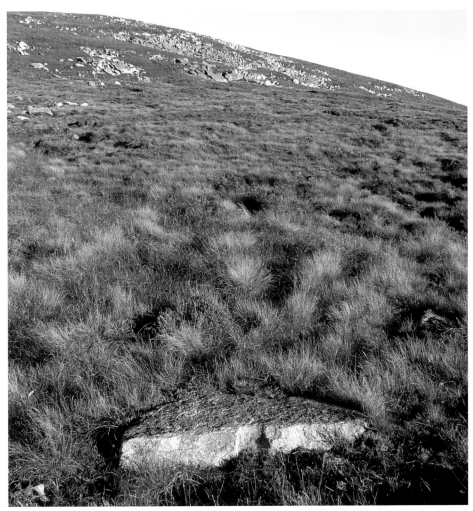

The other half of the broken millstone is not to be found

wrecking havoc on other stones? Your guess is as good as mine. The half millstone lies there mute.

Blaming the fairies for all the unfinished work around Millstone mountain was always going to be a light-hearted and fanciful explanation even though their existence a couple of centuries ago was taken as an undoubted fact. The more one walks around the hill the greater one's appreciation of the extent of the granite workings. I thought how similar these workings would be to the case of households exercising tubary rights at a bog and how each family would have their own bog face from which to cut their turf, only here on Millstone the families were cutting granite. One can trace the process of making a millstone from start to finish from the various stages of unfinished work. Indeed, unfinished

183

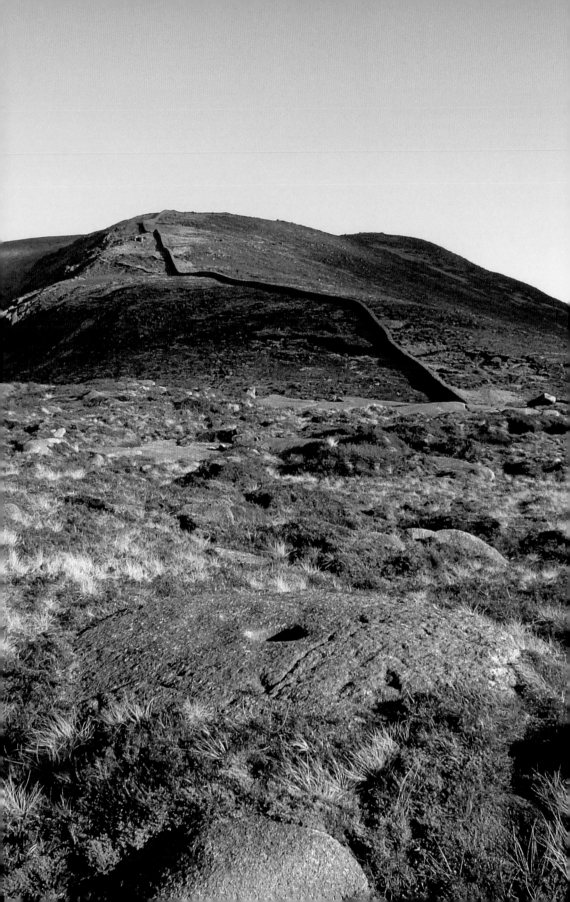

work is to be found right across the mountain. The most poignant of such works are a number of huge blanks of granite slabs already roughly dressed into a circle, some even dressed to a rough level on one side and then turned over to rest on a plinth of a convenient height in preparation for the other side to be finished. The faces of the stones show such numerous punch marks from the chisels there is no denying an enormous effort has already been invested in them yet they lie there uncompleted.

It was the story of a hurricane in January of 1904 that prompted a likelier reason for so much unfinished work. The answer suggested itself in the account of a lifeboat rescue detailed as follows:

> 'On Thursday evening the coastguards at Annalong telephoned to Newcastle that two fishing skiffs, returning from the fishing ground some miles distant, had their sails blown away and were fast drifting to sea, being unable to make headway against the off-shore hurricane. The Newcastle lifeboat signals were fired and the crew hurried from the quarries and other works to man the boat. Owing to the state of the tide, there was considerable difficulty in launching, the crew having to wade out to their necks to get the boat afloat in the surf. Once started, it ran fast before the gale for the channel. It came to the rescue of the skiffs just in the nick of time, and by floating barrels established a connexion and towed them to shelter at Annalong.'[4]

The significant phrase was 'the crew hurried from the quarries'. The fishermen of Newcastle had long worked at other occupations to help make ends meet including working the stone on the mountain[5]. Demand for millstones would have been falling in the early years of the nineteenth century due to new techniques of flour milling introduced with the industrial revolution. It is unlikely there would have been any production of millstones after John Lynn opened his quarry above the harbour in 1824. The steady reliable work at Lynn's quarry would have been more attractive than depending on declining demand for millstones. I suspect, however, that the production of millstones was dealt a final and fatal blow on 10th January 1814. That was the tragic date when a dreadful storm accompanied by a heavy snow struck the local fishing fleet at sea. Along the coast from Newcastle to Annalong to Kilkeel, forty fishermen were drowned, thirteen of them from Newcastle and twenty-seven from Annalong.[6] As I look at the uncompleted work around Millstone mountain I imagine that the men did not return to finish what they had started because they had died suddenly at sea.

Although the earliest *written* mention of the making of millstones on the mountain is found in 1740, we now know that millstones were cut either here or in the vicinity a thousand years before that again. In April 1999, a team of archaeologists had undertaken a small scale excavation at what was thought of as a fishpond at Nendrum monastery, when the discovery of a shard of pottery and a fragment of granite millstone just when their work was finishing changed

Although this is often referred to as the Slievenaglogh millstone it is found on Slieve Corragh, closer to half-way between Slievenaglogh and Commedagh where you can look down the Ben Crom reservoir valley

Draught horses harnessed to wooden slipes, such as these along the granite trail, would have hauled the millstones down the mountain

everything. What originally had been planned as a two week dig ended up as an investigation of many months spread over three years. The team had discovered two medieval tide mills which the monks had used to grind the corn for the monastic community. The mills worked by impounding water at high tide behind a dam on the foreshore. At low tide the impounded water was released to turn the waterwheel and milling could commence. The mills had the distinction of being not only the earliest mills in Ireland but also the earliest example of a tide mill anywhere in the world. Tree ring analysis established the date of the second mill at 789AD and there at the bottom of the mill in the soft mud of Strangford Lough were two millstones of Mourne granite.[7]

Millstones were quarried in various places in the Mournes. Walkers on Slieve Corragh will be familiar with the abandoned millstone that lies on its slopes. The west side of Pigeon Rock Mountain had a spot known as 'Millstone Hollow'[8]. It is the upper slope of Millstone mountain and the eastern flank of Donard however that retain such abundant evidence of millstone production. The likely source for the Nendrum millstones has seen the quarries in the upper reaches of the Bloody Bridge river valley proposed as their source. The workings on the slopes of Millstone mountain had not hitherto been substantially documented so it was not surprising that this site may not have received fuller consideration as the

source of the Nendrum millstones. As a source it would seem to have been dismissed on the grounds of being too difficult of access although patently this problem had certainly been overcome by the men of Newcastle. The millstones here have not, as was suggested, been produced from glacial erratic boulders but rather direct from outcropping granite where the spacing of the natural fractures in the rock allowed for the detachment of quite large leaves of granite ideal for millstone production. The granite of Millstone mountain is of the fine grained G2 variety (the top of Slieve Donard being G1) and is comparable with the Nendrum granite wheels. Thus the slopes of Millstone mountain remain a very strong contender for the honour of having provided Nendrum's stones over 1,200 years ago.[9]

The near finished millstones would have been levered onto wooden slipes and dragged by draught horses down the mountain. One horse would have been harnessed to the rear of the slipe to act as a brake on the steep gradient. It is difficult to imagine how the steep slope was safely managed. After two hundred years there is no discernable track that might have been followed down to the harbour area from the upper part of Millstone, although having looked at the mountain side during the winter when vegetation has died back and declivities are revealed, there are parts that seem perfect for the purpose. Such are the scope of the workings on the hill that many journeys were obviously made. Doubtlessly men experienced in the movement of heavy stone and skilled in managing two well trained horses would have made the task look deceptively easy. The nearest turf cuttings for the people of Newcastle were on the saddle between Millstone and the slopes of Donard. The feet of man and beast would have caused a well defined path up and down the mountain for the transportation alone of this important fuel.

Amy's River

The presence of draught horses on the mountain influenced the naming of the river which flows between Millstone and Thomas mountain. The river cut a small gorge for itself as it quickly flowed down the steep incline on its way to the woods of Donard demesne until it emerged parallel with that part of King Street known as Kennedy's Hill. The river flows past the church of Ireland rectory and then under the main road to Kilkeel at a place formerly referred to as Condy's Bridge, after a Mrs Condy who lived at the end of Glenada Terrace. This river, seldom cited by name on maps, is known locally as Amy's River. It gets a mention in an 1884 tourist book which in the course of describing the demesne of Donard Lodge states:

> 'Another mountain stream, called Amy's River, comes down through the demesne of Donard Lodge, and is crossed by a bridge just outside the gate. It rises in the glen above the granite quarries, and falls into the sea just below the new Spa Well.'[10]

The steep banks of the river earned it the Irish name *Amaí* after their similarity to the upright bars on top of a horse's harness

The river also gets a mention in *The Quay and the Rock* though by now the 'new spa well' has gone.

> 'A well once stood in the grounds of the Rectory. Here an old lady sold water from a tin mug and bottles at each one old penny each. The water was advertised as a tonic and believed to have high iron content. The well was removed after the damage caused to the garden during the floods of 1968. A huge boulder was washed down Amy's River and surfaced on the lawn.'[11]

The river gets its name from the bars on the top of a horse's harness. Amy's River is derived from the Irish *Amaí*, (pronounced Am–ee), meaning the hames or curved bars on the top of the harness. This is a metaphorical description of the profile of the river at the upper course near the millstone workings where the fast flowing water has cut a deep cross-section similar to the gap between the two curved bars of a draughthorse's collar.

The Stages of Making a Millstone

Although there is no hole in the ground like a normal quarry, the upper reaches of Millstone mountain were once a scene of remarkable activity exclusively making millstones. It really is an open air museum. Virtually every surface stone near Amy's river has been manhandled at one time or another. This has been a place of great striving and hard work. Centuries ago every day started with the steep uphill climb followed by such wrestling and breaking of stone that a convict on hard labour in Downpatrick gaol might have counted himself lucky by comparison. For walkers on the slope of Millstone mountain there is a most enjoyable excitement in searching around and wondering what new evidence of millstone production will lie a bit further ahead. Toil tainted stones a traveller will find a plenty. The evidence of effort is so abundant that when we remember this was done in the days before power tools or any mechanisation, one's admiration and respect for those responsible for such labours grows. I would like to let the photographs of the stones themselves speak about the stages of producing a millstone. Some of the photographs include the slopes of Slieve Donard below the southern end of the Thomas plateau known formerly as 'the top of the hill', and also further round the flank of Slieve Donard looking down the Glen Fofanny river valley.

Describing the evolution of a millstone from the living rock is not an exact exercise as the workers had various styles or methods of producing the end result. Some started by detaching large leaves of granite and then shaped and dressed them. Other workers scribed the outline of the desired shape on a slab and sought to release from the rock a blank of stone close to the finished size. The closer the blank was to the size required, the less time was needed for final dressing where the chisel of the craftsman moved continuously over the surface of the rock chipping off all excess to make a level face. Sometimes holes would be prepared for wedges to split a rock along a determined line. At other times a weakness in the rock was enlarged with a gouged line without any evidence of wedges. Despite a certain degree of overlap, I would depict the process of creating a millstone through various stages.

1. The natural rock itself and an overview of the workings.
2. Scribing or chipping out the outline of the stone required.
3. Holes for wedges.
4. The 'teeth-marks' left by the wedges.
5. Splitting the rock.
6. Rough blanks and hexagons.
7. 'Bites' left in the rock.
8. Dressing the stones.
9. Finished Millstones

The natural rock and an overview of the workings

The mountain surface was prepared by the ice sheets. During the glaciation period, the ice mass stripped, scoured and scored its way over the hill. The loose, crumbly, weathered stone at the top was cleared away exposing the gently inclined face of rock from which slabs could be easily detached.

Horizontal planes allowed the granite-men to split out large leaves of rock of an ideal thickness

A slab of natural rock on the lower slopes of Donard at the head of Glen Fofanny valley showing where a leaf of granite has been stepped out

190

Fragments of industry. An overview of part of the upper slope of Millstone mountain where every stone at some time or other has been man-handled. Note the hexagonal blank for a millstone near the centre of the photograph and a number of rough round blanks to the right of the picture

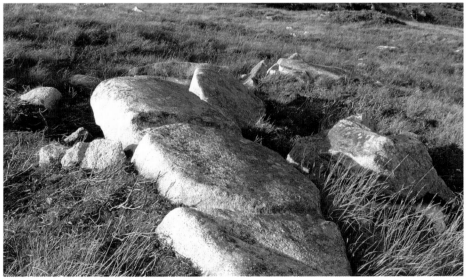

Another small millstone is almost released from the rock. This discovery was the lowest down the hillside

Here a circle has been scribed round the centre punch
and the millstone is being chipped straight out of the rock

Scribing or chipping out the outline

The important first step is to decide on the size of stone needed and then to mark the centre. At least six punches were made on this slab with the centre being slightly changed each time but the measurements must not have worked out so the slab was left

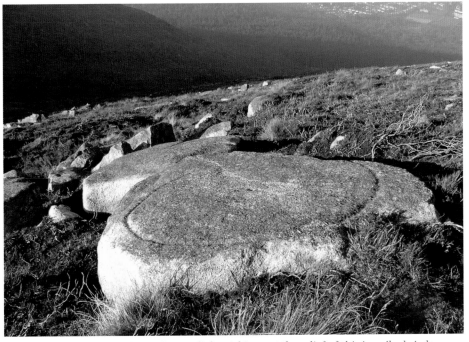

Only for the low evening December sunlight picking out the relief of this inscribed circle, I doubt I would have found it

Holes for Wedges

Estyn Evans described the old method of splitting granite by using wedges. The holes were cut with a double-ended handpick and measured three inches long, two inches deep, two inches wide and three or four inches apart. It was very laborious and usually resulted in rough fractures which had to be trimmed before dressing the stone. The wedge method was superseded in Mourne soon after the middle of the nineteenth century by the use of plug and feathers which was much faster. The fact that none of the stones on the upper reaches of Millstone mountain show the evidence of the smaller round holes indicative of plug and feather splitting, show that work on this part of the mountain had certainly finished by the 1860s and probably with the opening of Lynn's quarry lower down.

Numerous triangles of granite spoil on the hillside show that the removal of this section of stone was a favourite way of preparing the larger part of the slab

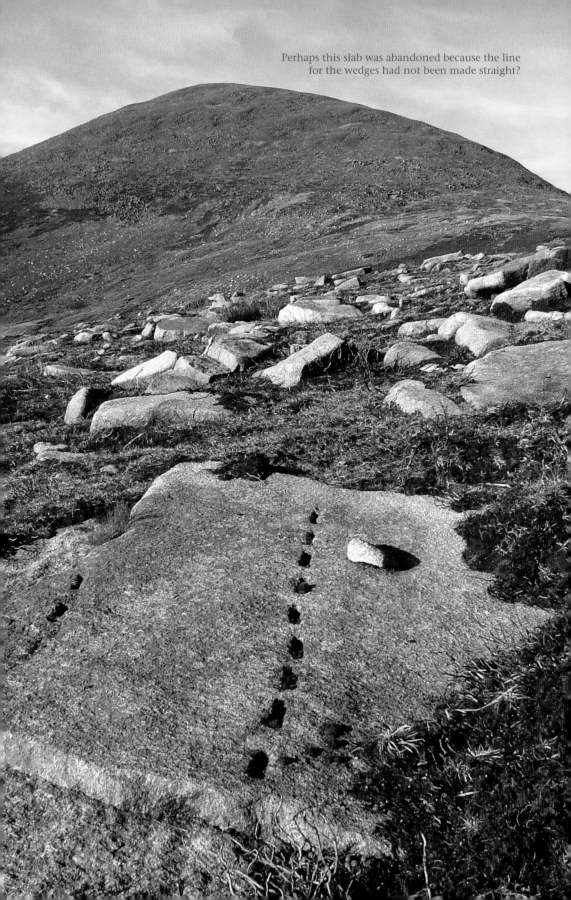

Perhaps this slab was abandoned because the line
for the wedges had not been made straight?

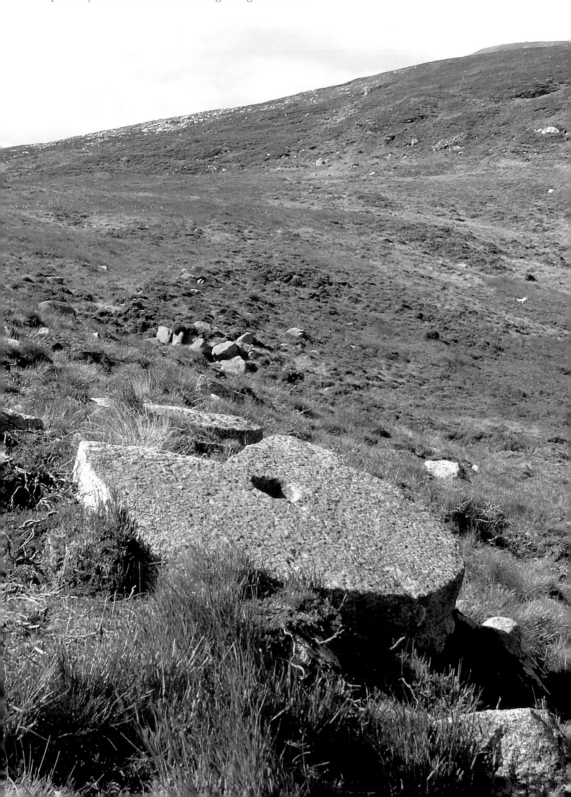

The Pie Piece Millstone. It must have been very frustrating for the men to have worked hard on a stone only for it to break at the very last. A tiny imperceptible flaw must have opened up, probably when the stone was being brought downhill

Teeth marks left by the Wedges

The sheer number of stones on the hillside which bear the scar of wedges, speaks of the scale of the work.

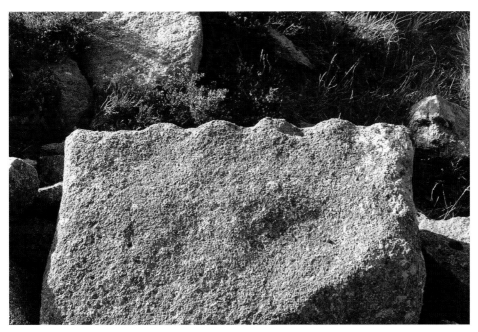

The rough serrated edge of a stone cut by the older method of wedges compared with the stone at the head of the granite trail, seen here below, which was cut by plug & feathers, introduced to the district shortly after 1850

Splitting the Rock

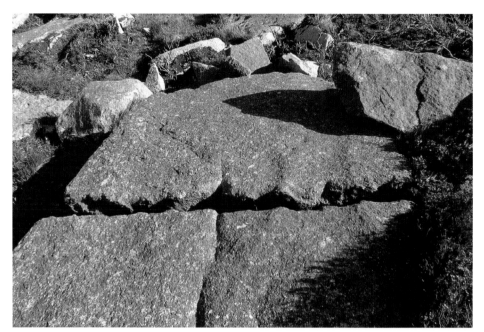

The marks of the old wedges show up on this slab. They were bigger and longer than the later iron plug and feathers. Quite thick stone could be split by the wedges although preparing the holes to receive them would have taken longer

This stone on Donard slopes opposite Millstone mountain, has been split almost into a blank shape for a millstone. Knocking off excess granite was always a tedious task, so the closer a stone matched the final shape the better

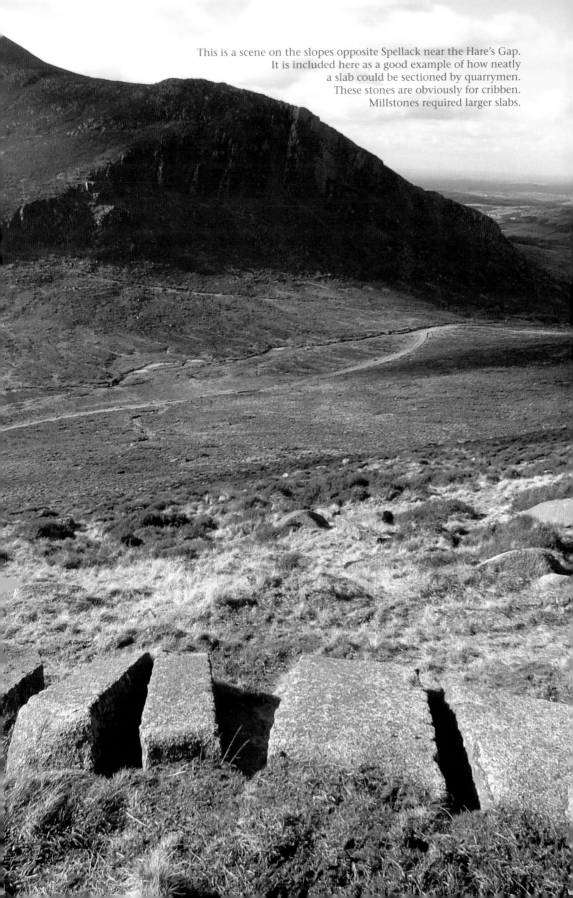

This is a scene on the slopes opposite Spellack near the Hare's Gap.
It is included here as a good example of how neatly
a slab could be sectioned by quarrymen.
These stones are obviously for cribben.
Millstones required larger slabs.

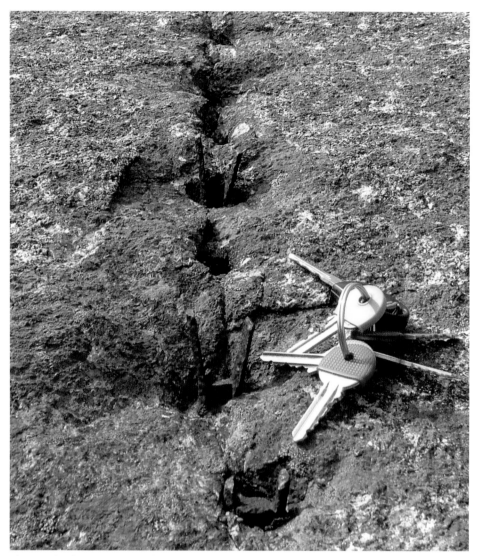

The iron feathers still project from this rock in the lower reaches of Glen Fofanny valley below Crossone. It was a huge stone about four meters across and had been successfully split once. However when attempts were made to further split the stone it proved impossible and the iron plugs and feathers had to be left in situ. This was a rare victory for the granite

Rough Blanks

The rough blank outlines for Millstones are to be found scattered in many places. It is one of the joys of discovery to find them as you walk around. The following photographs are just a very tiny sample, an aperitif if you like, as it would not be possible to include all the circular stones found in various stages of preparation.

These two blanks are to be found in the bog between Millstone and Thomas

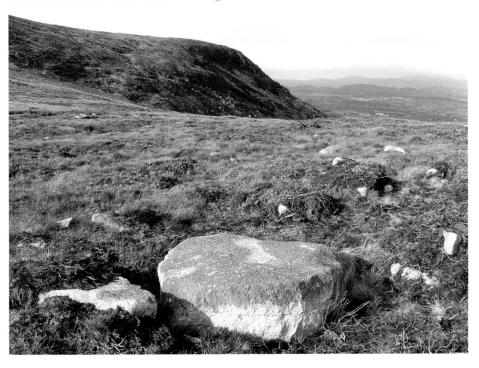

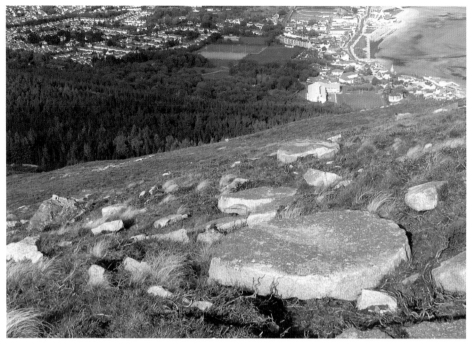

This large blank has been positioned for final dressing. Two other large blanks can be seen in the background further down the slope

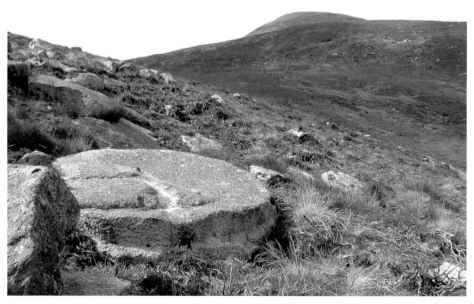

It was perhaps for ease of handling on the mountain or to help secure the stone when it was being moved downhill, but a number of blanks can be found with a projecting lump of stone still left on the dressed surface. Having served their purpose these lumps would have been trimmed off at the foot of the hill

This blank for a millstone can be found on the summit of Millstone mountain on the town side of the first cairn. A very neat circular stone has been popped from the rock and then left lying, unused. It is the same stone that features on the cover of the book only from a different angle

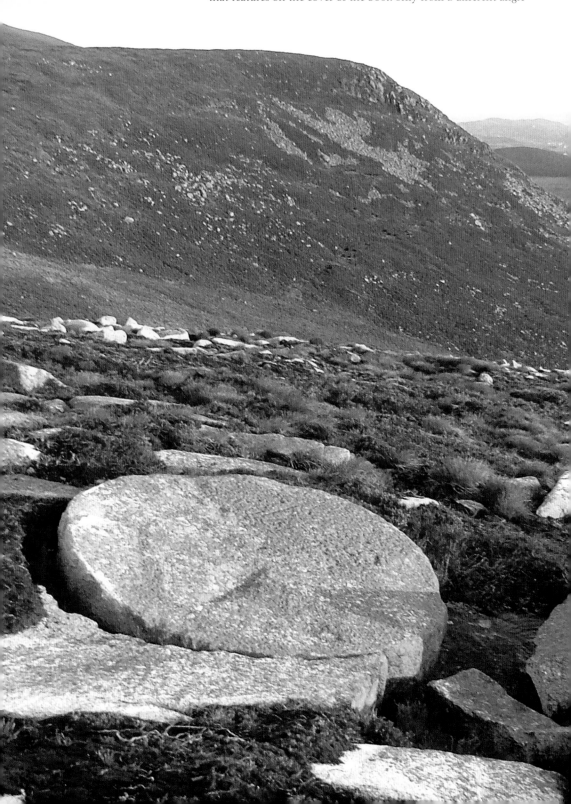

Nice examples of where blanks for millstones have been extracted from the rock

This is a special stone for me as it was the one that started my searches on Millstone Mountain. Lying as it does alongside Amy's river, it was on my path en route to the top of Slieve Donard. Its hexagonal shape attracted my attention when I stopped for a drink of water. I never made it to the top of Donard that day but enjoyed a most wonderful time of discovery on Millstone slopes instead. Note the fine crack on the left of the stone which opened up after it had been extracted making it useless to work any further on it

Bites from the Rocks

At least four stones here show the evidence of a millstone having been bitten out

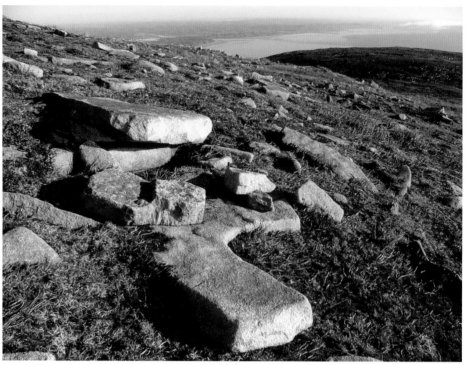

Not only have we the 'bite' mark where a millstone was extracted, but this is also a place to dress a millstone by wedging it under the overhanging rock and putting it on top of the plinth stones. This location is on the slopes of Donard

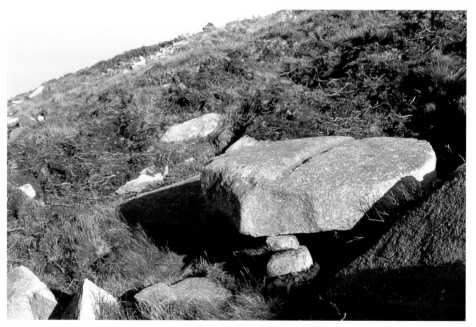

While other stones have slipped from their pedestals over the centuries, this one remains delicately balanced on its two supports in readiness for dressing

Some of the millstones being dressed lend themselves as very suitable tables for a picnic with incomparable views over the town and County Down

Dressing the Stones

To make transportation of the millstones down the mountain easier, the stones received a near final dressing on the mountain. All extraneous matter was chipped away and the milling surface almost completed. The dressing stations are scattered across the mountain, almost as if each family had their own particular quarter. The stones being worked upon are easily noticed as frequently they are propped up on stone plinths to make work on them easier. I found one blank being worked on at the back of Millstone that had slipped off the supports but many others have been left despite a lot of work already expended upon them. The stones remain almost as if the workers had only stopped momentarily for a cup of tea. The case of the ship *Mary Celeste* comes to mind. The dressing places are often in a slight hollow on the hillside; this is about the only concession to a bit of shelter the stonemen got.

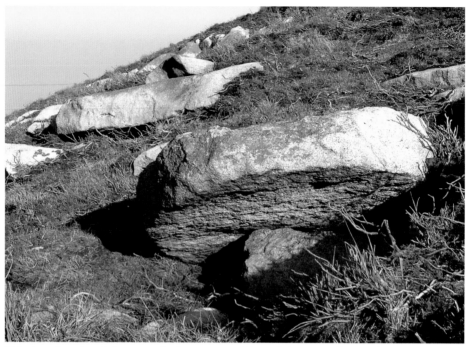

This stone has already been roughed out on one side and then turned over. The process would be repeated until the stone had a remarkably flat surface

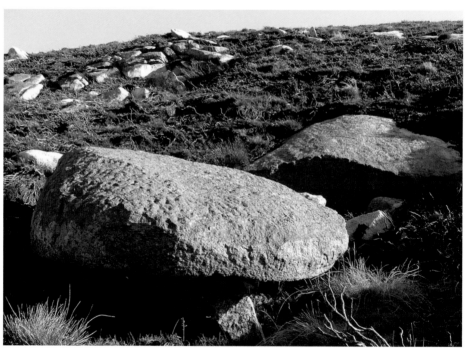

The nibbling chisel has clearly been at work here. The importance of this stone lies in showing just how much work would have been involved in chipping away excess granite before arriving at the final shape of the millstone

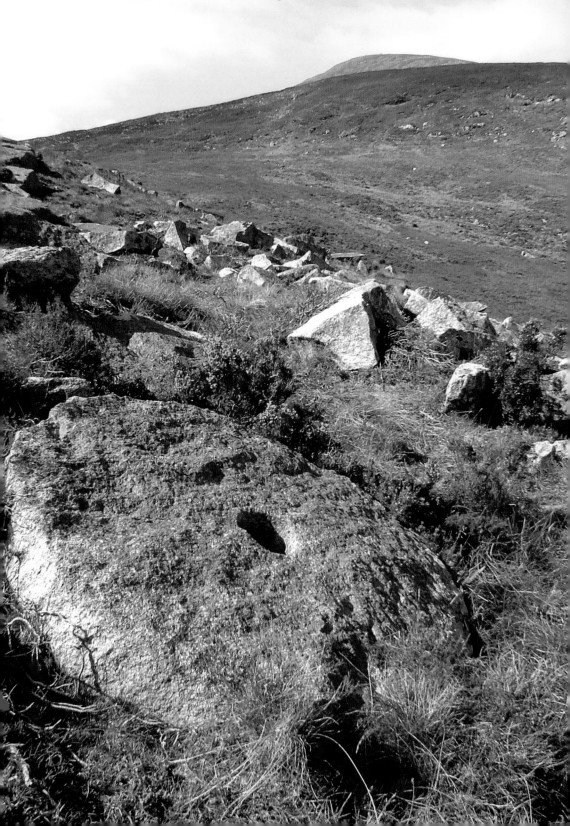

This stone would have needed a final surface dressing to be finished. It is to be found near the 'Pie' millstone. The tip of Slieve Donard can be seen in the background

THE SPA

The image of Newcastle being a healthy place was established by Walter Harris as far back as 1744. Newcastle, he said, 'is remarkable for health and old age, of which many instances might be given.'[1] While he did not list Newcastle at that time among the chalybeate, or iron bearing, spas of the county, he certainly made up for it by extolling the medicinal virtues of goat's whey. The whey was believed to be impregnated with the medicinal qualities of the herbs eaten by the goats on the mountains. Patients were recommended to take from one to nine pints a morning during springtime. It was no wonder that a goat in those days yielded more profit to its owner than a milch-cow.

The man who really highlighted Newcastle as a health resort was a retired doctor, Alexander Knox. A severe illness had required him to leave his position as physician and surgeon at Ballycastle dispensary and fever hospital. When his own doctor prescribed a tour of the continent for the good of Knox's health, Knox was horrified and looked on it as 'banishment'. He prevailed on his doctor to substitute a tour of Ireland instead. This tour saw him visiting every important bathing place in Ireland and resulted in 1845 in his very influential book, *Irish Watering Places, their climate, scenery and accommodations*. In the book Knox twinned Newcastle with another seaside spa town in England, namely Scarborough, and the association proved so advantageous that even a hundred years later Newcastle urban council was using Knox's description to promote the town. Hardly two pages in *Irish Watering Places* was devoted to Newcastle but Knox's description would be echoed for decades in the local press and was surely the most successful endorsement of the town in the Victorian era. The significant description started thus:

'Whether we look to the extent and variety of its accommodation, the numbers that resort to it, its spacious open bay, and firm sloping sandy beach, or its magnificent scenery of mountain, wood, and water, Newcastle may be fairly termed the "Irish Scarborough, or Queen of Northern Bathing places".
...It is situated on the bay of Dundrum, which is open to the eastward, having within a few years sprung up from a fishing hamlet to a cheerful and handsome little town, consisting of ranges of white houses, and vine-trellised cottages, lying in triple row along the base of Slieve Donard, which rises sheer over the level of the sea mark, to a height of nearly 2800 feet. Amongst the delightful environs of Newcastle, we many include the quiet English looking village of Bryansford, Dundrum with its ivy-clad castle now in ruins, and the

Two visitors here enjoy the tranquillity and beauty of Tollymore Forest Park. Decades ago visitors came to drink the iron rich waters of a chalybeate spring above Donard Lodge, to admire the beauty of the Annesley and Roden estates

grand and picturesque scenery of Tullamore Park. The invalid whose case is likely to be benefitted by clear, pure, bracing sea and mountain air, can choose no more appropriate summer residence than this; whilst Donard Lodge and Tullamore Park open to strangers by the courtesy of their noble proprietors, afford an endless variety of interesting walks, rides and drives.

Newcastle abounds in every description of furnished lodgings, and houses may be had varying in price from ten shillings to five pounds per week. There is every convenience for the enjoyment of hot, cold, and shower baths, with an abundant supply of fish, and provisions of all kinds at a moderate rate. A very good light chalybeate water, which was brought under my notice through the politeness of Lady Annesley, is situated on the slope of Slieve Donard, which may be reached by a bracing walk, or by a carriage way newly constructed, when there is anything to deter from up hill walking.'[2]

Dundrum too was worthy of an encouraging note being described as 'a quiet healthful little bathing place, about two miles from Newcastle, on the property of the Marquis of Downshire. There is a very good hotel, erected by the noble proprietor of the place, with suitable conveniences for hot, cold, and shower baths.'

Dr Knox may have had great success in throwing his 'health snowball' but it was Lady Annesley who had made it. Not only had she brought the medicinal waters in her demesne to his attention but the construction of the access carriageway to the spa that others might benefit was typical of her many charitable acts. A number of factors influenced the construction of the carriageway. 'Taking the waters' was a frequent recommendation of doctors at that time and would more readily be given when one was in decidedly poor health. In 1838, Lady Annesley's brother, Rev John Robert Moore, had interrupted a visit to Dublin to return to Castlewellan with two doctors due to Lady Annesley's 'alarming indisposition'.[3] The chalybeate waters in her demesne were well up the mountain side, so if Lady Annesley needed to take the waters for her own health or wanted her children to do so, then easier access was required. When Dr Hunter retired from the Castlewellan dispensary in November 1840 after eighteen years service, the Marquis of Downshire was informed that Lady Annesley desired the nomination of a person 'capable of attending to the rich as well as the poor'.[4] Such egalitarian sentiments were not commonly found among the aristocracy but Lady Annesley had long been known for her attentive concern for the poor. Making a road to the spa opened its medicinal benefits to all humanity. The road up the mountain enabled the frail and feeble poor to be brought to the waters for whatever easement it might give them. The road certainly benefitted the demesne but it was the generous sharing of the beauty of the demesne that particularly brought the noble lady great happiness. When Lady Annesley's death was announced to St John's select vestry in April 1891 by the rector Rev John Seymour, he was rightly able to say:

'She rejoiced in giving pleasure to the numerous visitors who availed themselves of the privilege of access to her beautiful demesne, which was freely thrown open to all...'[5]

The demesne road had the dual purpose of opening up the granite quarries as well as the spa. Lady Annesley, however, would have seen it as an opportunity to give work to her needy tenants. Dr Knox described the spa road in 1845 as 'a carriage way newly constructed'. This was only two years after the great fishing disaster of Friday 13th January 1843 when so many heads of households had drowned. At that time Lady Annesley supported the substantial number of forty-four workers in her demesne and the construction of the road could be regarded perhaps more realistically as a relief project.[6] Certainly, the commissioning of works as a way of providing relief from distress was a practice Lady Annesley continued to follow in the years of the great famine.[7]

I find it rather amazing that a feature that was so important to the promotion and economy of Newcastle for over six decades should, inside a century, disappear so utterly from the common recollection. The spa was certainly important enough to be literally put on the map. There were plenty of references to Newcastle's chalybeate waters in the early eulogies of the town but beyond a dot on the mountain, identified as the 'spa house' on the ordnance map, no-one was able to

Frogspawn in the orange spa water

give guidance on where the spa was to be found. The eventual discovery of our famous spa, after numerous fruitless walks through the forest, came from an unexpected recollection of an off-hand remark made by my father during a long forgotten childhood walk. 'That's where they turned their carriages', he had said.

To find the former famous medicinal spa, climb up along the Glen River to the second bridge.[8] On the quarry or east side of the bridge is to be found the distinctive widening of the otherwise quite narrow road which marks where coachmen or jarveys bringing fares to the spa were able to turn their horses and rigs. Walk on another few tens of metres and look carefully uphill for the signs of the tumbled remains back among the trees. A large beech tree crashed down over the spa house some years just past but the house of ablutions was already derelict long before that. The stone structures of the past are now just a collection of moss covered boulders. The spa spring had been a good steady trickle in the past but accumulated falling leaves and spreading tree roots have since very successfully masked it. The actual site of the spring is now more easily found by looking for the mucky patch on the forest floor a few metres up from the roadway and by paying attention to the colour of the water in the ditch. I recall with amusement how my finding of the spa waters some years ago was confirmed by the iron staining the water in the drainage ditch at the side of the road a strong orange colour. There was plenty of water in the ditch at the time but a frog had pointedly chosen the iron rich orange water in preference to the clear water nearby in which to lay its frogspawn. An iron bearing spa is called chalybeate. It is frequently mentioned that 'spa' is derived from a Roman acronym for *salus per aquam*, meaning, health through water. This is more likely to be a twentieth century invention but it still neatly captures the reason for taking the waters two or three times a day. The amphibian, by instinct or otherwise, knew that the water here was reliable and would not dry out. Nature knows best.

Lady Annesley, who was a life-long collector for charity, had a sign and a collection box placed beside the spa waters.[9] The import of the sign was:

> If here the waters you partake
> a penny please for Jesus' sake.

After her death in 1891, her son gave instructions that the funds from the missionary box in Donard Lodge demesne were to be handed to Rev J.H. Seymour, incumbent of St John's Church, to be applied 'to religious purposes'.[10]

The year 1861 saw a double fillip for the mountain spa. Firstly, *McComb's guide to Belfast, the Giant's Causeway and adjoining districts of the Counties of Antrim and Down* was published for the purposes of 'disclosing and enhancing the attractions of our highly-favoured province to persons of taste and travelling habits'. Secondly, an influential letter was submitted to the *Medical Times and Gazette* by Mr Alfred Eccles who confidently recommended Newcastle to his professional brethren.

Local historian, Eamon McMullan, looks at the muddy source of the spa water as it was in April 2006. He holds part of a broken stone cup used to take the spa waters and which was found in the mud

McComb's guide to Belfast and adjoining districts did great service to counties Antrim and Down. William McComb painted a most interesting picture and Newcastle was now quite the fashionable place to be seen in. It was such positive observations that encouraged W.R. Anketell, J.P., chairman of the Belfast and County Down Railway, to strongly push for the extension of the railway from Downpatrick to Newcastle.[11] Some of the pertinent words from McComb's guide were as follows;

'Newcastle is very neatly built, and every year handsome buildings for the accommodation of sea-bathers are being added. The beach is a hard sandy bottom, and the sea-water is clear and pure, and suited in graduation of depth to the capacities and tastes of all classes of bathers. The village is well sheltered by the mountain barrier in the rear from the South-Westerly winds, which prevail about eight months in the year. These recommendations, in conjunction with the varied and enchanting scenery of the vicinity, have rendered Newcastle the most aristocratic and generally patronised watering place on the Down coast. Dr Knox, author of that charming book, '*The Irish Watering Places*', has appropriately pronounced it 'the queen of Northern bathing-places', and so high an authority is not likely to be disputed.

The Glen river in spate as seen from the first bridge near the former Annesley residence. Such spectacles delighted Victorian visitors to the grounds of the estate

About half-a-mile from Newcastle, on the slope of the mountain, and nearly in a line above Earl Annesley's marine residence, is the *Spa House*. The mineral spring which exists here is chalybeate in its properties, and its waters have been used with much benefit by invalids to whose cases their curative qualities are suited. The scenery around the spot is diversified and pleasing, its effect being heightened by a series of cascades on a rapid brook which has its source far up in the mountain.'[12]

Locally it was the letter submitted to the *Medical Times and Gazette* by Mr Alfred Eccles that saw developments with the spa. The writer lived in a spa town himself, Tonbridge Wells, and had personally come to Ireland on holiday, visiting Bray and Newcastle, seeking more information on places of resort for invalids. He urged the medical profession in England to think of the convenience of patients and the benefits of climate when considering where to send them for the good of their health. Writing of Donard Lodge and the spa, he said:

'Behind the town on the mountain side, is Donard Lodge, with its pine woods, waterfalls and the extensive grounds which are thrown open to the public with the greatest liberality by the Countess Annesley. The arbutus, the

Portugal and common laurel are large trees and fuchsias and rhododendrons are also more trees than shrubs. In the grounds, too, is a fine chalybeate spring, much like that here (Tonbridge Wells). Lady Annesley has had it covered with granite as a fountain, with drinking cups attached; but, as it is too far up the mountain for an invalid to walk, a carriage drive has been made to it and especially as chalybeate waters generally require to be taken twice a day, I think, by means of pipes, it should be brought down to the excellent baths in the town, to which a pump-room might easily be added. Very different in character from Wicklow, the mountain and coast scenery about Newcastle is most beautiful, affording endless enjoyment in walks and drives. The view from the Bay, looking over the town and lodge to the Eagle's Nest, and Slieve Donard – the Mourne Mountains extending far away inland – reminding me much of the approach to Genoa from the sea, I do not know a place with more natural capability for a marine watering-place than Newcastle; and from our northern counties it is not difficult of access by way of Fleetwood and Belfast, the railway whence to Downpatrick brings you within a few miles of the place. The air is clear, pure, bracing, whether from the mountains or the sea; and the rock a close, grey granite, succeeded by greywacke schist; and there are good houses and an excellent hotel.'[13]

His letter brought changes. William Richard, 4th Earl Annesley, probably at his mother's instigation, had the water piped down the mountain from the spa as had been suggested in the letter, but rather than bring it the whole way to the baths beside the Annesley Arms Hotel, a stone grotto with a corbelled roof was built at the lowest end of the demesne near the main road. The site would later be sold to St John's select vestry for a rectory. Here Biddy Kearney used to sit at the well and dispensed, for a small fee and with much banter, drinks of the chalybeate water. The decline of the upper spa would date from the death of countess Annesley in 1891. Her son, Hugh, 5th Earl Annesley, was not so free in granting access to the demesne. Being in litigation with one of his younger brothers over a charge their father had put on the demesne, the Earl was even less disposed to spend much on the Newcastle part of his estate. Indeed, he auctioned off the effects of Donard Lodge in May 1891. The decline in the upper spa may be one reason why it did not receive a mention in *Beatty's Guide to Newcastle and Vicinity* when Eddy Beatty revised his local history in 1904. However as he was a bottler and seller of aerated waters at his general store, he may not have been keen to mention any competitive product. The moss covered stones lying amid the leaves on the forest floor are all that remain of a feature that once was of great economic importance for Newcastle. The water still flows but now only appreciated by the local wildlife. The grotto at the foot of King Street was redundant from the end of the first world war, became overgrown with ivy and was finally demolished in September 1961.[14] A shrub in the middle of the front lawn of the rectory marks the approximate site where the grotto once stood.

Victorian visitors came to take the spa waters and to
benefit from the 'clear, pure, bracing sea and mountain air'

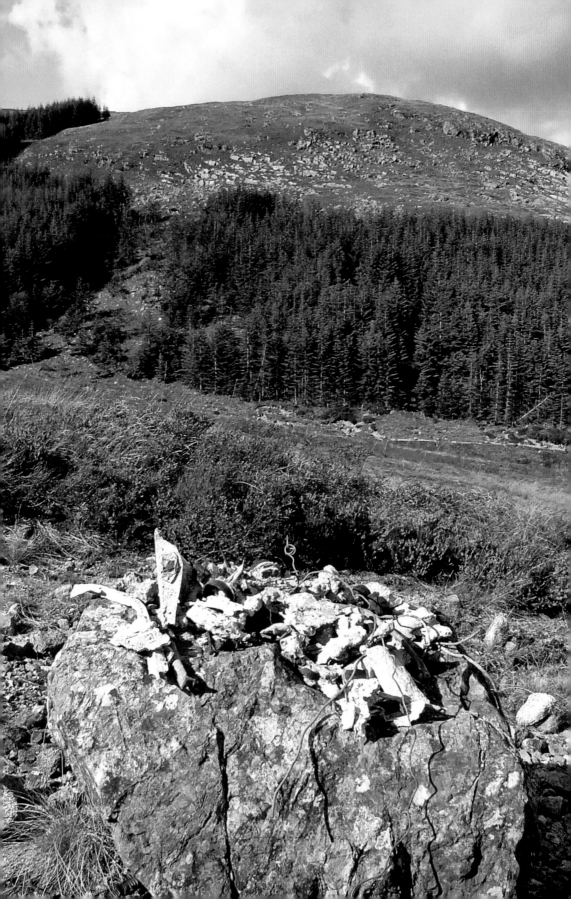

PLANE CRASHES
ON THE MOUNTAINS

A viation has come a long way since 1st December 1907 when the people of County Down gazed sky high in amazement. The French airship *La Patrie* had broken loose from moorings and to the wonder and no little consternation of those below was driven by the wind over the county. Nearly three years later on 8th August 1910, huge crowds watched as Harry Ferguson took off from the sands at the bar of Dundrum near Murlough House, made a flight of three miles and made a perfect landing near the Black Rock. A century later we were to see the best and the worst of aviation. To mark the centenary of Harry Ferguson's flight, unprecedented numbers of visitors came to Newcastle on Saturday 7th August 2010 to witness the spectacle of the Red Arrows formation flying. Under a headline 'Beat That!', the Mourne Observer declared 'Newcastle has never in its long history experienced the vast numbers of eager visitors who poured into the town from far and near on Saturday afternoon to witness the heart-stopping aerial display by the Red Arrows'. It was indeed both a wonderful day and a magnificent demonstration of aerial skill. They did Harry Ferguson proud.

Since this chapter was in contemplation, a number of crashes have added a sad counterpoint to local aviation. Two men had a miraculous escape on 1st June 2009 when their two-seater light aircraft stalled and plummeted around 200 feet to crash near the Greencastle Road, Kilkeel. Twelve days later three men were killed and a cloud of sorrow was cast over Mourne when another light aircraft crashed in a field near Ballyardle crossroads during very foggy conditions.[1] Saturday 23rd October 2010 saw a further triple tragedy when an eight seater Agusta 109 helicopter ploughed into Shanlieve Mountain stewing debris across a wide area.[2] Five days later on Thursday 28th October 2010, four men had a truly miraculous escape when a second helicopter that was assisting the investigation into the earlier fatal crash, turned over when lifting off and crashed at the top of Shanlieve. The pilot and passengers managed to free themselves from the badly twisted wreckage virtually unscathed. There have sadly been earlier fatal crashes in the local area.

Ernie Cromie, a member of the Ulster Aviation Society, in his important article *World War 11 Airplane Crashes in Mourne,* has determined that eight aircraft were written off as a result of war-time crashes in the Mournes.[3] With his kind permission I would reproduce details of the four crashes nearest to Newcastle namely the crashes of two Wellington bombers, a B-26 Marauder and a Mosquito.

Fragments of Wellington bomber X3599 which crashed into the lower slopes of Thomas Mountain on 16th March 1942 killing six people

Wellington Bomber X3599

I remember how locals used to talk about their concern the night they heard the very loud sound of a plane passing overhead in the clouds obviously flying dangerously low. It was the night of 16th March 1942 and Wellington bomber, serial number X3599, en route to Aldergrove from Feltwell in Norfolk, was heading towards the mountains. On board was the normal crew of six and twenty-four year old Miss Barbara Blakiston-Houston, a section officer in the women's auxiliary air force. Barbara had just got some days leave and had seized the opportunity of a lift in the plane flying over to Northern Ireland so that she could visit her home at the Lodge, Seaforde. It was a night of very poor weather and around Newcastle the cloud base was particularly low, obscuring the mass of the Mourne mountains. The crew had become disorientated and the aircraft was off course. About 12.30am that night, the plane passed over the town and flew into the lower slope of Thomas's mountain a bit further up the Glen River valley past the Black Stairs. So low had the plane passed over the town some guessed that they were actually below the mountain tree line and catching sight of their awful danger in the final seconds and the crew had tried unsuccessfully to pull the nose of the plane up before it ploughed into the face of the mountain.

Crash site of Wellington bomber X3599 on the slopes of Thomas mountain above the Glen River. Even after seventy years the crash and subsequent fireball have left a long scar of bare rock and scorched stones

The crash and subsequent fireball completely destroyed the bomber. Miraculously the rear gunner survived although injured. The other five crew members and Miss Blakiston-Houston were killed. Barbara was buried in the family grave at the Church of Ireland, Seaforde. Her grave is along the early rows close to the church on the left hand side as you go up the avenue.[4] Even now, nearly seventy years after the crash the mountainside bears a fifty metre gash where nothing yet grows. Parts of the granite strata still show the black burn marks of the fireball that engulfed the wreckage. Up until the mid 1980s the site was

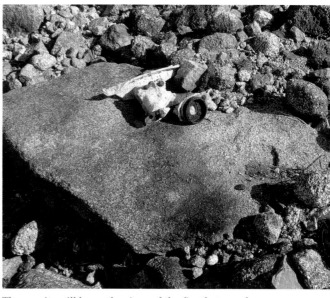

The granite still bears the signs of the fire that raged after the bomber crashed on 16th March 1942

also marked by the partly buried and badly damaged remains of the aircraft's engines. These were removed with permission from the Ministry of Defence by members of the Ulster Aviation Society in their ongoing project to recover and conserve Northern Ireland's military aviation heritage. The terrain at this first crash site is not awkward or dangerous but the other two sites we look at, close together on Slieve Commedagh, most certainly are. This prompts me to include the final paragraph of Ernie Cromie's article.

> 'It is entirely possible that this article may stimulate some readers to explore the sites referred to. This is understandable, but please exercise care as the terrain is difficult and dangerous. In addition, it should be borne in mind that people met their deaths at [almost] all of the sites, which should be treated with due respect. Finally, be reminded that any site investigations, however superficial, are subject to licences which can only be obtained from the Ministry of Defence.'

In my young days I seem to remember gossip that some boys had found a machine gun at the site. Anything was possible then because even the two large radial engines were to be found on site, albeit in a woeful condition, embedded in the earth with their propellers badly twisted around the engine couplings. All large parts of the bomber have now been retrieved and nothing is left except the extensive scar on the mountainside and various little scraps of twisted metal which walkers have placed on a large boulder. This stone, in the middle of the crash site, now acts as an impromptu memorial for these remaining fragments. Lower down-slope on the crash site some stones have been collected into a

The low headstone on the right marks
the grave of Barbara Blakiston-Houston
in Seaforde Church of Ireland graveyard

Extract of the burial register of the
Church of Ireland, Seaforde

little cairn. Perhaps in the future a more
permanent and appropriate marker may
be established in situ to the memory of
the six who died here, before time and
nature inevitably reclaim the site with
anonymity.

Wellington Bomber X9820

The Vickers Wellington, named after
Arthur Wellesley, 1st Duke of Wellington,
was a British twin-engine, long range
medium bomber. Widely used as a night
bomber in the early years of the Second
World War, by 1943 it was displaced as a
bomber by the larger four engine 'heavies'
like the Avro Lancaster. Although by the
autumn of 1943 the Wellington had
completed their useful life with Bomber
Command, other uses were being found
for them like training, anti-submarine
duty and transporting airborne forces. It
was while on a training flight between
Bramcote in the East Midlands and
Nutts Corner in Northern Ireland that
Wellington X9820 met with disaster on
12th September 1943. Bad weather was a
contributory factor and like the first crash
eighteen months earlier, the aircraft
was off course and flying in cloud when
it hit the north-western face of Slieve
Commedagh 150feet below the summit.
The three crew members were killed.[5]

As Ernie Cromie records, it was
customary after aircraft crashes for the
site to be visited by an RAF salvage team
in order to make the area safe and recover
reusable components or valuable scrap
metal for melting down. The unit responsible for this task in Northern Ireland was
No 226 maintenance unit based at Mallusk near Belfast. Despite the remoteness
of this part of the mountains, orders were issued to recover as much wreckage
as possible from the vicinity of Slieve Commedagh. A salvage team arrived at the

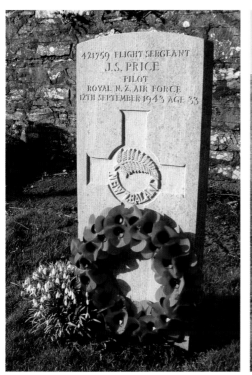

The well attended grave of New Zealand pilot Flight Sergeant J.S. Price at the Church of Ireland cemetery, Ardglass. He was one of three killed when their bomber crashed into the side of Slieve Commedagh

The crash site of Wellington bomber X9820 shows here as the darker patch on the upper left slope of Slieve Commedagh. Parts of the plane to be salvaged were manhandled down the cliff into the Pot of Legawherry

site on 5th October 1943. According to entries in their record book, engines, propellers, wings and part of the Wellington's undercarriage were manhandled and dragged down a cliff and over a distance of about five miles to the nearest point to which a special 'Queen Mary' trailer could be brought. A special tracked jeep was even borrowed from the USAAF at Langford Lodge, together with a tractor, to assist with the salvage. Both vehicles bogged down many times in soft, boulder-strewn ground but eventually, after hours of arduous work, the process was completed.

I have always imagined that the salvage team were a little circumspect with the entry in the record book. The crash site on Slieve Commedagh is on the lip of the Pot of Legawherry which is derived from the Irish *Lag an Choire* meaning 'the hollow of the cauldron'.[6] It is a substantial corrie, a feature of the ice age in Ireland, when snow accumulated on the north side of hills where the sun scarcely reached. The snow piled up, froze, and as the frozen accumulations slid downhill under gravity, stone was increasingly plucked from the rock face. Pulgarve,

Pollaphuca, and Eagle Rock also went through the same formation process. A dimple on the north facing slope of Thomas shows that the ice was in the process of shaping out a hollow on it too. By the nature of their development, corries are usually very steep-sided and Legawherry is no exception. Faced with the task of retrieving what they could of the crashed bomber, the salvage team, I believe, would have given the wreckage the heave ho over the top of the cliff and let gravity 'manhandle' it down below. There are certainly small pieces of the aircraft still occasionally to be found on the corrie floor.

B-26 Marauder

The B26 which crashed in the Mournes was part of the Combat Crew Replacement Centre Group based at Toome. On the day of the training flight the Mournes were enveloped in low cloud and mist. The weather also made for unpleasant working conditions in the quarry at the head of the Bloody Bridge river valley. Ernie Cromie preserved for us the recollections of the late James Cousins of Glasdrumman who was working in the quarry on that fateful day of 10th April 1944.

> 'We heard the engines of an aeroplane but couldn't see it because of the mist. The noise was faint at first but got louder and louder as the plane seemed to come in from the sea and fly up towards us. We were very scared it was going to crash on top of us when suddenly the engines revved up and the plane seemed to turn away to the south over our heads. The noise died away and we got back to work feeling very thankful.'[7]

The intervening ridge of Chimney Rock mountain prevented the workers in the quarry from hearing the crash. They didn't know that the Marauder, even though it had changed course at the last moment, had been too late and had flown into the rock-faced southeast slopes of Chimney Rock mountain. The aircraft completely disintegrated leaving a trail of bodies, wreckage and debris scattered across the side of the mountain and into Spence's River valley. Tragically, the crew of five were killed.[8]

This was the first fatal accident to an aircraft of the No 3 combat crew replacement centre and because of the bad weather conditions at the time the crash site was not actually discovered until some days later. The crew was listed as missing until members of the American 5th Infantry Division on a routine hike in the Mournes discovered the wreckage. Official confirmation of the accident reached the 365th Service Squadron on 15th April 1944.

The report on the accident dated 21st April 1944 by Major George Commenator, concluded that 2nd Lt Osborne 'made an error in technique by permitting himself to get too far out of position in formation and that the pilot made an error in judgement by flying into clouds in a known mountainous area'. No reason was offered to explain why Howell Osborne's plane had had difficulty

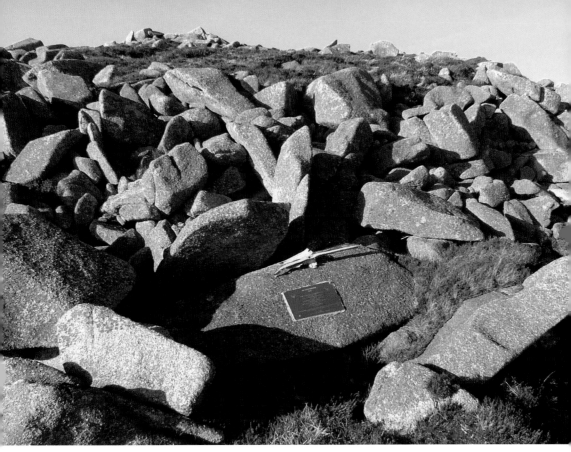

A piece of wreckage of the B26 Marauder along with a commemorative plaque to the five Americans who died. This can be found down below on the south side of the summit cairn of Chimney Rock

keeping up with the formation. The fact that the plane he was flying had been retired from frontline service because it was 'War Weary' may have been a contributing factor.

The Ulster Aviation Society recovered parts of the plane decades ago. Walkers to Chimney Rock will find a plaque glued to a large stone below the southern side of the summit cairn listing the names of the five Americans. Their memory has been further preserved by the recent establishment of a dedicated website.

Mosquito NS996

The last fatal plane crash of the war in the mountains was Mosquito NS996. The plane belonged to operational training unit No 60 at High Ercall in Shropshire and the crew were on night-time intruder tactics which occasionally saw planes range over to northern Ireland in the course of exercises. Mosquito NS996 left High Ercall on the night of 12/13th January 1945 and headed out over the Irish Sea but did not return. Searches were undertaken but due to the extreme weather conditions that winter, it was not until the beginning of March that the wreckage

227

was identified and the bodies of the two crew recovered from the crash site on the southern slopes of Slieve Commedagh, just above the Castles. A salvage team from the same unit that had sought to recover parts from the Wellington bomber X9820 that had also crashed in the vicinity visited the site in October 1945 but decided that salvage was pointless. Now that the war was over, there wasn't the same imperative to go to extreme lengths in the recovery of parts and this unit would have remembered the difficulties entailed. Deeming any salvage operation as futile, most of the remains were simply pushed into a nearby ravine and buried. For years afterwards however, one of the aircraft's main wheels could be seen in the bed of the stream below the Brandy Pad where it had bounced down the mountain about a quarter of a mile after the crash.[9] At the bottom of the gully where the aircraft had been pushed used to be found two large Rolls Royce Merlin engines. One of the engines was periodically covered by sliding shale. The Ulster Aviation Society saved what it could from the mountains and their collection is presently housed at the WW11 airfield at Long Kesh, about a mile from Sprucefield.

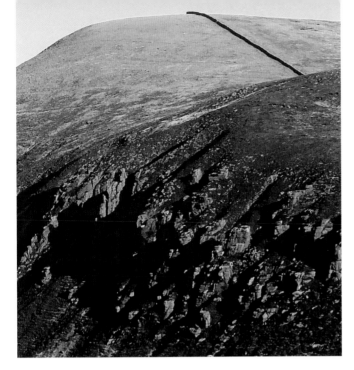

The crash site of the Mosquito in which two men died towards the end of the war is still visible here as a white blaze on the brow of the hill above the Castles of Commedagh

At his first attempt at flight at Newcastle Harry Ferguson crashed and broke a wheel on his plane. In 2010 tens of thousands came to see the Red Arrows mark the centenary of his ultimate success

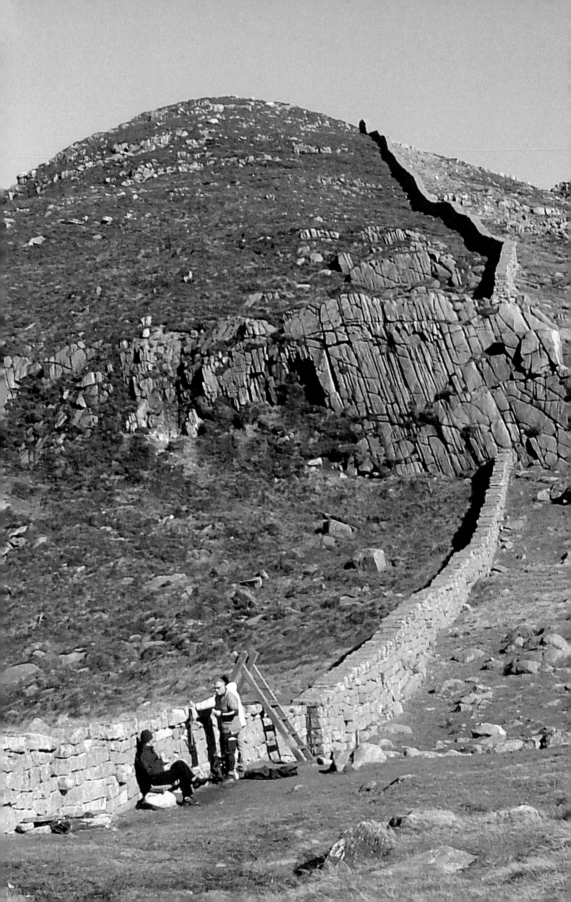

THE MOURNE WALL

A ccess to the mountains is so much taken for granted that it is hard to believe they were nearly closed to the public at the start of the twentieth century. In June 1900 the War Office served notice on Lord Downshire and twelve tenants of an application under the Military Land Act, 1892, to take 593 acres of land in Ballykinlar Upper, near Dundrum. This was an extension for the military rifle range that had already been constructed. The additional land brought the size of the entire range to over 1,200 acres. This was the time of the Boer War and the lack of fitness on the part of recruits and their poor training had already been revealed. The War Office in their zeal to improve matters were apparently not satisfied with Ballykinlar and wanted more.

A week after the extension plans for Ballykinlar were made known there was consternation in the chambers of the Down County Council when a map was tabled from the War Office delineating the Mourne range of mountains as an area for military manoeuvres. It was proposed to amend the Military Manoeuvres Act of 1897 to give further facilities for rifle and artillery practice. At that time two Acts had been passed to facilitate military training. The first was the Military Lands Act of 1892 which dealt with the permanent occupation of land for camps, rifle and artillery practice or other military purposes. It was this Act that was used for the acquisition of the land at Ballykinlar. The second was the Military Manoeuvres Act of 1897 which related to temporary occupation. Under this Act land could be occupied for three months for encampment and manoeuvres. However, the amendment of this Act which was being set before the council was more drastic in character. It authorised the Secretary for War to use for twenty days in the year, certain tracts of land, as for example the Mourne Mountains, 'for artillery and rifle practice under service conditions'. While the area was being so used 'no person may enter upon it except with the consent of the Secretary of War, and under such conditions as he may impose'. The circumstances for compensation were narrow. There would be no inquiry as to whether the Mournes was a suitable tract for the purpose. Neither would there be any consultation with the County Council. All the War Office had to do was advertise in the papers for a fortnight.[1] One section empowered the commanding officer to suspend for a time not exceeding two hours in any one day the use of any road or footpath within the limits, provided he had taken steps to make his intention public. The area scheduled in the Manoeuvres Bill comprised the catchment area of the new water supply for Belfast and, not unnaturally therefore, the City Water Commissioners were determined to petition against the Bill. One of the Down Councillors was Thomas Andrews who was chairman of the Belfast and County Down Railway. The company had invested greatly in Newcastle over recent years

to bring tourists to the town. Only two years earlier they had issued over a thousand invitations when Lady Annesley had opened the Slieve Donard Hotel on Tuesday 20th June 1898. Now the company chairman conjectured that it might be rather awkward if excursionists were stopped from going up Slieve Donard which was included in the scheduled area. Nothing more was publically said but powerful representations were obviously made behind the scenes. It is to be presumed that Hugh, 5th Earl Annesley, landlord of the mountain and a distinguished wounded veteran of the Crimean War, had the ear of influential men in the army because the military manoeuvres bill scheduling the Mournes as an area for artillery and rifle practice under service conditions was quietly withdrawn inside a month.

The Belfast city and district water commissioners were greatly relieved that no shells would now be exploding in the 9,000 acres of their catchment area. They continued the tunnel through the mountains making an aqueduct to bring water from Mourne to Belfast. The scare caused by the military proposal to schedule their catchment undoubtedly influenced the decision within a few years to copper-fasten their title to the area by the construction of the famous Mourne Wall.

The main impetus for building the Mourne wall started with events in Tennent Street, Belfast in 1898. A particularly virulent epidemic of typhoid broke out and although it was quickly brought under control the repercussions were wide ranging. At first the water commissioners were blamed because there had been a case of typhoid at Stoneyford which supplied the water for Tennent Street. The press made a sensation of the whole issue but the case was not proved. The typhoid controversy reignited some years later when a local government commission conducted a thirty-three day inquiry into the health of Belfast. One significant outcome of this inquiry was the recommendation that all water catchment areas should be depopulated as a guarantee of freedom from contamination. Therein lay the genesis of the Mourne wall which was intended to keep people and animals out of the catchment area thus maintaining the purity of the water.

Building the Wall

Back in 1981, Newcastle man Harold Carson preserved for us the names of many of those who built the Mourne Wall in his important work *The Dam Builders*. As he mentioned in the preface, time had by then taken its toll of those who had worked on the Silent Valley project and the Mourne Wall but fortunately some of the old men still survived and the relatives of others supplied significant information. As a result we are fortunate to have some record of this awesome feat of labour.

The building of the wall lasted approximately eighteen years from 1904 to 1922. There is no mention if the work was interrupted by the first world war but

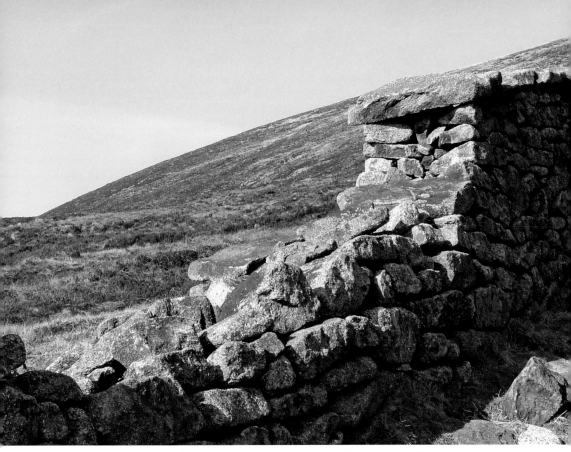

A broken part of the Mourne wall reveals it is actually a double wall with rubble fill in the middle

the employment was very welcome in an area where there were few other opportunities. Some of those involved in building the wall were Arthur Rooney of Oldtown, brothers Tommy and Johnny Cousins of the Head Road, Annalong, James Clutson, James Newell, John Trainor of Ballyvea, Charlie Fitzpatrick, Hugh Annett, John Walters, Robert Rooney, Willie Hamilton, Davy Nugent, Charlie Patterson, Willie McCartan, Jim Cousins, Roger McAlinden and Patrick McEvoy of Upper Moyad Road, Robert Skillen from Clanawhillan, and Dave Martin. Two serious accidents are recorded during the building. Ned Hagan got a leg broken in the stone quarry and Willie McVeigh lost his foot when it was crushed by a granite boulder.[2]

The specifications for the wall were high as it was intended to exclude all livestock as well as discourage people. The average height throughout its length is about five feet or 1.5 metres including the impressive capstones. The wall is thick, averaging from two and a half to three feet, or 0.8 to 0.9 metres. It is actually a double wall with a rubble interior built using traditional dry stone walling techniques. Some of the stones used in the wall are incredibly long. On Slievenaglogh I have looked at insertions that must have been a good six feet or two metres in length. Even just lifting these long stones into the wall would have

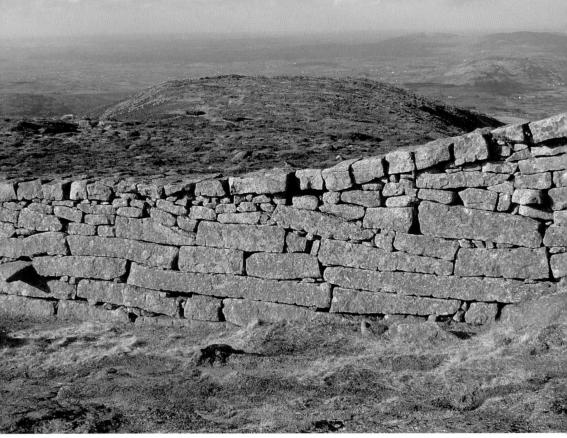

Some of the stones in the wall at Slievenaglogh are a good two metres in length

been a feat of strength. If you are impressed at the large capstones, then be doubly impressed for many parts of the wall required foundations using larger blocks again. Soil slip above the Pot of Legawherry has exposed foundations that are not otherwise in view. Large wide blocks were laid down in a trench to spread the weight of the wall and there are often another couple of feet or 0.6 to 0.8 metres more of stone underground.

The Mourne wall is twenty-two miles (35km) long. A race along the length of it is a most formidable physical challenge as the wall passes over fifteen mountains, or if you want to be strictly correct fourteen mountains as at Rocky mountain the wall extends along the lower reaches rather than over the top of it. At the western side of the Slieve Donard shelter tower iron pegs with holes can still be seen where they were hammered into the stones. From these pegs guide lines were stretched down the slope to keep the wall straight in alignment. As the wall advanced so the guide-lines moved as well. The stones for the wall were taken from the surrounding mountain-side though in many places small quarries had to be opened to supply sufficient. Slieve Donard has its little quarry on the south-east slopes and Slieve Commedagh's quarry is near the shelter tower. Every substantial capstone had to be securely lodged in place. W.H. Carson tells us how it was done.

'The granite blocks for the wall were cut and dressed with 7-lb hammers, but how the builders actually lifted the great rectangular coping stones into position has puzzled many walkers in the Mournes. The job was done by first sloping a stout plank against the wall. Then a squad of three strong men, one on each side and one behind, gradually inched the heavy stone block up the board and into place across the wall. "They were men", says Johnny Cousins, "with powerful shoulders and hands like shovels.'[3]

As we admire the magnificence of the twenty-two mile wall we should not under-estimate the truly gargantuan task of sourcing the thousands of tons of stone needed for its construction, the countless rocks that all had to be split by plug and feather, the conveying these stones to the building site as well as the constant hammering at forges to keep tools sharp, not to mention the carrying of coal up the mountains to fuel the forge fires. Out of respect for all their effort, a little word is appropriate about walking along the top of the wall. There is always the possibility of a dangerous fall for even the strongest man can trip, can put his foot on a stone that unexpectedly rocks, can be caught by a gust of wind or can lose his balance in an instant. Apart from the question of personal safely, the

The wall runs along the top of the Pot of Legawherry. Here soil slip has exposed the substantial foundations

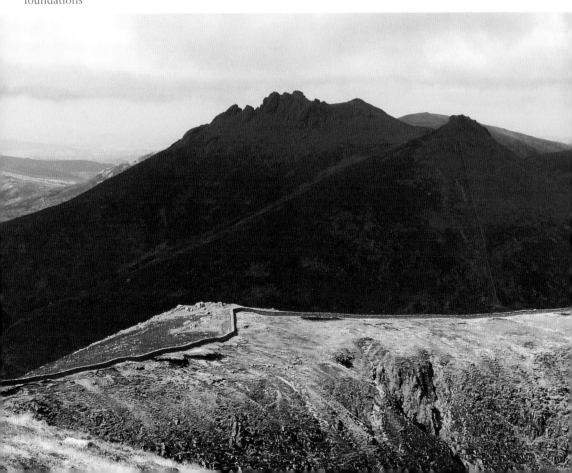

Department of the Environment who are the present owners of the wall are anxious to protect it from being tumbled. It was quite common practice until the 1980s for many to walk along the top of the wall but now it is discouraged. I well remember when the policy for protecting the wall was announced. The ordnance survey of northern Ireland had just produced an outdoor pursuits map of scale 2½ inches to one mile and there on the middle of the cover was a lovely little photograph of ten walkers going along the top of the wall. The map was hurriedly withdrawn by the ordnance survey and another more innocuous picture substituted instead. That 1981 map is now a collector's item.

The Belfast Water Commissioners may have ordered the building of the wall but the true glory lies with the men of Mourne who endured the back breaking work from March to mid October each year leaving us an awesome legacy in stone that will endure for millennia. The privations suffered must have been particularly daunting. Even in early spring the temperatures on the mountains can be bitterly cold and wind chill on the mountain summits must have caused much anguish. The long walk from home or lodgings to report for work at 8.00am saw many a journey across the mountains made by lamp-light. For men walking from Kilcoo to Slieve Bernagh it was rightly said the journey to work was almost a day's work in itself. It would be quite a mistake to look at the wonderful scenery of the Mournes and imagine that the task of building the wall was a great outdoor job. Harold Carson has recorded that the workers' name for the wall was 'The Back Ditch'. This requires a word of explanation as on the face of it the meaning of the English is discordant if not truly puzzling. The Back Ditch is a mnemonic of the Irish *biach duithir* and is exceedingly expressive in the original. The term was probably used more as a curse for a job involving such hard work; and a very sexual curse at that too! The Back Castles, a series of upright projections on the summit ridge of Slieve Binnian, derive their name from the same Irish word.

Thoughts about the hard work involved in the building of the Mourne wall remind me momentarily of a different physical feat on the summit of Slieve Commedagh by the Newry man Banjo Bannon. Banjo we recall, along with Richard Dougan of Markethill and Jamie Magennis of New Zealand, climbed Everest by the treacherous and precipitous North Face in 2003. Anyway, an exuberant Banjo was on the summit of Commedagh and doing a hand-stand at the summit cairn 'hand-walked' to the summit tower at the Mourne wall. It is some years now since I paced out the distance but a fickle memory seems to recall that the distance of this remarkable 'walk' was in the region of 370 metres.

The Mourne wall is built from the natural granite where available. On Slieve Muck the wall was raised using the local shale rock instead. The only place where cement was used in the entire project was in the construction of the three shelter towers and here the granite blocks were also properly dressed. The towers are on three summits, namely Slieve Donard, Commedagh and Meelmore. Originally all three had a stepped pyramid type apex but the capping on the Donard tower was

Footprints in the snow. Here on the top of Slieve Muck the Mourne wall is built from shale

changed in the 1950s when the ordnance survey triangulation station was placed on the top instead. The capping blocks on the top of the Slieve Commedagh tower have been displaced out of true as a result of weathering and lightning strikes. When a bolt of lightning would strike the tower, the searing heat would instantly change any water that had gathered in the cracks between the granite blocks into steam. The sudden explosive force has forced the blocks apart and this process would also have been assisted by the expansion of freezing ice.

It is on the towers that the Water Commissioners placed their warning notices 'Trespassers Prosecuted'. The tower on Slieve Donard has two of these signs, all of course, on the 'outside' of the wall. The social mores of society were such at the start of the twentieth century that these admonitions would actually have been usually scrupulously observed. After the second world war and with the arrival of widespread car ownership, the magnificent scenery of the Mournes came to a wider attention and visitors and walkers increased enormously. The trespass

The shelter tower on Slieve Commedagh, built in 1913, with its damaged pyramid cap

notices are now regarded as historical and quaint. At the beginning of the twentieth century however the commissioners enforced their ownership. September 1902 saw them institute proceedings against lessees of Earl Kilmorey who were working quarries in the Annalong Valley. The quarries, such as those at the Hare's Castle and Percy Bysshe bluff were compelled to cease working and vacate the commissioners' catchment area. It wasn't just the quarrymen who were

All the shelter towers carried these warning signs

affected by the exclusion. Many objections came from tenants who were losing their tubary rights at Lough Shannagh Bog, Mourne Mountains East, Glasdrumman Bog and Mullartown Bog.

The cause was taken up in the House of Commons by Jeremiah MacVeagh, MP for South Down, in March 1905. The question was asked of the chief secretary to the Lord Lieutenant of Ireland: 'whether he is he aware that the

Belfast Water Commissioners propose to prohibit after 1st May the letting of lands within the Mourne catchment area; whether he is aware that before the Commissioners obtained their Bill the parties concerned were led to believe that no local industry would be prejudicially affected; whether he is aware that the operations of the Commissioners have since resulted in the closing of several granite quarries and that the prohibition of the letting of lands will now injure the sheep-breeding industry, the two chief means of livelihood in the district; and, if so, whether any steps can be taken by the Estates Commissioners or the Department of Agriculture to safeguard the rights of the residents.'[4] The rights of the Water Commissioners however, were upheld. Since January 1991 Slieve Donard has been acquired by the National Trust and under the terms of their ownership access to the Mournes will remain free and unrestricted for all to enjoy.[5]

The Mourne wall climbs the steep slope of Slieve Bernagh. The Trassey valley is in the background

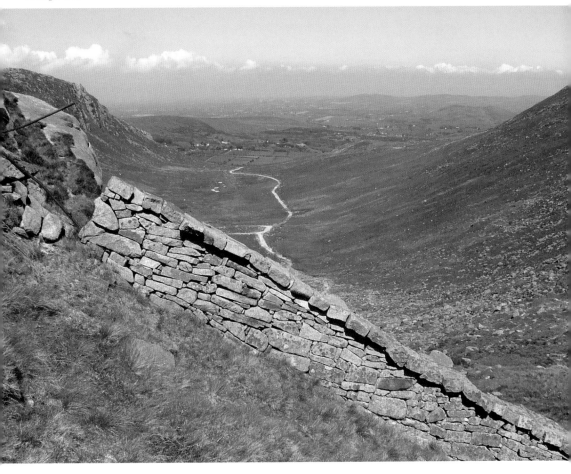

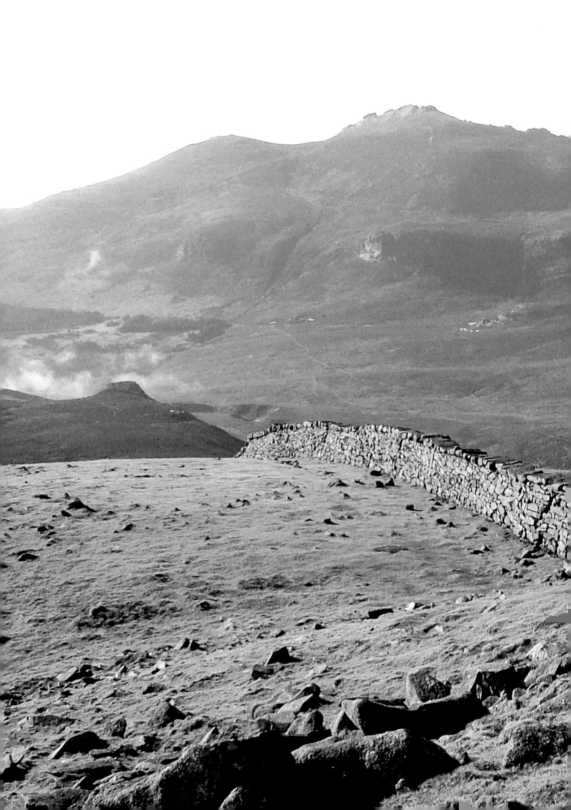

The Mourne Wall descends on the south slope of Slieve Donard

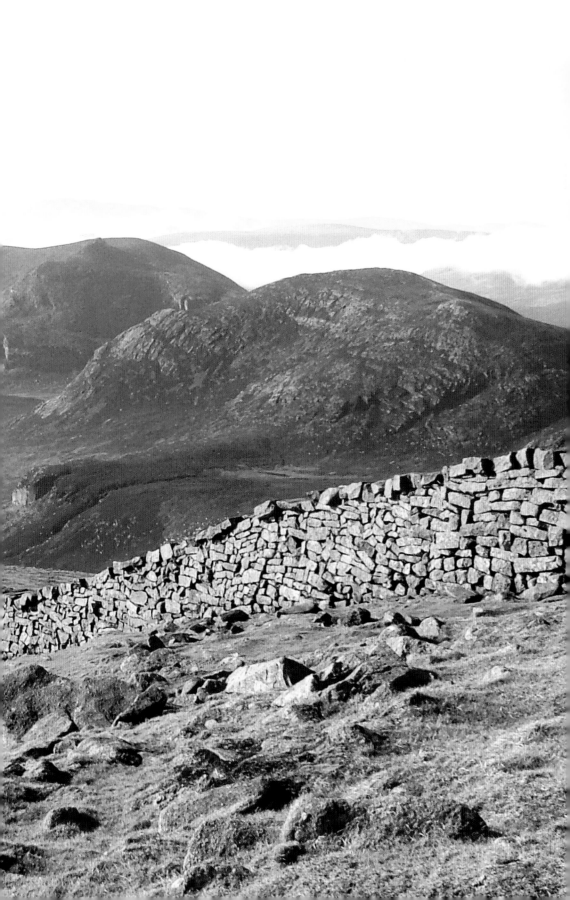

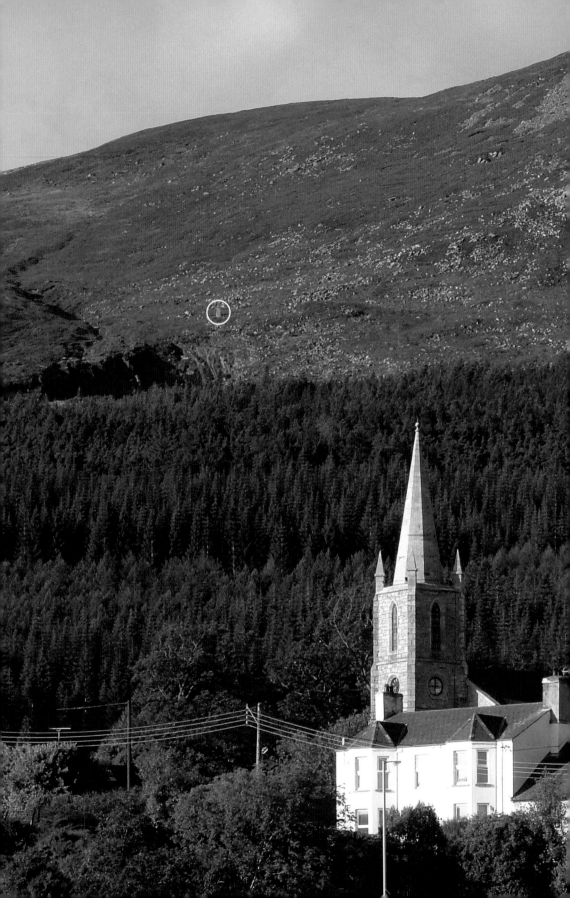

A NEOLITHIC MONUMENT
ABOVE THE QUARRY

'During the last 150 years the steady decline of the Gaelic language resulted in the loss of a great deal of information on local and regional life and of a vast store of oral literature, in which the lore of an ancient civilization was enshrined.'

FROM THE PREFACE OF *IRISH FOLK WAYS*, WRITTEN BY
E. ESTYN EVANS, PROFESSOR OF GEOGRAPHY, QUEEN'S UNIVERSITY, IN 1957

To the list of monuments around Newcastle left us by the Neolithic people, namely the Slidderyford dolmen, the standing stone at the Flush Loney and the cairns on top of Slieve Donard, must now be added another. For want of a name I will call it *An Chathaoir Mhór,* the Big Chair. The story of the re-discovery of this truly magnificent monument came to fruition in a wonderful eureka moment in the early morning of 13th October 2010. It was the culmination of years of research, many enquiries among friends, close inspection of dolmens and other Neolithic monuments around the county, journeys up and down the mountain, photographs, linguistics, trusting what my father had told me despite indications to the contrary, and a persistent curiosity to understand the significance of local placenames. I had already been rewarded with insights into the full import of *Leganabruchan,* the shoulder of mountain south of Millstone mountain, which is dealt with in the chapter on the smugglers, but the joy of final realisation at what had been found was so incredible and the excitement so intense it was difficult to get any sleep that night. One could begin to appreciate Howard Carter's feelings on 26th November 1922 when he looked though the little hole in the outer doorway of Tutankhamun's tomb and, by the light of a candle, caught his first glimpse of the gold and ebony treasures beyond.

The story began in January 2004. It was at the Local Studies department at library headquarters, Ballynahinch, that I was able to read a fiant[1] of Queen Elizabeth the First dealing with surrender of land by the Magennis clan and another fiant describing in some detail their territorial boundaries. It was in these court documents that Newcastle was first referred to variously as 'Shyleke' and 'Shyleike'. The court scribe had been struggling to phonetically transcribe the Irish *sithe leacht* meaning 'the hill of the monument'. The first difficulty was with the Irish *sithe* which had long fallen out of use and no longer appeared in Irish

The circle marks the magnificent Neolithic monument that
once gave Newcastle the name *sithe leacht*, 'hill of the monument'

243

dictionaries. The answer came from the writings of that most erudite scholar and member of the Royal Irish Academy, Bishop William Reeves. In his important work on Irish Church History, *Ecclesiastical Antiquities of Down, Connor and Dromore*, the learned bishop gave the vital explanation that *sithe* should be taken in the sense of a hill.[2] The Irish *leacht* was straight forward. The full meaning as given in Dinneen's Dictionary is 'a grave, cairn or sepulchral mound, any monument, a pile of stone, an obstruction'.[3] When I last wrote reviewing the meaning of 'Shyleke' in 2007, it was inconceivable then that a major Neolithic monument remained undiscovered in the locality. Accordingly one was disposed to look to the cairns on the top of Donard for an explanation. This satisfied the meaning of *leacht* but it remained unsatisfactory as it was too big a stretch of the imagination to refer to majestic Slieve Donard as a 'hill'. On the other hand looking lower down the mountain would satisfy the meaning of *sithe* but there was no eligible monument. The only remote contender was a putative stone circle in the grounds of Donard demesne, and only five stones at that, but even this was properly dismissed by professor Evans as 'bogus'.[4] The confusion thus arising was reflected in *Where Donard Guards*:

'When considering the hill of the monument, we might automatically think of this as referring to Slieve Donard with the cairn on top and such indeed is most likely the case. There is, however, another possibility – a lost stone circle and this is in addition to the circle, now gone, that once surrounded the dolmen at Slidderyford. Is the monument that *sithe leacht* refers to, the high cairn on the summit of Donard, or, the stone circle in Donard demesne? Surely the Irish *Sliabh* for mountain would have been more appropriate for high majestic Donard, rather that *sithe,* unless a monument in the foothills was being referred to?'[5]

With the state of knowledge at that time, no entirely satisfactory explanation for the location of *sithe leacht* was going to be possible. The purpose of revisiting this dilemma is to show that back in the time of Queen Elizabeth the First, the Irish knew of a monument of such importance in the Mourne foothills that they would call their little village after it.

The years passed and thoughts turned to writing a sequel to *Where Donard Guards*. Many themes about the mountains presented themselves. Each topic brought its own questions but one query seemed to defy an answer and remained to niggle. Where exactly was 'Lindsay's Leap'? As themes were addressed, walks to different parts of the mountains were called for as photographs were needed to illustrate the subject at hand. Often the weather would play up. One would get to the top of Slieve Donard only for the mist to come down, making photography pointless. Usually the preferred route to go up the mountain would be the

This part of the 1938 revised ordnance survey map of Newcastle – before Tullybranigan was built – shows Lindsay's Leap marked on the map below Donard quarry

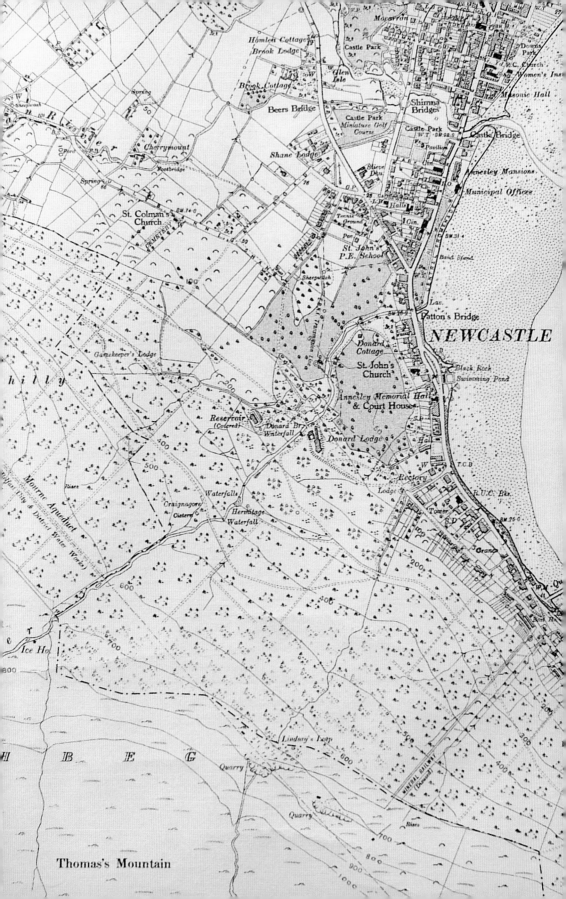

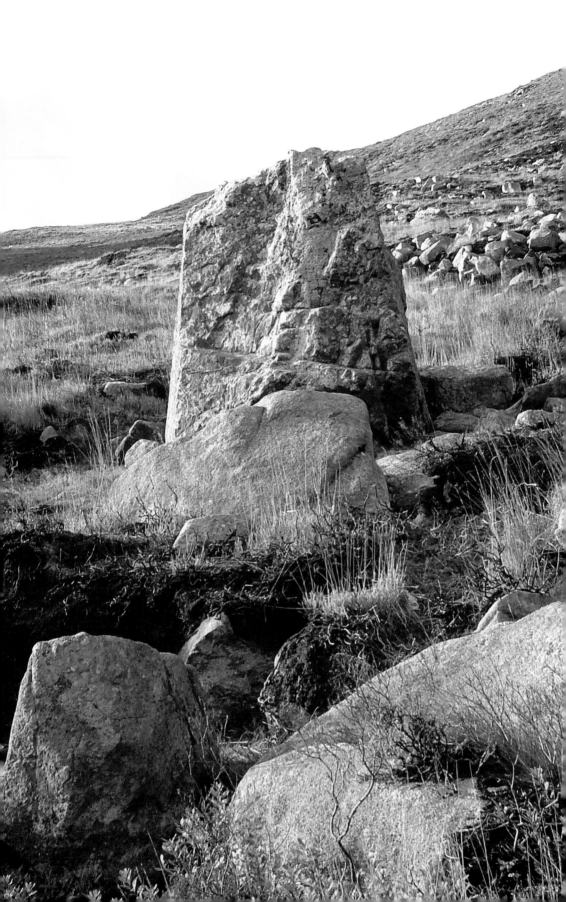

granite trail above the harbour. When the chapter about the millstones on the eponymous mountain came to be written, there were many journeys up the granite trail as I was quite taken by surprise at the scope of the workings. Professor Evans made mention of the millstones when writing his chapter on 'The Stone Men' but the workings were so extensive I felt drawn to visit time and again. It was always a pleasure. Millstone Mountain is a veritable open air museum, with the rocks showing at every turn evidence of skill and hard work. Every visit past Thomas mountain brought back the question, who was Lindsay? Did anyone know anything about him.

I should mention at this stage that while I was asking people 'where is Lindsay's Leap', I was only looking for confirmation as I felt I had already been given the answer. Clear recollections came of my father pointing out the mountains to me as a young lad and naming them. He named Thomas mountain and pointed also to the front of it and said it was called Lindsay's Leap. May we all be preserved from presumption. From those early days after hearing what my father had said, I always took it for granted that some poor unfortunate soul called Lindsay had jumped to his death from the eminence of Thomas mountain. As I asked around if anyone knew anything about Lindsay's Leap, it became increasingly disconcerting to receive the answer, 'never heard of the place'. Some fortunately had heard of it which was a comfort but no one could confirm a location. It was Eileen Starkey, on the Downs Road, who advised that the name was mentioned on the detailed Ordnance Survey map. When the map was checked it was a bitter sweet moment. Yes, the name did indeed exist but disappointingly the map showed it below the recent quarry. I was quite sure the map was wrong. Lindsay's Leap was above the quarry. My father had clearly said so. Unfortunately, at this stage he had suffered a stroke and couldn't be asked about it again.

The details for our maps were taken down from locals by officers of the Ordnance Survey in the 1830s. All it would take would have been a tremulous finger on the part of a local for the officer to get the area slightly wrong. Again, there was the question of revision of the maps and errors creeping in at that stage. Only the quarry directly in a straight line with the granite trail, Lynn's quarry, would have been open in the 1830s. Perhaps originally the name of Lindsay's Leap had been shown slightly higher up the mountain but when the details of the second quarry had to be engraved on the ordnance map the name of Lindsay's Leap was moved lower instead of higher. It was a moment that called for trust in the paternal information. Maps had been wrong before. At least, however, the name of Lindsay's Leap was not imaginary. It was on the map even if I had difficulty with the accuracy of its location.

The monument from the front showing the remarkable upright symmetry of both sides. The sloping line across the front of the rock is a narrow little projecting ledge which gives the stone the appearance of a chair

One had to consider whether Lindsay's Leap resulted from some forgotten folklore as proposed for nearby Drinneevar. The following explanation was given in *Place-Names of Northern Ireland.*

> 'Although the anglicized spellings of this place-name strongly suggest that it derives from Irish *Droinn Íomhair*, O'Donovan recorded a form *Dún Íomhair*, 'Ivor's Fort', in the ordnance survey name-books. Furthermore, there is a note in pencil on the ordnance survey letter map of the Mournes which reads 'Bridge of Ever oge a Giant'. It is clear that O'Donovan had heard some folklore concerning a giant called *Íomhar Óg,* young Ivor', in the locality, and it is reasonable to assume that this is the character from whom Drinneevar derives its name.'[6]

I would mention incidentally that there is no chasm or river on Drinneevar that would require a bridge. The nearest river is Amy's River which flows down into the quarry and to my mind the 'bridge' noted by O'Donovan would be none other than the natural rock bed which is still used by walkers to ford the river above the quarry at the pools. If the name Lindsay's Leap had come from folklore then the story would now be lost. It looked like the search to understand this name had come to an end.

While writing about herding in the Mournes, I had occasion to read professor Evan's writings on the subject. One particular passage was very influential and was to prove crucial.

> 'It was the shepherd who knew the hills best, and under all climatic conditions, for whereas other stock was taken to the mountains in summer only, some sheep were there at all seasons, and he was constantly coming and going through the hills. His marks were the great boulders, and scores of them have their names, though the Gaelic forms are almost forgotten. Some of them, which were probably ancient standing stones, were kept whitewashed, for example, the Grey Woman on Crotlieve.'[7]

It was this remark about great boulders having their own names that made me look twice at an imposing specimen near the stream above the quarry when next up that way searching for and photographing millstones. It was only about fifty metres on the west side of the stream. 'That is a stone that would have been worthy of a name', I thought. Getting across at the rock pool was the easiest place to ford; perhaps, as mentioned, this was the bridge of Ever Oge the Giant. I went over for what was to prove the first of many visits. The stone was impressive. I recollect a number of the first impressions. Top of the list was the magnificent view. Standing in front of the stone there was a complete panorama of Dundrum Bay, Murlough, Dundrum Inner Bay and Newcastle at my feet. Turning to look at the stone I remember thinking how remarkably upright it was given its great size. It was easily much taller than I was. 'How come it didn't land on its side but tumbled down to plonk itself so cleanly upright?' was a fleeting thought that I

The pool in the riverbed above the quarry which was the key to identifying the monument. In Irish its name was *linn an tsléibhe leacht*, meaning 'the pool of the mountain monument'. Newly arrived English and Scottish settlers in the Newcastle area heard the unfamiliar Irish and substituted the sound-alike name of 'Lindsay's Leap'

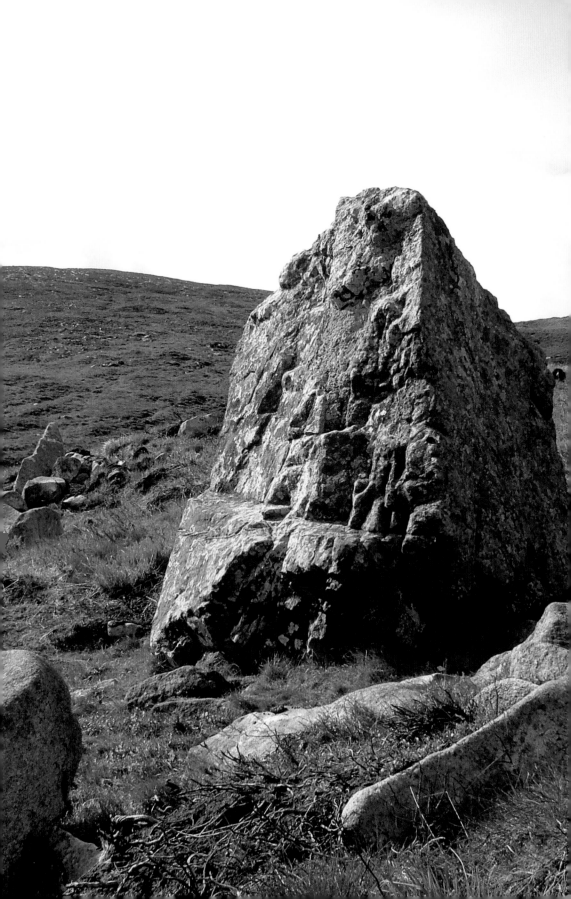

didn't stop to ponder on. There were also happy memories returning of being here as a child and trying unsuccessfully to sit up on the ledge at the front of the stone. Memories returned also of other children searching hopefully for treasure when they realised they could see underneath. In particular I now looked at how this large boulder was perched on top of a small granite stone at the back and thinking casually that it was a most unusual setting. I came away pleased at the short diversion. I had been there decades before and it was like meeting an old friend. The cumulative effect of the superb vista, the upright stance of the stone and the other stone jammed underneath it at the back, left me with a feeling that this was something special. I continued my climb but thoughts kept returning to the stone. I have learned in time past, however, to trust instinct. First impressions are important.

A good stew bubbles away and the flavours permeate each of the ingredients. It was early October 2010 and I was casually contemplating an appropriate name in Irish for the stone that had impressed me. Remembering the shelf at the front of it that I had been unable to reach as a child, the name 'the Big Chair' appealed to me. In Irish it would be *An Chathaoir Mhór*. It was while my thoughts were with Irish names for boulders that a moment of inspiration sparked the thought – 'what if 'Lindsay's Leap' comes from Irish?' Haste was made for the Irish dictionaries of Rev Patrick Dinneen and Tomás De Bhaldraithe and there was great joy when I quickly discovered that the Irish word *linn* meant a pool. The significance of this will be immediate to those familiar with the topography around Thomas mountain. Pools in plenty there are in the abandoned turf cuttings in the saddle between Millstone and Slieve Donard. There is even a pool or two after wet weather on the relatively flat summit of Thomas, the southern end of which was formerly referred to by locals as 'the top of the hill', but these are stagnant bog pools for which the Irish word *slodán* would be used. There was only one place in the area that one would find a 'living' pool and that was in the stream above the granite quarry. Many a youngster during the hot days of summer has enjoyed playing and splashing in the cold waters of the rock pools that the stream has worn for itself. Many a hill-walker has welcomed the opportunity to bathe tired feet. There are actually two little pools in the bed of the stream; one a little above the other. It is necessary here to insert a serious word of caution. No matter how tempting, it is strongly advised to completely avoid the lower pool. The granite around it has been worn smooth by the river and the rock has a pronounced slope leading to the precipitous edge of the quarry and a sheer fall. All it would take is a momentary slip on the wet rock... . One cannot be too careful. It must be acknowledged that the area around the head of the quarry is exceedingly dangerous.

The monument has been given the name 'The Big Chair', *An Chathaoir mhór*, on account of the narrow little projecting ledge that runs across the front of it

251

Having had success with *linn* the search was on for a further word that would both make sense in the geographical context and most importantly, could approximate in sound to the ending of Lindsay. The Irish word for mountain, *sliabh,* or its better known anglicised version, Slieve, quickly followed. A friend gave the genitive singular of *sliabh,* namely *sléibhe.* The full Irish was therefore rendered *linn an tsléibhe* (pronounced 'klave-a' – rhyming with the name 'Dave'),[8] which meant 'the pool of the mountain'. Topographically this made perfect sense. My friend pointed out that in normal speech the *an* of *linn an tsléibhe* would be elided and the final sound would approximate to 'lin slave'. 'You're on the right track', said my friend. I was delighted. This was the origin of Lindsay's Leap. It was an anglicised simulation of the Irish; a mnemonic. The Irish name was wearing an English skin when it was recorded for the Ordnance Survey. It seemed so reasonable that it escaped a deeper examination from later scholars who would give explanations and meanings for the Irish names of the Mournes. There seemed no need to explain a place-name which was already self-explanatory. Certainly the names of places and their meanings had been extensively examined by academics over the decades.

We owe much to the accomplished Irish scholar, John O'Donovan, for preserving for us the local places-names in Irish. O'Donovan was employed by the ordnance survey at Dublin to obtain the correct names of all the places for the ordnance maps of Ireland then being drawn up. For this work the engineers first visited every place and took down in a field-book from the residents, the names of every place. Afterwards O'Donovan visited each parish and corrected the spelling of the names in these books. One letter that he wrote from Newry to his superior, Thomas Larcom, at Mountjoy Barracks, Dublin, shows him conscientiously working on the names of Mourne.

> 'The names of the Mourne Mountains are very curious, but as Mr James has not his plans yet finished I cannot possibly know what names I am to get. He has furnished me with a perfect list of them as he could with a plan of their relative situations but I find that every *shoulder* on them bears a distinct appellation. Mr James shewed me the Boundary Surveyor's Sketch map of the Barony but the names of half the Mountains are not given.
>
> I shall obtain as many names as I can with their situations, but it is possible and very probable that I may omit some, but I expect to get the names of the most remarkable features as well (as) valleys and mountains.'[9]

I have wondered at some of the gaps in O'Donovan's local names, for being a great Irish scholar he would have certainly picked up the true significance of more of our neighbourhood names had they been presented to him. English names like Thomas Mountain, Millstone Mountain, Luke Mountain, etc., did not appear on O'Donovan's map of the Mournes. He greatly depended on the lists of names gathered by the survey officers and recorded his frustration to Headquarters at numerous omissions.

'It will puzzle me to ascertain the correct names of the Mourne mountains, and of others in this neighbourhood. The name Books do not give the whole of them, and I fear that I may omit some of them in despite of my most minute enquiries. Those who have surveyed the land and who therefore know every name that must appear on the face of the map should have furnished me with a perfect list of all the mountains, hills, Trig. Stations, rivers, streams, forts, rocks & in each parish, because I have no plan of any parish, and it is hard for any inhabitant to recollect all these names, without some such help.'[10]

When O'Donovan came to Newcastle he was let down when he sought this help.

'I have this day made a pilgrimage to the summit of Sliabh Domhanghairt. I have been induced to perform this pilgrimage from many motives. (1.) To endeavour to get the names of the Mourn (sic) Mountains from its lofty summit and for this purpose I have employed a guide, but in this I have been much disappointed...'[11]

Four years earlier when O'Donovan had joined the ordnance survey in October 1830, he began work examining the place-names of the northern counties. It was while working on the Derry names that he compiled a manuscript with the hefty title, *Glossary in which the disguised form of Irish words in their English dress are unmasked and their general and local meanings pointed out with observations upon the fluctuating state of the orthography and general and particular rules laid down to fix it drawn from analogy and approved custom*. How our knowledge might have changed had only O'Donovan been fortunate in acquiring a knowledgeable guide on his pilgrimage to the summit of Slieve Donard and been patient enough to stay with the man and hear what he had to say on the uphill climb. Obviously O'Donovan was never informed of the local name 'Lindsay's Leap' for I feel sure he would have perceived its full significance in the Irish had he heard it. On the journey to the mountain top however he was not side by side with his guide. Instead, as he says, 'I skipped from stone to stone with the agility of a goat, but was obliged to wait for my guide whom age had rendered less vigorous'. O'Donovan never heard the Irish name on his journey up the mountain; it was not listed in the ordnance survey name books; that night he was in Castlewellan and the following day in Downpatrick looking at place-names of Lecale. The chance to unmask any local words from their English dress was gone. Many others would subsequently draw upon O'Donovan's researches to provide lists of names with their English meaning. The most important of these were Canon Henry William Lett, Fr Bernard Mooney, Professor E. Estyn Evans and the Institute of Irish Studies at Queen's.[12]

Canon Lett, described by Robert Lloyd Praeger as 'an excellent companion, full of country lore and quaint experience',[13] read a paper on *Names of Places in the Mountains of Mourne* to the Royal Irish Academy in 1906.[14] He formed his list by taking all the names given on the 6 inch to 1 mile maps of the Ordnance Survey of County Down and collating them with O'Donovan's map and manuscripts, Williamson's map of county Down and other sources. Canon Lett

did not treat of Lindsay's Leap. In 1950 two works again looked at Mourne place-names. Fr Bernard Mooney produced his now scarce *The Place-names of Rostrevor* and professor Evans looked at the meanings of the place-names in an appendix in *Mourne Country*. Professor Evans expressed the hope that 'Father Mooney's valuable work in the Western Mournes will be extended over the whole range' but unfortunately it wasn't to be. Latterly the Northern Ireland place-name project, magnificently researched by the institute of Irish studies at Queen's, has given us a wealth of information. It is hardly surprising that Lindsay's Leap did not feature in these works. The Irish place-name was too well disguised.

Perceptive readers will already have noticed an incompleteness in the explanation so far. While the way to understand Lindsay's Leap was to look at it through the prism of Irish, I was just too pleased to notice that I hadn't finished. The omission was obvious but it was only when I was trying to give an explanation to a friend that the challenge came; 'what about the Leap?'

By way of preface to the next part it might be helpful to recall more modern mnemonics. Many English soldiers going over to France in the First World War substituted sound-alike English words in place of the French. This was a common practice among those who neither knew or spoke a foreign language and had no inclination to do so. Precision in language was sacrificed for an easily remembered approximation. Many of the mangled French expressions are now recalled with amusement. Thus, *très bien* became 'tray of beans'; *merci beaucoup* was changed to 'mercy buttercups'; and, my favourite, *je t'adore,* became 'shut the door'. A very common slang word used by the troops was 'napoo' for none left or finished. It was a corruption of *il n'y en a plus,* meaning there is no more. Of particular interest is how the strange sounding names of places were made more amenable. The most famous example is probably the change of Ypres to Wipers. Other towns that were changed were Wytschaete, a Belgian village on the ridge just north of Messines. It became White Sheet. Étaples, an important transit port in the Pas-de-Calais, became Eat Apples and Auchonvillers, a village in the Somme region north of Albert, became Ocean Villas. The same process was at work here in the seventeenth century when Scotch and English speaking settlers arrived during the plantation of Ulster.

I will always remember how the final piece of the puzzle fell into place in the early morning of 13th October 2010. It was while writing that a single Irish word came to mind that made sense of everything. The words of Lindsay's Leap converged with Elizabethan fiants, topography, research and Irish to give me the happy solution of *linn an tsléibhe leacht*. The missing word that ultimately was transposed into the English 'Leap' was *leacht,* the Irish for 'monument'.[15] It wasn't just this word that came to mind but also the realisation that to capture closely the sound of the Irish, Lindsay's Leap was, as the name Lindsay itself would suggest, pronounced in the broad brogue of a Scottish settler.[16] Think Ballymena

This massive stone has been carefully aligned by Neolithic man to face towards the summer solstice and out over the hunting grounds at Murlough. It is an outstanding addition to Newcastle's antiquarian heritage

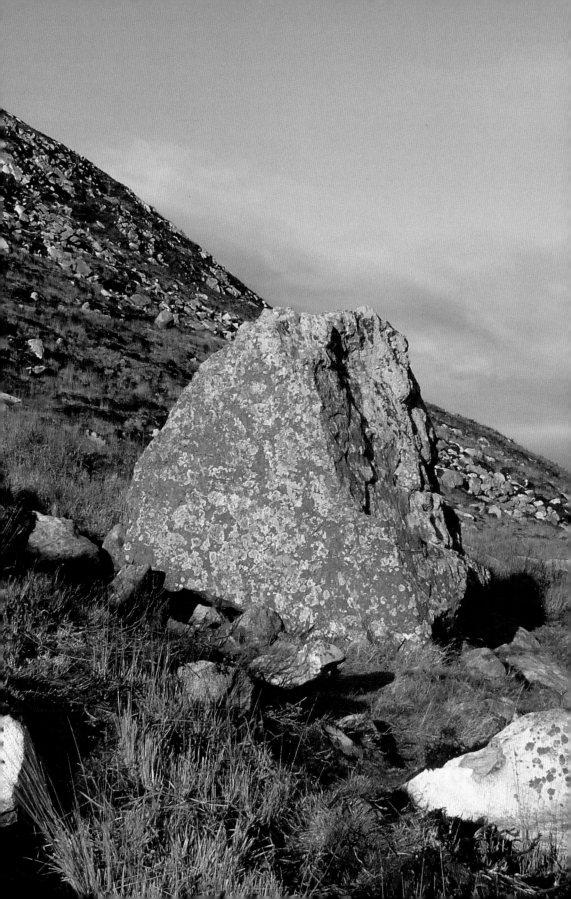

The monument stone is on the left and beyond is a remarkably flat area which may hold archaeological promise for the future

hey; or better still, if you have ever heard two people from Annalong talk on the bus, you will know the mystification of trying to understand a very broad accent. The original 'Leap' of Lindsay's Leap would have sounded much closer to that part of the anatomy on which a computer rests and accorded therefore very closely with the Irish *leacht*. The full meaning of Lindsay's Leap as derived from the Irish was 'the pool of the mountain monument'. The monument was none other than the magnificent standing stone I had thought of as *An Chathaoir Mhór*, the Big Chair, only about fifty metres from the pool in the stream. The ecstatic realisation that the answer to Lindsay's Leap had been found brought a simultaneous realisation that it was also the answer to Shyleke, *sithe leacht*, mentioned in the Elizabethan fiants. Further, this was a Neolithic monument that remained undocumented.[17] What a magnificent monument it was too. What better hiding place could it have had from the eyes of earlier antiquarians than being on a mountain-side of boulders.[18] *An Chathaoir Mhór* was actually and quite literally an outstanding addition to Newcastle's antiquarian heritage.

Three months later in January 2011, a second, if belated, pleasing insight came to mind. If the early planters amended one name from the Irish in a loose phonetic way, why not others? I checked the *Place Names for Northern Ireland; The Mournes*. Referring to Thomas Mountain it stated:

'This name appears to be of comparatively recent origin. O'Donovan refers to both it and Millstone Mountain as 'two very high mountains situated at the base of Slieve Donard to the north-east and north, and originally considered

a part of it, before these mountains received separate names'. Unfortunately, there is no record of the Thomas from whom it derives its name.'[19]

Much the same was said of Luke's Mountain at the back of Tollymore Park. 'It is quite likely to be of comparatively recent origin but the identity of the Luke from whom it derives its name is a mystery'.[20] In their present form these names are indeed comparatively recent. We all have been diverted by the assumption that the names for these mountains were derived from actual people, Thomas or Luke, whose details had been lost in history. The names of these mountains however, have been transposed, like Lindsay's Leap, from the original Irish into English sound-a-likes. Luke's Mountain could be a phonetic simulation of *luachair*, meaning rushes, or possibly from *lóiche* meaning 'light', or *luigín* meaning a hollow, referring to the depressions on the summit of the hill which are usually water filled small ponds. Deciphering mnemonics therefore, is far from being exact and one man's guess is as good as another's. Thomas Mountain could indeed be said to be a promontory or projection from Slieve Donard but rather than being an unnamed part it always was recognised by the Irish as distinct and worthy of its own name. There was a wonderful moment of excitement when I realised that Thomas Mountain was an English substitution for the Irish *Sliabh an Tuama*, meaning literally 'mountain of the tomb'. The *an* in the Irish name would be elided in normal speech. In my excitement I was rather carried away and started clapping my hands not realising the noise I was making until my mother's concerned voice called from another room, 'Do you want me?' I now had further corroboration that *An Chathaoir Mhór* at the foot of Thomas Mountain was a tomb monument. Tuam in Co Galway has the same derivation. In the annals it is referred to as *Tuaim da ghualann*, the tomb of the two shoulders, from the shape of the ancient sepulchral mound from which the place took its name.[21] It was now time to have a closer look at the morphology and general surroundings of this remarkable stone.

An Chathaoir Mhór is situated on a tiny level platform of rough mountain pasture which then slopes down sixty metres towards the precipitous edge of the quarry at Newcastle. Behind it rises the steep face of Thomas Mountain. About thirty metres to the west, and slightly higher than the stone, is a small but remarkably level platform which, after being viewed from above, may have the potential of further exciting discoveries. The present state of knowledge does not allow any claims for this flat area, the very presence of which is quite extraordinary on the steep slope of Thomas. Whether it was ever used for habitation or ceremonial purposes must be left to future archaeology. Since my searches had begun with Shyleke in the Elizabethan Fiants, *sithe leacht* in Irish, I would append a rider to the meaning of *sidh* as interpreted by Bishop Reeves. Professor Glyn Daniel of Cambridge university added an important editorial note at the side of the text when preparing George Coffey's 1912 work on *Newgrange and other incised Tumuli in Ireland* for re-publication in 1977.

'*Sid* or *Sidh,* was anciently applied to a hill or mound, the interior of which was supposed to be inhabited by fairy folk, who were called *sidhe* (pronounced shee-e). It appears also to have meant 'a caved hill' and is considered to signify 'a burial place'.[22]

The implication of this is the chance of a lost 'caved hill' in the vicinity. To this interesting speculation could be added an extract from the Annals of the Four Masters under the year 861.

'Amhlaeibh, Imhar, and Uailsi, three chieftains of the foreigners; and Lorcan, son of Cathal, lord of Meath, plundered the land of Flann, son of Conang. The cave of Achadh-Aldai, in Mughdhorna-Maighen; the cave of Cnoghbhai; the cave of the grave of Bodan, i.e. the shepherd of Elcmar, over Dubhath; and the cave of the wife of Gobhann, at Drochat-atha, were broken and plundered by the same foreigners.'

Cnoghbhai and Dubhath have been identified as Knowth and Dowth on the river Boyne and the gaelic scholar John O'Donovan thought the third cave might be Newgrange though he did so cautiously, saying 'it is highly probable, if not certain'. Mughdhorna-Maighen, he said, was situated 'in the barony of Cremorne, in the county of Monaghan'. A tribe of Mughdohorna, however, moved from there to here and the name of 'Mourne' was thus applied to this area.[23] The conjecture raises a possibility, however tenuous, that the cave of Achadh-Aldai in Mughdhorna-Maighen might possibly relate to an undiscovered passage grave in Mourne raided by the foreigners. Speculation aside, and in the absence of good sound facts which can only properly come from a professional archaeological examination of the area, I hold on to my intuition that this level spot may have more to reveal. Indeed, with water nearby and steep slopes offering good protection to front and rear, the level area would also be an ideal location for the *Dun Íomhar* noted by O'Donovan in his survey notebook around 1834.

To the east about fifty metres is the mountain stream, Amy's River, draining the heights of Millstone and Thomas Mountains. The northern facade of the stone faces towards the summer solstice and also towards Murlough and Dundrum inner bay, a known settlement area. The ground in front of the stone then slopes down towards the quarry and the vista that unfolds before the visitor is breathtaking. With one's back to the stone the scenic view unfolds starting on the left with Slieve Croob in the distance, then Castlewellan Castle, the spire of St Malachy's Castlewellan and the finial tip of St Paul's. Most of lower Tullybranigan can be seen but not St Colman's or Curraghard. The entire pastoral scene is there from Castlewellan to Dundrum and Newcastle is still close enough to pick out individual houses. Below we see the playing pitches in Donard demesne and part of the upper field where the Americans had their camp during the war. We see St John's Church and the swimming pool as well as part of the roof of Shimna integrated college. The expanse of Dundrum Bay unfolds with the Isle of Man in the distance. To the right the stile at the top of the granite trail

The monument is on the bottom right. An interesting juxtaposition of stones present themselves on the flat area in this view taken from above

can be seen but the harbour is masked by the trees. Time was suspended and I was lost in admiration at the beauty before me.

The monolith is of Silurian shale. There is no incongruity about this huge shale stone being above the granite quarry. It is not an erratic block transported here by ice but has tumbled from the summit of Thomas mountain where the last thirty metres or so of the mountain still retains the shale cap over the underlying granite. The shale stones on the mountain side are easily and quickly distinguished from the many granite boulders by the lovely lime green lichen which profusely favours the shale. Other large shale boulders are found on the west side and one about twenty metres towards Castlewellan direction on the edge where the slope falls markedly away. Only an archaeological examination of the area would determine if any of these have significance as satellites but the presumption must be for the time being that they are just random falls. There is no sign of there ever being a circle of stones around it or evidence of any cairn. Had there been a stone circle the significance of this megalith would have been apparent long before now. We are also fortunate in a sense that the stone was shale as it was thus spared the attention of the stone-men who are known to have cleared several standing stones and megaliths in Mourne. As professor Evans described it: 'Many once familiar landmarks were destroyed and a litter of granite chips is their only memorial'.[24]

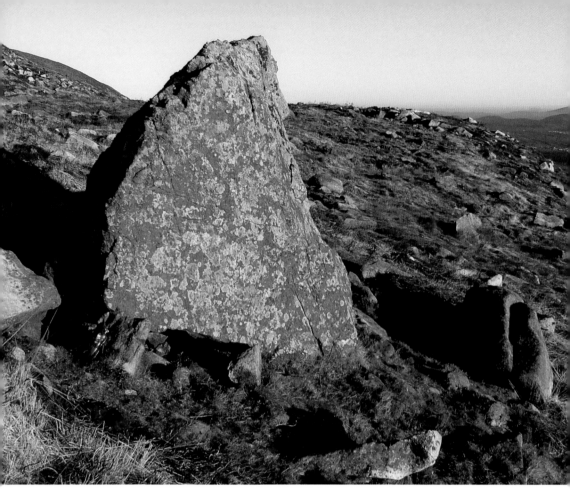

This wedge stone at the back of the monument has been used to fix the huge boulder in a very precise and symmetrical upright position. It also allows you to look underneath and through to the other side

The stone measures 285cm in height at the front (9 feet 4 inches) and has a distinctive thin sloping ledge of between 20 to 25cm width about a metre above the ground which descends to an attainable perch at a height of 75cm on the west side. It is this characteristic ledge at the front which gives the megalith the appearance of a chair. Indeed, as the rock continues to rise a further 180cm above the seat, it has all the grandeur of a high backed throne. Looked at from the front, the stone is wedge shaped, both sides being quite flat. The megalith is quite sloped at the back and it is possible to scramble up onto the top because of the rising ground at the rear. Taking a measurement about 60cm above the ground, this megalith has a circumference of 785cm or 26 feet. *An Chathaoir Mhór* worthily deserves its name as 'The Big Chair'.

One of my first impressions of this megalith, before its importance was known, was of surprise at its upright posture. The presumption is that it covers one or more burials although there is no recognisable chamber structure below.

The bottom of the megalith is flat. It is above ground to the extent that one can put an arm full length underneath it and even see right through from the east side the two metres to the west side. It is not a boulder burial, however, after the class of Irish field monument intimately associated with Cork and Kerry.[25] The base of the monument has contact with at least half a dozen stones both underneath and at the back, but the most striking stone is the one at the back left which serves as a wedge. Placed just under the rear corner to steady the megalith, it gives a pleasing symmetry to the shape of the monument when viewed from the front. It is at this east side that one can lie down and have a good look underneath. The sheer weight of the huge megalith above locks the stones below into a solid mass safe from treasure seekers. But who in their right mind would dare try compromise the stability of the supporting stones and risk being immediately crushed by a shifting megalith? I must leave it to others to give an accurate estimation of the weight of this megalith but reflecting on the size of the capstone of Goward dolmen which is reputed to be in the region of fifty tons, then the monstrous size of this stone must command a very healthy, indeed an awesome respect. Very many men must have been involved just to move the megalith for the final positioning of the wedge stone never mind raising the megalith to its upright position and moving it around so that the little seat would face to the front and supposedly allow the spirit of the deceased the happy contemplation of the wonderful view.

The monument lies about 270 metres above sea level. It is best reached by going up the granite trail above the harbour, over the stile and then up the path, formerly the bogie track, to the quarry. Such is the magnificent size of this stone that once one knows where to look on the mountain, the megalith can be seen with the naked eye even from the front of the old railway station. This, though, is easier done on a summer morning when the sun shines on the front of the mountain. A careful scramble up around the quarry brings one to the mountain stream where the pool of *linn an tsléibhe* is to be found and the monument is a stone's throw across on the other side. It is a walk which richly rewards the effort to get to the top. To perch on the ledge at the front of *An Chathaoir Mhór* and quietly absorb the beauty below is to find the true treasure here that can never be stolen. Sit and enjoy.[26] May you have the blessing from the wishing cup of Tutankhamun which was appropriately carved on the gravestone of Howard Carter in Putney Vale cemetery, London.

> 'May your spirit live,
> May you spend millions of years,
> You who love Thebes,
> Sitting with your face to the north wind,
> Your eyes beholding happiness.'

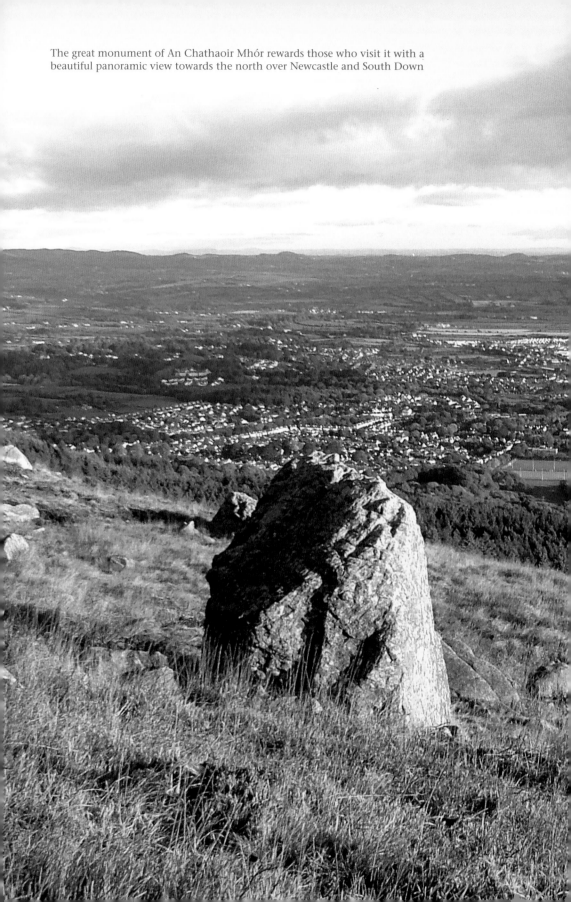

The great monument of An Chathaoir Mhór rewards those who visit it with a beautiful panoramic view towards the north over Newcastle and South Down

NOTES

CHAPTER 1

Getting to the top of Slieve Donard

1 The bridge at the bottom of King Street which supports the main road to Kilkeel was formerly called Condy's bridge after Mrs Condy who lived nearby at Glenada Terrace. It is referred to by this name in the minutes of Newcastle urban council.

2 John O'Donovan to Thomas A. Larcom, 23rd April 1834, from *Ordnance Survey Letters Down*, edited by Michael Herity, published by Four Masters Press, 2001.

3 'Kilkeel, Newcastle, Bryansford and Castlewellan' (from a roving correspondent of the Daily Telegraph). In the *Down Recorder*, 29th August 1874. The Mourne Observer recorded a feat of a different kind in its issue of 12th August 2009. Three year old Gemma Peters from Dundrum, to the great pride of her accompanying parents, made it all the way to the top of Donard under her own steam on Wednesday 29th July 2009.

4 The horse races took place on what was then known as either the front or the back shore. As most Newcastle houses in the 1800s were at the harbour, that part of the beach then in front of them, i.e. from the mouth of the Shimna to the harbour, constituted the front shore, while the part furthest away, from the Shimna northwards to Dundrum bar was known as the back shore. It was the back shore that was the favourite location for the horse racing. The dropping in later years of horse racing from the day's sport was probably due to the strong rise in the county at the turn of the century of the anti gambling league.

5 In trying to compare this first race with later ones much depends on the course. Because the competitors raced off 'up the street', one might assume a start at the Annesley tourist centre as at present but it could just as properly have been at the harbour. The exact starting and finishing place, it is important to say are not mentioned. The verbatim report is, 'At the word 'go' the crowd rushed off like mad, most of them tearing up the street and on to the quarry road. A few took a near cut and clambered over the demesne wall. Trimble was in the van, closely followed by Johnston, which pair scaled the rib of Thomas Mountain, crossed the glen and were first to arrive at the summit. Next were Parkinson, McPoland, and Carlyle after whom at intervals came T. McLelland, McWilliams, McCourt, Skillen, Mooney, Smith, Waller, McKibbin and Clarke. The remaining fifteen were weeded out from the exhausting ordeal and returned at leisure. Trimble and Johnston kept together in the descent and when the former emerged on to the road he was a minute ahead of his companion. This lead he maintained to the close.'
Down Recorder, 11th July 1903.

6 Deon McNeilly's winning times for the Slieve Donard race over the years are given in the *Mourne Observer* 24th June 2009. A list of all the winners of the race since 1945, together with their times, is given on page 54. It was only in 1975 that timekeepers started to be more precise and included the seconds.

7 'Bogman's' report of the Slieve Donard race for 2010 appeared in the *Mourne Observer* on 30th June 2010, pages 62–63. Ninety-two runners recorded a time to the summit that year of under the magic hour.

8 The problem of comparing records between races that ended at Donard Park and those that now end at the Annesley Buildings is especially poignant in regard to the descent record. Ian Holmes, three times British champion from Bingley in Yorkshire, won in 2000 with the incredible descent time from the summit to Donard Park of 14.16 minutes.

9 The leader in the *Down Recorder*, Saturday 13th December 1902.

10 *Official Guide to Snowdon by the Snowdon Mountain Tramroad*, printed by Tom Litherland, Carnarvon. No date. Also: *Snaefell Mountain Railway, 1895–1955*, printed by the Light

Railway Transport League in conjunction with the Manx Electric Railway, London, July 1957. Also locally, D.B. McNeill, *Ulster Tramways and Light Railways,* W. & G. Baird, Belfast, 1956.

11 The clerk, Daniel Curran, was formerly stationmaster at Tullymurry on the Belfast & County Down line between Downpatrick and Newcastle.

12 Heading in *Sunday Dispatch* 14th April 1957.

13 These remarks by Mr Fred Wadsworth were supplemented in a similar vein by comments from the town clerk J.R. Watts, from Rosina Bennett, Anne McCance, Jean Robinson, Archie Cairns then council chairman, Mary Magill, Connie Connolly, Phil McGrath, and Violet Fitzpatrick. *Sunday Dispatch* 14th April 1957.

14 *'Scenic railway to top of Slieve Donard would cost £117,000 plus',* heading in the *Mourne Observer,* 7th June 1963. British Chairlifts Ltd., who gave the quotation even suggested early and late season charges as follows (prices pre decimal); 7/6 single and 10/- return; peak season and weekends, 10/- single and 15/- return; children half-price. The firm reckoned on an operating and maintenance cost at that time of £3,260 per annum.

15 *'Newcastle still hopes for chair-lift helping hand',* heading in *News Letter,* Thursday 25th July 1963. Figures showed that if the cost of the annual maintenance was to be borne by the town it would put up the rates by 1s 4d.

16 *Mourne Observer,* 5th Nov., 12th Nov., and 19th November 1965.

17 The author's father, Patrick Curran, was then the local correspondent for the Northern Whig, Telegraph, Irish Press and Independent and personally witnessed the journey of the Haflinger to the top. While fortunate to have his recollection of this unique event which must have taken place in the late 1950s or even at the start of the sixties, it has been a point of frustration to have searched extensively without finding the date it took place. This joy awaits another.

18 The period of construction for the ice-house is as given on the information board near the top bridge of the Glen River. There is no mention of the ice house construction in the letters of the Rev John Robert Moore who was trustee for the Annesley estate during the fourth earl's minority (ie up until 21st February 1851). Lady Annesley is known to have kept a modest table and certainly never served alcohol with meals. It is unlikely that she who gave away so much to relieve distress among the people during the famine and was not known for hosting grand social gatherings at Donard Lodge, would have contemplated the building of what would have been regarded as an extravagant luxury. The ice-houses at Donard Lodge and Castlewellan are likely to have been built by her son, William Richard, 4th Earl Annesley, after his coming of age.

19 Chapter on the Ice House in *Take a Second Look Around County Down,* by Noel Kirkpatrick, p. 212–215, Alkon Press, Comber, 1993.

20 Chapter 10, Giants' Graves, in *Mourne Country,* p. 85.

21 *Report on the Botany of the Mourne Mountains,* Samuel Alexander Stewart and Robert Lloyd Praeger, Proceedings of the Royal Irish Academy, February 1892.

22 Slieve Muck is usually understood as 'mountain of the pigs' (see *Place-names of Northern Ireland,* page 159). We are reminded however, in the Irish dictionary of Fr Dinneen that the Irish word *muc* can be anything resembling a pig and he mentions 'a wrinkling of the brows'. The dominant feature of Slieve Muck is the extended scarp face and it would seem that this has been regarded as a pig-like wrinkling on the face of the mountain, hence the name. Slievenamuck a little further north overlooking Spelga Dam is certainly 'mountain of the pigs.'

23 Ireland's Mammals: an annotated list (Paddy Sleeman and Derek Yalden); the final chapter in *From Bann Flakes to Bushmills,* Oxbow Books, Oxford, 2009. See also: *Wild boars raise question of nationality,* by Michael Viney in *The Irish Times,* Saturday 23rd January 2010.

24 'Giants' Graves', chapter 10 of *Mourne Country,* page 86.

25 John O'Donovan to Lieut. Thomas Larcom, Dublin. Letter from Castlewellan, April 21st 1834 and another on Tuesday 23rd April 1834 (the day he climbed Slieve Donard). See Michael Herity's *Ordnance Survey Letters Down,* Four Masters Press, Dublin, 2001, p.54.

26 Walter Harris, *The Antient and Present State of the County of Down,* pp 121–122, Dublin, 1744.

27 Well on top of Donard; see *The correspondence of Mary Delany, 1731–68,* p 226 in *Letters from Georgian Ireland,* by Angélique Day, Friar's Bush Press, 1991.

28 Rev Francis Chambers, *'Anecdote of Tobermoney and Neighbourhood'* [original manuscript held by Down County Museum]. From this manuscript F.J. Maxwell submitted an extract, *'An Extraordinary Day's Walk'*, which appeared in *Lecale Miscellany*, p 29, No 10, 1992. Isle-a-Long was formerly a variant of Annalong. See 'The element *island* in Ulster place-names', *Ainm iv* ,p 200–210, by M.B. Ó Mainnín, 1989–90.

29 John O'Donovan to Lieut. Thomas Larcom, Dublin. Letter from Castlewellan, April 21st. See Michael Herity's *Ordnance Survey Letters Down*, Four Masters Press, Dublin, 2001, p.55. The italics in the quotation are O'Donovan's emphasis.
 Sir William Petty (1623–1687), was physician-general to Oliver Cromwell's army. Between 1655 and 1656 he mapped Ireland so that those who lent funds to the army might be repaid in land. This project became known as the Down Survey because the results were set down in maps. This work was later published in 1685 as *Hiberniae Delineatio*.
 John Colgan (Seán Mac Colgáin, ?1592–1658) was a Franciscan hagiographer. He edited the collections of material on the ecclesiastical history of Ireland. In 1645 he published *Acta Sanctorum Veteris et Maioris Scotiae seu Hiberniae, Sanctorum Insulae*, on the saints whose feast-days fell in the period 1st January to 30th March. St Donard's feast is 24th March. Colgan's work drew attention to the scholarship, richness and detail of Irish ecclesiastical records.

30 *Black's Picturesque Tourist*, p.360, by Adam and Charles Black, Edinburgh, 1884. This was the 18th edition, the first being in 1854.

31 *Down Recorder*, 30th June 1860.

32 *Ibid* 29th June 1861.

CHAPTER 2

Slieve Donard a Place of Pilgrimage

1 Peter Harbison, *Pilgrimage in Ireland: the monuments and the people*. p. 70

2 The reader is referred to Máire MacNeill's magnificent work, *The Festival of Lughnasa*, Oxford University Press, 1962 (reprinted in 1982 & 2008). Pages 84–96 deal with Mountain Pilgrimages and Slieve Donard in particular. For anyone who wishes to learn about St Donard, this is the place to start. She has gathered here from earlier works all references to the saint, mythical or otherwise, and is most deservedly praised for her 'exemplary scholarship'. Máire died in 1987.

3 Tomás Ó Fiaich, *The Celts, 1*, p.31, chapter two of *The People of Ireland*, Appletree Press, Belfast, 1988.

4 Rev James O'Laverty, *An historical account of diocese of Down and Connor*, Dublin, 1878. Vol 1. p 38.

5 *Connecting the mountains and sea: the monuments of the eastern Irish Sea zone*, by Vicki Cummings, a contributory article to *The Neolithic of the Irish Sea; Materiality and traditions of practice* edited by Vicki Cummings and Chris Fowler, published by Oxbow Books, Oxford, 2004.

6 Morton, Dr WRM, *Unurned Cremations from Site l, Dundrum Sandhills*, Ulster Journal of Archaeology, Vol 22.

7 The possibility of hill exposure for the dead was raised by Peter Woodman, professor of archaeology at University College, Cork. Well known for his excavation of the Mesolithic site at Mountsandel beside the Bann, he also wrote and introduced the television series *From Stone to Stone*. He carefully avoided claiming hill exposure of the dead for the top of Donard, possibly being content that such an inference would be made by his mention of Slidderyford dolmen. The quotation is from Peter Woodman's chapter *Prehistoric Settlers*: page 17. From *The People of Ireland*, Ed. Patrick Loughrey, Appletree Press, Belfast, 1988.

8 Colgan's *Acta Sanctorum Hiberniae* was printed in Louvain in 1645. This passage was one of the motives for the Irish scholar John O'Donovan making a pilgrimage himself to the top of Donard in 1834. He quoted Colgan's lines to his superior at the Ordnance Survey, Phoenix

Park. The parts in italics are therefore O'Donovan's emphasis. *Ordnance Survey Letters Down,* page 54, by Michael Herity, published by Four Masters Press, Dublin, 2001.

9 Walter Harris, *The Antient and Present State of the County of Down,* p. 121, Dublin, 1744.

10 Rev John Dubourdieu, *Statistical Survey of the County of Down,* p. 287, Dublin 1802. The Irish scholar John O'Donovan recorded his low opinion of Dubourdieu in a letter of 15th April 1834. 'I have called this morning upon Rev John Dubourdieu, Rector of Drumballyroney and Drumgoolan, and you will be surprised when I say that I have been quite disappointed in him. He is now a very old grey headed, peevish man, and a haughty, aristocratic, half-civilized, self-sufficient little bit of an Irish Frenchman … . I was never so disgusted with any little *Cur, whelp,* or *pup* in all my life. His petty aristocratic assumptions and ungentlemanly remarks had a very disagreeable effect upon my sensitive nerve.'

11 Whitley Stokes, *Félire Oengusso: The Martyrology of Oengus the Culdee,* printed by Henry Bradshaw Society, London 1905.

12 Prof E.Estyn Evans on page 86 of *Mourne Country,* speaking about the lesser cairn on Donard mentions that 'the smaller stones of the cairn have been piled into a number of small 'cairns' round about'. Prof Evans regarded the summit cairn as 'a corbelled passage grave of the early Bronze Age' although 'all that can now be seen of the grave or 'cell' it once covered are two parallel rows of upright slabs, possibly part of the passage that led into the grave'. I could not find the parallel rows of slabs.

13 Field work was undertaken at St Mary's, Ballaghanery, in 2006 by the Ulster Archaeological Society. For their report see *Field Surveys undertaken by the Ulster Archaeological Society in 2006,* by Henry Welsh co-ordinator. Ulster Journal of Archaeology, Vol 67, 2008, pages 187–192.

14 *The Post-Chaise Companion or Travellers Directory through Ireland,* by W. Wilson, printed at 6, Dame Street, Dublin, 1786. The Dublin to Downpatrick road is described in the columns of pages 14–17.

15 Note on Slieve Donard, page 252 of *The Parliamentary Gazetteer of Ireland, 1844–45, Vol 3, N-Z.* A. Fullarton & Co., Dublin, 1846. The same tome carries sixteen entries for Newcastle in Ireland. Our own 'small sea-port town in the parish of Kilcoo' was described at that time as 'now a thriving village, but which not very long since, consisted of a few fishermen's huts scattered at random along the beach, wherever the convenience or fancy of the owner suggested.'

16 *Beatty's Guide to Newcastle and Vicinity,* p. 16, R. Carswell & Son, Belfast

17 *The excavation of a burnt mound at Rossmacaffry, County Fermanagh,* by Brian Sloan, page 19 of UJA, Vol 66, 2007; also *The excavation of a burnt mound at Ballywilliam, County Down,* by Robert M. Chapple, pages 21–39, in the same issue. See also *A Cooking Place at Fofannybane, Co Down,* by Richard Warner, Vol 4, 1991, in *12 Miles of Mourne.*

18 *Excavations and experiments in ancient Irish cooking places,* J. O'Kelly, JRSAI, 1954

CHAPTER 3

Smugglers on the Mountains

1 *The topography of Ireland,* by Giraldus Cambrensis, from chapter 5, page 21 of Thomas Wright's edition of 1863.

2 *Four Shots from Down,* Francis Joseph Biggar, p 45. A 'tun' was the largest barrel size and held 210 imperial gallons or 955 litres. Shane O'Neill's stock of over two hundred tuns would be in the region of 200,000 litres of wine.

3 French wine at 5d a bottle; see *The correspondence of Mary Delany, 1731–68,* p 210 in *Letters from Georgian Ireland,* by Angélique Day, Friar's Bush Press, 1991.

4 For a complete picture on the trade and trends in smuggling see *The smuggling trade in Ireland in the eighteenth century,* by L. M. Cullen, TCD, a lecture given to the Royal Irish Academy [Volume 67, Section C, No 5], and published March 1969.

5 The glory days for smuggling from the Isle of Man ended with the Revestment Act of June

1765. By this Act the British purchased the rights of the island from the Duke of Atholl. After that the king's custom officers had power to search all ships and to seize goods on the island that had been landed without payment of duty. The Isle of Man continued to be involved in 'the trade', though on a far smaller scale.

6 *The Isle of Man in Smuggling History*, by Francis Wilkins, page 12, published by Wyre Forest Press, 1992.

7 Chapter Xl, 'Traders and Smugglers', p.115–118, in *A History of The Isle of Man*, by R. H. Kinvig, University Press of Liverpool, 1950.

8 Fuller details on Richard, 2nd Earl Annesley, builder of the old quay, are in *Where Donard Guards*, page 83–89, Ballaghbeg Books, 2007.

9 *19th Century Coastguard Stations in Mourne*, Denis Mayne, p 13 of Vol 7, Journal of the Mourne Local Studies Group, 1996.

10 Limitations at the coastguard station: The following from a letter of Annesley's agent, James Moore-Garrett, to McSpadden the foreman carpenter, dated 23rd February 1893: 'Dr Magill says earth closets will do for the Widows' Row. All you have to do is put a seat in each yard in a shed and a bucket under it. See the arrangements at the Coast Guard.'

11 Prof. Evans mentions 'there are two smaller caves nearby which appear to have been used only by sheltering sheep'; see reference following.

12 *Mourne Country; Landscape and life in South Down*, page 173, by Prof. E. Estyn Evans, Dundalgan Press, Dundalk, 1951. Chapter 18 is on 'Pedlars and Smugglers'. Speculation that the smaller hole 'may have been the socket for holding some signalling device' can now be laid to rest.

13 It was important for the smugglers to hide their signalling fire as the penalties on being caught were very severe. The following from George 1V, Cap 53; *An Act for the Prevention of Smuggling*. [28th August 1833].
 'And be it further enacted, that no person shall, after sunset and before sunrise between the twenty-first day of September and the first day of April, or after the hour of eight in the evening and before the hour of six in the morning at any other time in the year, make, aid or assist in making, any signal in or on board or from any vessel or boat, or on or from any part of the coast or shore of the United Kingdom, or within six miles of any part of such coasts or shores, for the purpose of giving any notice to any person on board any smuggling vessel or boat; ...and it shall be lawful for any person to stop, arrest, and detain the person or persons who shall so offend, and to carry and convey such person or persons so offending before any one or more of His Majesty's Justices of the Peace...and it shall not be necessary to prove on any indictment or information that any vessel or boat was actually on the coast; and the offender or offenders being duly convicted thereof shall...either forfeit and pay the penalty or forfeiture of one hundred pounds or, at the discretion of such court, be sentenced or committed to the Common Gaol or House of Correction, there to be kept to hard labour for any term not exceeding one year.'

14 *Place-Names of Northern Ireland, Vol 3, The Mournes*, by Mícheál B. Ó Mainnín, page 145. Without Ó Mainnín's erudite explanation of the Irish name, I could not have appreciated the synecdoche of the smugglers' hidden hollow becoming the source of the name for the whole mountain. Ó Mainnín remains true to the meaning of the Irish in explaining Leganabruchan as a 'depression on a shelf projecting from Millstone Mountain'. Millstone mountain is still a fair distance away and the 'depression' is less than two metres across. Happy hunting for it.

15 The place-names in Irish were gathered by John O'Donovan for the ordnance survey in April 1834. *Ordnance Survey Letters Down*, Edited by Michael Herity, Four Masters Press, Dublin; 2001.

16 *Mourne Country; Landscape and life in South Down*, page 173, by Prof. E. Estyn Evans, Dundalgan Press, Dundalk, 1951.

17 Page 27, *County Down Guide and Directory*, George Henry Bassett, Dublin 1886.

18 *Take a Second Look around County Down* by Noel Kirkpatrick, chapter 12, pages 223–224, Alkon Press Newtownards, 1993.

19 George 3rd, Cap 121, section 5 of 'An Act to make further Regulations for the Prevention of Smuggling'. [12th July 1819].

20 Ibid: Cap 121, section 4.

21 See *King's Cutters and smugglers, 1700–1855,* by E. Keble Chatterton, printed by George Allen & Co., London, 1912. The author drew on the records of the Board of Customs and has much useful information on the ships of the revenue service.

22 *Shipwrecks of the Irish Coast,* vol 2, covering the years 932–1997; printed by the author, Edward J. Bourke, 1998.

23 Besides the words of caution about climbing in the Smuggler's Hole, it is important to mention that access is really only safely made coming round nearby rocks at low tide. Great care must be exercised to avoid being stranded by quickly rising waters as the surrounding cliffs which made this place so secluded for the smugglers also militate against escape. Please do take care. The sea is dangerous.

24 Smugglers have come and gone like the tides and left little trace of their passing. The explanation of the use of the ramp at the Bloody Bridge is, however, only a theory and there is no means of proving whether or not it is correct.

25 The law sought to frustrate smuggling by requiring ships to carry their cargo in bulk. Spirits had to be in casks of not less than sixty gallons and tea and snuff were not allowed in any cask or package that weighed less than four hundred and fifty pounds weight (205 kilos) on penalty of seizure of the boat and the entire cargo. Those on board were 'liable to all the pains and penalties and shall and may be detained, prosecuted, convicted, or delivered over to His Majesty's Navy'.
 George 3rd, Cap 121. *An Act to make further Regulations for the Prevention of Smuggling.* Printed by George Eyre and Andrew Strahan, printers to the King's most excellent Majesty. London 1819.

26 For many of the tricks, techniques, deceptions, disguises and general ingenuity brought to bear on the system of smuggling see, *Smuggling Days and Smuggling Ways, or the story of a Lost Art,* by Lieut Henry N. Shore, RN, printed by Cassell & Co., London, 1892. This naval officer was able to draw on the fruit of his experience as inspecting officer of coastguard for eight years.

27 The beginning of 'The Smugglers' Pad' from *Ballads of Mourne,* p 32, by Richard Rowley, printed by Dundalgan Press, Dundalk, 1940.

28 Blue Lough as described by Jack Loudan in his book on the history of the Belfast water supply, *In Search of Water,* chap 6, The kingdom of Mourne, p 83.

29 The story of the battle of Kilkeel is documented in *Margaret O'Mourne,* page eight, by W. J. Fitzpatrick, printed by the Mourne Observer in 1963. Miss Margaret McCartan, or 'Big Margaret' as she was known, lived at Moneydarraghbeg, Annalong, and was 83 years old when she died on 6th December 1936. She had a very retentive memory and was an authority on local legendry lore. The author's great, great, great aunt, Margaret Sawey, married into the clan. 'Big Margaret' and her brothers are buried in Ballymartin churchyard.

30 The smugglers' cave made it into the 2010 Mourne climbing guide. Referring to the Percy Bysshe rockface it said: 'It is probably better known for its small hidden cave than for the rock climbing'. *Rock Climbing in the Mourne Mountains,* page 84, published by Mountaineering Ireland, Sport H.Q., Dublin 12.

31 I am indebted to the scholarship of L.M. Cullen who culled these names and others from customs records in the public records office. I quote directly from p 86 of his chapter *Smugglers in the Irish Sea in the Eighteenth Century,* which is found in *The Irish Sea; Aspects of Maritime History,* edited by Michael McCaughan and John Appleby, Institute of Irish Studies, 1989.

32 Details of Jeremiah Atkinson's appointment as captain in Annesley's yeomanry are given in *Where Donard Guards,* pages 7–9, Ballaghbeg Books, 2007, including an illustration of his name chiselled onto the standing stone at the Flush Loney.

33 Concluding verse of Richard Rowley's poem, 'The Smugglers' Pad' from *Ballads of Mourne,* p 32, Dundalgan Press, Dundalk, 1940.

34 The seizure of smuggled goods at Ballyhalbert was reported in the *Down Recorder* on 28th January 1937. Captain John Mitchel and his men of the Cloughey station made the seizure 'on the coast', ie. just when the smugglers were at their most vulnerable. The goods were transferred to the customs house, Belfast.

35 Prices at Downpatrick in 1770 are from the *Down Recorder* 8th June 1850. You could then also buy gin at 4s 4d a gallon, brandy at 5s a gallon, a quart of beer for 3d, sugar at 9d a pound, salmon at 2½d a pound and coffee for 6d a pound.

36 Alex Forrester, retailer of superior teas at 8, High Street, Belfast, listed the prices of all his teas by advert. Statistics of consumption of tea in Belfast as listed in the *Down Recorder* for 18th August 1855, show that 1,162,674lbs had thus far been used in the town since the start of that year.

37 The discovery of the smuggler's cave at Kilkeel was reported in the *Down Recorder* 18th January 1868.

38 Article in the *Down Recorder* 23rd June 1838: *'Duties on brandy in Great Britain and Ireland – Quantities consumed'*

39 Ibid.

40 The gentry were not averse to having and using poteen. The long trusteeship of the Annesley estate by Rev John Robert Moore ended when William Richard, 4th Earl Annesley came of age on 21st February 1851. To mark the day a new and handsome fishing boat named *The Earl* was launched. It is recorded that before this 'beautiful little specimen of naval architecture' glided into the sea 'a bottle of pure native' was broken on her bows.

41 Regarding the demise of smuggling, I found the following still pertinent. It is from a letter to the *Down Recorder* 4th April 1908 on the closure of coastguard stations.
'Those who know outlying parts of the coast know also that the old wrecking and smuggling spirit is not dead. It is only asleep. It is, indeed, the seashore form of a spirit common to most men; the same spirit which evades income tax and death duties. The coastguards put the smuggling spirit to sleep. In their absence it may be trusted to wake up again, with modern improvements added.'

CHAPTER 4
Slieve Donard and the surveying of Ireland

1 *A Paper Landscape,* by J.H. Andrews, page 40, Clarendon Press, Oxford, 1975.

2 Bearings for the ordnance survey were taken from Donard to Snowdon (1085metres) in Wales, South Barrule (483metres) on the Isle of Man, Scafell Pike (978metres) in Cumbria, Goat Fell (874metres) on the Isle of Arran, Criffel in Southern Galloway and Merrick (843metres) in South Ayrshire. In Ireland bearings were taken to Divis (478metres), Sawel (678metres) in Derry, Trostan (554metres) in Antrim, Vicars Cairn in Armagh, Cuilcagh (665metres) on the border of Fermanagh and Cavan, Croghan (234metres) in Offaly, Kippure (757metres) in Wicklow and Hill of Howth (171metres) at Dublin.

3 *A Compendium of Irish Biography,* page 85, by Alfred Webb, Dublin 1878

4 *Memoir of the life of Major General Colby,* by Lieutenant Col. Joseph Portlock

5 *On the Means of Facilitating the Observation of Distant Stations in Geodetical Operations,* by Thomas Drummond, printed by W. Nicol, London, 1826.
Limelight, otherwise known as the Drummond light, enjoyed widespread use in theatres throughout the world in the 1860s and 1870s. Although it has long since been replaced by electric lighting, the term has nonetheless survived, as someone in the public eye is still said to be 'in the limelight'. Sir John Herschel describes the impression produced when the light was first exhibited in the Tower: 'The common Argand burner and parabolic reflector of a British lighthouse were first exhibited, the room being darkened, and with considerable effect. Fresnel's superb lamp was next disclosed, at whose superior effect the other seemed to dwindle, and showed in a manner quite subordinate. But when the gas began to play, the lime being brought now to its full ignition and the screen suddenly removed, a glare shone forth, overpowering, and as it were annihilating, both its predecessors, which appeared by its side, the one as a feeble gleam which it required attention to see, the other like a mere plate of heated metal. A shout of triumph and of admiration burst from all present.'

6 John O'Donovan to Lieut. Thomas Larcom, Dublin. Letter from Castlewellan, Tuesday 23rd April 1834 (the day he climbed Slieve Donard). See Michael Herity's *Ordnance Survey Letters Down*, Four Masters Press, Dublin, 2001, p.56.

7 Harris; *The Antient and Present State of the County of Down*, p 121.

8 *The Archaeological Survey of Northern Ireland; County Down*, Slieve Donard Cairns, p 85–86; Ed. by H.M. Jope, HMSO, Belfast, 1966.

9 Harris; *The Antient and Present State of the County of Down* p.55

10 *A Paper Landscape*, by J.H. Andrews, page 43, Clarendon Press, Oxford, 1975.

11 Datum point: derived from the Latin word 'to give'; the information literally 'having been given'. From the same root we have our word 'data'. Ordnance datum in Ireland is fixed as being 21 feet below a mark on Poolbeg Lighthouse in Dublin Bay. This figure has been taken as it represents low water of spring tides at that location. Altitudes on maps are indicated in feet (now metres) above the datum line.

CHAPTER 5

The Botanists

1 Details of the earliest botanical exploration of the Mournes from *A Flora of the North-East of Ireland*, the introduction, by S.A. Stewart and T.H. Corry, Belfast Naturalists' Field Club, 1888.

2 The ground plan map of the Slieve Donard hotel featuring the Fernery, appeared on page 170 of the *Official Guide to County Down and the Mourne Mountains*, by Robert Lloyd Praeger, published in 1900, two years after the hotel opened. When the guide was up-dated in 1924, the hotel plan showing the Fernery was dropped in favour of photographs.

3 Harris's report of Sherard's discovery of a rare fern appeared in *The Antient and Present State of the County of Down*, p 183, published in 1744. Harris, in chapter eleven of his work, gave a catalogue of more rare plants found in the county but was using the cumbersome and confusing names of the time. Carl Linnaeus had only started to introduce the world to the scientifically concise and now familiar 'binomials' with his printing nine years earlier (1735) of *Systema Naturae*.

4 Canon Lett's *'Names of Places in the Mountains of Mourne'* appeared in the May 1906 issue of the Ulster Journal of Archaeology. He formed his list by taking all the names on the 6" ordnance survey map and collating them with the map and manuscripts of the great Irish scholar, John O'Donovan, together with Williamson's map of County Down and other sources. In 1889 he gave a voluminous report to the Royal Irish Academy on the Mosses, Hepatics and Lichens of the Mourne Mountains. *Proceedings of the R.I.A., series 3, vol I, p.265*

5 *Botany of the Mourne Mountains, Co Down*, by, Robert Lloyd Praeger, printed by Ponsonby and Weldrick, 1892.

6 *Stewart & Corry's Flora of the North-East of Ireland*, 3rd edition edited by Paul Hackney, Institute of Irish Studies, Queen's University, Belfast, 1992, page 297.

CHAPTER 6

The tunnel through the Mountain and its tragedies

1 Letter of 14th December 1892 from James Hugh Moore-Garrett, Annesley's agent, to Messrs Jas McClean & Sons, solicitors for the Belfast commissioners; 'please inform me what compensation you will offer him in exchange for the right or easement of using his land.'

2 Letter of Garrett to Henry Smyth, civil engineer and county surveyor, dated 31st January 1893, asking his urgent advice. Smyth lived at Eastern Lodge at the start of King Street and had the interest of Newcastle at heart.

3 Letter of Garrett to Luke Macassey, chief engineer for the Belfast water commissioners, dated 15th May 1894. Macassey had been engineer to the Belfast Water Board since 1875. It was his report that led to the building of the Silent Valley dam. He also had an extensive practice as a railway, harbour and sanitary engineer and was a distinguished member of the Parliamentary Bar. He died at his Belfast home, aged 65, on 9th May 1908.

4 The government arbitrator, Edmund Murphy, lodged the final Mourne Water Scheme awards in Downpatrick courthouse at the end of August 1896. While Annesley owned the land at Ballaghbeg, the compensation of £1 went to John Cunningham, a shepherd, for disturbance to his flock while the air vent was constructed on the shoulder of Millstone Mountain. Awards listed in *Down Recorder,* 29th August 1896. The compensation to Roden for 'cut and cover' at Tullybranigan was £153.

5 The influx of waterworks employees and their impact on the population figures of Newcastle was mentioned by Dan Hunter, a town commissioner, at the public inquiry to make Newcastle an urban district. Reported in the *Down Recorder,* 29th October 1904.

6 Raid on Tullybranigan navvies' hut was dealt with at Castlewellan court on 1st September 1896, Lord Annesley in the chair and three other magistrates attending.

7 'Porter for their Tay'; this little gem of rural charm was collected by Eamon McMullan of the folk group 'The Poachers' when at a house party in Paddy Cunningham's near Dundrum in 1972. It was recited by Jock Truesdale and had been written by Joe Marks from Drumaness to mark a police raid at McAlnea's near the village. The words of the poem were given to Cahal O'Baoil and appear at the end of his book *Songs of County Down,* published by Gilbert Dalton, 1979. Paddy Cunningham, Jock Truesdale and Joe Marks have all since died.

8 The famous quote from the speech by The Prince of Wales at the 150th anniversary of the Royal Institute of British Architects, at Hampton Court Palace on 30th May 1984; the prince was referring to an extension to the elegant façade of the National Gallery, London.

9 Details of the tunnelling from *In Search of Water, being a History of the Belfast Water Supply,* by Jack Loudan, pages 89–95, printed by the Belfast News Letter, 1940.

10 'Serious accident at Newcastle', report in the *Down Recorder* on 18th June 1898.

11 The dynamite explosion that blinded John Traynor was reported in the *Down Recorder* on 10th September, 17th September 1898 and 21st January 1899.

12 The inquest at Newcastle into the death of William Donaghy in the tunnel at Ballaghbeg was reported in the *Down Recorder* on 31st December 1898.

13 *The Leprechaun and tunnel tragedy* pages 318–319 of *Kilcoo – A Gaelic & Social History,* Cassidy Printers, Newry, 1986.

14 Several fatal accidents at the waterworks scheme are acknowledged in the *Down Recorder* on 23rd September 1899.

15 *The Mourne Scheme: Development of the Silent Valley and Annalong Valley Catchments,* printed for the commissioners at Belfast by Nicholson & Bass, 1959.

CHAPTER 7

Bonfires on the mountain

1 Coal poverty: letter of Annesley's agent, Moore-Garrett to Rev J. McWilliams, P.P., Newcastle, dated 12th December 1892: 'Lady Annesley is thinking of raising a fund to buy coals for the poor in Castlewellan and would like the charity to be non sectarian. It is proposed that when the collection is completed tickets for coal shall be given to the clergy of each church to distribute among their poor. May we count on your kind cooperation?'

2 Annesley estate letters of Moore-Garrett; letter to Sergeant Magowan, Crumlin Road, 15th May 1891, giving him a warning: 'I have decided not to allow turf to be cut out of any of the spent bog lately let as it is quite low enough, so Stewart is only doing his duty in warning your brother not to cut turf on that spent bog.'

3 'Rejoicings on the Annesley Estates', *Down Recorder,* 1st March 1851.

4 Details of the largest bonfire on the top of Slieve Donard are found in 'Rejoicings at Castlewellan', *Down Recorder,* 14th July 1877.

5 Peter's Hill was an earlier name for the Green Hill. The Green Hill was a lovely open field of grass much favoured for picnics in the 1950s as it then enjoyed panoramic views over the town. When the YMCA centre was built screening trees were planted and as the green field disappeared so has usage of the name Green Hill.

6 Scouts light beacons on top of Slieve Donard. See *Always Prepared; one hundred years of the 1st Newcastle scout group (1908–2008),* by Terence Bowman, printed by the Mourne Observer, 2008. A date misprint on page six of the original Mourne Observer covering the scout celebrations on 8th March 1958 would later give rise to a little misunderstanding in the centenary booklet that the scouting anniversary was celebrated a year early. The anniversary was indeed properly marked in March 1958.

CHAPTER 8
Earlier names of Slieve Donard

1 The definitive work on the etymology of all our local place-names is *Place-Names of Northern Ireland, Vol 3, County Down, The Mournes,* by Micheál B. Ó Mainnín, The Northern Ireland Place-Name Project, Department of Celtic, Queen's University, Belfast, printed by Bairds, Antrim, 1993.

2 Monsignor O'Laverty contended that Boirche's fort was located at Kilcoo in a letter in the *Irish News and Belfast Morning News* on 13th August 1904. See also Ó Mainnín's place-names, page 123.

3 *Souvenir of Newcastle's first GAA week, 1954,* Cromac Printers, McAuley Street, Belfast, 1954. St Mary's G.A.C. Newcastle, sponsored a GAA week at St Patrick's Park to celebrate their golden jubilee and this programme marked the occasion.

4 Cambrensis refers to Salanga. In his second chapter he further says: 'St Dominic having many ages afterwards built a noble monastery at the foot of this mountain, it is now better known by the name of Mount Dominic.' The necessary correction from Dominic to St Donard was made by the Irish Franciscan John Colgan in his great work *Acta Sanctorum Hiberniae* (Lives of Irish Saints) of 1645 and duly noted also by Bishop William Reeves on page 27 of *Ecclesiastical Antiquities of Down, Connor, and Dromore, consisting of a taxation of those dioceses compiled in the year 1306.*

5 *The Porcellanite Axes of North-East Ireland,* E.M. Jope, *Ulster Journal of Archaeology,* Vol 15, 1952.

6 *The Palynology of Ringneill Quay, a new Mesolithic Site in Co Down,* Proceedings of the Royal Irish Academy, Vol 61 C6, by M.E.S. Morrison, Dublin 1961.

7 For Nicholas Malby see: *Dictionary of National biography,* Smith, Elder & Co. *Sixteenth-Century Ireland; the Incomplete Conquest,* by Colm Lennon, 1994 *The Plantation of Ulster,* by Philip Robinson, Gill & Macmillan, 1984
How Slieve Donard got its Name, by Tom Porter in Vol 8, *12 Miles of Mourne*
Sir Thomas Smith's forgotten English Colony of the Ards and North Down in 1572, by Mark Thompson, published by Loughries Historical Society. Malby also gets a flattering mention in the *Annals of the Four Masters,* under the year 1584.

8 Ó Mainnín in his *Place-Names of Northern Ireland,* pages 154–157, mentions Donard's name in association with the mountain being found in 'The *Lebar Brecc* Homily on St Patrick' which is dated to around 900AD.

9 O'Donovan to Thomas Larcom, Mountjoy Barracks; letter of 17th April 1834 from Hilltown.

10 The legend of St Donard's conversion was recorded by John O'Donovan a week after he heard it from Mrs Con Magennis. Letter to Larcom, Mountjoy Barracks, from Downpatrick dated 24th April 1834.

Canon Henry Lett who was a member of the Royal Irish Academy, preserved the same letter verbatim in his address on *Slieve Donard, in the County of Down,* read before the society of antiquaries of Ireland on 3rd July 1905.

See likewise, Ó Mainnín in his *Place-Names of Northern Ireland,* pages 156–157.

CHAPTER 9

The Herdsmen

1 *The Antient and Present State of the County of Down,* by Walter Harris, page 125, Dublin 1744 (reprinted by Arthur Davidson, Spa, Ballynahinch, 1977).

2 *Excavations at the Deers' Meadow,* E. Evans & B. Proudfoot, article in *Ulster Journal of Archaeology,* p 127-131, Volume 21, 1958.

3 From the chapter 'Bally and Booley', p 36, in *Irish Folk Ways,* by E. Estyn Evans, Professor of Geography, Queen's, published by Routledge & Kegan Paul, in 1957.

4 *A Preliminary List of Booley Huts in the Mourne Mountains, County Down,* by Mark Gardiner, article in *Ulster Journal of Archaeology,* p 142–152, Volume 67, 2008.

5 Notice of poison laid in the mountains was given in the *Downpatrick Recorder* on 21st May 1870. Other interesting phonetic names for the mountains were Slieve Namaduary (for Slievenamaddy) and Crashone (instead of Crossone). A more extensive list of hill names on the Annesley estate is given the following year on 15th April 1871 with an interesting ambivalence between Church and Bunker's Hill.

6 *Irish Names of Places, Vol 2,* page 481, by P.W. Joyce, Dublin 1883.

7 *Placenames of Northern Ireland* propose Spelga as derived from the Irish *Speilgeach* meaning 'place abounding in pointed rocks'. Based on the phonetics of the Irish, this explanation is acceptable were it not that it hardly accords with actual topography. Given the ancient tradition of booleying in the area and the meeting of various herds on the summer pasture of the Deers' Meadow, a derivation from *Speileacha* (herds of cattle) is a much more satisfactory explanation. I am grateful to Victor Hamilton of Holywood, for assistance with the Irish.

8 There was correspondence in the Mourne Observer on 1st and 8th July 2009 on the origins of Aughlisnafin outside Castlewellan. One writer, perhaps influenced by the presence of the catholic Church of the Immaculate Conception, proposed a derivation from the Irish *Achadh lios an Aifrinn* (field of the fort of the Mass). Another, a resident of Whitefort Road, understandably maintained that it meant 'place of the Whitefort'. Neither version is correct. A word has been elided from the Irish. Centuries ago, when people shared the same landscape, way of life, customs and beliefs, there was no need for explanation and no necessity for detailed description of what was familiar to everybody. A white cow was such a rarity there was no need to state the obvious time and again. P.W. Joyce gives us an explanation in *Irish Names of Places,* Vol 3, page 141. "*Bó* often or generally means a cow. Sometimes *Bó* (cow) has an adjective, which often remains in the place-name, while *Bó* itself is omitted. This adjective (when *Bó* is the word omitted) is always feminine." Sound and context was important. When Scotch and English settlers came, these understood or inferred words such as *bó* were missed in translation as was the significance of the feminine form of the expression *na* (of the) in the original Irish. Also, the 'Augh' sound at the beginning of names could stand for *Achadh* a field, *Áth* a ford, or *Each* a horse. See Joyce Vol 3, page 54. It seems obvious that in the case of Aughlisnafin a field is meant.

9 *Placenames of Northern Ireland,* p 117–118, covers the various names of Newcastle in recorded history. See also *Where Donard Guards,* p 54-55 where the builders of the second castle at Newcastle, following the example of Nicholas Bagnal of Newry, made provision for 'a place for the cattell by nyght'.

10 The full and exact copy of the for sale notice of the Matthew estate as it appeared in an old Dublin journal of May 1749 is found in *Where Donard Guards,* p 75–77.

11 Regarding the closing of the Causeway Road by Annesley's agent, there were two comments at the county assizes of 1864. Firstly, from the report of Bernard Murray, county surveyor for the southern division dated 27th July 1864:
'The presentment No 209 in Upper Iveagh, Lower Half, in page 131 of the Schedule, was passed by the Sessions, to determine if the Causeway-road, in Newcastle, be a county road, it having been lately stopped at one end; and I was directed to procure evidence on the subject and lay it before the Grand Jury at the present Assizes. There is a presentment, No 830, in Warrant of Spring Assizes, 1840, to repair a road which answers the description of the road in question'.
Secondly, 'With reference to this road (the Causeway), the County Surveyor's Committee expressed an opinion that the old road should not be closed until the new one was opened, and that the matter of closing the road should be referred to the County Surveyor for the division.
Mr Shaw (Annesley's agent), said that the required accommodation had been afforded to the public at another place, and he never before knew that this old road was a county road.' Grand Jury proceedings reported in *The Downpatrick Recorder*, 30th July 1864.

12 'A Shepherd's Prayer' by Richard Rowley, from *Ballads of Mourne*, p 31, Dundalgan Press, Dundalk, 1940.

CHAPTER 10
Granite men and the Quarries

1 Chapter IX, page 39, The Search for Rock Bottom, *The Dam Builders*, by W. H. Carson, published by the Mourne Observer, 1981.
2 The angle of the 'rede' of the granite was established in *A tectonic analysis of the Mourne granite mass, County Down*, by Herbert P.T. Rohleder, Proceedings of the Royal Irish Academy, Vol 40, Section B, No. 12, February 1932, under *minor tectonic features*, page 168.
3 'Serious affray between females', report in the *Down Recorder* 11th May 1895.
4 'Inimical tendencies', Newcastle monthly court proceedings, reported on 17th August 1901 in the *Down Recorder*.
5 Advert for the sale of prime land above the Shimna, *Down Recorder*, 10th April 1869.
6 The early picture of Newcastle circa 1770 was reproduced on page 55 of *Where Donard Guards*, through the courtesy of David Good, Myra Castle
7 Page 21 of *The Quay and the Rock*, 2004.
8 See also *John Lynn – Architect/Contractor/Engineer* by Gordon Wheeler, in *Lecale Miscellany*, No 15, 1997. Lynn's work at Newcastle and beyond is detailed in this magnificent article. Of Lynn's work in relation to St John's Church he writes, 'At least there is no doubt about the attribution of this (St John's) church, originally built for Earl Annesley as a chapel-of-ease to Kilcoo parish, so that the noble lord would not have too far to travel to church from Donard Lodge, his house on the mountainside above. An inscription otherwise in Latin, on the east face of the tower, ends proudly and uncompromisingly in English: 'Architect J. Lynn'.
9 Work started on the building of the old quay shortly after the contract was signed on 31st August 1807 and the accounts for expenditure were lodged with the treasury chambers, Dublin in March 1809. See 'Richard, 2nd Earl, builder of the old quay', in *Where Donard Guards*, p 83–89.
10 *Topographical Dictionary of Ireland*, by Samuel Lewis, Vol. 2, p. 424, London, 1837.
11 PRONI D.1854/6/1 pages 128–130, letter of Rev John R. Moore to W. Freeman, Haytor Mining Company, dated 10th November 1839.
12 PRONI D.1854/6/2 page 58. Letter of 15th October 1840 to Hugh Wallace, solicitor.
13 PRONI D.1854/6/5 Rev Moore's letter dated 28th November 1842 to J.B. Bankhead.
14 New road up the mountain: see p 272 of *The Irish Watering Places, their climate, scenery, and accommodations*, by Alexander Knox, M.D., Dublin, 1845.

15 PRONI D. 1854/6/3 Rev Moore's letter of 25th September 1850. The inspector of the harbour works impeded the access to stone from the Newcastle quarries because it was being used for a Protestant church. This called for delicate, diplomatic and flattering words from the Rev Moore to his superior in Dublin. 'I know not whether you are a Protestant or Roman Catholic but whatever persuasion you are of, from the interview I had the honour of having with you, I know you are an intelligent gentleman and I feel confident that you will command that common courtesy to be shown which is due when I have on Lord Annesley's part co-operated so willingly in every way to carry out the wishes of your Board.'

16 Details of the consecration of St Paul's, Castlewellan, are given in the *Downpatrick Recorder* on 3rd December 1853.

17 Aynsworth Pilson lived from 1775 to 1863. We may ascribe his early recollections of Newcastle to circa 1785.

18 Pilson was referring to Dr Alexander Knox, who wrote *The Irish Watering Places, their climate, scenery and accommodations,* William Curry, Jun., & Co., Dublin, 1845 (ie. seven years before Pilson's article). Knox's description of Newcastle as the 'Queen of Northern Bathing Places' appeared on page 271. Knox would later write *A History of the County of Down,* in 1875.

19 Lord Downshire first built a pier in Dundrum at his own expense in 1822 (date given in the report of proceedings of the Tidal Harbours Commission; see *Downpatrick Recorder,* 11th Oc. 1845). An improvement in trade saw an extension in 1862. The *Down Recorder,* 27th September 1862 reported: 'The structure is a most substantial one, and it presents even a handsome appearance, being in part composed of hewn granite, while other portions, especially the upper tier of the work, are formed of quoins neatly dressed.' The paper further reported on 4th May 1867, 'The Marquis of Downshire expressed himself much satisfied with the progress of the various works, including the extensive structure and efficient apparatus on the new quay – the former for containing, and the latter for discharging the cargoes of the *Lady Alice Hill*.'

20 *Where Donard Guards,* page 140. We are pleased to note that the North Star Hotel where the unhappy event took place is still doing business at Amiens Street, Dublin.

21 Letter of Moore-Garrett to Annesley, dated 27th February 1892. The McAleenan who was charged 2/6 a load of granite was likely Joseph McAleenan, civil engineer, surveyor and builder from Castlewellan rather than his brother John, also a surveyor.

22 At the spring assizes, 14th March 1890, the Grand Jury adopted the following from the report of P.C. Cowan, county surveyor: 'In Upper Iveagh, Lower Half, the sum of £1,200 was presented for rebuilding the Castle Bridge over the Shimna River in Newcastle. The present structure is very old, and in bad repair; and on account of its crooked and narrow roadway is exceedingly dangerous both to foot passengers and vehicles. I consider there is no more pressing need for improvement in South Down than exists in this case.'

23 Letter dated 25th October 1892 to Thomas Andrews re site for the Slieve Donard Hotel. Lord Annesley revised this letter and a different version was sent the following day making no mention of the quarries. These letters are no 811 and 816 on pages 587 and 591/592 respectively of the Annesley Estate copy letter book for 1890–1894 in private hands.

24 Extract from the prospectus of the Downpatrick, Dundrum and Newcastle Railway, published in the *Downpatrick Recorder,* 18th November 1865. The company issued 7,500 shares of £10 each and immense crowds availed of the opening excursion to Newcastle on Easter Monday, 29th March 1869.

25 Optimistic claims from William R. Anketell, chairman of the Downpatrick, Dundrum and Newcastle Railway Company at the third half-yearly meeting of the shareholders held in the chamber of commerce, Belfast, on Saturday 1st March 1868.

26 Details of existing state of granite industry from Local Government Inquiry held in Newcastle on Wednesday 2nd September 1902 into road expenditure in Kilkeel Rural District Council area, conducted by Mr P.C. Cowan, chief engineer inspector.

27 Three sizes of setts are mentioned in *The Quay and the Rock,* namely, 4x4x4, 8x4x4 and 4.5x6x9 (all inches) but applying these sizes to the prices mentioned, viz. 7s, 8s and 9s a ton is only conjecture. Other sizes, such as the 6x6x8 sett in the author's garden, were also used.

28 Mourne Granite sett-makers strike reported in *Down Recorder,* 2nd December 1905. Union leader's advice criticised, 6th Jan 1906; resumption of work, 17th Feb 1906. The sett makers at Newry quarries also went on strike at this time too.

29 Report of the Congestion Commission given in the *Down Recorder*, 25th May 1907. Mr Charles Greene, chairman of Downpatrick Board of Guardians, 'described the land in the greater part of the electoral divisions of Castlewellan … as rough, weedy, and inclined to be mountainous, and the population was steadily decreasing.' I cannot pass the evidence of the commission without noting conditions then prevailing at Kilcoo: 'Rev D. Mullaghan, Kilcoo, stated that 63% of the holdings in that quarter did not reach £5 in valuation; that 80% of the people could not subsist on the product of their holdings; that many of them were dependent on help from abroad; and that the incomes of the households were supplemented by the female members' earnings from embroidery work.'

30 David McCauley now lives at Annalong and is a councillor with Newry and Mourne District Council. With his personal knowledge and skills in the granite trade he is working strenuously to both conserve the granite heritage and to promote it for the benefit of local tourism. Listening also to how Annalong man, Alan Kilgore, saved from a skip the historically valuable old work books and ledgers of a local granite firm is a treat to a historian's ears. Much is presently on display at the Cornmill Quay, near the harbour at Annalong.

31 Fatal accident at Ballyward after a gelignite explosion; report of coroner's inquest into the death of John Johnston featured in the *Down Recorder*, 11th March 1905.

32 One cubic metre of granite weighs 2119 kilos or 2.085 UK tons. For those familiar with imperial measurements, a cubic foot of granite weighs about 9st 6lb or 60 kilos.

33 Crossone, page 134, *Place-Names of Northern Ireland, Vol 3,*

34 A synopsis of the murders near the Blood Bridge in 1642 may be found in *Where Donard Guards,* pages 64–70. The depositions of the five thousand who gave evidence to the commissioners have been digitised and can be viewed free online at 1641.tcd.ie Have a look, for instance, at the deposition of Thomas Trevor, Co. Down, taken on 12th May 1653, reference MS 837 folio 086r–087v.

35 The words of warning by Rev W Armstrong Jones are from *Historical Notes of Newcastle* taken from the *Kilmegan Rural Deanery Year Book* for 1949.

36 The term 'old Carragh Mountain' for the area of Ballymagreehan quarry was found in a newspaper article *'South Down Granite Industry'*, reported in the *Down Recorder*, 26th December 1903. Carragh means 'rocky land' and if ever a name evoked the landscape to which it referred, this is it. It is derived from *carraig*, meaning 'rock'.

37 Slievenalargy as the source of the granite slab for St Patrick's Grave was confirmed in the *Down Recorder*, 25th October 1902. When Francis Joseph Bigger wished to present the monument in the name of 'all classes and creeds of Irishmen at home and abroad', the intention was 'to simply mark the grave in a primitive and suitable way and not to erect any elaborate or costly modern monument, as such would not be in keeping with the grave of a Celtic saint and the nature of the site renders the laying of any heavy foundations extremely undesirable.' (letter in *D.R.,* 16th December 1899). Downpatrick monumental masons, S. & T. Hastings executed the work on the huge slab that weighed several tons. On the slab's surface they incised the name 'Patric' in Irish characters, in keeping with the century in which the Saint died. The early Celtic cross on the granite was copied from a sixth or seventh century grave slab found on Iniscleraun in Lough Ree, on the Shannon. The monument was quietly put in place without any ceremony, probably at the start of April 1900. Because of the widely diverging views about the saint prevailing among the good people of Downpatrick, there may have been a wish to avoid dissension. One wonders if the timing may have had something to do with the visit to Ireland by Queen Victoria at the start of April? Two years later in a disgraceful act of vandalism, a large portion of one side of the slab was broken off in October 1902.

38 The natural stone database for Northern Ireland features a remarkable illustrated list of forty six buildings constructed from Newry granodiorite. Other buildings that may have availed of stone from Ballymagreehan quarries would be Lisnavaghrog church at Rathfriland; St Patrick's church, Gargarry Road, Castlewellan; The Grange in Castlewellan demesne; Ballyroney Presbyterian Church and Drumgooland parish church, Ballyward. See www.stonedatabase.com/buildings.cfm?bk=2307

39 The 'beautiful edifice' of the Fountain Bar was thoroughly described by the *Down Recorder* on 11th May 1907. The date of 1906 is above the entrance. This was the year construction started rather than the year of completion.

40 Test results showing Annesley's grey granite to be the hardest and most durable were published in the *Down Recorder*, 10th March 1906. The strength of the granite was also reported in an article 'The Iron Ore Resources of Co Down', again in the *Down Recorder*, 18th August 1883.

41 *A Treatise on the Building and Ornamental Stones of Great Britain and Foreign Countries, arranged according to their Geological Distribution and Mineral Character, with illustrations of their Application in Ancient and Modern Structures,* by Edward Hull, page 44, London, Macmillan, 1872.

42 The inquest on James Canning was held in Castlewellan courthouse on Friday 3rd March 1899. An investigation under the Boiler Explosions Acts of 1882 and 1890 was held on Thursday 23rd March, again in the courthouse. The Crown brought the charge of manslaughter against Robinson & Son at the monthly court at Castlewellan on Tuesday 5th June. The bench, presided over by Annesley's agent James Hugh Moore- Garrett, exonerated Robinson of all responsibility and unanimously refused informations for a full trial.

43 I have used the spelling of Altnadua throughout as found in the ordnance maps even though the present road signs are unfortunately spelt Altnadue.

44 The progressive state of McCartan's quarry was reported in the *Down Recorder*, under the Town Topics, on 6th October 1906. Given the lifting technology of that era, I must admit to complete wonderment at the moving of an 88 ton block of granite in the quarry precincts never mind its possible transfer down Altnadua Road to the firm's workshops at Ballyward. The journalist's mention of 'Ballymagreehan quarry' in the quote introduces possible confusion with the quarry accessed from Largy Road. McCartan preferred to call his site 'Castlewellan Quarry' to avoid this confusion.

45 The memorial to late Col Forde was described in the *Down Recorder* of 13th June 1903. 'A massive recumbent tombstone, believed to be one of the largest in Ireland, has been placed in Seaforde churchyard, to mark the resting place of the late Col. and Mrs Forde. It is a magnificent block of native granite; when rough hewn it weighed over 30 tons, and now with finished surfaces has a measurement of more than 90 feet. It is oblong in shape, with patent axed treatment on the top and sides. Broad walls built from great depth, resting on the solid rock, support the monolith and ensure its permanency. The late Col Forde himself selected new ground for burial at the southern portion of the cemetery. The work is set parallel to the church, almost opposite the south-west door, and the position is one of the finest in the churchyard. The following simple inscription is deeply engraved on the upper surface in strong block letters of Egyptian type: 'Sacred to the memory of Colonel Rt. Hon. William Brownlow Forde, P.C., of Seaforde; born 5th November 1823; died 8th February 1902. And of Adelaide, daughter of General Hon. Robert Meade; born 16th February 1818; died 5th September 1901.' There is added the verse: 'Life's race well run, Life's work well done, Life's crown well won, Then comes rest.' Also added is the Forde motto, *Incorrupta fides nudaque veritas.* Messrs. S. & T. Hastings, sculptors, Downpatrick and Newtownards, have executed the work most satisfactorily.'

46 The anecdote of O'Connell's County Down escape first appeared in *Temple Bar*. It was reprinted in the *Down Recorder* on 22nd September 1900. O'Connell gave up his practice at the bar after the government conceded Catholic emancipation in April 1829, so that he could devote his time completely to politics.

47 *Down Recorder* 13th November 1926

48 Letter dated 11th January 1897 by Devoir, Castlewellan, to the *Down Recorder*.

Chapter 11

Millstones

1 The survey of County Down appeared in a series of articles in the *Downpatrick Recorder*; this extract appeared on 17th October 1874. Joseph Lawrence, who copied the details to the paper, moved to Newcastle and for thirty years was proprietor of the Railway Hotel. He died,

aged 82, at his Newcastle residence 'Belvedere' on 5th June 1905. Four years after the rough sketch of county Down was produced, it was availed of by Walter Harris and Charles Smith in their work *The Antient and Present State of the County of Down,* which was published in 1744. Harris, in his introduction, itemised many of the 'mistakes and misrepresentations' of the London book of 1738. He dedicated his 'new work' to Sir Hans Sloan. Millstones got a small and slightly inaccurate mention: 'In Slieve Donard are quarried Mill-stones, and in another of these mountains are found christals (sic.)...', page 125.

2 *Manners and Customs of the Ancient Irish,* by Eugene O'Curry. Volume 1, page 360
3 *The topography of Ireland,* by Giraldus Cambrensis, from chapter 51, page 108 of Thomas Wright's edition of 1863.
4 Newcastle Lifeboat Rescue; *Down Recorder,* 16th January 1904.
5 That fishermen held down jobs working with granite was confirmed by Thomas McAuley, then councillor for the harbour, at the inquiry in July 1908 into trawling in Dundrum Bay. He told the inspector that the men working on the trawlers were not so much fishermen as sett-makers.
6 Full details of the fishing tragedy of 10th January 1814 can be found in *Where Donard Guards,* on pages 210-211. The fishing disaster of 1843 that took the lives of forty-six men on Friday 13th January is told on pages 154–157.
7 Chapter seven 'The Millstones and Millhouses'; *Harnessing the Tides; The early Medieval Tide Mills at Nendrum Monastery, Strangford Lough,* TSO, 2007.
8 Chapter 17, 'The Stone Men', p 155, *Mourne Country,* Evans, 1951.
9 *Sourcing the Nendrum granite Millstone Material,* by I.G. Meighan, p 204–205 of *Harnessing the Tides,* TSO, 2007. Meighan has thoroughly examined the petrology of the Nendrum millstones. Although particular mention has been made of Carr's Face quarries in the upper reaches of the Bloody Bridge as a likely source, the author himself admits that this proposal 'is suggested somewhat tentatively' (p 205).
10 The mention of Amy's River is found on pages 357–358 of *Black's Picturesque Tourist of Ireland,* Adam and Charles Black, Edinburgh, 1884
11 *The Quay and the Rock,* p 71, by Bernard Davey for Newcastle Harbour Area Community Association. Printed by Mourne Observer, 2003.

CHAPTER 12

The Spa

1 *The Antient and present state of the County of Down,* by Walter Harris, Dublin 1744, page 81. The virtues of goat's whey and the practice of drinking it in the mountains of Mourne was covered in chapter ten, p 178–180.
2 *Irish Watering Places, their climate, scenery and accommodations;* Alexander Knox, M.D., Dublin, 1845, p 271–272. The note about Dundrum in on page 273 but the 'two' miles from Newcastle should be understood as Irish miles and also quite approximate.
3 Remark on Lady Annesley's poor health in letter of Rev J.R. Moore to Robert Shaw, 12th November 1838. PRONI D.1854/6/4 page 28. Her husband had died on 25th August 1838 when she was six months pregnant. Priscilla Cecilia had already suffered one miscarriage and now faced a difficult birth. Her sixth son, but the late Earl's eighth child, was born on 29th November 1838 and called William Octavius Beresford Annesley. Octavius, the latin for eighth, denoted the total number of the Earl's progeny. As the eldest son was also called William, William Octavius was called 'Berry' by the family. Lady Annesley made a good recovery after his birth.
4 PRONI D.1854/6/2 page 49; letter of Rev J.R. Moore to the Marquis of Downshire concerning the appointment of the medical superintendent of Castlewellan Dispensary.
5 Remarks of Rev Seymour to St John's Easter select vestry, reported in *The Down Recorder* 11th April 1891. Two or three years after the construction of the demesne road up the mountain

to the spa, Ireland was in the grip of the famine. In writing of Lady Annesley's kindness to the poor, there can be no more revealing sentence than one from a letter of her brother, Rev J.R. Moore to his nephew in Amsterdam. 'Your aunt is nearly bankrupt as she gives all her money and denies herself in every way to feed the starving poor around her...' PRONI D.1854/6/3 page 125, letter dated 26th March 1847.

6 Details of the numbers employed at Donard Lodge demesne are taken from *The Down Recorder* of 13th January 1844. 'On the Thursday after Christmas she gave the children of Newcastle school, her usual annual dinner of roast beef and plum-pudding, and to the greater number of them she gave very handsome presents. Also at the close of the same week she gave a hearty and substantial dinner to her labourers, forty-four in number, who evinced their gratitude for the treat, and for all the kindness they had received, by several very hearty cheers.'

7 Lady Annesley's relief works are attested in a letter from Rev J.R. Moore to Rev Duffin of the Bryansford famine relief committee, dated 25th February 1847. 'I think it right to inform you that many of Lord Annesley's tenants in your district are employed at works purposely undertaken by Lady Annesley and myself.' PRONI D.1854/6/3 page 110.

8 There are three mountain bridges in total over the Glen River. Locals start their count with the bridge that served the former Donard Lodge. This was built in 1835 and had to be repaired some years ago when a joyrider demolished the parapet. The next bridge up the mountain is the one referred to here. There are, of course, other bridges over the Glen River further downhill but these are not counted. They are the bridge carrying the main road to Kilkeel and the next one called by locals 'Johnston's Bridge' after the family of that name who lived in a cottage beside it and were bailiffs for the Annesley estate. The main road bridge has or had the name Patton's bridge, but the original was washed away by flood waters in 1968. The Donard Lodge bridge enjoys primacy of count as, historically, it was the first bridge built over the Glen River inside the demesne.

9 A Dublin periodical early in 1880 carried details of Lady Annesley's charitable work: 'Her printed statement gives an annual account for those years of all the subscriptions and donations she has received and paid to religious societies for their several benevolent and Christian objects, which amount to the enormous sum of £16,173 8s 2d.' Lady Annesley had concluded her 1880 letter to her friends with the words: 'May I add that my labour for the year on which we have entered would be lessened by your kindly sending me your subscriptions on receipt of this list. The increasing infirmities of age warn me that I must soon cease to collect your little contributions.' The statement was copied in *The Down Recorder,* 31st January 1880. A clearer picture of the extent of Priscilla Annesley's labours may be gained by the addition of three zeros to the 'enormous sum'. Hence, in present financial terms, she collected in the region of £1,617,330 for charity. This sum, declared in 1880, would eventually be much greater as Lady Annesley was to live for a further eleven years.

10 Funds from the Donard Lodge missionary box were handed to St John's rector by Annesley's old retainer, Kennedy. Letter by Lord Annesley's directions to Rev Seymour, 11th September 1891. Page 341 of Annesley Estate Letters of James Hugh Moore Garrett, agent, 1890–1894, in private hands.

11 Two years before McComb's guide was published a single line of rail track had reached Downpatrick on 23rd March 1859 from Belfast. Now, with such favourable publicity, the chairman of the BCDR, William Anketell, was so enthusiastic about extending the railway to Newcastle that he commissioned an engineer to survey a route from Downpatrick at his own expense.

12 *McComb's Guide to Belfast, the giant's causeway and adjoining districts of the counties of Antrim and Down,* Belfast 1861, pages 159–160. The encouraging words of McComb's guide were not the first favour he had done for Newcastle. In 1843 he penned the *Lament for the Fishermen of Newcastle,* which was a Christian appeal for charitable aid for the destitute. See appendix 1, page 256, of *Where Donard Guards;* also, *The Poetical Works of William McComb,* London, 1864, pages 236–239.

13 Irish Health Resorts: Mr Alfred Eccles's letter to the *Medical Times and Gazette* was reprinted in *The Down Recorder* on 31st August 1861.

14 Details of the lower chalybeate spa are to be found in the earlier work, *Where Donard Guards,* pages 116–117.

CHAPTER 13
Plane Crashes on the Mountains

1 The fatal plane crash on 12th June 2009 claimed the lives of Stephen Annett (24), Andrew Burden (24) and Hugh McKnight (53). The three motorbike fans were returning from the Isle of Man TT Races when the crash happened. Hugh McKnight was an accomplished pilot and his church minister, Rev Stuart Finlay, said he must have taken hundreds of people up in the plane over the years to let them enjoy the spectacular beauty of the Mourne countryside from the air.

2 The helicopter crash claimed the lives of the pilot, Mr Ian Wooldridge and Mr Charles Stisted. The men were returning to England after a day's shooting in Co. Fermanagh.

3 *World War 11 Airplane Crashes in Mourne*, by Ernie Cromie, pages 15–25, Vol 4, 1991, *12 Miles of Mourne*.

4 Also killed in the crash were Flying Officer H.E. Hunter, Royal New Zealand Air Force, aged 25, married, from Christchurch, and Air Observer Flying Officer J.W. Elliot, Royal Canadian Air Force, aged 26, also married, from Toronto. They were both buried in Belfast City Cemetery.

5 The bomber crew killed on 12th September 1943 were Flight Sgt J.S. Price, RNZAF (pilot), aged 33, from Invercargill, New Zealand, Sgt. T. Brewin, aged 20, and Sgt. H.A. Walters also aged 20. Flight Sgt. Price was later buried in Ardglass Church of Ireland graveyard.

6 *Place-Names of Northern Ireland, Vol 3, The Mournes*, pages 148–149.

7 *World War 11 Airplane Crashes in Mourne*, by Ernie Cromie, page 21, Vol 4, 1991, *12 Miles of Mourne*.

8 The crew of the B26 Marauder who were killed were: 2nd Lt Howell C. Osborne Jr, (pilot) from Fort Smith, Arkansas; 2nd Lt Chester M. Turner (co pilot) from Cowley County, Kansas; Staff Sgt Roy R. Cappe Jr (aerial engineer) from Allegheny County, Pennsylvania; Staff Sgt William J. Devenney (radio gunner) from Carbon County, Pennsylvania; Sgt Jimmie Gyovia (engineer gunner) from Boone County, West Virginia. All but one of the crew were repatriated to the United States in 1947. Sgt William J Devenney was reburied in the American Military Cemetery in Cambridge, England Further details can be found at the website www.chimneyrockb26crash.com

9 Noel Kirkpatrick took photographs of various pieces of aircraft wreckage in the Mournes and these appeared in his book *Take a Second Look around County Down*, chapter eleven, The Mournes; Alkon Press, Comber, 1993.

CHAPTER 14
The Mourne Wall

1 Military manoeuvres on the Mournes; minutes of Down County Council meeting reported in *Down Recorder*, 7th July 1900. See editorial of *Down Recorder* of 14th July 1900. Withdrawal of Bill reported on 21st July 1900.

2 The names of the wall builders are from Harold Carson's book *The Dam Builders; The story of the men who built the Silent Valley Reservoir*, published 1981.

3 Chapter one of *The Dam Builders*, 'The building of the Mountain Wall', page 2/3.

4 Jeremiah MacVeagh speaking for the rights of the residents in the Mourne catchment area; report of House of Commons proceedings in *Down Recorder*, 11th March 1905.

5 *Slieve Donard: A new challenge for the National Trust*, article by Diane Forbes in *12 Miles of Mourne*, Journal of the Mourne Local Studies Group, Vol 5, 1992.

CHAPTER 15
A Neolithic monument above the quarry

1 The Irish fiants of the Tudor sovereigns, Henry Vlll, Edward Vl, Philip and Mary, and Elizabeth l, could be called the single most important source for sixteenth century Irish history. Fiants were the warrants issued to command the drawing up of Letters Patent, the formal royal letters by which grants of land, official appointments, pardons, etc, were made, but in the Tudor period the drawing up of the actual Letters Patent was often neglected, and the fiants remained the basic record. The word *fiant* is latin for 'let these things be done'.

2 *Ecclesiastical Antiquities of Down, Connor and Dromore* by Dr William Reeves, printed in 1847 by Hodges and Smith, Dublin. The note giving the full explanation of the meaning of the Irish word *sithe* is given in note q on page 22.

3 *Foclóir Gaedhilge agus Béarla, an Irish-English Dictionary,* compiled and edited by Rev Patrick S. Dinneen, Dublin 1927 with numerous subsequent reprints and revisions

4 Stone circle regarded as bogus; *Mourne Country,* Prof. EE Evans, 1950, note on p 89.

5 'When Newcastle was called Shyleke', from *Where Donard Guards,* p 52.

6 *Place Names of Northern Ireland, County Down lll, The Mournes,* by Mícheál B. Ó Mainnín, p 138, QUB,1993.

7 From the chapter 'Booleys and Blaeberries', p 133, in *Mourne Country,* Prof E Estyn Evans, Dundalk, 1950.

8 In acknowledging the help of Victor Hamilton, Holywood, in help with the Irish, I recall what O'Donovan wrote of his own work: 'It cost me much trouble to discover the correct names of the mountains, and I state emphatically that no person is qualified to obtain these but a good scholar'. O'Donovan was thinking of a scholar of the Irish language. Victor has the gold fáinne.

9 Letter of John O'Donovan to Larcom, from Newry dated 12th May 1834; *Ordnance Survey Letters County Down,* Four Masters Press, Dublin, 2001. The use of italics reflects O'Donovan's own emphasis.

10 *Ibid.* Letter to Larcom from Castlewellan on Sunday 21st April 1834.

11 *Ibid.* Letter to Larcom from Castlewellan on Tuesday 23rd April 1834.

12 An influential lecture entitled *Names of Places in Down* was given by Rev L.A. Pooler in the parochial hall, Downpatrick, on 29th October 1897. Although his talk was wide ranging and interesting he 'didn't make the cut' as his references to the Mournes were brief and conventional.

13 Page 118 of *Some Irish Naturalists, a biographical note-book,* by Robert Lloyd Praeger, Dundalgan Press, Dundalk, 1949.

14 Canon Lett's paper, *Names of Places in the Mountains of Mourne,* was reproduced in volume twelve of the Ulster Journal of Archaeology in 1906. Also of local importance is O'Donovan's manuscript map of the Mourne Mountains, which was produced in the same journal, volume eight, p 137, in 1902.

15 The Irish word *leacht* for 'monument' has influenced other names in County Down. Letalian, beyond Kilcoo, is from *Leacht Aillín,* Aillín's grave/monument. See *Place-Names of Northern Ireland, Vol 3,* page 111.

16 Edward Higgins was one of Newcastle's twelve town commissioners elected in 1904. Among papers of his found in a house clearance was a typed note giving the census of Newcastle circa 1659. We copy it verbatim:
 "Newcastle: Number of people 28; including 10 English and Scotts (sic) & 18 Irish.
 Landlord Tobias Norrice, Esq.
 Ballaghbeg: Number of people 12 (no particulars)
 Tollybranegan (sic): Number of people 18 (no particulars).
 (The figures may only refer to persons over 15 years of age) Editor: Seamus Pender"
From this we may infer that with over 36% of the people of Newcastle being of English or Scots extraction back in 1659, the change from *linn an tsléibhe leacht* to Lindsay's Leap may have happened quite early.

17 The inventory of megalithic structures and cairns is given on pages 71–96 of *An Archaeological Survey of County Down*, Ed. Edward Martyn Jope, HMSO, 1966. See also *Mourne County*, p 207–210, Inventory of prehistoric burial sites, appendix one.

18 An open mind is now called for in looking at many other large stones as possible burial markers especially if they are located in a commanding or scenic spot. I note an interesting gathering of rocks with a large shale stone about one hundred metres uphill behind *An Chathaoir Mhór*. Discovery still awaits.

19 *Place-Names of Northern Ireland, County Down, Vol 3, The Mournes*, page 171.

20 *Ibid.* Luke's Mountain, page 145.

21 Etymology of Tuam from *The Origin and History of Irish Names of Places*, by P.W. Joyce, Volume 1, page 254.

22 Professor Daniel's remarks on the meaning of *Sídhe* are mentioned on page 39 of George Coffey's reprinted work Newgrange and other incised tumuli in Ireland. He gives three references there for his interpretation.

23 See also *The medieval kingdom of Mugdorna*, by Pilip Ó Mórdha, p 432–447, *Clogher Record*, Monaghan, 1972

24 *Mourne County*, chapter on The Stone-Men, p 159; EE Evans, Dundalk 1950.

25 *Boulder-Burials* by S. Ó. Nualláin, proceedings of the Royal Irish Academy, Volume 78, C, Number 4 (ISSN 0035-8991), Dublin, RIA, 1978.

26 When my previous work, *Where Donard Guards*, was written it was always intended that there would be a sequel. After the history of the harbour area of Newcastle had been recorded it was time to tell the interesting stories of the rest of the town. Chapters were planned for topics such as the coming of the railway, Newcastle becoming a town, the war years, the churches, hotels, the development of the streets, the local council, the golf course and of course the rise of tourism. First, however, it was decided to write a little about the mountains that overlook Newcastle and so chapter one was started. I never did get any further. Chapter one took on a life of its own and evolved into this present work.

Despite the great failures in this author's past, perpetually public, many of merciful heart (God's Blessings be on them) have nevertheless encouraged me to persevere with my writing and the telling of Newcastle's history. I remember with deep gratitude so many good people with gracious and compassionate words. When criticism was rife they followed the words of St Paul,

'Do not use harmful words in talking. Use only helpful words,

the kind that build up and provide what is needed.' (Eph 4:29)

This work would not have been undertaken never mind come to fruition without them.

I am glad to remember again a deceased relation whose name was formerly only a footnote in history. Nicholas Russell, a maternal connection, was one of a large family who lived on a farm at the Middle Tollymore Road. He survived the famine but died young, probably of consumption. He is buried in Bryansford cemetery and his name, along with his brothers and sisters, is on the old parish confraternity register, the only mention of him in history apart from his headstone that I can find. The logo of Ballaghbeg Books is an Irish harp which belongs to my mother. It was made during the Celtic revival in the early years of the twentieth century by James McFall of Belfast who toiled to support his large family in a tiny workshop, since demolished, which was in York lane behind the Irish News in Donegall Street, Belfast.

As shown in the preliminary pages, this book is dedicated to my parents. My father taught me the names of the mountains while I was a child and my mother, as all good mothers do, worried all the time I was away walking on the hills. I give my sincere thanks finally to Victor, Raymond, Marie and Danny, Eileen B., Anne and the late Michael, Joe and Kitty, Anne, Denis and Etta, Eamon and Marcella, Rosemary, Gretta, Libby, Michael B., Eileen S., Martin and Roisin, Seamus B., Les H., Denis, Big Eamon, my family and my noble cousins. May St Donard, otherwise called Domangart, *Domhain Gárda*, 'the guard or protector of the world', keep a soft spot for all of us from Newcastle and very especially look after all who visit and climb in *Slieve Donard's Domain*.

BIBLIOGRAPHY

Andrews, J. H. *A Paper Landscape; The Ordnance Survey in Nineteenth Century Ireland*, Oxford University Press, 1975

ApSimon, A. *The Earlier Bronze Age in the North of Ireland*, UJA, Vol 32, p 28–72, 1969

Babtie Group Ltd., *Fofanny water treatment works; Environmental Statement*, 2003

Balfour's Photographic *Album and Guide Book of County Down Coast*, circa 1895

Bankhead, Robert (ed.) *A Rock Climbing Guide to the Mourne Mountains*, 5th Mourne climbing guide, 1998. Mountaineering Council of Ireland

Bassett, George Henry *County Down Guide and Directory*, Dublin, 1886

Beatty, William *Beatty's Guide to Newcastle and Vicinity*, 3 editions, 3rd by R. Carswell & Son, Queen Street, Belfast, 1904

Belfast Naturalists' Field Club *Guide to Belfast and the Adjacent Counties*, Belfast, 1874

Belfast Water Commissioners *Belfast and District Water Supply; Brief History and Description*, W. & G. Baird, Ltd., July 1931
Opening of the Tunnel through Slieve Bignian, Mourne Mountains, Thursday 28th August 1952, Bell & Logan, Ltd.
The Mourne Scheme: Development of the Silent Valley and Annalong Valley Catchments, printed by Nicholson & Bass, 1959

Bigger, Francis Joseph *Four Shots from Down*

Black, Adam and Charles *Black's Picturesque Tourist of Ireland*, Edinburgh, 1884

Bonwick, James *Irish Druids and Old Irish Religions*, published 1894

Bourke, Edward J. *Shipwrecks of the Irish Coast, Vol 2, years 932–1997*, Dublin 1998

Bowman, Terence *Always Prepared! One hundred years of the 1st Newcastle Scout Group (1908-2008)*. Mourne Observer, 2008.

Brennan, Martin *The Boyne Valley Vision*, Dolmen Press, Portlaoise, 1980

Buckley, Victor M. *Archaeological Inventory of County Louth*, Stationery Office Dublin, 1986

Cambrensis, Giraldus *The Topography of Ireland, its miracles and wonders*, edited by Thomas Wright, published by H.G. Bohn, London, 1863

Carroll, Michael P. *Irish Pilgrimage, Holy Wells and Popular Catholic Devotion*, John Hopkins University Press, Baltimore & London, no date.

Carson, W. H. *The Dam Builders; The story of the men who built the Silent Valley Reservoir*, Mourne Observer Press, 1981

Case, H. & ApSimon, A. *The Neolithic and Earlier Bronze Ages in the North of Ireland*, IIS, Queen's, Belfast, 1970

Case, H. *Settlement-patterns in the North Irish Neolithic*, Ulster J. Archaeology, Vol 32, p 3–27, 1969

Chambers, Rev Francis *Anecdotes of Tobermoney and Neighbourhood*, 1854 original manuscript held by Down County Museum

Chapple, Robert M. *The excavation of a burnt mound at Ballywilliam, County Down*, UJA, pages 21–39, Vol 66, 2007

Chatterton, E. Keble *King's Cutters and Smugglers, 1700–1855*, G. Allen & Co., London, 1912.

Chessell, Henry *National Parks for Britain*, Cornish Brothers Ltd., Birmingham, no date but early post WWll.

Collins, A.E.P. *Excavations in the Sandhills at Dundrum, 1950–1951*, Ulster J. Archaeology, Vol 15, p 2–25, 1952

Collins, A.E.P. *Further investigations in the Dundrum Sandhills*, Ulster J. Archaeology, Vol 22, p 5–20, 1959

Collins, A.E.P. & Wilson, B.C.S. *The Slieve Gullion Cairns*, Ulster J. Archaeology, Vol 26, p 19-40, 1963

Connors, Sean *Mapping Ireland; from Kingdoms to Counties*, Mercier Press, 2001

Cromie, Ernie *World War 11 Airplane Crashes in Mourne*, in Vol 4, 1991, *12 Miles of Mourne*, Journal of Mourne local studies group.

Cullen, L. M. *The smuggling trade in Ireland in the eighteenth Century*, Royal Irish Academy, Dublin, 1969

Cullen, L. M. *Smugglers in the Irish Sea in the Eighteenth Century,* which is chapter 9 in *The Irish Sea,* edited by M. McCaughan, 1989

Cullen, L. M. *Anglo-Irish Trade, 1660–1800,* Manchester University Press, 1968

Cullen, L. M. *The Brandy Trade under the Ancien Régime,* Cambridge University Press, 1998

Cummings, Vicki (ed.) *The Neolithic of the Irish Sea; Materiality and traditions of practice,* Oxbow Books, Oxford, 2004

Curran, Bob *Banshees, Beasts and Brides from the Sea,* Appletree Press, 1996

Davey, Bernard *The Quay and the Rock,* Mourne Observer, 2003

Davey, Bernard *Bernard Davey's Mourne; ten walks with the weatherman,* Cottage Publications, 1999

Davey, Bernard *Bernard Davey's Mourne, Part 2; ten more walks with the weatherman,* Cottage Publications, 2001

Day, Angélique (ed.) *Letters from Georgian Ireland; the correspondence of Mary Delany, 1731–1768,* Friar's Bush Press, Antrim, 1991

De Paor, Máire and Liam *Early Christian Ireland,* Thames and Hudson, London, 1958

Dept. of the Environment *Mourne, Area of Outstanding Natural Beauty,* 1986

De Valéra, Ruaidhri & Ó Nuallain, Sean *Survey of the Megalithic Tombs of Ireland,* Vols 1–6, Dublin Stationery Office,

Dillon, Paddy *The Mournes; Walks,* O'Brien Press, 2000

Dinneen, Rev Patrick *Foclóir Gaedhilge agus Béarla, an Irish-English Dictionary,* Dublin, 1927

Doherty, Gillian M. *The Irish Ordnance Survey, History, Culture and Memory,* Four Courts Press, Dublin, 2004

Doran, Joe *St. Colman's Church, Massforth, Upper Mourne, Centenary Souvenir 1879–1979*

Doran, J.S. *My Mourne,* Mourne Observer

Doran, J.S. *Hill Walks in the Mournes,* Mourne Observer

Doran, J.S. *Turn up the Lamp, Tales of a Mourne Childhood,* Appletree Press, 1980

Doran, J.S. *Wayfarer in the Mournes,* Outlook Press, 1980

Drummond, Thomas *On the Means of Facilitating the Observation of Distant Stations in Geodetical Operations,* W. Nicol, London, 1826

Dubourdieu, Rev John *Statistical Survey of the County of Down with observations on the means of improvement,* Dublin, 1802

Dweeryhouse, A. R. *The Glaciation of North-Eastern Ireland,* Quarterly Journal of the Geological Society, Vol 79, 1923

Emeleus, C.H. & Preston, J. *The Tertiary Volcanic Rocks of Ireland,* Queen's, Belfast, 1969

Eogan, George *Knowth and the passage-tombs of Ireland,* Thames and Hudson, London, 1986

Erskine, Thomas *Mourne, a photographic portrait,* Clonlum Publications, 2006

Evans, E. Estyn *Mourne County: Landscape and life in South Down,* Dundalgan Press, Dundalk, 1951

Evans, E. Estyn *Irish Folk Ways,* Routledge & Kegan Paul, London, 1957

Evans, E. Estyn *Prehistoric and Early Christian Ireland,* London, 1966

Farjeon, J. Jefferson *The Compleat Smuggler,* George Harrap & Co., London, 1938

Federation of Mountaineering Clubs of Ireland *Rock Climbs in the Mourne Mountains,* 4th F.M.C.I. guide, 1988

Fitzpatrick, W. J. *Margaret O'Mourne,* Mourne Observer, 1963

Forbes, Diane *Slieve Donard: A new challenge for the National Trust,* article in journal of Mourne Local Studies Group, *12 Miles of Mourne,* Volume 5, 1992

Forde-Johnston, J. *Prehistoric Britain and Ireland,* Dent & Sons, 1976

Forsythe, John (ed.) *A guide to Mourne Rock Climbs* (interim guide with Robin Merrick as co-editor), foolscap typescript, 1969

Forsythe, John *Mourne Rock Climbs,* Federation of Mountaineering Clubs of Ireland (F.M.C.I.), 2nd edition 1973

Forsythe, John *Mourne Rock Climbs,* F.M.C.I., 3rd edition, 1980

Four Masters *Annala Rioghachta Eireann; Annals of the Kingdom of Ireland from the earliest period to the year 1616,* with translation and notes by John O'Donovan, Hodges, Smith & Co., Dublin, 1856 (reprinted by De Búrca Rare Books, Dublin 1990)

Fox, Fortescue *The Spas of Britain; the official handbook of the British Spa Federation,* Pitman Press, Bath.

Fraser, Colin *Harry Ferguson, Inventor and Pioneer,* Camelot Press, 1972

Gardiner, Mark *A preliminary list of booley huts in the Mourne Mountains, County Down,* Ulster Journal of Archaeology, Vol 67, 2008

Gardner, Arthur *Britain's Mountain Heritage and its preservation as National Parks,* Batsford, London, 1942

Garrett, James Hugh Moore *Annesley Estate Letters, 1890–1894,* private owner

Government *The Parliamentary Gazetteer of Ireland, 1844–45, Vol 3, N–Z.* A. Fullarton & Co., Dublin, 1846

Gribbon, Dr Phil *Mourne Rock Climbs,* McCaw, Stevenson & Orr, Belfast, no date but 1959. 1st local guide, Irish Mountaineering Club

Harbison, Peter *The Archaeology of Ireland,* London, 1976

Harbison, Peter *Pre-Christian Ireland, from the first settlers to the early Celts,* Thames and Hudson, London, 1988

Harbison, Peter *Pilgrimage in Ireland: the monuments and the people,* London, 1991

Harbison, Peter *Treasures of the Boyne Valley,* Gill & Macmillan, Dublin, 2003

Harris, Walter & Charles Smith *The Antient and Present State of the County of Down,* Dublin 1744, reproduced by Davidson Books, Ballynahinch, 1977

Haughton Crowe, W. *Verses from Mourne,* Dundalgan, Press, 1966

Haughton Crowe, W. *The Ring of Mourne,* Dundalgan Press, 1969

Haughton Crowe, W. *More Verses from Mourne,* Dundalgan Press, 1970

Haughton Crowe, W. *Mourne Memories,* Dundalgan Press, 1975

Haughton Crowe, W. *Mourne View Farm,* Dundalgan Press, 1977

Herity, Michael *Irish Passage Graves,* Dublin 1974

Herity, Michael & Eogan, George *Ireland in Prehistory,* Routledge & Kegan Paul, 1977

Herity, Michael *Ordnance Survey Letters Down,* Four Masters Press, Dublin, 2001

Hewson, Rev. L.M. *Notes on Irish Sandhills,* JRSAI, Vol 66, p 154–172, 1936

Hewson, Rev L.M. *Notes on Irish Sandhills,* JRSAI, Vol 68, p 69–90, 1938

Hirons, Kenneth R. *The Changing Vegetation of the Mournes,* Vol 2, 1988, in *12 Miles of Mourne*

Hull, Edward *A Treatise on the Building and Ornamental Stones of Great Britain and Foreign Countries arranged according to their Geological Distribution and Mineral Character, with Illustrations of their Application in Ancient and Modern Structures,* London, Macmillan, 1872

Hull, Edward *Explanatory Memoir of the Geological Survey of Ireland, including the country around Newry, Rathfryland and Rostrevor in the county of Down; and the Mourne Mountains* Alex Thom, Dublin, 1881

Hull, Eleanor *Pagan Ireland,* M.H. Gill & Son, Dublin, 1923

Jope, E.M. *Porcellanite Axes from factories in North-East Ireland: Tievebulliagh and Rathlin,* UJA, Vol 15, P 31–55, 1952

Jope, Edward Martyn (Ed) *The Archaeological Survey of Northern Ireland, County Down,* HMSO, Belfast 1966

Jope, E.M. *The Rath at Ballymacash, Co Antrim,* Royal Irish Academy, Vol. 98c, No 3 (1998)

Joyce, P.W. *The Origin and History of Irish Names of Places,* Vol 1–2, M.H. Gill & Son, Dublin, 1891, Vol 3, produced in 1913

Joyce, P.W. *A Social History of Ancient Ireland,* Vol 1-2, Longmans, Green & Co., London, 1903.

Kinvig, R. H. *A History of the Isle of Man,* University of Liverpool, 1950.

Kirk, David *The Mountains of Mourne; a Celebration of a Place Apart,* Appletree Press, Belfast, 2002

Kirk, David *A Tollymore Year,* Laurel Cottage Ltd., 2010

Kirkpatrick, Noel *Take a Second Look around County Down,* Alkon Press, Comber, 1993

Knox, Alexander *The Irish Watering Places, their Climate, Scenery, and Accommodations,* Dublin, 1845

Knox, Alexander *A History of the County of Down,* Hodges, Dublin, 1875

Lawson, Leonard *25 Walks in Down District,* The Stationery Office, 1998

Lennon, Colm *Sixteenth-Century Ireland; The Incomplete Conquest,* Gill & Macmillan Ltd, Dublin, 1994

Lett, Canon Henry W., *Mosses, Hepatics and Lichens of the Mourne Mountains,* Proceedings of the Royal Irish Academy, series 3, Vol I, 1889

Lett, Canon Henry W., *Slieve Donard in the County of Down,* a paper read before the Royal Society of Antiquaries of Ireland, 3rd July 1905

Lett, Canon Henry W., *Names of Places in the Mountains of Mourne*, U.J.A. 1906

Lewis, Samuel *A Topographical Dictionary of Ireland*, London, 1837

Logan, David *The History of Belfast Water Supply;* paper presented to the Institution of Civil Engineers, Northern Ireland Association, 5th April 1993

Logan, Patrick *The Holy Wells of Ireland*, Colin Smyth Ltd., Bucks., 1980

Loudan, Jack *In Search of Water, being a history of the Belfast Water Supply,* on the occasion of the centenary of the Belfast City and District Water Commissioners, 1840–1940, Wm. Mullan & Son

Loughrey, Patrick (ed.) *The People of Ireland*, Appletree Press, Belfast, 1988

Lucas, A. T. *Cattle in Ancient Ireland*, Boethius Press, 1989

Lyle, Paul *Between Rocks and Hard Places; discovering Ireland's Northern Landscapes*, The Stationery Office, 2010

Macalister, R.A.S. *Ancient Ireland*, Methuen & Co., 1935

Macalister, R.A.S. *The Archaeology of Ireland*, London 1949

Mac an Rí, Tomás *Kilcoo; A Gaelic & Social Heritage*, Cassidy, Newry, 1986

MacNeill, Máire *The Festival of Lughnasa: A study of the survival of the Celtic festival of the beginning of harvest.* Oxford University Press, 1962. (*inter alia,* Slieve Donard: pages 84–96)

McCartan, Doreen *Wild Irish Roses; a Kiwi in search of her Irish Roots,* Aotearoa, New Zealand, 2004

McCaughan, Michael *The Irish Sea; Aspects of Maritime History,* IIS, 1989

McComb, William *McComb's Guide to Belfast, the Giant's Causeway and adjoining districts of the Counties of Antrim and Down,* Belfast, 1861

McComb, William *The Poetical Works of William McComb,* London, 1864

McCoy, Jack *An Index to the Mourne Observer, 1949–1980,* SEELB, 1984

McErlean, Thomas & Norman Crothers *Harnessing the Tides; The Early Medieval Tide Mills at Nendrum Monastery, Strangford Lough,* TSO, 2007

McFetridge, Stewart *The Cavehill Wagon Line. Belfast's Forgotten Railway,* 1999

McGaffin, Hugh J. *Southern County Down,* no date (circa 1960), Belfast

McGeehan, Anthony *Upland Birdlife in the Mournes,* Vol 4 (1991), *12 Miles of Mourne*

McKay, Patrick *A Dictionary of Ulster Place-Names,* IIS, Queen's, 1999

McNally, Kenneth *Standing Stones and other monuments of early Ireland,* Appletree Press, 1984

McNally, Kenneth *Ireland's Ancient Stones, A Megalithic Heritage,* Appletree Press, 2006

McNeill, D. B. *Ulster Tramways & Light Railways,* W. & G. Baird for Belfast Museum and Art Gallery, 1956

McPolin, F. *Fairy Lore in the Hilltown District, Co. Down,* article in *Ulster Folklife,* Volume 9, 1963

Mackle, H. *Fairies and Leprechauns,* article in *Ulster Folklife,* Volume 10, 1964

Maddocks, Anne *The Famine in Mourne,* Vol 9, 2010, *12 Miles of Mourne*

Mallory, J.P. & McNeill, T.E. *The Archaeology of Ulster,* IIS, Queen's, Belfast, 1991

Mayne, Denis *19th Century Coastguard Stations in Mourne,* Vol 7 (1996) of *12 Miles of Mourne,* Mourne Local Studies Group

Maxwell, F. J. *An Extraordinary Day's Walk;* article in *Lecale Miscellany* (being a walk to the top of Slieve Donard in 1795) Down Recorder Printing, Downpatrick, No. 10, 1992

Ministry of Development *Mourne,* HMSO, 1970

Ministry of Home Security *Rescue of Crews from Crashed Aircraft,* HMSO, December 1942

Mitchell, Arthur *How green is Our Kingdom?* Vol 4, 1991, in *12 Miles of Mourne*

Mitchell, Frank *The Irish Landscape,* Collins, Glasgow, 1976

Mitchell, Frank *The Way that I followed,* Country House, Dublin, 1990

Mitchell, W.I. (ed.) *The Geology of Northern Ireland, 2nd,* Baird, 2004

Moore, Donald (ed.) *The Irish Sea Province in Archaeology and History,* Cambrian Archaeological Association, Cardiff, 1970

Moore, Michael J. *Archaeological Inventory of County Meath,* Stationery Office Dublin, 1987

Moore, Simon, et al *Rock Climbs in the Mourne Mountains,* Mountaineering Ireland, Dublin 12, 2010. 6th climbing guide to the Mournes

Morton, Grenfell *Victorian and Edwardian Newcastle,* Friar's Bush Press, 1988

Morton, Dr WRM *Unurned Cremations from Site 1, Dundrum Sandhills,* Ulster J. of Archaeology, Vol 22

Mould, Daphne Pochin *The Mountains of Ireland,* Gill and Macmillan, Dublin, 1955

Mould, Daphne Pochin *Irish Pilgrimage,* M. H. Gill & Son, Dublin, 1955

Murray, Patsy *A History of Coolgreany,* no date, Coolgreany historical society

Newell, John *A Mourne Mile; a short history of and recollections about Ballykeel and Ballymartin,* Mourne Observer, 1998

Newell, John *History of Developments in Mourne from 1870–2000,* Mourne Observer, 2000

Newell, John *A Century of Water from the Mournes,* Mourne Observer, 2003

Nowlan, Kevin B. *Travel and Transport in Ireland,* Gill and Macmillan, Dublin, 1973

O'Boyle, Cathal *Songs of County Down,* Gilbert Dalton, 1979

O'Connell, Catherine *The Irish Peatland Conservation Council – Guide to Irish Peatlands,* Dublin, 1987

Ó Dónaill, Niall *Foclóir Gaeilge-Béarla,* Rialtas na hÉireann, 1977

O'Donovan, John *Annals of the kingdom of Ireland by the Four Masters,* Dublin, 1856, reprinted by De Búrca, seven volumes, 1990

Ó hÓgáin, Dáithí *The Sacred Isle, Belief and Religion in Pre-Christian Ireland,* Boydell Press, 1999

O'Kelly, J. *Excavations and experiments in Ancient Irish Cooking Places,* Journal of the Royal Society of Antiquaries of Ireland, 1954

O'Laverty, Rev James *Historical Account of the Diocese of Down and Connor,* 5 vols, J. Duffy & Sons, Dublin; vol 1, 1878, deals with Maghera parish

Ó Madden, Patrick L. *Cruach Phádraig, St Patrick's Holy Mountain,* Dublin, 1929

Ó Mainnín, Mícheál B. *Place-Names of Northern Ireland, Vol 3, The Mournes,* Institute of Irish Studies, Queen's, 1993

Ó Mórdha, Pilip *The medieval kingdom of Mugdorna, p 432–447, Clogher Record,* Monaghan, 1972

Oram, Hugh *Old Newcastle,* Stenlake Publishing, 2008

Ordnance Survey *Ordnance Survey in Ireland,* Criterion Press, Dublin, 1991

Paturi, Felix R. *Prehistoric Heritage,* Econ Verlag GmbH, Dusseldorf, 1976

Pearson, F. K. *Snaefell Mountain Railway, 1895-1955,* Fowler & Son, London

Platt, Richard *Smuggling in the British Isles; a history,* Tempus, Stroud, 2007

Porter, S. Tom *Mourne Ballads*

Porter, S. Tom *Annalong in the 1800's,* Outlook Press, Rathfriland, 1997

Porter, S. Tom *How Slieve Donard Got its Name,* article in journal of Mourne Local Studies Group, *12 Miles of Mourne, Volume 8,* 2000

Porter, Tom & Cunningham, Charles *Mourne Dialect,* Vol 1, 1987, *12 Miles of Mourne*

Praeger, Robert Lloyd *Botany of the Mourne Mountains, Co Down,* Ponsonby and Weldrick, 1892

Praeger, Robert Lloyd *Official Guide to County Down and the Mourne Mountains,* Marcus Ward, 1898, & second edition 1900

Praeger, Robert Lloyd *The Botanist in Ireland,* Hodges & Figgis, Dublin, 1934

Praeger, Robert Lloyd *A Populous Solitude,* Hodges & Figgis, Dublin, 1941

Praeger, Robert Lloyd *Some Irish Naturalists,* Dundalgan Press, Dundalk, 1949

Private Owner *Newcastle Area in the Downpatrick Recorder, 1836–1950*

Proudfoot, Lindsay (ed.) *Down, History & Society,* Geography Publications, 1997.

Public Record Office *Calendar of State Papers relating to Ireland, 1509–1670*

Quinlan, John *The cooking places of Stone Age Ireland,* JRSAI, 1887

Raftery, Joseph *Prehistoric Ireland,* Batsford, 1951

Rankin, Kathleeen *The Linen Houses of the Lagan Valley,* Ulster Historical Foundation, 2002

Rankin, J. Frederick *Down Cathedral, The Church of Saint Patrick of Down,* Ulster Historical Foundation, 1997

Rankin, Peter J. *Historic Buildings, Groups of Buildings, Areas of Architectural Importance in the Mourne Area of South Down,* Ulster Architectural heritage Society, May 1975

Rankin, Peter J. *Tollymore Park; The Gothick Revival of Thomas Wright & Lord Limerick,* The Follies Trust, Belfast, 2010

Rees, Alwyn & Brinley *Celtic heritage; Ancient Tradition in Ireland and Wales,* Thames and Hudson, London, 1961

Reeves, Rev William *Ecclesiastical Antiquities of Down, Connor and Dromore,* Hodges and Smith, Dublin, 1847

Robinson, Philip *The Plantation of Ulster*, St Martin's Press, USA, 1984

Roden, The Earl of *Tollymore, The Story of an Irish Demesne*, UAHS, 2005

Rodgers, W.R. *Awake and Other Poems*, Secker & Warburg, London, 1940/41

Rohleder, Herbert *A tectonic analysis of the Mourne Granite Mass, County Down*, PRIA, Vol 40, section B, No.12, February 1932

Russell, Nicholas *Where Donard Guards*, Ballaghbeg Books, Newcastle, 2007

Sheridan, Alison *Early Settlers of Mourne*, Vol 3, 1989, in *12 Miles of Mourne*

Shore, Lieut. Henry *Smuggling Days and Smuggling Ways; or the story of a Lost Art.* Cassell & Co., London, 1892

Sloan, Brian *The excavation of a burnt mound at Rossmacaffry, County Fermanagh*, UJA, pages 14–21, Vol 66, 2007

Smith, W.P. Haskett & H.C. Hart *Climbing in the British Isles; Wales & Ireland*, Longmans, Green & Co., London, 1895

Snowdon Mountain Tramroad & Hotels Co. Ltd. *The Snowdon Mountain Tramroad*, Tom Litherland, Carnavon,

Stanley-Jones, E. *A Guide to walking in the Mournes*, Mourne Observer, 1962

St Mary's G.A.C. *Souvenir of Newcastle's first GAA week, 1954*, Cromac Printers, McAuley Street, Belfast, 1954

Stewart, A.T.Q. *The Shape of Irish History*, Blackstaff Press, 2001

Stewart and Corry *Flora of the North-East of Ireland*, Belfast Naturalist's Field Club, 1888
 1st Supplement 1894–1895, by S.A. Stewart & R. Lloyd Praeger
 2nd Supplement 1923 by Sylvanus Wear
 3rd Edition, Edited by Paul Hackney, I.I.S., Queen's University, 1992

Stokes, Whitley *The Tripartite Life of St. Patrick* [Bethu Phátraic], Eyre and Spottiswoode, London, 1887

Stokes, Whitley *Félire Oengusso: The Martyrology of Oengus the Culdee*, printed by Henry Bradshaw Society, London 1905

Thompson, Mark *Sir Thomas Smith's Forgotten English Colony of the Ards and North Down in 1572*, published by Loughries Historical Society

Torrans, Calvin & Stelfox, Dawson *Rock Climbing in Ireland*, Constable & Co., London, 1984

Turner, Colin *The Mournes*, Cottage Publications, 1997

Waddell, John *The Prehistoric Archaeology of Ireland*, Galway University Press, 1998

Wall, C.W. *Mountaineering in Ireland*, F.M.C.I. guide, Dublin, 1976

Warner, Richard *A cooking place at Fofannybane, Co Down*, Vol 4, 1991, in *12 Miles of Mourne*

Water Service *The Silent Valley*, D.O.E. publication, May 1986

Watson, E. *The Megalithic and Bronze Ages in County Antrim*, UJA, Vol 8, p 80–118, 1945

Webb, Alfred *A Compendium of Irish Biography*, Gill & Son, Dublin, 1878

Welsh, Henry *Field Surveys undertaken by the Ulster Archaeological Society in 2006*, UJA, Vol 67, 2008

Wheeler, Gordon *John Lynn – Architect/Contractor/Engineer*, article in *Lecale Miscellany*, Vol 15, 1997.

Wilkins, Frances *The Isle of Man in Smuggling History*, Wyre Forest Press, Kidderminster, 1992

Wilkins, Frances *George Moore and Friends; letters from a Manx* (Smuggling) *Merchant (1750-1760)*, Wyre Forest Press, Kidderminster, 1994

Wilson, H.E. *Regional Geology of Northern Ireland*, HMSO, 1972

Wilson, W. *The Post-Chaise Companion or Travellers Directory through Ireland*, Dame Street, Dublin, 1786

APPENDIX: TO SLIEVE DONARD

Stupendous mount of granite stone,
With ample base, and lofty cone,
For ages thou hast stood alone,
 On that wild rocky shore.
And thou shalt still thy vigils keep,
As silent watcher by the deep,
Where storms rage, or tempests sleep,
 Till time shall be no more.

Sometimes thy brow with snow is crowned,
And blooming heather clothes thee round,
Whose purple hues, so rich are found,
 A royal robe for thee.
Now wrapped in cloud as dark as night,
Then bathed in floods of solar light,
O how magnificent the sight!
 Thy kingly peak to see.

Hibernia's ancient legends tell
How Donard built his lonely cell,
That near thy summit he might dwell,
 To meditate and pray;
Far from the haunts of human life,
Far from its pleasures and its strife,
And from the savage scenes so rife,
 In that uncultured day.

The saint at his high altar there,
Oft bowed and breathed his fervent prayer
Upon thy pure, untainted air,
 From which it rose to heaven,
To hear his prayer and even-song,
That flowed devoutly from his tongue,
Far from the thoughtless, vulgar throng,
 Perchance to thee was given.

At times the sage from thy proud crest
Could look out on old Neptune's breast,
Or gaze on landscapes richly dressed,
 In Nature's garments fair;
And see how wave, and wood, and hill,
And sparkling fount, and murmuring rill,
Picturesque vale, and glen so still,
 God's wondrous works declare.

The dark electric cloud when riven,
By some mysterious forces driven,
Has set the latent powers of heaven
 'Gainst thee in fierce array.
But thou, unmoved, hast calmly stood,
Despite the shock of flame and flood,
As now unchanged in form or mood,
 Amid the thundering fray.

Thou wast in olden time brought forth,
None knows the story of thy birth,
Writ in the records of the earth,
 'Tis hid from mortal's ken.
The misty past has it enrolled,
And none the secret can unfold,
So it must yet remain untold,
 Unto the sons of men.

Unnumbered years have pass'd away,
And myriads have lived their day,
Who, on the stage of life did play
 Their parts, as men do now.
The things in which they trusted most,
Of which they vainly made their boast,
Thou hast seen buried in the dust,
 And yet unmoved art thou.

But lo! Earth hastens to that day,
When flame shall seize it as its prey,
Then thou, even thou, shall melt away,
 In the consuming fire.
But millions of the sons of men,
Now sleeping in the dust, ere then
Shall wake, and rise, and live again,
 With their Eternal sire.

If thou, who hast for ages stood,
Against the storm, despite the flood,
Which down thy rugged steeps has flowed,
 Be doomed to pass away.
How fleeting all the works of man!
How vain his most ambitious plan! –
His life on earth is but a span –
 Yet he shall live for aye.

The God who fills eternity.
Whose mighty hand has moulded thee,
Under whose powerful decree
 Thy majesty must bow,
Hath purposed in His loved design,
That man may in His likeness shine,
Redeemed ! Immortal ! so divine !
 He's greater far than thou.

[By R.B. Printed in the Downpatrick
Recorder, 14th December 1895]

INDEX